Art Works

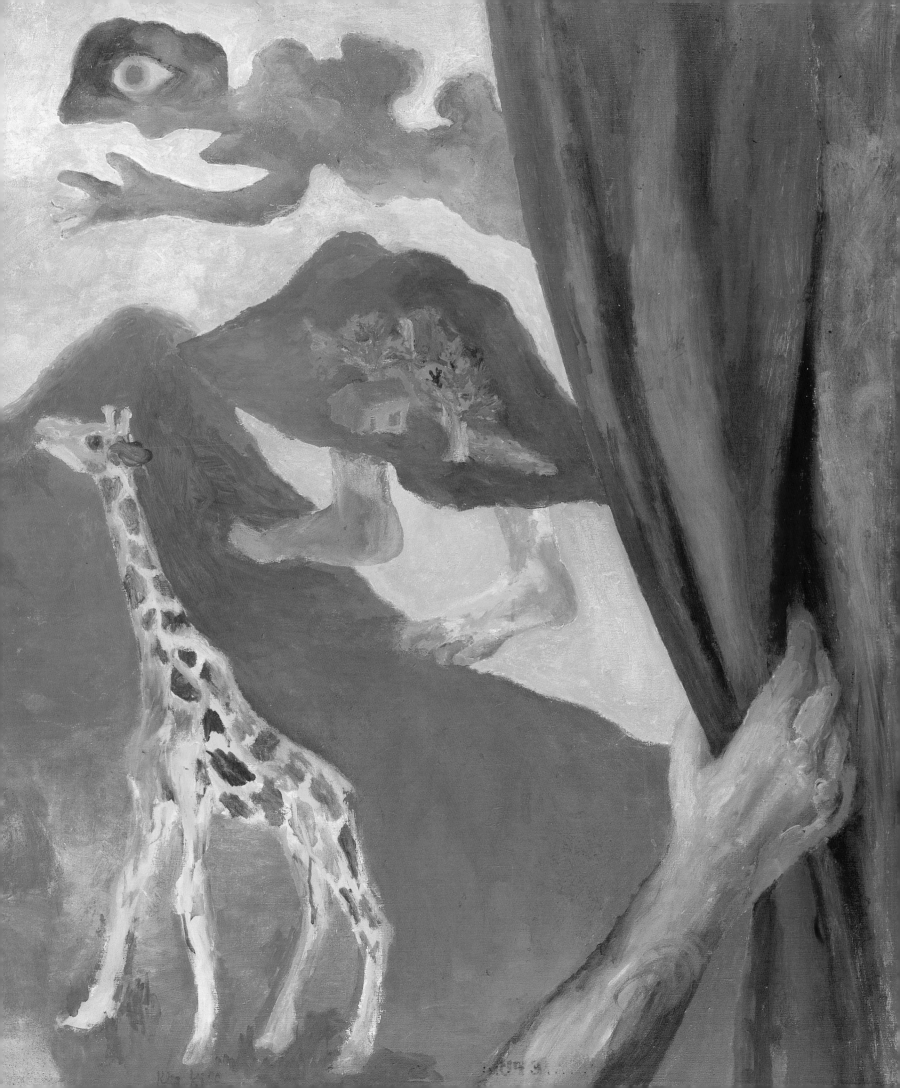

Alistair Hicks

Art Works

British and German Contemporary Art 1960–2000

Edited by Mary Findlay, Alistair Hicks and Friedhelm Hütte

MERRELL PUBLISHERS

Deutsche Bank

Acknowledgements

The formation of the collection and the preparation of this book have benefited from the participation of many individuals, both at Deutsche Bank and elsewhere, to whom we are very grateful.

We wish to thank the Deutsche Bank Art Committee in London, under the chairmanship of John Short, for their long-standing support. They are Jezz Farr, James McKechnie, Julien Prevett, John Short and Don Ventura.

We should also like to thank Merrell Publishers, whose expertise and enthusiasm for the project have made them a pleasure to work with. Special thanks are owed to Hugh Merrell, Julian Honer, Matt Hervey and Kate Ward, as well as to Peter B. Willberg, the designer of the book.

Special thanks also go to Ian Barker, David Case, David Cleaton-Roberts, Alan Cristea, Kathleen Dempsey, John Erle-Drax, Bärbel Grässlin, Jessica Holland, David Hubbard, Kim Kennedy, Nicholas Logsdail, Geoffrey Parton, Simon Pincombe, Nicola Shane, Marian Stone, Nicola Togneri and Anthony Wilkinson.

We should like to take this opportunity to thank Chris Brandon and his team at Pringle Brandon, architects, who, time and again, have ensured that the Deutsche Bank London buildings provide a wonderful environment for the hanging of the art collection.

We should like to thank Jan van der Wateran and his staff at the National Art Library, Meg Duff and her staff at the Tate Library, and Charlotte Lorimer at the Bridgeman Art Library, for their assistance.

We should like to thank Julia Duell, Britta Färber, Ariane Grigoteit and Carmen Schaefer from Deutsche Bank in Frankfurt, who have been very helpful and also very patient with our constant stream of questions.

Special thanks to Lucille Morris at Deutsche Bank, who has assisted the editors enormously in collating the immense amount of information that has gone into the production of this book.

Finally, and most importantly, the book would not have been possible without the artists, not only because of their work, but also for their constant willingness to answer our barrage of questions.

Photo credits

A large number of the photographs of works of art were taken by Gareth Winters, London. Installation shots were taken by Dennis Gilbert/VIEW, London, and Richard Bryant/Arcaid, London.

Contents

Trading floor with
Untitled (1993)
by Gillian Ayres
Gouache and acrylic
on paper

6

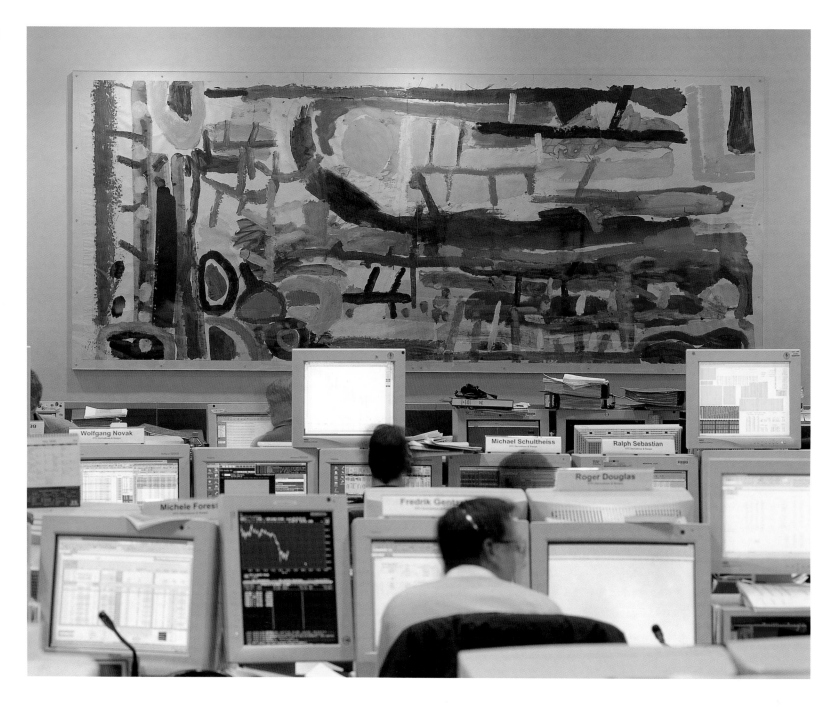

Art works

Deutsche Bank's art collection seeks to bring together art and everyday life, specifically art and the working world, for the mutual benefit of both. Our commitment is based on the conviction that art, as part of our culture and as a major element of our society, should be directly accessible, in the bank, to members of staff, customers and visitors. This means, first and foremost, that it should be visible. Deutsche Bank has therefore been buying modern art since 1979 and displaying it on its premises. Today the collection contains more than 48,000 works of art worldwide.

Besides the Twin Towers in Frankfurt, our commitment to contemporary art also covers 850 branches, including 64 outside Germany. In co-operation with branches and subsidiaries, we devise individual themes on the basis of which works of art are positioned in new or converted buildings. The works displayed at foreign branches form a variant on this theme: works by contemporary German artists are juxtaposed with works by artists from the host country, which often produces interesting dialogues and parallels. In this way, the collection takes on an international flair reflecting the development of the art scene and the profile of the bank.

Art at work stimulates interest. The response has been lively: members of staff have works of art from the bank's collection in their offices and they take part in tours and obtain advice for their private art-collecting activities; museums and art societies borrow individual works or entire exhibitions; about 200 guided tours take place each year in the Twin Towers alone; art calendars and numerous catalogues present works from the collection to a broader public.

A cross-section of art from the bank's Frankfurt towers was shown for the first time in 1988 in Munich and Mannheim. This was followed by exhibitions in Tokyo, Madrid, London, New York, Rome, Paris, Moscow, Latin America and many German cities.

Since 1997 the exhibition space, Deutsche Guggenheim Berlin, has been attracting attention as one of the most interesting places to visit in the German capital. A unique joint venture between a museum and a bank, the name is derived from both partners, Deutsche Bank and the Solomon R. Guggenheim Foundation, as well as from the city itself. Each year the exhibition space hosts three to four important exhibitions, many of which showcase a work specially commissioned by an artist.

The first commission for the Deutsche Guggenheim Berlin, James Rosenquist's ninety-foot-long painting, *The Swimmer in the Econo-mist (Painting 3)*, is now to be seen in the large hall of Winchester House in London.

I am pleased that the acquisition of art in London has taken on the spirit of Deutsche Bank's art concept and hope the collection continues to receive the wholehearted reception it has already.

Dr Rolf-E. Breuer
Spokesman of the Board of Managing Directors, Deutsche Bank AG

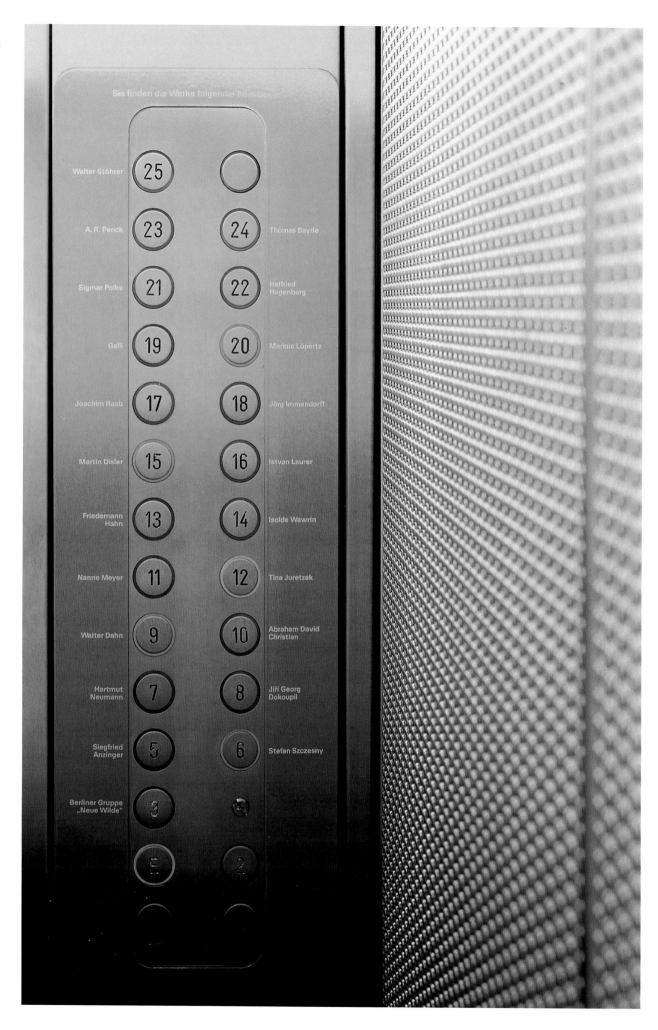

Lift buttons with artists'
names in the Twin Towers
in Frankfurt

Paper works: The bank's concept

Continuity (1986) by Max Bill,
outside the Twin Towers building
in Frankfurt

As witnessed by the ever-increasing size of contemporary art catalogues, art history tends to get thicker the nearer we get to it. While Deutsche Bank's art concept takes account of the need for such extensive explanation of today's art, it has also produced the briefest of all recent histories, the lift buttons at its headquarters in Frankfurt. The visitor to the Twin Towers is confronted not only by floor numbers, but by names of artists to designate each floor. The highest floor of Tower A is dedicated to the painter Horst Antes, and Tower B is topped by Joseph Beuys's floor. The artists get younger and younger as one goes down the building.

The lift buttons are, of course, just a sign that the whole building has been used to tell the recent story of German art. Although the bank has bought art for most of its 130-year-long history and had built up a collection of primarily classic modern works, it was in 1979 that Dr Herbert Zapp, a *Vorstand* member from 1977 to 1994, decided it was time to formulate a coherent art policy for the bank. Dr Zapp asked Professors Peter Beye and Klaus Gallwitz to develop with him an art concept for the bank. By putting this concept into action under professional management the bank has shown that corporate collecting can become an integral part of a company's image. The concept was first introduced in several smaller branches, but the move of the bank's headquarters into the Twin Towers, Frankfurt, in 1984 provided its decisive test.

Concept

The focus of the bank's collection was initially to be works on paper by artists from German-speaking countries from the second half of the twentieth century. Peter Beye and Klaus Gallwitz explain their reasons for this specialization:

"The works in the collection have a very broad spectrum from the first rough depiction of an idea to the final composition, from autonomous drawings, watercolours, collages and gouaches to works in the most varied of composite technical forms. The far-reaching preference for this medium … lies primarily in the unique diversity of its artistic use, while also accommodating the possibilities of younger artists for whom paper is often the most practical, easily accessible and economical material."[1]

As the bank has grown, nationally and internationally, so too has the collection. The concept has therefore broadened, so that in Deutsche Bank's offices outside Germany, works by artists from the host country sit alongside those of German artists. As a result,

Director's office with works by
Andrea Zaumseil

Reception area with works by
Andrzej Jackowski and John Davies

Corridor with works by
Gillian Ayres and Sigmar Polke

Reception area with works by
Tony Cragg and James Rosenquist

10

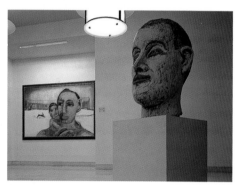

the bank now has the largest international contemporary collection on paper in the world. In Paris, for instance, a Baselitz stands beside a Combas, a Stöhrer beside a di Rossa, and in London the work of Gillian Ayres hangs with that of Polke.

The bank uses its buildings to tell the recent history of art, as this is one of the most direct ways of interesting people in art. Since London has been able to emulate Frankfurt in using its London Wall headquarters, Winchester House, to give a coherent glimpse of today's art, the interest in the collection has dramatically increased. Winchester House has a skeletal collection of the work of older artists, but this is meant to lead into the many other buildings in London. The thrust of the collection is towards young artists.

From the beginning the bank recognized the need to break their own rules by using canvases and sculptures when the scale of the space demanded it. For instance, the third

floor of the Twin Towers has several large canvases by *Zeitgeist* painters. In the reception area of Winchester House in London we have large sculptures such as Anish Kapoor's *Turning the World Upside Down III* (1996) and Tony Cragg's *Secretions* (1998). While the work in this area is largely abstract, next door, at 23 Great Winchester Street, there are figurative paintings and sculpture in the entrance hall.

The bank does not buy art for investment. It puts art on the walls to bring staff and clients into contact with the arts and to support young artists and the galleries that represent them. Works are purchased on the primary market – from galleries or occasionally directly from the artists – but not from auction houses.

It is not just the purchase of works of art that is important. The hanging of the pictures is also crucial, as the purpose of the collection is to encourage people to like art, not to antagonize them. Dr Zapp went beyond this in stating:

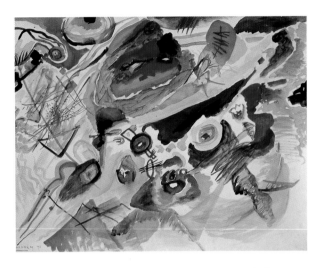

11

"Our concept does not end when the art works are hung, but includes the 'communication' of contemporary art to employees and customers. By purchasing and hanging pictures in staff or client meeting rooms, people who have previously had little or no contact with this segment of our cultural life are brought face to face with contemporary art."[2]

Dr Breuer adds, in his preface to this book, that employees are encouraged to become involved with the collection, and in Frankfurt, London and New York tours are organized with this aim in mind. In Frankfurt, most of the represented artists have visited the building. Around the world, employees and visitors have bought from the artists' galleries on the basis of what they have seen in the offices.

Frankfurt

In 1984 Deutsche Bank moved into the newly designed Twin Towers in Frankfurt am Main. It was the successful application of the concept in the Twin Towers that was to supply the role model for the bank around the world.

The Art Department in Frankfurt was responsible for using a building to give a three-dimensional introduction to art. As the idea evolved into practice, the building became a stage for artists and their work.

There was a reaction between art and those that use the building. In naming each floor after an artist, some staff began to associate with a particular artist. Artist visits and talks have built up this relationship.

The original art concept concentrated on the development of a collection of the very latest art. In devoting floors and rooms to artists there was always an emphasis on buying considerable holdings of their work. The bank wanted to give a reasonable idea of each individual artist's œuvre.

To balance the new collecting activities it was decided that important single works should be acquired in the areas in which the bank had already been collecting – classic modern art, and in particular German Expressionism and Bauhaus. An appreciation of art does not need to be tied to one era, and as artist after artist has admitted in their statements in this book, the work of the masters of the first half of the twentieth century, such as Kandinsky and Klee, have a very real impact on the creation of new art today. The bank filled in gaps in this earlier collection so that it could be exhibited in Frankfurt, Leipzig and Berlin to celebrate the bank's 125th anniversary, in 1995.

David Bomberg
El Barrio San Francisco Ronda, Andalucia,
1954
Oil on board
62×76 cm (24¹/₂×30 in.)

The bank's commitment to art led to the opening of the Deutsche Guggenheim Berlin in 1997, an exhibition space created jointly by Deutsche Bank and the Solomon R. Guggenheim Foundation. The galleries were designed by the architect Richard Gluckman and are on the ground floor of the newly restored Berlin branch of Deutsche Bank, in Unter den Linden. Three or four exhibitions of modern and contemporary art are presented each year, some of which are specially commissioned for the space.

Independently of the Deutsche Guggenheim Berlin, the bank also organizes exhibitions of various parts of the collection in external venues. For instance, in 2000 the *Landschaften eines Jahrhunderts* (One hundred years of landscape) exhibition travelled to Duisburg, Lübeck and Passau.

London
David Bomberg's *El Barrio San Francisco Ronda* (1954) was presented by the Board of Managing Directors in Frankfurt to the London branch when it opened in 1973. This canvas is still a highlight of the collection, which now consists of over 2500 pictures.

Once the art concept had been shown to work it was decided to extend its application worldwide. This started seriously in London towards the end of the 1980s. Under the guidance of Claus Bertram and Manfred Zisselsberger a department was created, which was run by Ann Slavik until 1996. An art committee was formed to supervise all events, which is currently under the chairmanship of John Short.

The opening in March 1999 of Winchester House, the new British headquarters of Deutsche Bank, gave London the opportunity to emulate the display of art in Frankfurt's Twin Towers. With its double reception hall, Winchester House could have been designed to show the dual-nationality collection. In the Great Winchester Street entrance there is a sentinel totem by the young German sculptor Hubert Kiecol. It guards a diptych by Imi Knoebel, which leads on to a hall of British art. Anish Kapoor's *Turning the World Upside Down III* (1996) sits in front of Damien Hirst's spot painting *Biotin-Malemide* (1995; see p. 140). In contrast, those approaching from London Wall see a pair of paintings by the German artist Günther Förg. Förg openly mocks art as interior decoration and yet,

Untitled, sculpture by
Hubert Kiecol, and *Figure I and II*
by Imi Knoebel

Corridor and conference room
with works by Francis Bacon
and Graham Sutherland

in parallel with Hirst, plays along with it.

In a reflection of the floors in Frankfurt, each of the conference rooms in the London building have been named after British and German painters, sculptors and photographers. Graham Sutherland, Victor Pasmore and Francis Bacon start off the British-named rooms, while Arnulf Rainer, Wolf Vostell and Dieter Roth begin the rooms devoted to German-language artists. As in Frankfurt, each room contains a biography of the artist and a book illustrating their work. The concept is not only applied to Winchester House but is also continued in the other London buildings.

The diagrams overleaf show the thinking behind the Frankfurt and London collections. While a few floors in the bank's London buildings are devoted to single artists, the larger trading and staff floors have been given themes, some of which link with the reception areas. Prints and drawings by sculptors such as Anish Kapoor and Hubert Kiecol have one floor, landscape artists such as Ian McKeever and Andy Goldsworthy adorn another, and

photographers such as Rut Blees Luxemburg, Susan Derges and Christopher Bucklow furnish another. Famous exhibitions supply themes for three other floors: *The Human Clay*, which was held at the Hayward Gallery in 1976; *Zeitgeist*, held in Berlin in 1982; and *Sensation*, the Royal Academy's exhibition in 1997 of the YBAs (Young British Artists: Damien Hirst and friends).

Frankfurt

Tower B	Tower A
B 37 Joseph Beuys	
B 36 Erwin Heerich	
B 35 Marcel Broodthaers	
B 34 Karl Bohrmann	
B 33 Stefan Wewerka	
B 32 Horst Janssen	
B 31 Arnulf Rainer	
B 30 Dieter Roth	
B 29 Bernd + Hilla Becher	
B 28 Gerhard Richter	
B 27 Dieter Krieg	A 27 Horst Antes
B 26 Antonius Höckelmann	A 26
B 25 K.H. Hödicke	A 25 Walter Stöhrer
B 24 Georg Baselitz	A 24 Thomas Bayrle
B 23 Imi Knoebel	A 23 A.R. Penck
B 22 Pidder Auberger	A 22 Helfried Hagenberg
B 21 Blinky Palermo	A 21 Sigmar Polke
B 20 Nicole Van den Plas	A 20 Markus Lüpertz
B 19 Johannes Brus	A 19 Galli
B 18 Michael Buthe	A 18 Jörg Immendorff
B 17 Ann Reder	A 17 Joachim Raab
B 16 Artur Stoll	A 16 Istvan Laurer
B 15 Hubert Kiecol	A 15 Martin Disler
B 14 Felix Droese	A 14 Isolde Wawrin
B 13 Bernd Vossmerbäumer	A 13 Friedemann Hahn
B 12 Peter Bömmels	A 12 Tina Juretzek
B 11 Peter Chevalier	A 11 Nanne Meyer
B 10 Gerald Domenig	A 10 Abraham David Christian
B 9 Thomas Schütte	A 9 Walter Dahn
B 8 Andreas Schulze	A 8 Jiři Georg Dokoupil
B 7 Manfred Stumpf	A 7 Hartmut Neumann
B 6 Markus Oehlen	A 6 Stefan Szczesny
B 5 Gunter Damisch	A 5 Siegried Anzinger

E3 Elvira Bach, Hans Brosch, Rainer Fetting, Johannes Grützke, K.H. Hödicke, Bernd Koberling, Thomas Lange, Helmut Middendorf, Max Neumann, Meret Oppenheim, Salomé, Bernd Zimmer

E2 Georg Baslitz, Jörg Immendorff, Anselm Kiefer, Dieter Krieg, Markus Lüpertz, A.R. Penck, Sigmar Polke

London

British Painters	German Painters	Sculptors	Photographers
Michael Andrews	Georg Baselitz	Edward Allington	Kate Belton
Frank Auerbach	Rainer Fetting	Joseph Beuys	Christopher Bucklow
David Austen	Ralph Fleck	Lynn Chadwick	Hannah Collins
Gillian Ayres	Günther Förg	Stephen Cox	Susan Derges
Francis Bacon	Friedemann Hahn	Tony Cragg	David Hiscock
John Bellany	K.H. Hödicke	Michael Craig-Martin	Michael Kenna
Ann Bergson	Jörg Immendorff	John Davies	Rut Blees Luxemburg
Tony Bevan	Imi Knoebel	Richard Deacon	Katharina Sieverding
Elizabeth Blackadder	Markus Lüpertz	Hamish Fulton	Thomas Struth
Peter Blake	Christa Näher	Andy Goldsworthy	Catherine Yass
Rachel Budd	Marcus Oehlen	Anish Kapoor	
Patrick Caulfield	A.R. Penck	Henry Moore	
Prunella Clough	Sigmar Polke	David Nash	
Maurice Cockrill	Arnulf Rainer	Ana Maria Pacheco	
Melanie Comber	Gerhard Richter	Eduardo Paolozzi	
Alan Davie	Dieter Roth	Cornelia Parker	
Jonathan Delafield Cook	Eugen Schönebeck	Richard Wilson	
Arturo Di Stefano	Walter Stöhrer		
Felim Egan	Günther Uecker		
Stephen Farthing	Wolf Vostell		
Mark Francis	Bernd Zimmer		
Lucian Freud			
Terry Frost			
Richard Hamilton			
Tom Hammick			
Adrian Henri			
Patrick Heron			
Roger Hilton			
David Hockney			
Howard Hodgkin			
John Houston			
Paul Huxley			
Bill Jacklin			
Andrzej Jackowski			
Glenys Johnson			
Allen Jones			
Ken Kiff			
R.B. Kitaj			
Leon Kossoff			
Christopher Le Brun			
Alice Maher			
Ian McKeever			
Ian Mckenzie Smith			
Lisa Milroy			
Hughie O'Donoghue			
Thérèse Oulton			
Victor Pasmore			
Celia Paul			
Michael Porter			
Libby Raynham			
Paula Rego			
Bridget Riley			
Sean Scully			
Estelle Thompson			
Charlotte Verity			
John Walker			

15

"Here's how *The Human Clay* came about: The Arts Council asked me to select a show for them in the mid-seventies and to buy them many of the pictures. I think they gave me £12,000 to spend. I decided to do two main things. First, I thought I'd buy and borrow mainly drawings of the human form because the teaching and learning of drawing had been going down the toilet in the art schools despite the fact that the two greatest Modernists had also been the two greatest draughtsmen of the human figure in our time.[1] Secondly, I looked at London and I realized in a flash that some of the best artists and art in the world were being shown there in my then adopted city, my double diaspora. It was a stunning moment. Bacon and Moore were still alive and Hockney was mostly in London. Freud, Auerbach, Hamilton, Blake, Kossoff, Caro, Andrews, Hodgkin and others were doing world-class art. So, I chose about fifty artists, both known and unknown, and I called them School of London, which for some reason became a hated term to many mean-spirited art critics. All my life I had heard the very loose terms School of Paris and School of New York, meaning only that many very good artists were at work in those cities at the same time during brilliant periods (many of whom were born abroad). School of London was an inexact term but so were the other two schools. Little did I know that coining the term would add to the storehouse of personal hatred for me built up by Xenophobes in London's heated Art Kulcher. My enemies would not be undercut by an American Jew Polemicist Exegete.

Anyway, I was deeply in love and London had mostly been good to me and to my beautiful Sandra. So, she and I spent about a year going to studios and collecting pictures of people. It was fun and we discovered some lost treasure. Two Americans showing the Brits how good their art was. London had never known a period of such grand artists before or since.

Over the next twenty-five years, the term School of London was often preceded by the term 'so-called' by dreary hacks, and protagonists cut the original dozens down to about six painters as a core group in many shows and books. To make a long story short, when Sandra died, during my Tate War, London also died for me. As I was leaving London to return home to California, the Royal Academy gave me a goodbye room including some of the painters shown in *The Human Clay*. And so I wrote on the wall that the vexed School of London was closed that Summer of 1997."

R.B. Kitaj March 2000

1 Questioned on this, Kitaj reassured us that Picasso and Matisse were the two greatest Modernists.

previous page
R.B. Kitaj at Work, 1980
Photograph
Courtesy of National
Gallery, London

Frank Auerbach
Working drawing for
Looking Towards
Mornington Crescent
Station, 1972–74
Pencil on paper
22.5 × 22.8 cm (9 × 9 in.)

Theme 1: *The Human Clay* (1976)

An exhibition selected by the Anglo-American
artist R.B.Kitaj for the Arts Council of Great
Britain. It was shown at the Hayward Gallery,
London, in 1976 and toured the country.

"I have felt very out of sorts with my time", was
Kitaj's opening confession in his catalogue
for *The Human Clay* back in 1976. He acted on
these words in 1998 when he finally decided
to leave Britain and return to the States after
living in London for over thirty years. Yet in
the intervening years his exhibition had a
dramatic impact for British art and the way
it was perceived, both at home and abroad.
It was in this catalogue that Kitaj coined the
phrase "The School of London".

Kitaj pointed out that London boasted many
artists who were prepared to work outside the
rigid avant-gardism of the time. As he wrote:

"The bottom line is that there are artistic per-
sonalities in this small island more unique
and strong and I think numerous than any-
where in the world outside America's jolting
artistic vigour …. There is a substantial
School of London … if some of the strange
and fascinating personalities you may
encounter here were given a fraction of the
internationalist attention and encourage-
ment reserved in this barren time for

provincial and orthodox vanguardism,
a School of London might become even
more real than the one I have construed
in my head. A School of real London in
England, in Europe … with potent art
lessons for foreigners emerging from this
odd, old, put upon, very singular place."[3]

Kitaj's vision of a School of London caught
on, and with the help of the British Council
and curators around the world it became as
internationally famous as Kitaj predicted.
However, the art world is chronically prone
to fashion, and the 1990s have witnessed a
return to another type of vanguardism that
once more made Kitaj feel excluded.

There were fifty-four artists included in
The Human Clay, and almost all of them were
chosen to illustrate Kitaj's point that the study
of the human figure was still alive and well.

Rainer Fetting
Klaus, 1983
Acrylic on paper
70 × 50 cm
(27 1/2 × 19 3/4 in.)

Kitaj's argument was against the rigid application of theory to art. As he concluded, "No one will own the truth – as [Ezra] Pound said once, 'despite all the hard-boiled and half-baked vanities of all the various lots of us' – there will always be various lots of truths according to the odd lives we lead".[4]

Participating artists:

Michael Andrews	Richard Hamilton
Frank Auerbach	Howard Hodgkin
Francis Bacon	Allen Jones
Adrian Berg	R.B. Kitaj
Peter Blake	Leon Kossoff
Frank Bowling	Helen Lessore
Olwyn Bowey	John Lessore
Stephen Buckley	Kenneth Martin
Rodney Burn	Robert Medley
Richard Carline	Leonard McComb
Anthony Caro	Eduardo Paolozzi
Patrick Caulfield	Philip Rawson
William Coldstream	William Roberts
Richard Cook	Tony Scherman
Peter de Francia	Peter Schlesinger
Jim Dine	William Scott
Sandra Fisher	Colin Self
Lucian Freud	Stella Steyn
Patrick George	William Turnbull
John Golding	Euan Uglow
Lawrence Gowing	Elizabeth Vellacott
Maggi Hambling	Carel Weight

Theme 2: *Zeitgeist* (1982)
At the Martin-Gropius-Bau, Berlin. Curated by Norman Rosenthal of the Royal Academy, London, and Christos Joachimides.

Zeitgeist (meaning 'spirit of the moment') was the exhibition that brought figurative painting screaming to international prominence. Though preceded by its sister exhibition, *A New Spirit in Painting* (1981) at the Royal Academy, it was *Zeitgeist* that demonstrated most clearly the desperate desire to break free from the formalist thinking of critics.

Mentors such as Joseph Beuys, K.H. Hödicke, Georg Baselitz, Sigmar Polke, Cy Twombly and Andy Warhol were included, but the exhibition was dominated by the wild painting of a new generation, mainly German with vital contingents from Italy and America.

Participating artists:

Siegfried Anzinger	Anselm Kiefer
Georg Baselitz	Per Kirkeby
Joseph Beuys	Bernd Koberling
Erwin Bohatsch	Jannis Kounellis
Jonathan Borofsky	Christopher Le Brun
Peter Bömmels	Markus Lüpertz
Werner Büttner	Bruce McLean
James Lee Byars	Mario Merz
Pierpaolo Calzolari	Helmut Middendorf
Sandro Chia	Malcolm Morley
Francesco Clemente	Robert Morris
Enzo Cucchi	Mimmo Paladino
Walter Dahn	A.R. Penck
René Daniels	Sigmar Polke
Jiři Georg Dokoupil	Susan Rothenberg
Rainer Fetting	David Salle
Barry Flanagan	Salomé
Gerard Garouste	Julian Schnabel
Gilbert and George	Frank Stella
Dieter Hacker	Volker Tannert
Antonius Höckelmann	Cy Twombly
K.H. Hödicke	Andy Warhol
Jörg Immendorff	

Theme 3: *Sensation* (1997)

Exhibition of Young British Artists from the Saatchi Collection, shown initially at the Royal Academy, London (1997), and then at the Hamburger Bahnhof, Berlin (1998–99), and Brooklyn Museum of Art, New York (1999–2000).

"With the exception of Lassie, Sean Connery is the only person I know who's never been spoiled by success." Terence Young[5]

Young British Artists (YBAs) never had any desire to emulate Sean Connery, or Lassie for that matter. They had every intention of being spoiled by success from the moment they decided to be artists. The *Sensation* exhibition did not create their fame, it just confirmed it, propelled it on to another level.

The hard core of the *Sensation* artists had made their reputations even before they had left Goldsmiths' College, London, in a series of East End, artist-organized, warehouse shows – the most famous of which was *Freeze* in 1988. Nine out of the original sixteen *Freeze* artists were included nine years later in the Royal Academy show, among them Damien Hirst.

The dictonary definition of sensationalism is, "n.: theory that ideas are derived solely from sensation".[6] The YBAs have carried on where Andy Warhol left off, with a dry reflection on society's preoccupation with fame.

Simon Patterson
The Great Bear, 1992
(detail)
Four-colour offset
lithograph
109×134.8×5 cm
(43×52³/₄×2 in.)
Edition: AP/50

Participating artists:

Darren Almond	Paul Finnegan	Martin Maloney	James Rielly
Richard Billingham	Mark Francis	Jason Martin	Jenny Saville
Glenn Brown	Alex Hartley	Alain Miller	Yinka Shonibare
Simon Callery	Marcus Harvey	Ron Mueck	Jane Simpson
Jake and Dinos Chapman	Mona Hatoum	Chris Ofili	Sam Taylor-Wood
Adam Chodzko	Damien Hirst	Jonathon Parsons	Gavin Turk
Mat Collishaw	Gary Hume	Richard Patterson	Mark Wallinger
Keith Coventry	Michael Landy	Simon Patterson	Gillian Wearing
Peter Davies	Abigail Lane	Hadrian Pigott	Rachel Whiteread
Tracey Emin	Langlands and Bell	Marc Quinn	Cerith Wyn Evans
	Sarah Lucas	Fiona Rae	

"I don't see myself as an artist. My pictures are nothing more than reportage photography. It is the people in front of the camera that matter. The only art is being in the right place at the right time. My aims have changed a little since I first started taking photographs in 1996. I suppose I've calmed down a bit and would like to think that it is possible to combine reportage with creating a beautiful image. Posed formal portraits attempting to capture the creative spirit don't interest me.

It all began one night at the restaurant St John's in Clerkenwell, after Cerith Wyn Evans's opening at White Cube. I had an Instamatic camera in my pocket and started to take late-night photographs. I continued over the next few years. St John's was to the 1990s what Wheeler's was to the 1960s. John Deakin, who took all those photographs of Bacon, is by far my favourite photographer. Nothing tricksy – just in-your-face portraiture. Although I realize it looks contrived, it was in fact pure accident that I caught Cerith and Gary Hume under Deakin's best-known image, which was hanging in another old haunt of the 1960s, The French House.

I used to work in a Bond Street gallery. The thing that turned it for me was the Leigh Bowery memorial exhibition I helped organize with Nicola Bowery and Sue Tilley. Both the contents of the show and the people who visited the gallery opened my eyes to the necessity of getting out of Bond Street. Shortly after my departure I started to use my 'point-and-shoot', and a new career emerged. I try not to impose my ideas on a picture. I don't ever go along with preconceived ideas. Things just happen and the skill is just to capture them. Of course, there are some places where you can be pretty sure to find a good image – the Colony Room, for example. Sarah Lucas used to work behind the bar there one night a week. Some artists require the solitude of the studio; others, like Sarah, require the contact of her contemporaries to stimulate her. Artists do have a good time but they are also each other's toughest critics – very healthy.

The picture of Jay Jopling before and after the missed penalty in the German-English semi-final shows how all-embracing it all is. His gallery, White Cube, doesn't represent either Sarah Lucas or Angus Fairhurst, who also feature in the photograph.

As I was a great fan of *Private View*, the book of Snowdon's photographs of the art world in the sixties, I thought it would be a good idea to make a book for the nineties. Though I am glad of the reservoir of images I gained from my time as a dealer in nineteenth-century pictures, it was pure heaven when I left – no more rich spoiled clients to worry about. I was with my own age group again."

Johnnie Shand Kydd, April 2000

Johnnie Shand Kydd
*Cerith Wyn Evans and
Gary Hume*, 1996
Photograph
46×30.5 cm (18×12 in.)

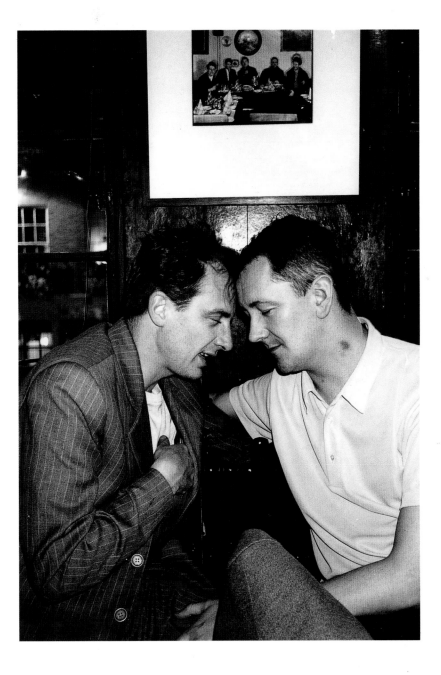

Ian McKeever
Blue No. 1, 1998
Woodcut monoprint
in four parts
224 × 160 cm
(88¼ × 63 in.)

24

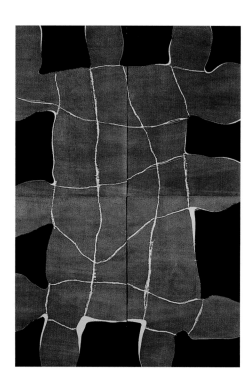

Theme 4: Landscape

At last nature is coming back into young artists' vocabulary. For much of the second half of the twentieth century landscape art had become a victim of its own success, but now young painters as well as photographers and sculptors have found this forbidden territory a rich hunting-ground.

Critical support for neo-Romantic painters such as Graham Sutherland, John Piper and John Minton declined with a rising distrust of the idyllic view of the land. In the 1930s, Piper, in his abstract period, was considered radical, yet his commendable achievement of record-ing a disappearing heritage, with photographs in the Shell Guides and in his paintings, placed him by association in the conservative camp.

The first attempts in recent history to present landscape in a radical way were by sculptors – the Land artists (in Britain, Richard Long and Hamish Fulton). Andy Goldsworthy, the next generation, showed an increasing reliance on photography. Susan Derges, Garry Fabian Miller and Daro Montag have all engaged directly with nature, using processes on the borders of sculpture and photography.

"Since we no longer know what it is to be natural, nature is no longer a norm",[7] wrote the American critic Donald Kuspit in 1983. This widening gap between man and nature has stimulated a response from artists. In the last twenty years they have subjected nature to the microscope and used its own diagrams and internal maps. Two recent exhibitions, *Global Art* at the Museum Ludwig, Cologne, and the *Greenhouse Effect* at the Serpentine Gallery, London, have concentrated on how installation artists are increasingly incorpor-ating animals and plants into their work, but this is only part of a broader move by artists, whether they are painters, photographers or sculptors, literally to revitalize art.

Andy Goldsworthy
Hollow Snowball Wet Rapidly Thawing Snow, 7 March 1995

Unique Cibachrome prints
Title page: 24.6×24 cm
(9¹/₂×9¹/₄ in.)

Others: 47.6×132 cm
(18³/₄×52 in.) each

Theme 5: Sculpture

"Thought is Sculpture", Joseph Beuys frequently proclaimed. As well as being the ultimate conceptual statement, the artist was offering a solution to a very practical problem that has plagued sculptors throughout the ages – the cost of materials.

The expense of making sculpture is a serious barrier to young artists. It means that even well-established sculptors spend much of their time raising money and presenting plans, rather like architects. It also means there is a large waste of ideas, as many projects lie unfulfilled.

Photographs, drawings and prints are sometimes the only records of a work of sculpture. With Andy Goldsworthy, it is actually conceived that way. He knew that the snowballs that he placed in the heart of the City of London on Midsummer's Day were going to melt in hours. For Rachel Whiteread, though she fought the destruction of her *House* in the East End of London, she always feared the day would come when the bull-

dozers would knock it down. Richard Wilson believed he was going to be able to transform the Baltic Flour Mills in Gateshead into a windmill with beams of light for sails, but in the end the first director of the Tyneside museum decided against it. Wilson's drawings, some of which are in the bank's collection, remind us of the potential of the thought – the sculpture.

Theme 6: Photography

"Photography is truth",[8] declared Jean-Luc Godard. He went on to add that "Cinema is truth twenty-four times per second". Yet artists today of all descriptions, whether they use canvas, cameras or ready-mades, are questioning precisely this – the verisimilitude of photography, the truth of the images with which we are bombarded day and night. Our society is based on information being supplied on screens, yet years of political and commercial propaganda – Hollywood films, advertisements and computers – have taught us the joys of manipulation.

The mistrust of the photographic image is a recent phenomenon, built up by our increasing reliance on photographic honesty. Painters have incorporated photographs to give their work a solid point of reference. In the 1970s and 1980s Bernd and Hilla Becher built up the objectivity of the photograph, with their direct frontal shots developed into a series. Thomas Ruff, a pupil of theirs, continued the approach into human portraiture, but then advertisers started copying them. The authority of the photograph was undermined by its own success.

In the 1990s the line between advertising and art was mocked on both sides, so that the young German photographer Wolfgang Tillmans, who lives in London, presents images from his commissioned commercial work alongside his 'art'. Mat Collishaw goes round catching fairies. Don Brown produces a mountainscape on his computer that might even be too sweet for Julie Andrews. Anna Mossman confronts us with frontal shots of people, but unlike Ruff's models, hers are

shrouded in darkness as they are in the process of confiding their innermost secrets.

Rut Blees Luxemburg has capitalized on the frustration at the ambiguity of the medium. She shows a purgatorial vision of the city at night, yet always seems to be promising a way through the smooth, rich surface. There are tempting gaps, but, however seductive, there is a sense that the truth will be cold, shocking and icy. Her photographs are a warning that we are no longer used to the truth, that we have been lulled for so long by soothing images that we are no longer capable of living with the truth.

Paper bias

Attempting to tell the recent history of British and German art using a collection that is composed mainly of works on paper has its restrictions and its excitements. In our frequent references to artists and works outside the collection we are acknowledging the limitations of the collection. Paper can

provide only part of the story. The history of paper works may be a humble one, but it has its own moments. As Peter Beye and Klaus Gallwitz observed, paper is often one of the few materials that young artists can afford.

There is a gentle irony that a bank that relies less and less on paper to carry out its everyday work should build up a collection of some 48,000 works of art on paper. The most modern technology is being harnessed by artists, yet sometimes the end result can be found on paper – often as the only solid record of a valuable transaction or event. Many artists at the moment are interested in memory, and how we use and abuse it. Paper is a trusted material. Paper works.

**Mary Findlay, Alistair Hicks
and Friedhelm Hütte**

1 *Auf Papier. Kunst des 20 Jahr-hunderts aus der Deutschen Bank*, exhib. cat. by Peter Beye, Klaus Gallwitz, Ariane Grigoteit, Friedhelm Hütte, Claudia Schicktanz, Herbert Zapp, Frankfurt, Schirn Kunsthalle, *et al.*, 1995, p. 8.
2 *Contemporary Art at Deutsche Bank London*, Frankfurt (Deutsche Bank) 1996, p. 7.
3 R.B. Kitaj, in *The Human Clay*, exhib. cat. by R.B. Kitaj, London, Hayward Gallery, 1976, unpaginated.
4 *Ibid.*
5 Quoted in David Lodge, 'Fame: What is it good for?', *The Times*, 7 July 2000, p. 4.
6 *Concise Oxford Dictionary*, 5th edn, Oxford (Oxford University Press) 1964.
7 Donald B. Kuspit, in *Expressions: New Art from Germany*, exhib. cat., The St Louis Art Museum *et al.*, 1983, p. 44.
8 Jean-Luc Godard, *Le Petit Soldat*, directed by Godard, 1960.

K.H. Hödicke
Berlin Mural, 1994
Hahnemühle passepartout card
100×140 cm
(39 1/2 × 56 in.)
Edition: 18/20

28

Before I moved to Berlin at the end of the fifties I was in Munich, so was very much aware of *Die Brücke*, *Der Blauer Reiter* and the Expressionists. Then at America House in Berlin I saw exhibitions of the Abstract Expressionists. For a couple of years or so I was an *informel* painter.

At that time it was bad to be a narrative painter, but on reflection I found it to be a good thing. After all, we have painted narrative pictures for thousands of years. The painting at the time became just nothing, it was white and boring, my Catholic attitude rebelled. I am not actually Catholic, but I did yearn for colour sensations and wanted images. I remember seeing Pollock's *Portrait and a Dream* (1953), the painting with the big head. I returned to figures and colours.

My studio in the sixties and seventies was in Grossgörshenstr. 35, then Dessauer Strasse, and I could look out and see straight across to the Martin-Gropius-Bau. There was just a big open space of bleak rubbish and sand in the middle. This had once been the centre of the city. It was on the wind shadow of the Wall. It was the former centre of the city and it had imploded.

I made some pictures of a pretty girl taking a dog for a walk beside the Wall. It had a Sunday afternoon atmosphere. There was a dirty old dog around called Big Slaughterer. I called one of the paintings *Beauty and the Beast*.

Being a painter in Berlin has been good. We had no customers here, which gave us the opportunity to think about art. I painted with an industrial primer and a brush designed to paint radiators. My students and I used cheap materials.

I didn't invent the term *Zeitgeist*. I had known Christos Joachimides for some ten years before *The New Spirit in Painting* at the Royal Academy and *Zeitgeist* in the Martin-Gropius-Bau. I do remember taking my students[1] and showing them my paintings of 1962–64. It was good when we came to London, as gallery people who hadn't seen much German art seemed quite interested in what we were doing."

K.H. Hödicke, April 2000

Of the *Heftige Malerei* painters, Salomé and Middendorf were students, and although Fetting and Zimmer never actually studied under

Georg Baselitz
The High Stone, 1969
Ink, watercolour, oil, chalk
and pencil on paper
57×43 cm (22×16 in.)

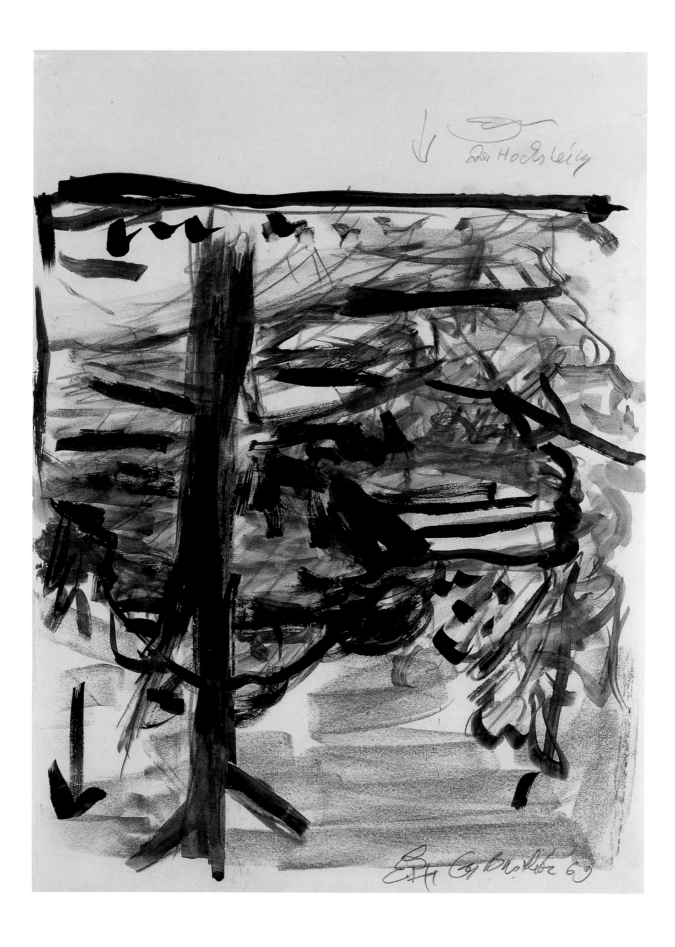

Roots

"History is more or less bunk. It's tradition. We don't want tradition. We want to live in the present and the only history that is worth a tinker's damn is the history we make today."
Henry Ford[1]

Bunk and debunk are useful words in the study of the last forty years of art. A number of recent artists have gone as far as believing that art history is at an end. Their attack has been directed at the way critics and the public at large like to pigeon-hole artists to fit into a neat linear view of the world: Cézanne (1839–1906) begat Picasso (1881–1972), Picasso begat Bacon (1909–1992), Bacon begat Dumas (born 1953) and so on in biblical succession. As feminists, conceptualists and others have fought to break away from the idea of beauty that prevailed before female emancipation or before the death of imperialism, art historians have equally struggled to find a new approach to presenting history.

The attempts to devise totally new structures of aesthetics, both by artists and historians, have not succeeded. Indeed, in the London of the 1990s it looked almost as if debunking artists had banished theory for good, but though subversive one-liner art may have dominated the art headlines, much of the strongest work being produced now has links with that of earlier Modernists. The threads connecting today's artists with the founding fathers of twentieth-century art may be taking some strange convoluted routes, but they are very much in evidence. The last forty years have witnessed the failed attempt to kill Modernism. Post-modernism is over (it was only a negative catchphrase anyway); we are now entering the age of the Ultra-modernists, those artists prepared to pick their way through the magpie vagaries of Post-modernism and commit themselves to intellectually coherent positions.

It is impossible to make any sense of British and German art in the latter half of the last century without looking at America. There is no doubting the leading role of American culture. It hangs over us in Europe rather like the ninety-foot-long painting by James Rosenquist (born 1933) that dominates Deutsche Bank's London reception. Paradoxically, British and German artists have shown both the greatest dependence on and greatest resistance to the American view of art in the last forty years. One might have suspected that the most vigorous attempts to revive Modernism would have come from American artists. After all, it has been their lifeblood ever since New York came to prominence in the art world in the 1950s. Yet in Britain and Germany we are more used to the idea of regeneration, the need to build again and reinvent ourselves.

32

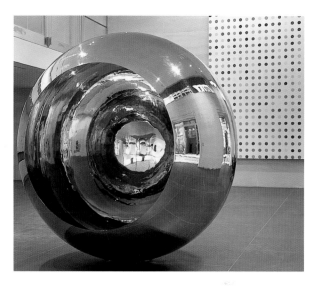

Turning the World Upside Down III (1996), a large steel sphere by Anish Kapoor (born 1954), is a contemplative work, strangely out of step with the quick-fix, one-liner works of Damien Hirst (born 1965), with whom he is contrasted in the bank's London reception hall. Viewers can see their reflections upside down in the bowl of the ball. It is a straight-forward challenge, an invitation to question the way we see ourselves and the world. The quiet manner of the question does not suggest that the artist is asking us to make a complete break with the past.

Back in 1969, however, when Georg Baselitz (born 1938) first turned the world upside down, there was a sense of outrage, a great urgency to start completely afresh. One of the first images that he inverted was the tree. It can be read as the boldest of attacks, a fundamental uprooting of tradition. Yet there was another side to it. The artist has always claimed that the main reason he turned the image upside down was to make the viewer concentrate on the formal qualities of the picture – to see the composition afresh, not to be distracted by the image. As Gombrich frequently declares, the human eye and brain are naturally lazy and see what they expect to see. Baselitz was turning the world upside down to show us anew the sheer joys of composition and the strengths of painting that were completely out of fashion at that time.

Though he was not an exile from his homeland like Baselitz,[2] Ken Kiff (born 1935) has been an isolated figure for much of his career. The uprooted tree in his drawings and paintings can be read as a direct reference to the plight of the artist prepared to acknowledge his roots. Kiff has declared his debt to early twentieth-century German art and, in particular, to the Swiss artist Paul Klee (1879–1940), yet he has survived as an artist only because of his intense meandering questions. This makes him an almost exaggerated model of the Ultra-modernist artist. When he was Associate Artist at the National Gallery, London, the organizers had to extend his lecture into two because of his relentless analysis. When he examines his work, he not only goes off on a tangent of the question, but a tangent of the tangent of the tangent, before referring back to the original point. I mention this purely to illustrate how deeply rooted he is in earlier art of all descriptions. The 'primitive' Indian goddess figure has a stranglehold on modern art. Kiff is acknowledging the need for a Jungian break

Ken Kiff
Untitled, 1996
Ink on paper
20.5 × 29.5 cm
(8 × 11 ³/₄ in.)
Courtesy of the artist and
Marlborough Fine Art,
London

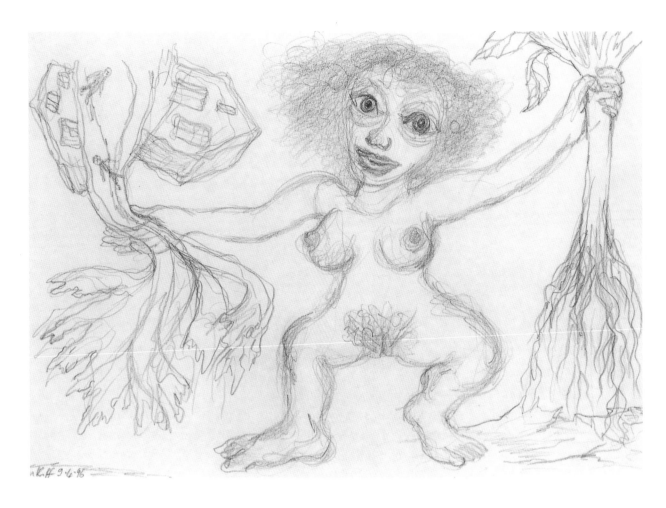

with the past, but he poses questions about the future. Even if you uproot a tree, some of its old roots survive.

The model of history that presents artists on the equivalent of a family tree has been criticized as inadequate. Baselitz inadvertently gave us a more realistic possibility in turning the tree upside down. The complicated network between artists is much more like the tangled roots than the open branches. At the risk of straining this analogy as far as Peter Sellers did in the film *Being There*,[3] the roots are more sustaining when left in the soil; in other words, the oft-repeated demand of art historians that artists be seen in context holds true. Even given T.S. Eliot's warning that "immature poets imitate; mature poets steal",[4] which partly explains artists' interests in keeping their roots covered, we must theoretically have the greatest chance of understanding the art of our own time.

The most famous rejection of the art of his time was by Hitler – his denunciation of 'Degenerate Art'. The Modernist tradition antagonized the Nazis, not just because it had Jewish practitioners, several of whom were later in exile to provide vital contributions to the blossoming of British and American art, but for its disturbing view of the modern. An essential Modernist premise is that artists open themselves up to sources other than Classicism.

The German 'thought police' of the 1930s have not been the only ones worried by the so-called 'primitive' influence on modern artists. Some of the most controversial exhibitions of the last fifty years have been about the connection between contemporary art and African, Polynesian, Pre-Columbian and other cultures. *"Primitivism" in 20th-Century Art* caused a ferocious debate in the art press[5] after it was shown at the Museum

Henry Moore
*Three Reclining Figures
on Pedestals*, 1966
Lithograph
37.5×28.5 cm
(14³/₄×11¹/₄ in.)
Edition: AP/75

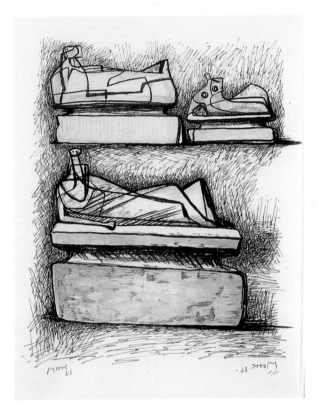

of Modern Art in New York in 1984. Similar division was stirred up by a series of exhibitions in London at the end of the 1940s and beginning of the 1950s (particularly *40,000 Years of Modern Art* at the Institute of Contemporary Arts [ICA] in 1948 *and Traditional Art of the British Colonies* at the Royal Anthropological Institute [RAI] in 1951). Fortunately, the debate had developed: it no longer questioned the "purity of the art", but rather worried over the condescension of the term "primitive". Despite the ferocity of the debate over semantics, there was an increasing acceptance that, as Leon Underwood wrote in 1947, "[European art] has turned gradually from the classical precedent towards the primitive".[6]

In the middle of the last century Underwood and others were definitely contrasting the merits of "child-like" tribal art with the tired decadence of the Classical tradition. As Henry Moore (1898–1986) admitted, "there was a

period when I tried to avoid looking at Greek sculpture of any kind. And Renaissance. When I thought that the Greek and Renaissance were the enemy, and that one had to throw all that over and start again from the beginning of primitive art."[7] He was speaking in 1960 and had already doubted the wisdom of throwing out Classical art. Greek and Roman art was beginning to become as remote to some as African wood sculpture, which led to the attempted amalgamation of cultures in Post-modernism.

The latest shift in interest in the sources for twentieth-century art can most clearly be seen in two major exhibitions in Germany at the very tail end of the century, *Global Art* and *Documenta X*. *Global Art* actually ran over the millennium period at the Museum Ludwig, Cologne. The first part of the exhibition was very similar to the New York *"Primitivism"* show fifteen years earlier, but it was more far-reaching. The greatest difference was at the end of the exhibition, as the organizers had made a far greater effort to find young artists from around the world. Ironically given the multiplicity of influences, which one might think would encourage Post-modernism, the most forceful new work displayed had a strong underlying Modernist structure. For instance, while the organizers stressed the importance of the East on the two New York

video artists Bill Viola (born 1951) and the Iranian-born Shirin Neshat (born 1957), their sense of composition is highly structured. Post-modernist is not an adequate term for artists such as this. They have much more in common with such early Modernists as Cézanne, Munch (1863–1944) and Picasso, who proposed to start again from the beginning to capture the 'primitive' forces within them.

Catherine David, the French director[8] of *Documenta X* (1997), would certainly give short shrift to the concept of one culture being more primitive than another. She used the tenth *Documenta* as an attack on globalization. In her assault on the political and economic control exerted by a few countries on the rest, she made an attempt to break up the artistic hegemony enjoyed by American, German and British artists today.

Much to David's chagrin, it would be perfectly possible to give a reasonable idea of the last forty years of art by a study of the ten *Documenta*s, or more shockingly just by looking at the American, German and British art there. Arnold Bode planned the first *Documenta* as a one-off international show-case. It took place in Kassel in 1955 and, because of its success, has become a regular event. Although more press attention is given to the Venice Biennale, the *Documenta*

programme provides a more thorough record of serious contemporary thought.

The early *Documenta*s, particularly *II*, *III* and *IV*, played a critical role in reviving German art, which was at its twentieth-century nadir in 1955. Yet the rivalry between American and German art did not manifest itself fully until *Documenta VII* in1982. This coincided with two other important exhibitions, *The New Spirit in Painting* (1981) at the Royal Academy of Arts in London, and its sister exhibition, *Zeitgeist*, at the Martin-Gropius-Bau in Berlin in 1982. Though much has been written in America about the wave of new painting being little more than a market phenomenon, there was a major and lasting shift in perception. It can be explained most simply by a comparison of the first and second editions of *The Story of Modern Art* by Norbert Lynton. Chapter Seven, 'Art in the American Grain', in the first edition published in 1980, begins with the bold declaration that "America dominates the story of art from the 1940s on". Only nine years later, in the second edition, he has amended this to "America dominates the story of art from the 1940s to the 1970s".[9]

The period 1960–2000 is effectively the story of the German and British challenge to New York's dominance of the contemporary art scene. As witnessed in *Global Art* and *Documenta X*, much of the recent attack on

New York's status within the art world has revolved around the morality of a centrally based view of the art world. Still, there is no avoiding the fact that nationalism has played a part in recent art history.

Although 1945, with the end of the Second World War, and 1955, with the first *Documenta*, supply dividing lines, 1960 is increasingly seen as a convenient place to start a history of recent art.[10] It was at about that time that European artists began to challenge the American dominance of the art world, and though many of the significant trends in European art did not receive the attention they deserved until the end of the 1970s, the seeds were being sown as far back as the 1940s and 1950s. Perhaps the simplest way to look at the background to the art of America, Germany and Britain is to compare the emergence of the leading artists in each country.

Thomas McEvilley has made a fascinating comparison between Joseph Beuys and Andy Warhol,[11] and adding Francis Bacon into the equation will help show us not only how much the three countries have shared, but also how far they have diverged. As we are looking to learn about the roots of the artists' works we will begin with their death and travel backwards. All three of them were totally preoccupied with the idea of death. Bacon said he woke up every morning thinking of death, Beuys made much of his work around the theme of his escape from death, and an even higher percentage of Warhol's work was obsessed with the end of life. Beuys (born 1921) and Warhol (born 1930) died in 1986 and 1987 respectively, with the asthmatic Bacon living until 1992.

The contrast of Warhol's work at *Zeitgeist* and Beuys's at *Documenta VII* could not be more extreme, yet both tackle the rupture of the Second World War. Warhol sniped at the vision of European history by taking images of Nazi architecture to Berlin, while Beuys, with one of his grandest gestures, tried to restore the old symbolism of the oak and free it from its Third Reich connotations. Seven thousand basalt stones were piled high in the main square outside the Museum Fridericianum, Kassell, to stand in for the *7000 Oaks* that were to be planted in the city. The artist wished to reclaim the ancient sanctity that oak groves gave to druids and some early Northern European religions. He accepted that oak leaves had been tainted by being one of the highest military honours in a creed that believed in Blood and Soil, yet he strove to overcome this and reclaim their original sanctity. He thought it was dangerous to bury the past without examining it. He wanted people to remember their roots and not build a society on a foundation of sand.

Andy Warhol
Electric Chair, 1964
Screenprint and acrylic
on canvas
60.8×75.7cm (24×30in.)
Courtesy of Tate Gallery,
London

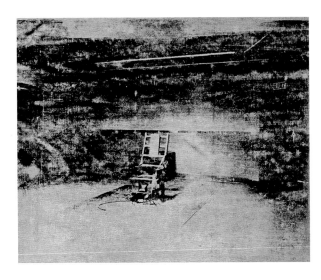

Rudi Fuchs, the Director of *Documenta VII*,[12] took up this expansionist vision of art in the foreword of the catalogue:

"Only a few people are really conscious of what art has to offer. One must seriously question whether there is still a culture out there in the world that is capable of taking art and supporting it – in other words, really making something of it above and beyond its mere exhibition. That is the decisive question today: should we place more trust in the artist or should we leave them in this isolation in which they are free – but simultaneously in captivity, like Indians in a reservation?"

Whereas Bacon had been content to declare that he didn't believe in progress, Warhol and Beuys took this a step further. They both thought that Modernism had come to an end, but their different responses to their end-of-history theories could not have been more marked. As Thomas McEvilley points out, "Beuys had been the king, Warhol the jester … if there were a theological duel, Beuys would represent the soul, Warhol the anti-soul."[13] Warhol subverted society, Beuys wanted to redeem it. Warhol was a reductionist, who was enjoying putting the last ironical full stop on a dry vision of the world, while Beuys saw art as the way forward. They were united in their belief that art was for everyone, but Warhol went out to destroy the divide between high and low culture by introducing advertising techniques and presentation, while Beuys was convinced that art could elevate everyone to new heights. "Beuys remained committed to the idea of the spiritual in art, and Warhol was uncompromisingly against it from the beginning."[14]

Warhol celebrated standardization, while Beuys fought the Americanization of the world. Apart from his swipe at Fascist architecture in *Zeitgeist*, one can argue that Warhol's portrayal of the (broadly speaking) German heroes – Beethoven, Goethe, Einstein and Beuys – is as reverential as any. There is an ironic ambivalence in creating an icon of Beuys *à la* Marilyn Monroe and Campbell's soup tins, but it does not compete with Beuys's vehement attack on the increasing detachment in the American way of life.

Beuys went for the underbelly of America in May 1974 with *I like America and America likes me*. This performance took place on only his second trip to the States; his first had been an unmitigated disaster. Indeed, the American

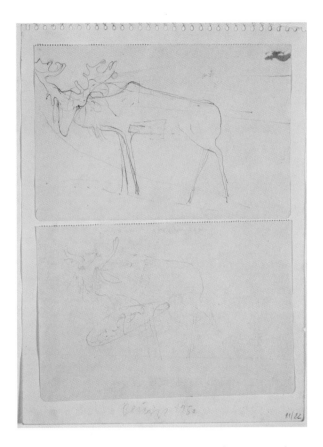

audiences for his evangelist performance/ lectures were treated on the same level as the dead hare in his performance of the same year. He had talked to a dead hare, maintaining that, "Even in death the hare can understand more than man with stubborn rationalism". *I like America and America likes me* operated on the same principle. As soon as he arrived in the States, and before he had come into contact with a single American, he was wrapped in felt and transferred by ambulance to the René Block Gallery. Here he spent his entire visit of five days locked in a room with a coyote, the spirit of Native American freedom. He communicated with the coyote, then was wrapped in felt again and returned to Germany.

Francis Bacon may have used Greek myths to highlight the isolation of man, but Beuys looked to myths as part of the healing process of an ill society. Warhol was happy to revel in the rootlessness and horrors of modern life. It was as if he wished to reduce everything to a lifeless state by repetition. His commercial background gave him a cynical understanding of competition. He knew how to present his images in an increasingly competitive world.

We live in terror of mistakes. There was always a safety net in the past with any number of people offering redemption for our sins. But in a society overcrowded with success-worshippers, there is no room for failure. Beuys learnt his lesson on his first trip to the States. He accepted the challenge and threw it back at the American people like an Old Testament prophet dealing with Sodom and Gomorrah.

The Warhol solution has found many more followers than that of Beuys, as he was advocating a policy of minimal risks. Warhol has often been presented as the antithesis of Clement Greenberg, the great guru of American Modernism. True, he flagrantly broke the edicts against imagery, but only so he could go further in another direction. Greenberg, the art critic who dominated New York in its years of unchallenged supremacy, had demanded of the protagonists of Post-painterly Abstraction that all illusion should be cut out of paintings: pictures should be reduced to what they inherently were – flat surfaces. They should not be windows. Yet Greenberg was perfectly happy for this sur-

face to resonate with spiritual, contemplative values. Warhol was not. He flattened these spiritual loose ends.

Neither Beuys nor Warhol were too keen on admitting to influences from their own contemporaries, so it would have been very surprising if they had both admitted to a shared root, but both did have interests in common with Yves Klein (1928–1962). Warhol went to Klein's first one-man exhibition in New York.[15] Also, "at that time Tàpies [born 1923], and especially Yves Klein, were almost as well known in the Rhineland as in Paris", Christos Joachimides writes. "Between 1957 and 1962 Yves Klein's visits to Düsseldorf became increasingly frequent and in 1957 he decorated the foyer of the theatre in Gelsen-kirchen. In 1961 Paul Wember organised his first exhibition in the Haus Lange Museum in Krefeld, at the same time Klein developed close contacts and friendships with the ZERO artists Uecker, Mack and Piene."[16] Beuys, born in Krefeld and a professor at the Staatliche Kunstakademie Düsseldorf from 1961, was certainly affected, though his own brand of Utopian vision would never have included the sick suggestion that Klein made to the leaders of the nuclear nations, advocating that "their atom and hydrogen bombs should carry IKB [International Klein Blue] to colour their explosion and aestheticise the whole world".[17]

Klein died at the age of thirty-four in 1962, and though he was more popular outside France his death was a further blow to the position of Paris as the world's art centre. Not that French writers have been quick to accept the demise of Paris at the expense of New York. In 1991 Alfred Pacquement wrote that, "The year 1960 will one day be acknowledged as an historical landmark … . On both sides of the Atlantic there was a mood of cheerful rebellion; the dominant idea was that of the Happening, an ephemeral work of art linked to a playful and often aggressive and subversive action."[18] He was thinking of Paris and New York, but if Frenchmen such as Klein had to look to the Rhine and Italy for support it was likely that the French capital would lose out. London, Berlin and Düsseldorf were to supersede it as European centres of con-temporary art.

Patriotic jingoism is not meant to play a major role in art criticism today, but it would be wrong to underestimate its effect at the heart of the Cold War. In America art was regarded as another weapon in its armoury in the propaganda war – for Capitalism versus Communism read Abstract Expressionism versus Social Realism. Porter A. McCray, both as Director of the Museum of Modern Art's International Program and as organizer of the exhibition sector of the Marshall Plan, played

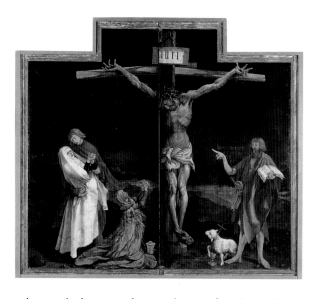

40

a key role in securing a victory for the wildest expression of the free spirit. *Documenta II* proved the turning point. The organizers, Werner Haftman and Arnold Bode, felt they did not know enough about American painting so asked McCray to make the selection. In the end, thirty-five out of the two hundred and nineteen artists in *Documenta II* were American and it was the likes of Jackson Pollock (1912–1956), Mark Rothko (1903–1970), Robert Rauschenberg (born 1925), Barnett Newman (1905–1970), Robert Motherwell (1915–1991), Willem de Kooning (1904–1997), Franz Kline (1910–1962), Philip Guston (1913–1980), Arshile Gorky (1905–1948), Sam Francis (1923–1994) and Helen Frankenthaler (born 1928) who stole the show. As the dealer Rudolph Zwirner recalls:

> "The second *Documenta*, in 1959, was intended as an apotheosis of international *Art Informel*; it ended up as its funeral. Unavoidable comparisons between paintings by Pierre Soulages and Franz Kline, or between the *Tachistes* and Pollock, revealed differences not only of principle but of quality."[19]

In crude terms, *Art Informel* (or Tachism) was the last French-led movement that could claim to dominate Europe, and this claim was put under severe scrutiny at *Documenta II*. At Kassel there was far more interest from British and German artists in the action painting of their American colleagues than in the French. Although Gillian Ayres (born 1930) still maintains that her European contemporaries made just as significant an impact upon her as Pollock, Tachism never had the same vigour. With hindsight it is easy to see the declarations of its inventors as rather tired, weak and wordy attempts to remain at the centre of the world. Georges Mathieu's explanation of Tachism certainly supports this theory: "The artist does not make his blot (*tache*) for the sake of the blot", writes Matthieu (born 1921), "but because he needs a certain kind of texture in a specific area and because this is the most direct way of applying his brush to the canvas, with a greater or lesser degree of force, and without first delineating the space that he wishes to cover with paint."[20]

Self-justification came hand in hand with the fear of mistakes. Initially this led to an explosion of art theory. Ironically, by the 1970s this had two very different results, with some artists becoming the mere tools of the theoreticians, while others, in ensuring that they were in control, had become nothing

Francis Bacon
*Study for a Portrait of
Pope Innocent X*, 1989
Lithograph, based on a
painting of 1965
116.5×77 cm (46×30½ in.)
Edition: AP10/60

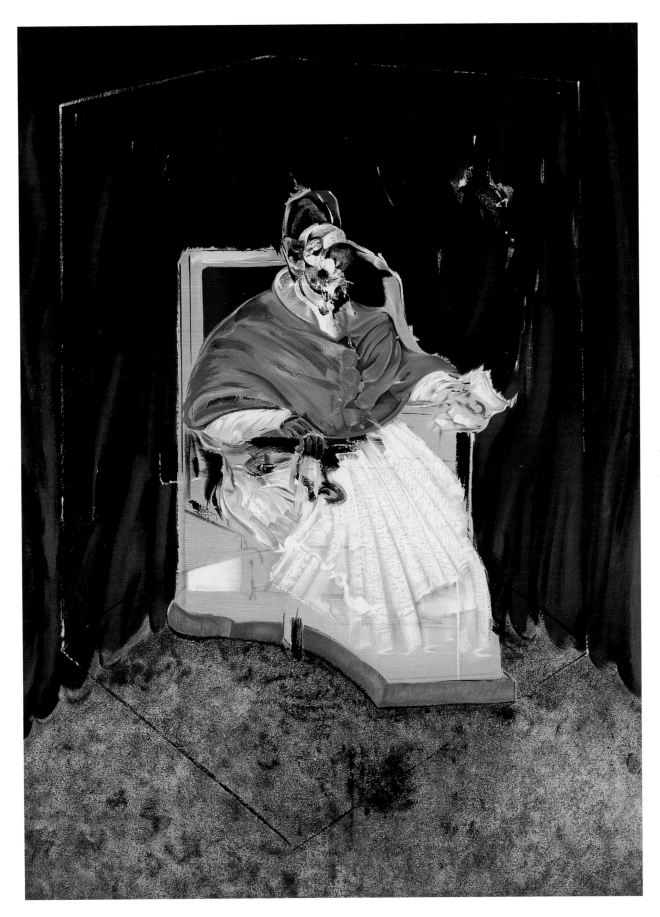

Walter Stöhrer
Ménage à trois II, 1971
Lithograph
60×82 cm (23³/₄×32¹/₄ in.)
Edition: 134/150

more than theoreticians. Neither situation was satisfactory. Beuys and Warhol had their own solution, in becoming their own works of art. They were rather more effective in this than Gilbert and George (born 1943 and 1942), who actually posed as living sculptures. None of them put it quite as eloquently as Oscar Wilde: "I have put my genius into my life; all I've put into my works is my talent".[21]

The comparison between Beuys, Warhol and Bacon shows quite how far Britain was out of synchronization with German and American art in the 1950s. While it would be perfectly possible to start a history of art in Germany treating 1960 as the year dot (indeed the Zero group did),[22] the first signs of a British revival in the arts came earlier. It is difficult to overemphasize the inspirational impact of Francis Bacon and Henry Moore on other painters and sculptors. They led the way out of the provincialism that had dogged British art for the first half of the twentieth century. Bacon plundered earlier art in a typically twentieth-century fashion. Some of the distortion of his faces and figures comes from Africa through Picasso. In *Triptych Inspired by T.S. Eliot's Poem 'Sweeney Agonistes'* (1967), he goes out of his way to acknowledge

that the poet's own use of Greek myths had helped him discover the raw emotion of the Harpies and Furies. He did not hide his admiration of the great early German masterpiece, Grünewald's Isenheim altarpiece (1512–15) in Colmar, but after his early *Three Studies for Figures at the Base of a Crucifixion* (1944), he built up his own structures to reveal the isolation of the human being. The honesty of Bacon also supplies a revelation about the way artists have learned from earlier art. He flagrantly admits that he never saw Velázquez's *Portrait of Pope Innocent X* (1650) in Rome. He took the image for his pope series from a postcard. His point was that he needed to have a certain distance from the work if he was to assimilate it into his own vision.

Francis Bacon was included in *Documenta II* in 1959 along with fellow British painters Alan Davie (born 1920), Victor Pasmore (1908–1998), Peter Lanyon (1918–1964), Ben Nicholson (1894–1982), William Scott (1913–1989) and Graham Sutherland (1903–1980). Davie was the one that caught the spirit of the moment. He has been linked frequently with both the American Abstract Expressionists, particularly Jackson Pollock, and the European Tachists, but as Davie himself says:

"I didn't meet Pollock until 1956 when I had my first show in New York and then though

Emil Schumacher
Untitled, 1973
Mixed media
88×61 cm (34½×24 in.)

Ernst Wilhelm Nay
Composition in Blue, 1957
Oil on canvas
117×89 cm (46¼×35 in.)

I got on well with him and liked him it was the museums of primitive art that bowled me over. It is primitive art that is the source of modern art. But at the time we were all striving for a complete freedom. We thought if we could just paint that creativity would come out of the unconscious. It goes back to Surrealism." [23]

As much as that of any major British artist, Alan Davie's art has been dominated by his interest in other cultures. In the 1950s he did find that forms and symbols came out of working on the floor, but he increasingly discovered that he was making marks that were to be found in other civilizations, and this interest fed his art.

Most participants recalling the 1950s do not see art in terms of cultural warfare. Davie's talk of a common striving for freedom is supported by Dennys Sutton in the catalogue of *Metavisual, Tachiste, Abstract*, an exhibition held at the Redfern Gallery, London, in

1957. He saw action painting as an international synthesis, "the hybrid child of the Frenchman Dubuffet, the German Ernst, the American Jackson Pollock". [24] Although at times Gillian Ayres's work comes as close as any British artist's to that of Pollock, she certainly would not subscribe to the simple perception that everyone looked to Pollock and to no one else. As a participator in the *Situation* exhibitions, [25] she continually stressed the influence of such fellow British artists as Roger Hilton (1911–1975) and other Europeans. [26]

This brief look at the background to our year zero, 1960, is in danger of creating the skeleton of names that we have tried to avoid from the beginning. Deutsche Bank's collection has been put together with the aim of encouraging its staff to look at the work of their contemporaries, not just the famous names. The collection, however, like the

Horst Antes
Double portrait (frontal)
blue, 1984
Aquatec on paper
65×101 cm
(25 3/4 ×39 3/4 in.)

human brain, has its limitations. Though the number of rooms and the buildings themselves are always changing, the number of walls remains limited. The art in these rooms is just meant to hint at the sea of art outside. No mention has been made yet of Walter Stöhrer (born 1937), for instance, who has a floor in the Twin Towers, Frankfurt, and a room in Winchester House, London. A visitor to the Stöhrer room in London might pick up a catalogue and read more about him. An essay by Manfred de la Motte highlights that any history is just like the tip of the proverbial iceberg:

"Although we cast effusive praise on the paradisiac era of painting at the end of the 1950s, and portray the world of this period as 'ideal' and 'in order', we tend to forget the fact that – beyond the acknowledged

masters like Schumacher or K.O. Götz, Brüning or Hoehme, Schultze or Sonderborg – there was a veritable sea of minor painters, one which we hardly became aware of and which flooded the salons and group exhibitions with second-class *Informel* or *Tachism* paintings – until the art world finally got fed up with them."[27]

Being an artist is not an easy option at the best of times, and it was not the best of times in Germany in the 1940s and 1950s. As Willi Baumeister (1889–1955) recalled in his diary of 20 October 1945:

"The year 1945 did not bring with it the kind of general artistic rebirth that took place in 1919. The energy of creative individuals was impaired by years of systematic humbug and intimidation. The young had

Max Bill
Continuity, 1986
Granite
465.5×464×414 cm
(179½×179×159¾ in.)

Victor Pasmore
*Linear Development in
Black & White: Turmoil*, 1951
Oil on canvas laid on board
59×28.5 cm (23½×11 in.)

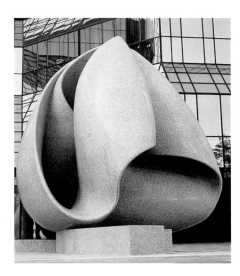

seen no real contemporary art. Klee and Kandinsky had died abroad; Schlemmer had died in Germany; Kirchner had shot himself in Switzerland … ."[28]

There were fewer German artists in *Documenta II* than Americans. Emil Schumacher (1912–1999), Bernard Schultze (born 1915), Richard Oelze (1900–1980), K.O. Götz (born 1914) and E.W. Nay (1902–1968) were represented, but were largely overshadowed by German artists still living or who had recently died in exile, such as Max Ernst (1891–1976), Max Beckmann (1884–1950) and Wols (1913–1951). Wols in Paris had been much more at the centre of the *Informel* Group than Schumacher. It was to take years for the full influence of such artists as Schumacher and Nay to be felt.

The Twin Towers of Deutsche Bank's headquarters in Frankfurt gives great prominence to two other artists, the painter Horst Antes (born 1936), who has the top floor of Tower A named after him, and Max Bill (born 1908), whose massive granite sculpture sits outside.

Antes is refreshingly honest and revealing about the way other artists and cultures have interested him. Like his British contemporary Alan Davie, Antes has demonstrated a lifetime's interest in early civilizations, particularly in the creation myths of the Majas, but beyond that there is an admirable transparency in the way he has built his art afresh like a Cartesian philosopher. He talks of the fifteenth-century Italian artist Piero della Francesca as a "quarry" of inspiration and also of "stones" taken from other painters' "quarries". His logical structure has literally been born out of the seeds of earlier thinking and imagery. He manipulates and modifies these building blocks.

Antes's explanation for his double portraits works as an analogy for his use of other art.

David Bomberg
El Barrio San Francisco
Ronda, Andalucia, 1954
Oil on board
62 × 76 cm (24 ½ × 30 in.)

The progress does not necessarily come out of direct confrontation:

"When I make a lone face or lone figure, there is a direct connection and interconnection between the picture and me. In the process of work on two figures, a group comes into being in which I am the third person. I am not an opposite, as is the case with a painting of a lone figure; rather, I am included as a third person within a group."[29]

Functionalism, the idea that beauty has to come out of function, was a twentieth-century invention, but by the second half of the century the Constructivism of Russia and the Bauhaus had both been derailed by political events. The Swiss artist Max Bill was trained at the Bauhaus when it was at Dessau, and from 1951 to 1956 developed the Hochschule für Gestaltung in Ulm along similar lines to the original Bauhaus.

Bill fought one of the side effects of earlier Bauhaus theory. He did not wish to see art subsumed into design, although he strongly believed in the mathematical underpinning of art: "I am convinced of the possibility of developing art wherein the mathematical approach is fundamental", he claimed.[30] Many of his sculptures, including the one outside

the Twin Towers, explore the idea of space. He captures space with the minimum of effort. Titles such as *Surface in space delimited by one line* emphasize his interest in three-dimensional drawing, delicately pointing out the infinite properties of space.

While every visitor to Deutsche Bank's headquarters in Frankfurt is greeted with the highly ordered vision of Max Bill, Victor Pasmore plays a correspondingly pivotal, if less clear-cut, role in British art. His exploration of colour and space took him to a similarly wide range of art forms (architecture, relief sculpture, painting and an extensive range of prints). The reaction to his 'desertion' to abstraction at the end of the 1940s also reveals a rapidly evolving art scene in Britain with many divisions: abstract versus figurative, Constructivist versus *Informel* and 'American' versus 'European'. The Communist/Capitalist division in our island was not as polarized as in America or on the Continent. Most British artists fell somewhere between the mesh of interconnecting and opposing ideas abounding at the time.

The social motivation for Pasmore's art did not receive as much support as it might have done in France and Italy, where the Communist Party was stronger, or as the Russian Constructivists did, at least for a while at the beginning of the century.[31] He did receive

Roger Hilton
Untitled, c. 1965
Graphite on paper
25.4 × 20.3 cm (10 × 8 in.)

Ben Nicholson
Forms in a Landscape, 1966
Etching on Vélin
31 × 31.5 cm (12 × 12 ½ in.)
Edition: 68/300

48

commissions to work on the construction of new towns.[32] There was the further complication that his flight to abstraction removed him further from the support of the brightest left-wing critic of the era, John Berger. Berger championed the realism of John Bratby (1928–1992) and the Kitchen Sink school, while lambasting the supposed sense of freedom to be found in action painting and *Informel.*

The career of Naum Gabo (1890–1977) illustrates the impossibility of restricting artists to their supposed social and ideological context. Gabo was born in Russia and, with his brother Antoine Pevsner (1886–1962),[33] was the inventor of Constuctivism. As such he was very much behind the idea that art should serve society, but ultimately he argued with the Soviet authorities because of his commitment to the making of abstract constructions that represented nothing but themselves. He left Russia and once more became involved with the functionalism of art at the Bauhaus, then lived in Paris before coming to Britain. He took up residence in Hampstead and St Ives before emigrating to

America in 1946. With Ben Nicholson and the architect Leslie Martin he edited *Circle*, a survey of Constructivist art.

London was primarily a stepping-stone for artists escaping persecution in Germany in the 1930s. New York was the main beneficiary, as was acknowledged by Walter Cook, Director of New York University Institute of Fine Arts, who quipped that "Hitler shakes the tree and I pick up the apples".[34] The impact on Britain should not be underestimated. The exodus of Jewish people and other intellectuals from central Europe to and through Britain in the first half of the twentieth century did a great deal to drag British art out of the provincial quagmire that it had seemed happy to occupy at the beginning of the century.

The first picture in Deutsche Bank's London collection was David Bomberg's *El Barrio San Francisco Ronda* (1954), which was given to the London branch in 1972 by the *Vorstand*.[35] Though Bomberg himself was born in Birmingham in 1890 of Polish Jewish origins, his reputation has risen in recent years partly because of his influence, as a teacher, on

Kenneth Armitage
Reclining Figure, 1956
Gouache on paper
33.5×76 cm (13 ½ ×30 in.)

Frank Auerbach (born in Berlin in 1931) and Leon Kossoff (born in London in 1926 of émigré parents). Critics have perhaps tended to overexaggerate their similarities of technique, as both students actually spent only a relatively short time in Bomberg's evening classes;[36] more important was their inspirational single-minded determination to produce art of great intensity. Of course Auerbach's friend and undoubtedly the most famous living British painter today, Lucian Freud, was also born in Berlin (1922).

The physical presence in St Ives of one of the founders of Constructivism, Gabo, obviously did have an impact on Ben Nicholson and Barbara Hepworth (1903–1975). They responded to his belief that space and time are the backbone of constructive arts, combined with the need to erase the human hand, though Hepworth's pioneering work as an abstract sculptor was more in the spirit of Constantin Brancusi (1876–1957) and Hans Arp (1887–1966). Gabo also had inspirational influence on younger artists such as Terry Frost (born 1915), Roger Hilton (1911–1975) and Patrick Heron (1920–1999). Heron was

among the earliest British champions of American art, though from the late 1950s on he liked to play up the British contribution, particularly attacking the flatness that Greenberg so admired in American art. Another interesting parallel with American painting is the energy found in Roger Hilton's work as counterpoint to Pollock. In the spirit of Matisse (1869–1954), Hilton learned to combine the energy with figures literally bursting off the canvas.

The St Ives School goes further back than Heron and even Gabo. Indeed, the stories that surround its origins give a wonderful twist to the history of Modernism. Modern art can be read as a series of attempts to start art afresh. There have been two main ways in which artists have achieved this: developing leads by earlier Modernist artists, and looking for new sources in art previously considered outside the canons of Western art history. As Margaret Garlake relates, the St Ives School found its "primitive" source in its very own "unrecorded anthropological specimen" in August 1928, when the two London-based artists, Ben Nicholson and Christopher Wood

(1901–1930) were visiting Cornwall on holiday. This "specimen's" name was Alfred Wallis (1855–1942), a naïve "fisherman painter"[37] who was even more an integral part of the St Ives School movement than Le Douanier Rousseau (1844–1910) was of the Post-Impressionists.

There was grudging resistance to the American influence from the very beginning, as Lawrence Alloway wrote on the occasion of the Tate Gallery's exhibition *Modern Art in the United States* in 1956: "There is an intellectual tariff in Elizabethan England on American culture … the general feeling about American painting and sculpture is one of resistance."[38] It had little effect. Though the American cultural invasion was not quite as clear cut in Britain as in Germany with *Documenta II*, it is hard to imagine such exhibitions as *Situation* happening without the quickening of the pace for change supplied by American artists.

Having made much of American cultural warfare, it would be wrong to conclude this chapter without mention of the British propaganda. In the 1940s and 1950s Henry Moore was promoted so successfully by the British Council that Britain was seen to be a leading force in world sculpture. Moore's family groups have been interpreted as part of the social desire to drive women back to the home and out of the workplace that they had occupied in wartime, but, more importantly, they were also symbols of peace. *Documenta II* not only featured Moore prominently, but also gave generous room to Barbara Hepworth, Lynn Chadwick (born 1914), Kenneth Armitage (born 1916), Reg Butler (1913–1981), Bernard Meadows (born 1915) and Eduardo Paolozzi (born 1924).

Phillip King (born 1934), at the time of writing President of the Royal Academy of Arts, visited *Documenta II*. Eight years later he recalled his perspective of the event. Though a sculptor, he reserved his greatest praise for the painting:

"The sculpture there was terribly dominated by a post-war feeling which seemed very distorted and contorted. Moore stood out with the English school. Then you had Germaine Richier and the brutalist sculpture of the time, and it was somehow terribly like scratching your own wounds – an international style with everyone showing the same neuroses. The contrast with the American painting there was important too – it was the first time I'd seen it in context with what was going on in the world at the time; a sort of message of hope and optimism, large-scale, less inbred. There were Motherwell and De Kooning, for example, and Newman, and a large showing

Phillip King
Untitled, 1995–96
Mixed media on paper
72×52 cm
(28 1/4 × 20 1/2 in.)

one has only to look at most of Phillip King's drawings in the collection, which are far more like Pollocks than studies for his hard-edged sculpture. As the different media available to artists have multiplied, the roles of the work on paper have also increased. This reached its most extreme form in the 1990s, when diversity was just another form of camouflage for artists of no fixed medium. Any self-respecting artist would be at home with video, installation, painting, photography, drawing and performance. There is currently a reaction to this as artists wish to nail their allegiance to the masthead.

Many artists today would love nothing more than to be able to throw out the whole baggage of the past. However, in an increasingly complicated world that has largely shed the philosophies and theologies that attempted to bind it together in the past, artists are becoming tempted to do more than fire the occasional sniping shot across our bows. Rather than the sweeping attempts completely to rebuild new structures of aesthetics, there is a swelling belief in finding new sources to help artists start afresh. Tony Cragg (born 1949), for instance, has discovered the most 'primitive' form possible, to revitalize his Modernist path. He is looking at pre-biotic molecules – those that are just waiting for life.

of Pollocks; even people like Sam Francis stood out then. Tapies appeared the best Europe could produce in comparison."[39]

Deutsche Bank is lucky enough to have a good number of drawings and prints by sculptors. Traditionally, sculptors' drawings have been among the most functional, showing the artist working their way through ideas, though immediately to disprove this

52

1 Henry Ford, 25 May 1916, from an interview with the car manufacturer by Charles N. Wheeler.

2 Georg Baselitz moved from East Berlin to West Berlin in 1958.

3 *Being There* (1979), a film directed by Hal Ashby.

4 T.S. Eliot, 'Philip Massinger', *The Sacred Wood* [1920], 2nd edn, London (Faber and Faber) 1928, reset and reissued 1997, p. 105.

5 The debate began with a long, damning review by Thomas McEvilley, 'Doctor, Lawyer, Indian Chief: *"Primitivism" in 20th Century Art*', *Artforum*, November 1984, pp. 54–61. This was replied to by William Rubin from the Museum of Modern Art, in 'Letters', *Artforum*, February 1985, pp. 42–45; Kirk Varnedoe also wrote, pp. 45–46, and McEvilley replied, pp. 46–51. The correspondence continued in this vein.

6 Leon Underwood, the British painter and sculptor, wrote several texts on African art including *Figures in Wood of West Africa*, London 1947, p. ix.

7 Henry Moore, quoted in Philip James (ed.), *Henry Moore on Sculpture*, London (Macdonald) 1966; originally from Donald Hall, 'An Interview with Henry Moore', *Horizon*, 3, no. 2, 1960.

8 Catherine David was a curator at the Musée national d'art moderne, Centre Georges Pompidou, Paris, 1982–90; a curator at the Galerie nationale du Jeu de Paume, Paris, 1990–94; and Director of *Documenta X*, 1994–97. In 2000 she curated *L'Etat des Choses* (part I) at Kunstwerk, Berlin.

9 Norbert Lynton, *The Story of Modern Art* [1980], 2nd edn, Oxford (Phaidon) 1989, p. 226.

10 The birth of Pop and Zero signified a desire for a new start in art. 1960 has now become an accepted dividing line – hence Michael Archer, *Art Since 1960*, London (Thames and Hudson) 1997.

11 Thomas McEvilley, '(Op)Posing Cultures: An Investigation of Beuys and Warhol', *The Froehlich Foundation: German and American Art from Beuys and Warhol*, exhib. cat., ed. Monique Beudert, London, Tate Gallery, 1996, pp. 35–44.

12 Rudi Fuchs was Director of the Stedelijk van Abbe Museum, Eindhoven, 1975–87; he has been Director of the Stedelijk, Amsterdam, since 1993.

13 Thomas McEvilley, *op. cit.*, p. 35.

14 *Ibid.*, p. 41.

15 *Yves Klein: The Monochrome*, exhib. cat., New York, Leo Castelli Gallery, 11–29 April 1961.

16 Christos M. Joachimides, 'A Gash of Fire Across the World', *German Art in the 20th Century*, exhib. cat., ed. Christos M. Joachimides, Norman Rosenthal and Wieland Schmied, London, Royal Academy of Arts, 1985, p. 10.

17 John Gage, quoted in *Into the Blue*, exhib. cat. by Peter Jenkinson, Walsall, The New Art Gallery Walsall, February 2000, p. 7. Gage refers to H. Gercke (ed.), *Blau: Farbe in der Ferne*, exhib. cat., Heidelburg Kunstverein, 1990, 2nd edn 1995, pp. 426–27.

18 Alfred Paquement, in *Pop Art*, exhib. cat., ed. Marco Livingstone, London, Royal Academy of Arts, *et al.*, 1991, p. 214.

19 Rudolf Zwirner, quoted in Dieter Honisch and Jens Christian Jensen, *Amerikanische Kunst von 1945 bis Heute*, Cologne (Dumont Buchverlag) 1976, p. 142.

20 George Matthieu, *Au–Delà du Tachisme*, Paris (Rene Julliard)

1963, quoted in the *Dictionary of Twentieth Century Art*, Oxford and New York (Phaidon) 1973, p. 377.

21 Oscar Wilde, quoted in André Gide, 'Oscar Wilde: In Memoriam (Souvenirs)', *Mercure de France*, 1910, pp. 12–13 ("*J'ai mis tout mon génie dans ma vie; je n'ai mis que mon talent dans mes œuvres*").

22 The Zero group was active for a few years before 1960.

23 In an interview with the author, 20 March 2000.

24 *Metavisual, Tachiste, Abstract*, exhib. cat. by Dennys Sutton, London, Redfern Gallery, 1957, unpaginated.

25 The first British *Situation* exhibition, held at the RBA Galleries (Royal Society of British Artists) in September 1960, gave artists an opportunity to exhibit paintings that were too large for commercial spaces.

26 Gillian Ayres talks of Roger Hilton as "someone who spoke well about art". Alistair Hicks, *The School of London*, Oxford (Phaidon) 1989, p. 61.

27 Manfred de la Motte, 'Incandescence', *Walter Stöhrer*, exhib. cat., Berlin, Galerie Georg Nothelfer, 1993–94, p. 121.

28 Willi Baumeister, *Diaries*, Cologne 1971, p. 189.

29 Horst Antes, quoted in *Horst Antes: Recent Paintings and the Votive*, exhib. cat., New York, Lefèbre Gallery, 1984, unpaginated.

30 Max Bill, 'The Mathematical Approach in Contemporary Art', in Thomas Maldonada, *Max Bill*, Buenos Aires (Nueva Visión) 1955, p. 37.

31 Support from the Communist party was dangerous; artist after artist fell foul of the purges and emigrated or disappeared. Gabo fell out with the authorities over

whether his constructions were functional.

32 Pasmore worked on Peterlee in County Durham, 1954.

33 Gabo was born Naum Pevsner but changed his name.

34 Walter Cook, quoted in *Exiles and Emigrés*, exhib. cat. by Karen Michels, Los Angeles County Museum of Art, 1997, p. 304.

35 Deutsche Bank's worldwide governing board of directors.

36 Bomberg taught evening classes at the Borough Polytechnic, London, between 1945 and 1947.

37 Alfred Wallis had actually been a scrap-metal dealer rather than a fisherman.

38 Lawrence Alloway, 'Modern Paintings', *Art News & Review*, 21 January 1956, pp. 1, 9.

39 Phillip King, 'My Sculpture', *Studio International*, June 1968, pp. 300–02.

"For me, as an artist, images are not made as ART OBJECTS but as CHANNELS of communication with THE DIVINE.

My work, like that of the shaman, making visible the unthinkable, brings forth images from the unknown that can have universal significance.

True art is timeless and entails the evocation of the inexpressible, be it through signs, symbols, rituals, poetry, pageantry colours or musical sounds.

This is certainly what religion is about, and one could say that my art is religious in this sense.

I am a creator of myths; a digger in the depths of the human psyche, through intuition, love and passion.

Having always been a musician as well as a poet and painter, I find these arts interchangeable.

One conjures magic from musical instruments – be it from my own creative imagination or through playing the works of the masters. When I play Bach I become Bach. His music flows from his own creativity through the depths of my own being in the manipulation of the keys.

I have a passionate interest in so-called primitive art, and this is a real inspiration in my own work.

The more one studies the arts of primitive people, the more one realizes how sophisticated they in fact are.

Ancient or Tribal art is no longer remote but becomes more and more enfolded in our notion of the timelessness of the human spirit, a never-ending spiraling thread winding through all ages and cultures.

Modern science, in the exploration of the deeper mysteries within the matter of the universe, is now aware that reality, at the root of things, is no longer measurable or predictable; we can now agree with primitive people when they claim that stones, trees, water and sky are alive and inhabited by spirits.

It is now agreed that true meaning cannot be conveyed by the outer appearance of things.

Creation would appear to be the very stuff of life in all its manifestations; and the ways of Mother Nature include so much that would appear irrational and destructive as well as constructive.

Art must move our poetic sensibility, and arouse, in its most profound manifestation, an intense uplift of the spirit. It enables us to enter a state of WONDER, when the inexplicable is given tangible form, enabling us to enter a state of TRUE LOVE, beyond the personal, and achieve a true communication with 'GOD, that sphere whose centre is everywhere, and whose circumference is nowhere'."

Alan Davie, March 2000

R.B. Kitaj
Study (Jean), 1969
Pencil on paper
52.1×30.2 cm
(20 1/2 × 12 in.)

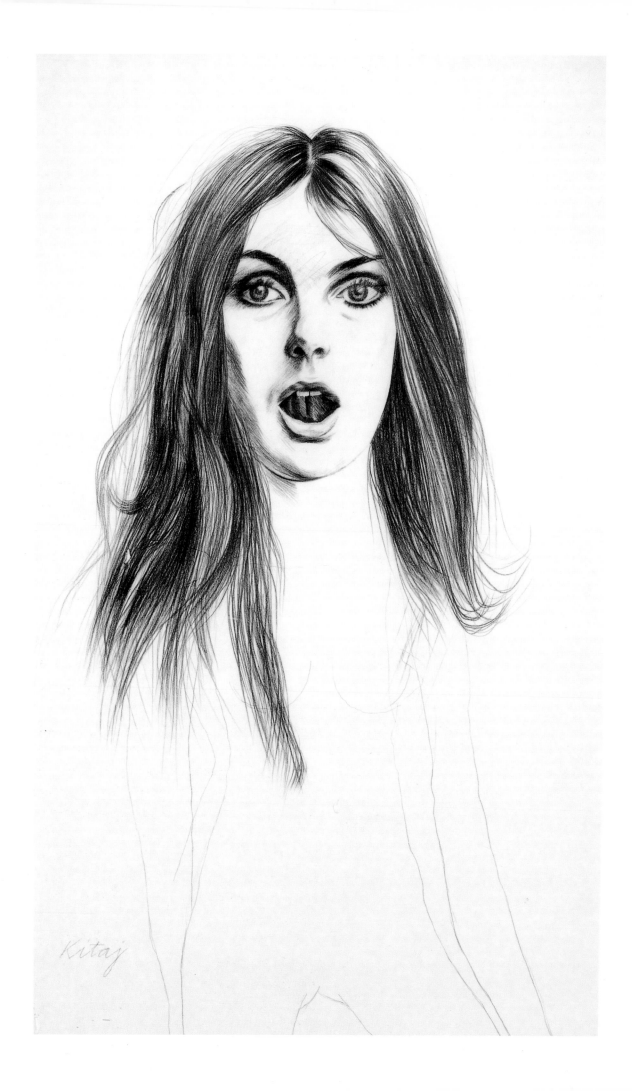

Otto Piene
Untitled, 1961
Exposed photographic paper
63×46 cm (24³/₄×18 in.)

"The Pop artists did images that anybody walking down Broadway could recognise in a split second – comics, picnic tables, men's trousers, celebrities, shower curtains, refrigerators, Coke bottles – all the great modern things that the Abstract Expressionists tried so hard not to notice at all." Andy Warhol (1928–1987)[1]

The Zero group provides a useful starting-point for any study of this period, with its gloriously Modernist attempt to take art back to the year dot. It began in 1957 when Otto Piene (born 1928) and Heinz Mack (born 1931) organized the first of several evening exhibitions in Piene's Düsseldorf studio. In April 1958 came the first of three issues of the magazine *Zero*. The main outside impetus came from Yves Klein, with whom both artists corresponded, and Lucio Fontana (1899–1968), but its beauty came from the enthusiastic rebellion against the incestuous ramblings of current art-world thinking. It was a return to basics. As Wieland Schmied explains:

"ZERO believed that it had a novel understanding of nature and could use this understanding in the service of art. It believed that, at the height of the scientific era, it could once more return to simplicity and begin again at a zero hour in history. ZERO's credo was back to the origins, back

to the elements. Its aim was to find ways and means of directly involving the elements – light and air, water and wind, earth and sand, fire and smoke – and letting them speak for themselves so directly that the result would be a new, simple revelation of the elements, of nature, of natural forces."[2]

Light was the real creative force in both life and art for Zero artists, and although Mack has remained more loyal to this belief in later years, it was Günther Uecker (born 1930) who most emphatically conveyed how light could purge the past. In July 1961, as part of the first Zero Festival, Uecker painted a whole street, Hunsrückenstrasse, in old-town Düsseldorf. He painted it white – clean, pure – the amalgam of all colours that make up light.

Uecker's white street was on the straight evangelistic road between Yves Klein and Joseph Beuys. This is emphasized by the intense sense of purpose displayed by his nail campaign, began in 1969, when he walked in

Heinz Mack
Textured Drawing, 1958
Wax and chalk on paper
64×48 cm (25×19 in.)

Günther Uecker
Rain, 1972
Imprints on paper
59.3×49 cm
(23¼ × 19¼ in.)

a straight line nailing everything to the floor, but there is another more formal side to Uecker's work. He is best known for his nail paintings, which he has been making since the late 1950s. These can be read like Fontana's slashes, as a way of expanding the flat picture surface, in direct opposition to the art in America that was progressing under Greenberg's dictates.

At first sight the colour planes of Gotthard Graubner (born 1930) look in tune with the Minimalist approach of such Americans as Agnes Martin (born 1912) and Robert Ryman (born 1930), but he was coming from a very different angle, out of the Zero ambience. "Graubner's painting has no theoretical starting-point but a sensuous one",[3] maintains one of his supporters. He was taking the monochromatic approach of Klein and Fontana in a very different direction from Uecker, Piene and Mack, trying to achieve the maximum effect with minimal variations of colour. He sees himself close to nature, reminding everyone that he was born in the open space of the Vogtland country, not in the

city. "The direct reference to nature in my painting is the re-creation of an organism, the breathing, the expansion and the contraction; organic movement as it is found in an accumulation of clouds, in the rhythm of flowing water or in the quiet movement of a human body."[4]

Graubner's quiet work could not be further removed from the Pop movement that had been brewing in Britain in the 1950s and burst out as part of the Swinging London scene of the 1960s. British artists were to play an important part in Pop; indeed, the earliest developments in Pop were made by, among others, Richard Hamilton (born 1922) and Eduardo Paolozzi in Britain, but the heart and spirit of the movement could not have been more American. In the long term, Germans embraced Pop art more wholeheartedly than the British. *Documenta IV* in 1968 was awash with Pop art, and Peter Ludwig bought almost all of it.[5]

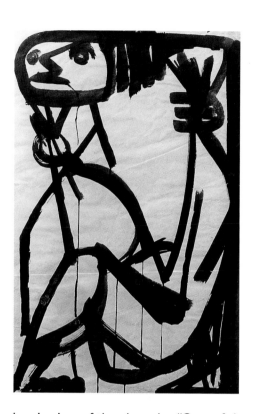

Looking back, many of the most important events in Pop history happened in the early 1960s (and late 1950s). Indeed, Andy Warhol had already declared the Pop movement dead by 1965 when James Rosenquist made *F-111*, his most famous Pop image, the second updated version of which is in the front hall of Deutsche Bank London. Pop, with its exploitation of the most vivid modern imagery and its connections with pop music, had a better-than-usual reception from the media and the public, but not everyone welcomed this populist movement.

Pop was an assault on intellectual art, so it is not surprising that the greatest resistance came from those linked to the ideas of Greenberg. In Britain this centred around the Situation group and the sculptor Anthony Caro (born 1924) and his pupils. As much as any American sculptor, with the possible exception of David Smith (1905–1965), Caro was responsible for putting Greenberg's ideas on three-dimensional art into practice. St Martin's School of Art, London, where Caro taught, became a hotbed of Greenberg's ideas. In an interview for the catalogue of *The Sixties*, an exhibition that attempted to play down the importance of Pop, one of Caro's students, Tim Scott (born 1937), talked of the close dialogue between painters and sculptors of different persuasions at the

beginning of the decade. "One of the nice things was the interaction …", he recalled, "then Pop came along."[6]

Anthony Caro was an assistant to Henry Moore. Before meeting Greenberg in 1959, in the house of fellow sculptor William Turnbull (born 1922), his style was similar to that of those doomed by Moore's success to be perceived as his satellites – Kenneth Armitage, Lynn Chadwick and Bernard Meadows. Caro's meeting with the American critic, followed by a visit to the States, had immediate results. "America was certainly the catalyst in the change", he wrote. "For one thing I realised that I had nothing to lose by throwing out History – here we are all steeped in it anyway. There's a fine-art quality about European art even when it's made of junk."[7] Materials became of vital importance in his effort to bring sculpture into the everyday world. "I'm fed up with objects on pedestals",[8] he complained. He literally

Phillip King
Untitled (Study for Rosebud), 1962
Coloured pencil on paper
21 × 13 cm (8¼ × 5 in.)

brought sculpture down to earth by making it of iron girders, nuts and bolts, and placing it on the ground.

International debates raged around Caro's sculpture as Greenberg and his leading detractor, Michael Fried, fought over its precise level of abstraction. Charles Harrison cut nicely through the American critics' argument by writing, "There are no references to the body; only to the open mind within the body".[9]

Caro painted his sculpture in bright colours from an early stage, but it was his New Generation[10] students such as Phillip King, William Tucker (born 1935) and Tim Scott who developed this and extended the use of materials into fibreglass and polyester. One of the most flamboyant examples of the bright new things was King's *Rosebud* (1962). It was a shocking-pink plastic cone. As King explains, "*Rosebud* was really a key piece. The pink I used was colour no longer subservient to the material but something on its own, to do with the surface and skin"[11]

One of the essential premises of modern art history in recent years has been that art should be seen in its social context. Therefore art must reflect the age. For all its efforts to create images of the moment out of materials and colours of the moment, the New Generation sculpture was never going to be able totally to fulfil the requirement of the age – accessibility.

It is one of the art historical mysteries of the twentieth century why Minimalism, one of the most logical steps in the history of art, was almost exclusively an American movement. Graubner in Germany and the New Generation in Britain were as close as Europe got to meeting the emphatically muscular attempts of Carl Andre (born 1935) and Donald Judd (1928–1994) to reduce art to its simplest forms. Judd went beyond Caro in wishing to see European art going down the drain.[12] Judd developed a puritanical horror for the evils of artistic trickery and storytelling. As Barbara Rose wrote, "Judd's rejection of illusionism is deeply rooted in the pragmatic

tenet that truth to facts is an ethical value. For Judd, illusionism is close to immorality, because it falsifies reality."[13] This unforgiving stance of Minimalism was certainly not going to court popularity; it was banging a heavy door shut in the public's face. In contrast, Pop art was inviting everyone to indulge every whim in an all-embracing party.

Pop art developed independently in America and Britain, though the artists in both countries were responding to a need to flaunt the good things in life. On 20 July 1957 Harold Macmillan declared, "Let us be frank about it: most of our people have never had it so good".[14] This in turn was an echo of the American Democratic Party's slogan of 1952, "You Never Had It So Good".

The target and flag paintings of the mid-1950s[15] by Jasper Johns (born 1930) reproduce two-dimensional commonplace objects as flatly and unemotionally as possible. The heroic, romantic 'I' of the artist is being replaced by objects; worse as far as some shocked patriots were concerned, the symbol of America was reduced to an object. As he used collage, Robert Rauschenberg's appropriation of everyday objects was even more direct. In placing three Coca-Cola bottles in a row and giving them a pair of mighty wings in *Coca-Cola Plan* (1958), the artist gives us an image of imperialist consumerism that was

superseded only by Warhol's more slick presentation of the famous bottle a few years later.

From 1955 Johns and Rauschenberg were living and working in the same building (in Pearl Street, off Fulton, in New York). Though they were breaking down barriers, their approach was still primarily intellectual. It lacked, indeed it made no attempt to acquire, the 'commercial' presentational skills now so identified with Pop.

Pop, this essentially light, frivolous, art-of-the-moment movement, actually developed out of the heart of highbrow Britain of the 1950s – a discussion group, the Independent Group. Victor Pasmore, William Turnbull, Richard Hamilton, Eduardo Paolozzi, the critic Lawrence Alloway and others met now and then at the Institute of Contemporary Arts (ICA), London, between 1952 and 1955. They met "in opposition to … ivory tower modernism".[16] It was Alloway, the former British proselytizer of Abstract Expressionism, who first coined the word Pop in written form, in 1958,[17] but this was well after the word had actually appeared in collages by Paolozzi and Hamilton.

With the advantage of hindsight, some pages out of Paolozzi's scrapbook compiled from 1948 to 1950 contain some strong Pop images. One of them, *I was a Rich Man's Plaything* (1947), actually contains the word

Eduardo Paolozzi
I was a Rich Man's Plaything, from *Bunk* portfolio, 1972, based on a scrapbook page of 1947
Screenprint and collage
36×24 cm (13³/₄×9¹/₄ in.)
Edition: 76/100

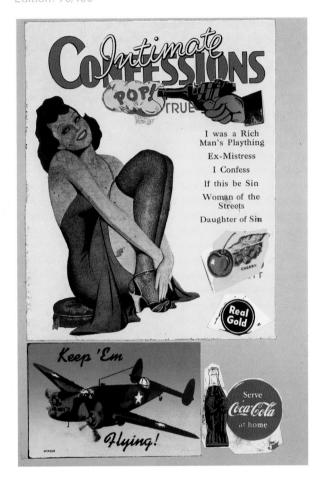

Pop. The hallmarks of Pop were present. One of the strengths of Pop art was its scrapbook mentality, the magpie ability to pull out all the glistening jewels in the pulsating, partying world around – glimpses of famous people and a wish-list of consumer goods. The key, however, was in turning these images into sovereign icons. Paolozzi never intended to do this; they were devised as a reference library of images, and he did not frame them up to show them until his retrospective at the Tate Gallery in 1971. The following year he turned them into a portfolio of screen-printed collage facsimiles entitled *Bunk!*.[18]

The first Pop image is usually accredited to Richard Hamilton and was the result of his participation in the exhibition *This is Tomorrow* at the Whitechapel Art Gallery in 1956. Twelve teams, each to have consisted of an architect, painter and sculptor, were set to design pavilions for modern living. As a poster for the show and as a page in the catalogue, Hamilton put together a collage of the essential ingredients for a modern home, *Just what is it that makes today's home so different, so appealing?* (1956). Over thirty years later Hamilton turned this image into a colour laser print. He had to change the title marginally to *Just what was it that made yesterday's homes so different, so appealing?*. Three years later he did another laser print of a 1990s' home. The bank has both these prints.

Shortly after the Whitechapel exhibition, in January 1957, Hamilton wrote to his architect friends Alison and Peter Smithson (also members of the Independent Group). The letter included a list of mass-culture attributes that might be incorporated into his art. The Smithsons had just written an article maintaining that fine artists were being outgunned by the ad men. "Advertising has become respectable in its own right and is beating the fine arts at their old game …",[19] they claimed. Hamilton's list could almost be read as a manifesto for Pop art:

Popular (designed for a mass audience)
Transient (short term solution)
Expendable (easily forgotten)

Richard Hamilton
Just what was it that made yesterday's homes so different, so appealing?, 1991/92
Colour laser print: the 1956 collage, electronically restored on an image processor
42×29.7cm
(16 1/2 × 11 1/2 in.)
Edition: 22/25

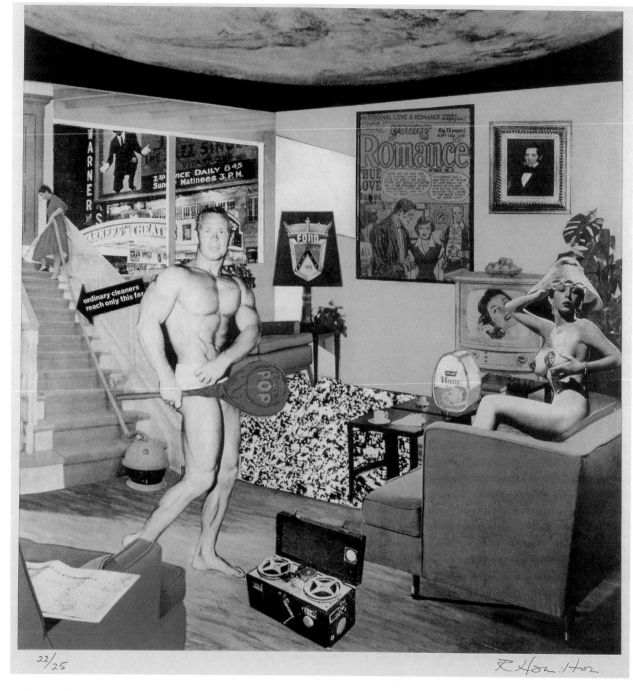

22/25

Low Cost
Mass Produced
Young (aimed at Youth)
Witty
Sexy
Gimmicky
Glamorous
Big Business

Hamilton's poster image certainly conjures up the prospective wild delights ahead as Britain finally shook off rationing. The roof has been taken off this ideal world as though already the future is as limitless as Space.

Food comes easily in tins. There are machines for everything – Hoovers can now walk up stairs. Sex is easily available for men and women; the girl in the lampshade looks as though she can be turned on or off at the touch of a hand, the he-man has a bulbous lolly-POP on offer. It is people power. They are everywhere. Even the carpet is a blow-up photograph of a crowded beach.

Advertisements, comic strips, posters, billboards, packaging, postcards, reproductions, magazines, newspapers, commercial brochures all became fair play. Hamilton's *Toaster* (offset lithograph, 1967) is based on

Richard Hamilton
Soft Blue Landscape, 1979
Screenprint on
Ivorex paper
72×91 cm (28¼×35¾ in.)
Edition: 76/136

Giorgione
Tempest, c. 1505
Oil on canvas
68×59 cm (26½×23 in.)

Courtesy of Galleria
dell'Accademia,
Venice/Bridgeman Art
Library

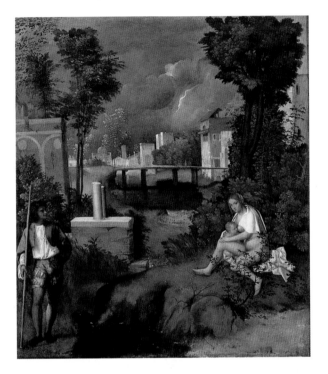

an advertisement for Braun, a company whose products, including toasters, now feature strongly in twentieth-century design sales. The story behind *Soft Blue Landscape* (screenprint, 1979) is even more circuitous, demonstrating the increasingly incestuous relationship between art and design. Hamilton was fully aware that Andrex, in their advertisements for lavatory paper, were exploiting the tradition of the *fête champêtre* (there is a strong echo of Giorgione's *Tempest, c.* 1505), but what he had not known, until she told him years later, was that Op artist Bridget Riley (born 1931) had devised the original Andrex campaign when she was a graphic designer.

As an Op artist, Riley has often been bracketed with the Pop movement. In one sense this is totally misleading as the theory behind Op could not be further removed from Pop despite the phonetic proximity. It developed out of Constructivism and Gabo's suppression of personal handwriting and a new understanding of the way the eye works. It is totally 'eye' orientated, using the way we see to play tricks on our brain. Riley is not concerned with trickery; rather, she is after deeper transformations. Her work was triggered by the effect of rain on a patterned pavement in Siena. The

patterns of the water and the floor violently disrupted each other.

The only real connection between Riley and the Pop artists was that she was around at the same time. She was part of the same 'sexy' scene, but was not driven by the same need for accessibility. Indeed, when she arrived in New York to find her paintings had been turned into designs for dresses, she was livid.

If Bridget Riley and Andy Warhol came out of a commercial design background, Peter Blake (born 1932) is probably most famous for designing the Beatles' album cover *Sergeant Pepper's Lonely Hearts Club Band*.[20] Yet he played a pivotal role in British Pop. He was emphatically not part of the Independent Group. His path to Pop came out of a direct desire to produce a more accessible art. His childhood love of folk art helped lead him to make images that the critic Marco Livingstone describes as "the embodiment of a collective fantasy".[21] In the mid-1950s, even before Blake left the Royal College of Art, where he

studied graphic design, he was making circus paintings such as *Loelia, World's Most Tattooed Lady* (1955). With her tattoos, Blake had latched on to the fetish of wishing to celebrate events. The Beatles' cover was a mass of insignia, all indicating the intense desire that lonely hearts have to belong to a tribe. In *Self-Portrait with Badges* (1961), Blake identifies with the cult of the fan. The largest badge is reserved for Elvis, and to underline his allegiance he holds a book about the American singer. It was through the depiction of stars such as the Everley Brothers, Frank Sinatra and Marilyn Monroe that his mature Pop style had emerged by 1959. In *Everley Wall*, *Sinatra Wall* and *Girlie Door* the artist was simply turning the public's gaze upon the teenager's bedroom.

Joe Tilson (born 1928) and Richard Smith (born 1931) were both close friends of Blake at the Royal College. Smith went on a scholarship to New York in 1959 as the links between American and British Pop blossomed. By 1961 Blake was making pictures like *The First Real Target* (1961), which refer directly to Jasper Johns's targets.

Pop was a loose movement. There was no binding manifesto, but all artists who have been given the Pop label share a passionate interest in the technical advances of the day. As Hamilton had demonstrated at *This is Tomorrow*, there was an optimistic belief that everything was possible. The great paradox about Pop was that it was both a celebration of Capitalism and the most democratic movement of the century. Where the drive to make art for the people by the Omega Workshops in Britain and Constructivism in Russia had seen early idealism and ambition tail away into pure decoration, Pop artists cleverly exploited design and technology to create an art that was genuinely popular.

Not all Pop artists were happy with the indulgence of every Capitalist whim. Colin Self (born 1941), for instance, had reservations about wallowing in materialism, but he participated in Pop because he saw it as a working-class affront to traditional fine-art élitism. In a letter to Marco Livingstone, Self gives a deliciously pessimistic explanation for his work in the 1960s:

"I spent my teenage years ... having been psychologically devastated by the preachings of Bertrand Russell and thought Armageddon would have exploded its nuclear end when he predicted. By 1967 or 68. For seven years I worked towards that end, thinking the most civilised thing one could do (with what time was left) would be a 'record' of 'how come' the world ended?"[22]

66

Self supplies the other side of the Blake coin. His art catches the nerve of the paranoiac streak that festers in lonely minds throughout the world. Self mentions Russell, but his outsider persona has links with the Existentialist thinking of Jean-Paul Sartre and Albert Camus. His experiments that resulted in the printing of the *Nude Triptych* also reveal a connection to the thinking of Klein in 1950s' Paris. Klein dipped women in his famous blue to create an image of their body. Self actually made a woman lie on the printing plate so that he could make a multiple image. The full title of the *Nude Triptych* is *Figure No. 2, 1971, from Prelude to 1000 Temporary Objects of Our Time.* It was very much part of Self's anticipation of the apocalypse. It catches a

fossilized moment in the flight from the nuclear bomb. With her far-flung limbs pressed as if against an invisible glass wall, she is a modern version of a woman from Pompeii.

In 1962, the year of his death, Klein made one of the classical Pop images. He stole one of the great images of Classical art, taking a reproduction of the Victory of Samothrace (*c.* 190 BC) and covering it in blue. Here was a Modernist totally unafraid of the Classical tradition, prepared to gobble it up wholesale and show it in a new coat of paint. It was made out of a plaster multiple; it was approachable.

The 1960s saw an explosion of new printing techniques that not only enabled artists to produce cheap multiples, but also coincided with the urge first expressed by Gabo to lose the impact of the outdated human hand by submitting to the mass production of the machine. Once again Richard Hamilton was a leader in the field,

Richard Hamilton
Toaster, 1967
Offset lithograph,
screenprinted, with
collaged metalized
polyester
89×63.5 cm (35×25 in.)
Edition: 24/75

Toaster

New, practical, outstanding, this print was made possible by a number of fresh ideas. The proof of the excellence of the toaster that inspired this work of art has been supplied by the results of severe endurance tests recently performed. The appliance was kept working for a total of 1458.3 hours (not counting brief periods for cooling). This was the time taken to toast 50,000 slices of bread. That is a pile of bread well over a quarter of a mile high.
Just how outstanding the design is can be proved by the fact that it has been included among the most attractive objects for everyday use exhibited at the New York Museum of Modern Art – the only automatic toaster in the world to achieve this honour.
White bread, black bread or even rye bread? Ask your friends and neighbours and they will tell you that toast is a first-class delicacy. It tastes good and has never been the cause of anyone losing their driving licence. It keeps you fit and your body needs it.
Printed on Saunders plain mould special printing s/o demi 80.5 lb/500 (complete with Marlerfilm and Marlerflex ink and applied metallized silver polyester) in an edition of 75.
Dimensions 25" wide, 35" high, image area 23" square.

making his first editioned screenprint in 1962 and commissioning twenty-four artists for a portfolio of screenprints for the ICA, which was published in 1964. In doing this he introduced Gillian Ayres, Peter Blake, Patrick Caulfield (born 1936), David Hockney (born 1937), Howard Hodgkin (born 1932), Allen Jones (born 1937), R.B. Kitaj (born 1932), Pasmore, Paolozzi, Peter Phillips (born 1939), Riley, Tilson and Turnbull to the medium.

The clearest example of Hamilton's identification with machines is *Toaster*, as he replaces the word Braun with Hamilton. He is identifying himself with a leading brand of toaster. Underneath the image, as part of the collaged offset lithograph, he has written:

"New, practical, outstanding, this print was made possible by a number of fresh ideas. The proof of the excellence of the toaster that inspired this work of art has been supplied by the results of severe endurance tests recently performed. The appliance

was kept working for a total of 1458.3 hours (not counting brief periods for cooling)."

Does the artist imagine himself establishing a brand image with machine-like precision?

Hamilton has consistently responded to technical advances. Often images that he has made as paintings have waited decades before the right technique has come along to turn them into prints. The collage *Just what is it that makes today's home so different, so appealing?* (1956) waited thirty-five years to be restored electronically on an image processor and printed directly from the computer on to a Canon CLC500 printer in the artist's Oxfordshire home.

Hamilton's interest in the impact of communication technology on the world's population has meant that he has maintained his position in the avant garde. As Caroline Tisdall says in commenting on Joseph Beuys's friendship with him, "Hamilton was the most international-minded artist in London".[23] He has maintained this as he was one of the very few British artists selected for *Documenta X*. The other Pop artist who has had an impact on young artists, particularly the YBAs (Young British Artists of the 1990s), is Patrick Caulfield. His deadpan delivery was as good as Warhol's. From his college days he was brilliant at cutting out any hint of his own

67

Patrick Caulfield
Café Sign, 1968
Screenprint
71.1×93.3 cm (28×37 in.)
Edition: AP/75

James Rosenquist
View of F–111, in Rosenquist's studio at 429 Broome Street, New York, 1964–65
Oil on canvas
305×2621 cm (117×1024 in.)

Courtesy of Sololmon R. Guggenheim Foundation

hands' involvement in his art. This tight marketing of images was taken up by Michael Craig-Martin (born 1941), who was to pass it on to his pupils at Goldsmiths' College, London.

Café Sign (1968) is an example of Caulfield paring down a picture to its essentials. "Instead of representing figures seated at a café, an archetypal romantic image of the bohemian artist's life in France", writes Livingstone, "he asks us to contemplate an apparently artless sign more likely to grace the exterior of a British roadside café."[24]

Mass reproduction was essential to the concept of Pop. Warhol took this to its logical conclusion with his serried ranks of Marilyns and Coca-Cola bottles. Size was also an issue. James Rosenquist, as an ex-billboard painter, was an obvious exponent of this. He knew it was a way of catching attention. Roy Lichtenstein (1923–1997) magnified comics, but it was Rosenquist who had been up ladders to spread the word of American consumerism. The level of irony in Pop has been much debated, though Richard Hamilton's remark in explaining *$he* (1948–61) provides the benchmark. Generally, Pop was an explosion of enthusiasm. "Irony has no place in it except in so far as irony is part of

the ad man's repertoire",[25] wrote Hamilton.

Warhol may have been right in suggesting that 1965 witnessed the death of Pop. Rosenquist admits to a sense of irony with the kaleidoscope of advertising imagery and the crashed fuselage of a bomber: "In *F-111* [1965], the little girl under the hair dryer was a metaphor for the pilot and the economy that produced the obsolete bomber".[26] However, Joe Tilson's *P.C. from N.Y.C.*, from the same year, was sending a straight message back to London. There was little irony in a two-metre foldout postcard; it was just a question of telling fellow Londoners that everything was bigger in America.

British Pop was very much associated with the Royal College of Art. As well as Peter Blake and Joe Tilson, who were there from 1953 to 1956 and from 1952 to 1955 respectively, there was a younger group consisting of Allen Jones (attended 1959–60), R.B. Kitaj (1959–61), Peter Phillips (1959–62), David Hockney (1959–62) and Patrick Caulfied (1960–63). On the advice of Alloway, one of the judges, this latter group rehung their paintings together at the *Young Contemporaries* exhibition of 1961. It was quite easy to implement, as Peter Phillips was president of the hanging committee and Allen

Joe Tilson
P.C. from N.Y.C, 1965
Screenprint in three parts
203×74 cm
(80×29 in.)
Edition: 63/70

69

Jones the secretary. Things did not always go smoothly for this group of precocious students. Hockney's teachers threatened to throw him out, Phillips only escaped expulsion by transferring to television studies in his third year and Allen Jones was sacked in his second year.

Hockney's career took off from his first days at college when Kitaj cast a friendly if envious eye over his shoulder at the facility of his drawing. The American Kitaj, a natural draughtsman in his own right, was just at the beginning of his thirty-year stay in London, but he was several years older than the others and had travelled the world as a merchant seaman. He came to England on a GI grant. As a natural philosopher he played the elder statesman in the group and was particularly influential on Hockney. His wide-ranging knowledge, ability to assimilate styles and rabbinical interest in interpretation were useful in showing how to make an intelligent picture, but it was Hockney who first became a star. At the age of twenty-six, the year after he left college, he had his first one-man show with Kasmin in London.[27] By 1967 he had produced one of the most famous images of the second half of the century, *The Bigger Splash*.

Although the diver who caused the big splash is completely hidden from view, *The*

Bigger Splash can be read as a comment on the ever-increasing gap between figurative and abstract artists – a gap that became a chasm with the arrival of conceptual and Minimal art. As far as Hockney is concerned, the impact of man can never be obliterated.

Allen Jones
Shoe Box, 1968
Suite of seven lithographs
and an aluminium sculpture
35.5×28 cm (14×11 in.)
Edition: 26/200

David Hockney
A Bigger Splash, 1967
Acrylic on canvas
244×244 cm (96×96 in.)
Courtesy of Tate Gallery,
London

His swimming pools are hardly typically British scenes; they were a result of his emigration to the West Coast of America. Here he was able to enjoy and depict a bright gay lifestyle far removed from his Bradford origins.

Bradford may not have been instantly transformed by Pop culture, but Liverpool, home of the Beatles, certainly was. One of the Liverpool poets, Adrian Henri (born 1932), was also a Pop artist. Maurice Cockrill (born 1936), Henri's neighbour in 1968, recalls that "Liverpool has a cultural simmer, illustrious sight-seers include Tom Wolfe, Clement Greenberg, Kenneth Noland, Allen Ginsberg, Don McCullin".[28] Two years later, Cockrill was a Photo Realist, although his flirtation with this style was almost as brief as Hockney's. Hockney regards one of his Super Realist works, *Early Morning, Sainte-Maxime* (1968–69), as his worst painting ever. Hockney's Photo Realism was the result of his increasing interest in the camera and a meeting with another British exile, Malcolm Morley (born 1931), who coined the phrase Super Realism. His images, often based on postcards, rather like Tilson's, have a populist feel to them, though Morley, who learnt to paint in prison, denies an interest in the subject-matter, claiming to have painted them upside down. Irony and an elusive refusal to be categorized also separate him from the Pop movement.

Though many attempts at Pop across Europe emphasized the wide gap between American art and that produced elsewhere, the clash of cultures did have some interesting results. So whereas *Nouveau Réalisme* in Paris supplied little more than pale pastiches, *Fluxus*, a Happening-led American/German movement, generated a unique energy, but there were other German artists perhaps closer to Pop.

Pop proved as popular in Germany as anywhere in the world. "American Pop really Turns on German Art Lovers" was a headline in *The New York Times,*[29] but the wholesale purchases by Peter Ludwig, Wolfgang Hahn and Karl Ströher happened only at the end of the 1960s. There were also some artists who showed fairly direct Pop impulses in Germany, notably Thomas Bayrle (born 1937), Uwe Lausen (1941–1970) and Peter Roehr (1944–1968).

Thomas Bayrle is one of the few German artists whose work attracts comparison to Pop art. His theme is mass society, with the big city and advertising appearing in his work from as

David Hockney
Volcano, 1967
Crayon
43.2 × 35.5 cm (17 × 14 in.)

Adrian Henri
24 Collages No. 2: Hayley
Mills Painting, 1964
Collage
53.7 × 45.6 cm (22 × 18 in.)

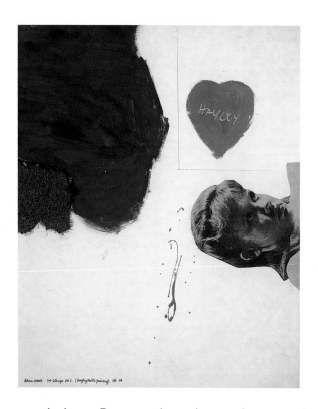

early as 1965. After producing early mechanized objects, in 1967 he switched his focus to silkscreen. Characteristically, he uses small motifs, arranged in series of simple recurring patterns. Colour differences and distortions create new, format-filling motifs. Bayrle's critical and ironic view of mass culture is consistently pursued in his more contemporary works, which make use of computer generation.

The protective distance of irony was one denied Uwe Lausen. Influenced by Francis Bacon and Pop art, the Munich artist came to prominence in the mid-1960s with collage-like works that make visual allusions to reality. His keynote themes are destruction, despair and death. In the same way that Lausen's pictures fail – for all their clear formal references – to correspond to the overriding direction taken by Pop art in terms of actual content, Peter Roehr's fail to correspond in terms of their aesthetic conception. Although the use of everyday materials – such as advertising brochures, stickers or punchcards – and their serial arrangements also display a formal

proximity to Pop art, closer inspection reveals a far more essential link to Minimal art. In the Germany of the 1960s, therefore, the young Frankfurt artist occupied an isolated though, in retrospect, ground-breaking position:

"Few if any others of his generation used the picture motif in such consistent fashion to negate the critical reflex of his historical environment, or to negate the individually controlled inspiration as both formal and semantic information and the context of the work; and no one questioned the content-linked image as searchingly as Peter Roehr did with his array-like sequences. His aesthetic is determined solely by the treatment and arrangement of the materials available to him. With a remarkable degree of sensitivity, he reacted to properties of the material such as density, the structure of the paper, and to dimensions and proportions; quite immaculate is the hand-

crafted production of these series of montages in printed or punched paper, and in plastic, board, celluloid."[30]

As Gerhard Richter (born 1932) is probably today the world's leading abstract painter, it is difficult to see him presenting himself as a Pop artist, but that is precisely what he did in 1962. In his visit to *Documenta II* in 1959 it was the abstract art of Pollock and Fontana that strengthened his resolve to emigrate from East Germany and settle in Düsseldorf in 1961. Yet one year later he travelled to Paris with Konrad Lueg (born 1939) to try to persuade the dealer Ileana Sonnabend to show their work as the new "German Pop Artists".

Lueg gave up his aspirations as an artist and, after changing his name to Fischer, became a successful dealer, promoting both Richter and Sigmar Polke (born 1941), but not before he had put on a show of his own and Richter's work in October 1963 – *Life with Pop* at the Berges furniture store in Düsseldorf. Art and life became interchangeable. The artists' own exhibits were made to compete with the normal stock of the building, which included an extensive furniture exhibition of all current styles on four floors: eighty-one living-rooms, seventy-two bedrooms, kitchens

and individual pieces. This "Demonstration for Capitalist Realism" owes as much to the ironic ambivalence of Marcel Duchamp (1887–1968) as to American and British Pop. Long term, Richter found more in Pop's roots than in Pop art itself. For instance, he discovered the found-object collages of German exile Kurt Schwitters (1887–1948) through Rauschenberg's interest in his work.

In coining the phrase "Capitalist Realism", Richter was underlining his freedom to make realist art that was not Communist. It was an early example of his skill at positioning himself as an artist. Pop art renewed the great twentieth-century tradition of appropriation of objects, but Polke and Richter have been two of the most adept appropriators of styles. Walking the narrow line between commitment and irony was an essential skill for those wishing to achieve anything under the old Communist régimes. Some of their younger

Uwe Lausen
Double Life, 1967
Screenprint
60.3×42.5 cm (24×17 in.)

Peter Roehr
Untitled, 1965/66
Collage in plastic
70×70 cm (27½×27½ in.)

all conditions and that its meaning is to be found in nothing other than its continuation."[31]

followers have fallen off the tightrope and relied totally on presentation, but the ability learnt at an early age by Polke and Richter has served them well. They have consistently re-invented themselves and adapted to the changing world and managed to deliver their message to an all-too-fashion-conscious world without compromising their art. They have been able to hold up the mirror to society, while often marching at a slight tangent to the way the world appears to be going.

In his blend of sincerity and irony, Richter has discovered one of the cornerstones of contemporary art. As Wieland Schmied explains:

"… Richter consistently painted his permanent non-identity. He was not able to commit himself, nor did he want to. From this stance of deliberate non-commitment he gained a new confidence for the role of the art … Gerhard Richter's painting demonstrates only one thing in all its changes: that painting will continue under

Richter's and Polke's use of photography is a case in point. Although there are similarities with Warhol, Lichtenstein and Hamilton, in retrospect the long-term goals differed. From the beginning, Richter's choice of unknown people displays his wider social concern. He was not after famous landmark icons, as was Warhol; rather, he was examining men and women's behaviour within society. His later extensive study of the Baader-Meinhof could be read as an exception to this, or merely as another example of his interest in how society functions and malfunctions.

Polke takes a certain pleasure in imperfections, in a similar way to Francis Bacon. Bacon defined his own modernism by quoting his friend Michel Leiris, who debunked the classical ideal of beauty. "We can call 'beautiful' only that which suggests the existence of an ideal order", wrote Leiris, "– supra-terrestrial, harmonious and logical – and yet bears within

Sigmar Polke
Weekend House, 1967
Screenprint on board
59.5×84 cm (23¹/₂×33 in.)
Edition: 30/80

Eugen Schönebeck
Mayakovsky, 1966
Crayon on paper
85×60 cm (33¹/₂×23¹/₂ in.)

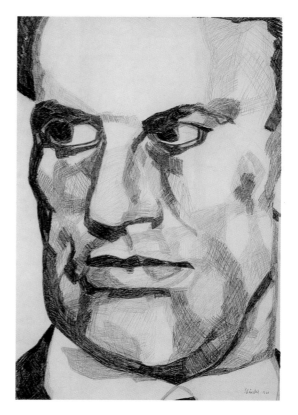

74

itself, like the brand of an original sin, the drop
of poison, the rogue element of incoherence,
the grain of sand that will foul up the entire
system."[32]

In *Wochenendhaus* (1967), Polke gives us
a neat suburban house, depicting it with the
rough grain of badly printed newspaper. It
could have been a Lichtenstein up until the
moment he splashes crude pink strokes
across the surface to create the flower that
rips the image apart like a sunflower in a field
of barley. Marco Livingstone interprets this
need to disrupt the image as part of Polke's
desire to take Lichtenstein at his word, "to
get a painting that was despicable enough so
no one would hang it".[33] Livingstone admits
that Lichtenstein could never achieve this,
but that Polke was prepared to throw out
good taste.

In November 1961 two other East Germans,
Georg Baselitz and Eugen Schönebeck (born
1936), announced their presence in Berlin
by issuing the *First Pandemonium Manifesto*.
It was little more than an excuse for a neo-
Nietzschean rant, but both artists made
serious efforts to find some order out of the
chaos that greeted them after escaping their
Socialist Realism induction. Schönebeck
"attempted to combine experiences of *l'art
informel* (Jean Fautrier [1898–1964]) and the

new figuration with a socialist realism reduced
to its basics (the late Kasimir Malevich
[1878–1935] and Alexander Deineka [1889–
1969])".[34] We illustrate one of his last drawings,
part of a series limited to those revolutionary
figures whom he felt rose above the bourgeois
confusion among which he found himself
living. Perhaps he ran out of role models;
either way, he stopped painting in the year
he drew this, 1966. His friend Baselitz was
forced to an even more radical solution, to
the dilemma of making paintings that were
modern and yet fitted into the structure of
Western history; in 1969 he turned painting
on its head. By refusing to grant viewers their
expected vision he makes them look at the
picture anew.

It may seem heretical, but Baselitz was
looking to solve the same problem as the
Minimalist Judd. Both artists wished to rise
above stale compositional effects. While Judd

Markus Lüpertz
Three Acorns and a Shovel, 1974
Pastel crayon on
wrapping paper
60×80 cm (23×31 in.)

Bernd Koberling
Long River, 1967
Felt pen and ballpoint pen
on paper
21×14.7 cm (8¼×6 in.)

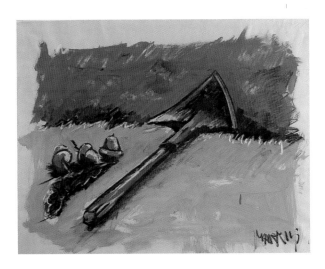

pared down his work to avoid them altogether,
Baselitz found a way of revitalizing them.
As Baselitz elaborates:

"Up until 1969, I painted pictures that had
both content and expression. The expres-
sion was found in the content. This content
suddenly disappeared. You could say it
marked the end of puberty. At the time,
I asked myself: Is your head empty? Is it the
end of the road for painting? But then I came
across an answer that enabled me, as it
were, to apologise for this past. You were
dealing with themes, not with pictures. You
failed to deal with painting itself. I started
to paint pictures without content, without
expression, without any story to them.
And that suddenly gave me a lot of freedom.
I was able to paint what I had previously
denied myself: still lifes, portraits, female
nudes, landscapes – everything." [35]

The rebuilding of painting is most clearly
shown by another East German who arrived in
Berlin in 1963 – Markus Lüpertz (born 1941). In
1966 he published the *Dithrambic Manifesto*,
and, rather like the British painter John Walker
(born 1939) some fifteen years later, this led

him to use a single form to develop the craft
of painting in front of the public's eyes. It was
almost the same as a pianist playing his scales
at a concert. In his 'motif painting' of 1969 to
1975 he applies the same rigour to subject-
matter. It is as though he is trying to take a few
forbidden motifs out of Germany's recent past
and piece them back together. Steel helmets,
military caps and guns lie discarded on
German soil. In *Three Acorns and a Shovel*
(1974) there is a clear implication of the task
ahead of replanting the spirit of Germany,
replanting the spirit of painting.

Other artists such as Bernd Koberling
and K.H. Hödicke (both born 1938), who
showed alongside Lüpertz at Galerie
Grossgörshen 35, were taking parallel steps,
but figurative painting had to wait until the
end of the 1970s and beginning of the 1980s
to burst on to the world scene. Koberling even
made attempts in the 1960s and 1970s to
forge a new art based on the bleak Northern
landscape, but he was continually questioning
whether these works were relevant and

75

Dieter Roth
Six Piccadillies, 1970
(detail)
Series of six screenprints
50×69 cm
(19 1/2 × 27 in.) each
Edition of 150

political enough for the time. Minimalism and conceptualism dominated the end of the 1960s and the 1970s.

Fluxus, by its own definition, is difficult to pin down. It can be seen as a cross between Pop and conceptual art, but that is only part of the story. It was a succession of Happenings, unresolved debates and arguments. There was a strong political content. Among many other ideas, the 'Critical Theory' propelled artists to look for new artistic structures, aesthetics untainted by the past. Thomas McEvilley wrote that Joseph Beuys "was moved by a feeling similar – whether or not there was actual influence – to Theodor Adorno's pronouncement that 'to write poetry after Auschwitz is obscene'. Extending this dictum to the visual arts meant that the making of pretty paintings was obscene."[36] Beuys was certainly not the only *Fluxus* artist to believe this.

Beuys and Wolf Vostell (born 1932) proved to be the leading German participants, but an American, George Maciunias, who joined the American Air Force to avoid the creditors of his New York Gallery, started *Fluxus*. He was posted to Wiesbaden in 1961. He first used the name *Fluxus* (in flux) as the proposed title of a magazine that never appeared.

Once Maciunas was in Germany he organized a festival devoted to *Fluxus* at Wiesbaden in 1962.[37] This immediately showed the importance of music to *Fluxus* as most of its important events were connected to music – not the music of the Beatles and other popular music that Blake and Hamilton were associated with through album covers, but that of John Cage (1912–1992) and other avant-garde composers. At the Wiesbaden festival fellow-travelling Americans such as Emmett Williams (born 1925), Alison Knowles (born 1933) and Dick Higgins (born 1938), as well as Vostell and Nam June Paik (born 1932), provided a weekend of piano compositions. *Fluxus* artists indulged in precisely the type of intellectual activity from which the Pop artists had fled.

Detailed comparison between Pop and *Fluxus* would probably do little more than spread confusion, as ostensibly *Fluxus* was opposed to the very star system Pop worshipped, but there was a definite overlap, or rather a whole series of circuitous connections. Dieter Roth (born 1930) was associated with several *Fluxus* actions, yet he produced 'Pop' images such as *Six Piccadillies* (1970). In this series of six postcard views of Piccadilly Circus, he applied twenty-four layers of screenprint over his offset blow-up, creating an alienating device at odds with the straight

Eduardo Paolozzi
Die Versunkene Glocke
[The sunken bell]
from the portfolio
Ravel Suite, 1974
Etching
50.8×38.1 cm (20×15 in.)
Edition: 7/15

Pop of, say, Blake or Tilson. "The artist presents the viewer with the unresolved dilemma that faced him", Marco Livingstone writes: "whether to content himself with the role of consumer and manipulator of existing images, or to assert his creativity as the inventor of marks sufficient unto themselves."[38]

Dieter Roth, who collaborated to make works with Richard Hamilton, was much closer to the more intellectual developments of Hamilton and Paolozzi. Both of these British artists have many connections with Germany, so perhaps it is not surprising that in *The Ravel Suite* (1974) Paolozzi declares his musical allegiance. His convoluted mechanical forms echo not the jazz of Piet Mondrian (1872–1944) or Alan Davie, not Pop, not Cage, but the classical music of Ravel.

The German–American axis was built out of a certain friction. In Maciunias's manifesto of 1963 he had demanded, "Purge the world

of 'Europeanism'". In 1970 Beuys replied with "Purge the world of Americanism". *Fluxus* may have been started by Americans, but for most of its German contributors it was merely a starting-point. Beuys's favourite student, Johannes Stüttgen, explains how Beuys used merely the levelling element of American art as the first step: "Andy Warhol pointed his camera at the non-artistic, the art-killing area of life, the everyday world, the 'factory', the conveyor belt: i.e., at the end of art – the very region from which Joseph Beuys started out, and thus the beginning of art".[39]

The Korean-born American Nam June Paik, who has spent a lot of time in Germany, epitomizes the nomadic and versatile nature of *Fluxus*. One moment it was a casual meeting of like-minded spirits, the next the sparks were flying and Beuys and Vostell were fighting for the heart of German art. There was a wild, anarchic, antagonistic edge to many of the artists, despite their generous, ambitious aim to improve society. Paik had his *Kill Pop Art* manifesto distributed by a robot. *Fluxus* may not have had the same impact but it made Pop look tame. In the performance of the *Opera Sextronique* by Paik and Charlotte Moorman (1933–1991) she squeezed a cello between her wet thighs.

The irreverence of Dada was so strongly felt in *Fluxus* that René Block, the Berlin dealer,

77

who put on many of *Fluxus*'s key shows, mounted a show in 1964 called *Neodada, Pop Decollage, Capitalist Realism*. Wolf Vostell, who was the chief layout designer at the *Neue Illustrierte*, had become the master of décollage. His belief that art and life were indistinguishable was reinforced by his regular intake of news photographs. "Why is reality sometimes more interesting than its fiction?" he asked rhetorically.[40] A sign of the changing times was that Galerie Parnass in Wuppertal, which had once been a stronghold of *Informel*, gave him an exhibition in 1963. *Black Room* was one big collage of photographs. There was not enough life within the four walls for Vostell so he hired a bus to take visitors to the exhibition and show them a further nine natural décollages around the city of Wuppertal.

Vostell traces his linking of life and art back to his childhood: "My dominant image from my childhood [is] the dying person ...", he recalls. "I lived through my first Happenings when I was eight or nine: during an air raid we all had to run a kilometre away from the school, and every child on his own had to find a different tree to shelter under ... and from there I saw aerial dogfights and bombs falling on the earth." [41]

Projects frequently did not materialize. For *Documenta III* (1962) Vostell wanted to place an F-111 on the roof of the main exhibition building in Kassel. This was three years before Rosenquist made his painting *F-111*. In 1970 Vostell's contribution to an exhibition was to supply a pregnant cow, which was physically going to symbolize the rebirth of society within the museum. The cow and its dung were thrown out and the artist retorted that a society that stinks cannot beat a stinking exhibition.

Fluxus could not be contained within museum walls. As Friedrich Wilhelm Heubach explains, it should not be isolated from the life of the time:

"These anti-art, anti-culture tendencies in art can be rightly understood, and their radicalism appreciated, only if they are seen within the cultural and political context of their day. The context, that is, of a fetid culture of psychological denial, barely conceivable today (though in places it is creeping back), with its remarkable ideological crop-rotation, its far from coincidental combination of historical amnesia and *Art Informel*, conflict taboo and abstract art, anti-intellectualism and *Ecole de Paris*. The context was the age of the Economic Miracle, which saw its panicky fear of giving offence attain the dignity of art through Tachism: which cultivated its thwarted sexuality through grubby, second-

hand forms of Surrealism – and which finally found an object of revelation for its burning spirituality in the shape of mono-chrome painting … Only by visualising how totally politics and culture were dominated by a half-baked, Christian-castrated Existentialism, by invocations of a nebulous Western heritage, by militant bigotry and by the all-distorting tyranny of the 'positive', the 'authentic', the 'profound' – in short, by a mentality that abhorred anything that was concrete or critical – only then can you assess just how radical Happening, Fluxus, Situationist, even early Pop artists were."[42]

The fight was going on in the head now. Language had become the main weapon. Musicians and philosophers had led the way in yet another twentieth-century quest to go back to square one. In 1949 John Cage had given a talk entitled *Lecture on Nothing*.

In the 1960s Beuys emerged as a leader in the battle of words. As Michael Archer points out:

"the distinction between American and German art of the period could also be demonstrated by a comparison between the character of Happenings and of *Fluxus* events. Both drew on Dada, but while Happenings were extensive, a multiplicity, full of things, *Fluxus* events were simple and unitary in conception. In addition, the 'anti-art' of the *Fluxus* artists, and this of course included Beuys, was aimed at reconnecting art with life in a fully political sense."[43]

Beuys spent much of the 1960s in conflict. He fought the authorities at the Staatliche Kunstakademie Düsseldorf in his attempt to establish a Free University and was finally evicted from his classroom; and in *Der Chef The Chief* (1964) he blatantly established American art and its dominance of world art as the enemy of free thought. Beuys may have been one of those who established the new parameters of art in the 1960s, but it was in the 1970s that he rose up above the conflict to reveal his messianic healing vision.

1 Andy Warhol with Pat Hackett, *POPism: The Warhol '60s,* London (Pimlico) 1996, p. 3.
2 Wieland Schmied, in *German Art in the 20th Century*, exhib. cat., ed. Christos M. Joachimides, Norman Rosenthal and Wieland Schmied, London, Royal Academy of Arts, 1985, p. 62.
3 Dietrich Helms, 1969, quoted in *Gotthard Graubner*, exhib. cat., ed. Hans Albert Peters and Katharina Schmidt, Baden Baden, Staatliche Kunsthalle, 1980, p. 234.
4 Gotthard Graubner, *ibid.*, p. 235.
5 Chocolate manufacturer, collector and founder of the Ludwig museums in Cologne, Aachen and elsewhere.
6 Tim Scott, interviewed by David Mellor, 27 July 1992, quoted in *The Sixties Art Scene in London*, exhib. cat., ed. David Mellor, London, Barbican Art Gallery, 1993, p. 94.
7 Anthony Caro, quoted in Lawrence Alloway, 'Interview with Anthony Caro', *Gazette,* no. 1, 1961, p. 1; reproduced in *The Sixties Art Scene in London*, *op. cit.*, p. 95.
8 *Ibid.*
9 Charles Harrison, in *Anthony Caro*, exhib. cat., British Council, British Pavilion, Bienal de São Paolo, 1969, unpaginated.
10 The group of sculptors who

Gerhard Richter
Electric Train, 1965
Pencil on paper
39.7 × 29.5 cm
(15 ¹/₂ × 11 ¹/₂ in.)

surrounded Caro at St Martin's School of Art was given the name New Generation after an exhibition of this title at the Whitechapel Art Gallery, London, in 1965. The group consisted of Phillip King, William Tucker, David Annesley and Michael Bolus. William Turnbull was associated with the group but had no formal links with St Martin's.
11 Phillip King, 'My Sculpture', *Studio International*, June 1968, pp. 300–02.
12 In recent years Caro has produced works based on Greek architecture and has returned to the study of the figure.
13 Donald Judd, quoted in Michael Archer, *Art Since 1960*, London (Thames and Hudson) 1997, p. 53.
14 Harold Macmillan, speech in Bedford on 20 July 1957, reported in *The Times*, 22 July 1957.
15 Jasper Johns's target and flag paintings were not shown until 1958, at Leo Castelli's Gallery, New York.
16 Marco Livingstone, *Pop Art: A Continuing History*, New York (Abrams) 1990, p. 33.
17 Lawrence Alloway, 'The Arts and the Mass Media', *Architectural Design*, no. 2, February 1958, p. 28.
18 Paolozzi gave his 'Bunk' lecture at the ICA, London, in April 1952.
19 Alison and Peter Smithson, 'But Today We Collect Ads', *Ark*, 18 November 1956, pp. 49–50, reprinted in *Modern Dreams*, p. 53.
20 *Sergeant Pepper's Lonely Hearts Club Band* was released on 1 June 1968.
21 Marco Livingstone, *op. cit.*, p. 45.
22 Letter from Colin Self to Marco Livingstone, 23 September 1987, reproduced in

Marco Livingstone, *op. cit.*, p. 257.
23 Caroline Tisdall, *Joseph Beuys: We Go This Way*, London (Violette Editions) 1998, p. 111.
24 *Pop Prints from the Arts Council Collection*, exhib. cat. by Marco Livingstone, London, The South Bank Centre, *et al.*, 1993, p. 19.
25 Richard Hamilton, 'An Exposition of $he', *Architectural Design*, October 1962, pp. 485–86.
26 James Rosenquist, quoted in Robert Rosenblum, 'Interview with James Rosenquist', *James Rosenquist: The Swimmer in the Econo-mist*, exhib. cat. by Robert Rosenblum, Berlin, Deutsche Guggenheim Berlin, 1998, p. 9.
27 John Kasmin, always known simply as Kasmin, ran the quintessentially sixties gallery in Cork Street, London, for some thirty years.
28 Maurice Cockrill, 'Fragments of an Autobiography', in Margaret Drabble, *Margaret Drabble on Maurice Cockrill*, Modern British Masters, vol. V, London (Bernard Jacobson Gallery) 1992, unpaginated.
29 Phyllis Tuchman, 'American Pop Really Turns on German Art Lovers', *The New York Times*, 27 November 1970.
30 Christa von Helmolt, *Zeitgenössische Kunst in der Deutschen Bank*, 3 vols., Frankfurt am Main 1989–90, p. 222.
31 Wieland Schmied, 'Developments in German Art', *German Art in the 20th Century*, exhib. cat., ed. Christos M. Joachimides, Norman Rosenthal and Wieland Schmied, London, Royal Academy of Arts, 1985, p. 63.
32 Bacon quoted this to me in an interview, but I have never identified the source, which Bacon described as a small book written under the influence of Baudelaire. He kept it in his studio

and had ringed this passage. Quoted in Alistair Hicks, *The School of London*, Oxford (Phaidon) 1989, p. 21.
33 Sigmar Polke, quoted in Marco Livingstone, *Pop Art: A Continuing History*, *op. cit.*, p. 152, which quotes G.R. Swenson, 'What is Pop Art?', *Artnews*, 26 November 1963, p. 24.
34 Wieland Schmied, 'Typical and Unique: Art in Berlin 1945–1970', *BERLINART 1961–1987*, exhib. cat., ed. Kynaston McShine, New York, Museum of Modern Art, p. 47.
35 Georg Baselitz, quoted in 'Das Bild hinter der Leinwand ist keine Utopie', *Die Welt*, no. 267, 16 November 1987, p. 9, quoted in Ariane Grigoteit, 'The Reformed Motif – Figure I', *Georg Baselitz: Deutsche Bank Collection*, exhib. cat. by Britta Färber, Ariane Grigoteit and Friedhelm Hütte, Moscow, Chemnitz and Johannesburg, 1997–99, p. 15.
36 Thomas McEvilley, '(Op)Posing Cultures: An Investigation of Beuys and Warhol', *The Froehlich Foundation: German and American Art from Beuys and Warhol*, exhib. cat., ed. Monique Beudert, London, Tate Gallery, 1996 p. 41.
37 *Fluxus: Internationale Festspiele Neuester Musik* was held at the Städtisches Museum in Wiesbaden, September 1962.
38 *Photographics*, exhib. cat. by Marco Livingstone, London, Alan Cristea Gallery, 26 April–26 May 2000, p. 11.
39 Johannes Stüttgen, *Das Warhol-Ereignis*, 2nd edn, Wangen (Free International University) 1979, quoted by Evelyn Weiss, *Pop Art*, exhib. cat., London, Royal Academy of Arts, 1991, p. 223.

40 Wolf Vostell, in Jürgen Becker and Wolf Vostell, *Happenings, Fluxus, Pop-Art, Nouveau Réalisme: Eine Dokumentation*, Reinbeck bei Hamburg 1965, p. 403; quoted in Stefan Germer, 'Intersecting Visions, Shifting Perspectives: An Overview of German Artistic Relations', *The Froehlich Foundation: German and American Art from Beuys and Warhol, op. cit.*, p. 32.
41 Wolf Vostell, in Jurgen Beck and Wolf Vostell, *op. cit.*; quoted in Monique Beudert (ed.), *op. cit.*, p. 32.
42 Friedrich Wilhelm Heubach, 'Die Kunst der 60er Jahre: Anmerkungen in enttuschender Absicht', in Herogenrather and Lueg, 1986, pp. 113–14.
43 Michael Archer, *op. cit.*, p. 110.

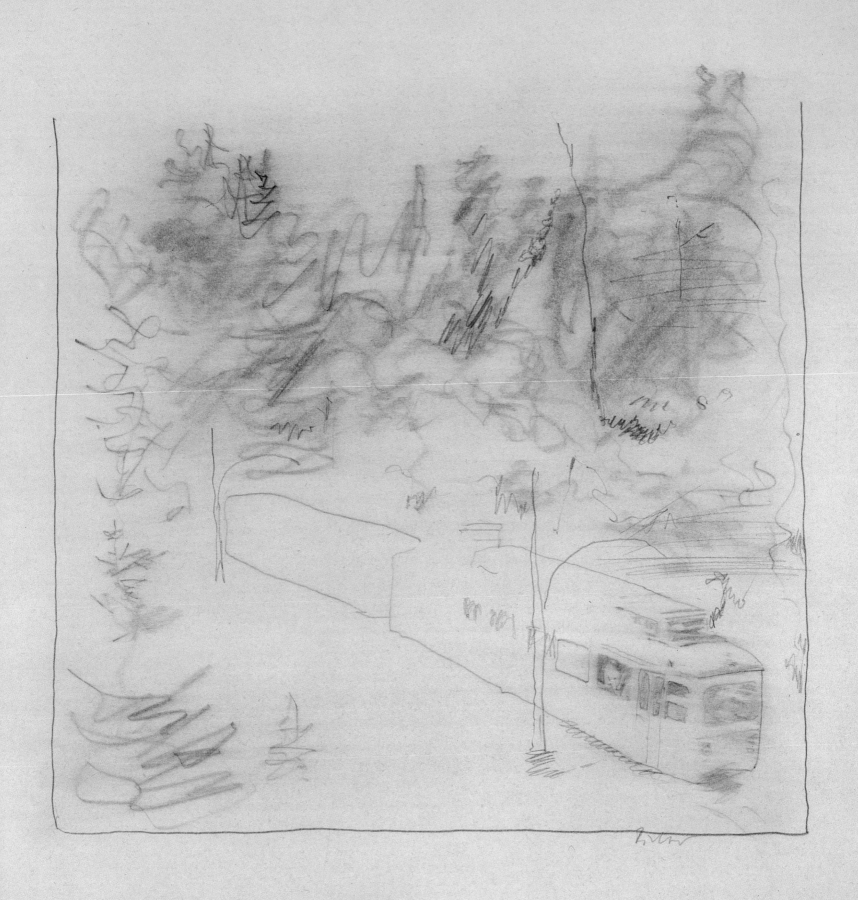

To the
Neue Deutsche Wochenschau[1]
Düsseldorf

"Dear Mr Schmitt

Allow us to draw your attention to a quite remarkable group of painters and their quite remarkable exhibition. We are staging this exhibition in Düsseldorf, and have chosen former retail premises in the condemned section of Kaiserstraße as the venue. For this exhibition, which is not of a commercial but an exclusively demonstrative character, no gallery, museum or exhibition organization could ever be considered. What makes the exhibition such a noteworthy event is the range of themes featured in the works. For the first time in Germany, we shall be presenting pictures illustrative of terms such as pop art, junk culture, imperialist or capitalist realism, new representationalism, naturalism, German pop, and similar trends. Pop art acknowledges the mass media to be a genuine cultural manifestation and uses its attributes, formulations and content for artistic purposes by presenting them in unaccustomed form. In doing so, it is changing the face of modern painting quite fundamentally, ushering in an aesthetic revolution. It has overcome conventional painting, its sterility, isolation, and artificiality, its taboos and codes, and, by creating a new perspective on the world has gained rapid international exposure and recognition.

Pop art is not an American invention, and for us is not an imported product, even if the terms and names were largely coined in America, and became popular there sooner than they have here in Germany. The fact that this art is growing organically and autonomously here in our own country, while also acting as an analogy to American pop art, is due to the presence of certain psychological, cultural and economic conditions that are shared by both Germany and America.

We feel that it would be appropriate for the Wochenschau to document this first exhibition of *German Pop Art*, and thus urge you to consider reporting it. If you would like to receive further information about us, our work, and our artistic tendencies, we shall be happy to provide further details.

We[2] look forward to hearing from you and remain

Respectfully yours,

Gerd Richter
Düsseldorf
Hüttenstr. 71
Düsseldorf, 29.4.63 Tel. 18970"[3]

1 The *Neue Deutsche Wochenschau* was the news shown in the cinema.
2 The painters Manfred Küttner, Konrad Lueg, Sigmar Polke, and Gerhard Richter.
3 This statement by Gerhard Richter is taken from Hans-Ulrich Obrist (ed.), *Gerhard Richter: Text, Statement and Interviews*, Frankfurt (Insel Verlag) 1993, p. 11.

Frank Auerbach
Reclining Figure, 1972
Oil on paper
58.4×80.4 cm (23×31 in.)

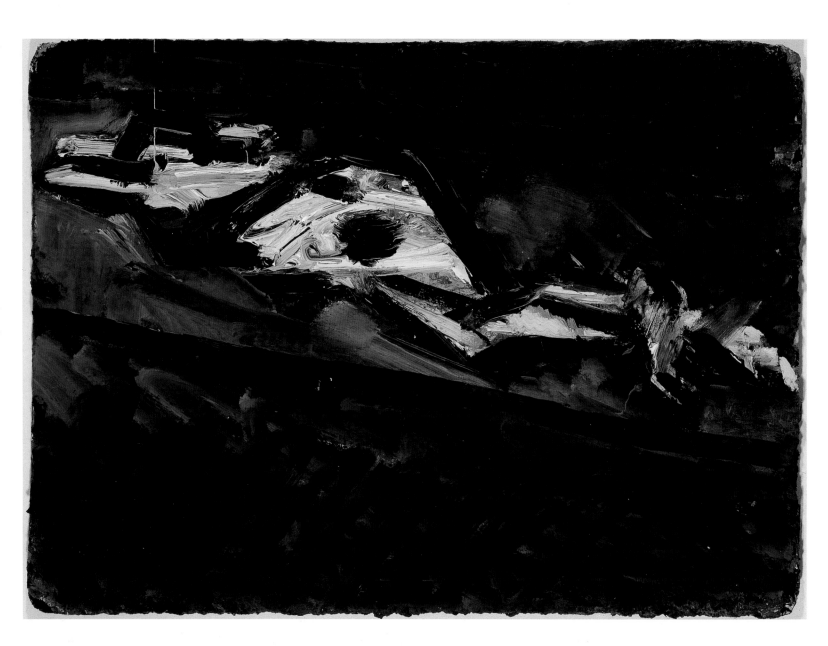

1970s: Out of their minds

Christo

*Wrapped Reichstag,
Project for Berlin,*
drawing, 1978,
in two parts
Pencil, charcoal, pastel,
crayon and map
38 × 244 cm and
106.6 × 244 cm
(15 × 96 in. and 42 × 96 in.)

"He [Beuys] lived and watched the world as if he were once dead. Everything was a bonus to him." Nam June Paik, 1986[1]

Plato was the first conceptual artist. With his low opinion of artists, I doubt he would thank us for pointing the finger at him, but he invented conceptual art. It was his idea that there was an ideal to which all depictions, sculpture, architecture, landscape and, yes, nature itself aspire. As a result, most of the artists of the last two and a half thousand years have slavishly attempted to spill out their images from their heads. Conceptual art, first broached by the American Henry Flynt in 1960, was simply reaffirming that it was the image in the head that mattered.

In describing the contents of their heads, even artists have to resort to words. The joy of the 1970s is that artists had a way of cutting through semantics, definitions and metaphysics and bringing us down to earth with a bump. It was a British artist, Keith Arnatt (born 1930), who submitted this message shown in 1970: "Is it Possible for Me to Do Nothing as My Contribution to this Exhibition?"[2]

Arnatt's shock tactics did not win the day. Burying himself up to his nostrils in his self-burials, and at other times carrying a billboard tied around his neck with the words "I'M A REAL ARTIST", ultimately did not convert a wide audience. There was a very serious problem for many artists opposed to the commercial structures of the day. Not only were a large number of artists unable to make a living, but their principles ensured that their art failed to have a sustainable presence within a system of which they disapproved.

The conceptual artists of the 1960s and 1970s who made it into the mainstream of twentieth-century art were exceptional. One area that did offer opportunities was public art, in which the Bulgarian-born American artist Christo and his partner Jeanne-Claude (both born on 13 June 1935) have proved phenomenally successful. In developing the surreal idea of wrapping objects into a communal activity, which had earlier been explored by Man Ray (1890–1976), they have shown themselves to be brilliant organizers and money-raisers. The sheer scale and ambition of their projects, such as the wrapping of the Reichstag in Berlin and the Pont Neuf in Paris, have involved countless people, and it is this participation that is an important part of the work.

Another American, Sol LeWitt (born 1928), took this to its logical conclusion. To distinguish between the making of the art and its inception, he gives the plans to others to execute. Theoretically, anyone can make his works of art; they just have to follow his instructions.

He did much to define conceptual art in 'Paragraphs on Conceptual Art' in the journal *Artforum*. Living up to his name, he began, "The editor has written me that he is in favor of avoiding 'the notion that the artist is a kind of ape that has to be explained by the civilized critic.' This should be good news to both artists and apes."[3] On a more serious note he stresses that "the idea or concept is the most important aspect of the work. When an artist uses a conceptual form of art, it means that all of the planning and decisions are made beforehand and the execution is a perfunctory affair. The idea becomes a machine that makes the art."[4] Perhaps more radically still he states, "What the work of art looks like isn't too important. … The work does not necessarily have to be rejected if it does not look well."[5] Here we can see connections with Lichtenstein, Polke, Beuys and many others looking to change the aesthetic structure.

There are strong echoes of Constructivism in LeWitt's work. His process of manufacture is a natural progression from Gabo's ideas. "To work with a plan that is pre-set is one way of avoiding subjectivity",[6] continues LeWitt. He also pinpointed the potential weakness of his formula in admitting, "Conceptual art is only good when the idea is good".[7]

Once again, new ideas from America centred around Anthony Caro in Britain.

Another generation of his students at St Martin's School of Art, London, were at the forefront of conceptual, Performance and Land art: Richard Long (born 1945), Hamish Fulton (born 1946), Gilbert and George (born 1943 and 1942), Barry Flanagan (born 1941) and Bruce McLean (born 1944). Gilbert and George took the opposite route to Sol LeWitt and made themselves into living sculptures. The Glaswegian McLean, though he is represented in the bank's collection only by figurative prints, had an equally satirical voice in the 1970s. Indeed, when he was offered a retrospective at the Tate Gallery in 1972 he opted that it should last for only one day. The title of the exhibition was *King for a Day*.

Flanagan is probably even more elusive than McLean. In 1966 he very publicly declared his intent to distance himself from Caro and the god Greenberg. John Latham (born 1921), who was a part-time teacher at St Martin's, took Greenberg's *Art and Culture* out of the college library. Flanagan and Latham then invited students and friends to come and eat the book. They chewed and when necessary spat out the remains into a flask. This they immersed in acid and then turned into a neutral solution. Latham returned the bottled liquid and the distilling equipment to the library a year later. He was dismissed.

Flanagan produced work that seemed

awkward within a gallery space. Its soft, vulnerable nature was a visual retort to Caro's hard, uncompromising girders. He shared the impoverished look of the Italian *Arte Povera* artists. Yet as early as 1973 he was carving stone, and from 1980 making the bronze hares for which he has become famous. He was refusing to be typecast.

Richard Long and Hamish Fulton supplied the most lasting British contribution to conceptual art. Land art has not been just a British movement. Indeed, Jeffrey Kastner, in the preface to *Land and Environmental Art*,[8] devotes a single paragraph to the European contribution, mentioning Long, the Dutchman Jan Dibbets (born 1941) (who also studied at St Martin's) and the Germans Günther Uecker (born 1930) and Hans Haacke (born 1936), but not Fulton. This is not totally surprising, as this shambolic book is an example of Post-modernist thinking at its worst. The editors and authors of *Land and Environmental Art* seem to be arguing that Land art is Post-modernist: "As Irving Sandler notes in his *Art of the Postmodern Era*", writes Kastner, "the chaos of the moment derived from and reiterated an essential crisis of faith in the Western body politic."[9] One can turn this on its head. Throughout the history of Modernism there have been constant attempts to inject 'primitive' forces into art, to give art new life.

Land and Earth artists were simply resorting to the rawest material possible.

Long readily admits to being influenced by having seen Isamu Noguchi (1904–1988) at the Tate,[10] but there is a fundamental difference between most American Earth artists and Long. While Robert Smithson (1938–1973) was happy to get out his bulldozer and dramatically rearrange nature, Long and Fulton have no desire to change the natural environment. "Nature has more effect on me than I on it", says Long.[11] Long has moved stones and made paths, he has moved mud and stones into galleries, but Fulton is more of a purist. He does not alter the landscape but just photographs it. As Patrick Elliot clarifies, "Fulton's subject matter is the landscape and his relation to it (through walking) and his medium is the word and, to a lesser extent in recent years, the photograph".[12]

Long and Fulton have made the Modernist break with the classical view. They are not trying to reveal the romantic or idyllic side of nature. They are not idolizing nature, but just using it as their subject. "Art can be made anywhere", says Long, "perhaps seen only by a few people or not recognised as art when they do."[13] In this he is being a true concep-tualist, but not purely intellectual, particularly when he declares, "I like to see art as being a return to the senses".[14]

Richard Long
Connemara Sculpture,
1971
Photography and text
83.2 × 66 cm (32³/₄ × 26 in.)
Courtesy of Anthony
d'Offay Gallery, London

88

For a man who spends a great deal of his time thinking on his own while he walks great distances, Long is not dogmatic. He is disarming in the way he accepts criticism:

"I don't think you can separate childhood from adulthood. I think you are the same person all through your life. So all the sensibilities that energise you as a child sort of flow through. And being an artist means you can use them. So when newspapers derogatorily talk about my work as being sort of playing, like making mud pies or skimming stones across rivers or damming streams – all these childhood pursuits that people leave behind – I say 'great!' I don't deny that I'm doing all the same stuff."[15]

"There are no words in nature",[16] declares Fulton. This might be read in the Romantic

spirit of Caspar David Friedrich (1774–1840), of man overwhelmed by forces greater than himself, but to Fulton it is a practical problem. In the same piece he proclaims that, "A work of art can be purchased but a walk cannot be sold". Words are usually regarded as the preserve of the intellect, sight is supplied by one of the senses. By supplying photographs Fulton is conceding that words are not enough to reveal the art contained within his head.

Long and Fulton are emphatically not photographers, but the parents of contemporary German photography also emerged in the 1970s: Bernd and Hilla Becher (born 1931 and 1934). At the Staatliche Kunstakademie Düsseldorf they have taught a staggeringly high percentage of Germany's leading photographers. Since the 1950s they have used their camera systematically to examine the industrial legacy of the twentieth century. As Ulf Erdmann Ziegler says, they "address things, the made, the framework of civilisation, with a probing meticulousness. The 'I' is concealed in the anonymity of the apparatus, and the work is like a dictionary that one can raid down the years without ever stopping to ask who wrote it."[17] By grouping together various shots of certain types of buildings, often industrial, and installing them as one work, they have built up the impact. Unlike Warhol's repetition of objects, the Bechers show a range of different

Bernd and Hilla Becher
Houses: 3 Views, 1977
Black-and-white
photograph
40.3×30.9 cm
(15.7×12 in.) each

 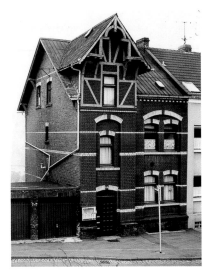

buildings with a common link. Rather than diminishing the object the Bechers are giving an accumulative vision.

Words do not come into play with the Bechers. They are crucial to Fulton, but the 1970s' love of wordplay is best demonstrated by the group of artists that called themselves Art & Language. The name first appeared as a magazine in Coventry in May 1969. Its founders were Terry Atkinson (born 1939) and Michael Baldwin (born 1945), but its existence has the same volatile feel to it as *Fluxus*. There have been over a dozen people associated with it over the years, but in a statement of 1999 Art & Language admit to having been in "the hands of Michael Baldwin and Mel Ramsden [born 1944]"[18] since 1976. As their very art is made of words and is about the control of words, it is not surprising there has been so much internal division or that they refute virtually every label thrown at them. They state, "Art & Language work of the period 1965–1975 is untidy, multivocal, inchoate, complex, conversational and obscure. With certain exceptions, it is an inconvenience to the agendas of the art world and an eyesore in the landscape of historical overview."[19]

Despite their own dismissive view of the past and the fact that they were included in *Documenta X* (1997), their highpoint was probably in 1972 when a group of them attended *Documenta V* with their contribution *Index 01*. It consisted of a room whose walls were pasted with charts and text. In the middle stood eight filing-cabinets full of theoretical texts. That was all that was needed to make art. Theory had won out over practice. *Sighs Trapped by Liars* (1996–97), their *Documenta X* installation used furniture made from paintings. They literally sat on the traditional idea of painting, and talked.

Another, perhaps more genuine, revival highlighted by the latest *Documenta* is that of Hans Haacke. Haacke was born in Cologne in 1936, but has lived in New York since 1965. Like Art & Language, the theme of his work is control, but unlike the British group, who hide behind obscurity and ambiguity, Haacke could not be more direct. He wanted to wrest art back from the ivory tower reserved for it by Clement Greenberg and return it to the real world. He is highly political and he has set about exposing the control structure of the art world. He is a social researcher, who has

become a master of analysis and its delivery. "Information presented at the right time and the right place", he says, "can be potentially very powerful. It can affect the general social fabric. Such things go beyond established high culture as it has been perpetrated by a taste-directed industry."[20]

Haacke's career is littered with rejections as he goes for the jugular of the institutions that support him or might potentially support him. In his *Manet Project* (1974), for instance, he traced the ownership of *The Bunch of Grapes* (1880) by Manet. Although selected by the curator of the Wallraf-Richartz Museum in Cologne, it was not shown because it listed all the directorships of the Chairman of the museum. Another benefactor of Cologne, Peter Ludwig, the great collector of Pop art and founder of the Ludwig museums, was also the subject of a work, *The Chocolate Master* (1981), about the working conditions at his factories. One of the stipulations of the artist was that it could not be sold to Ludwig. Again in *Documenta X*, Haacke showed a work that was originally intended for an exhibition at the Guggenheim in 1971. *Shapolsky et al. Manhattan Real Estate holdings, A Real-Time Social System, as of May 1, 1971* was a rampaging attack on the activities of a slum owner. The Director of the Guggenheim, Thomas Messer, refused to accept the work on the grounds that it was not art.

Deutsche Bank itself was attacked in Haacke's *Documenta VIII* contribution, *Zeitgenössische Kunst in der Deutschen Bank Frankfurt* (1987). The artist appropriated the bank's logo and superimposed it over a photograph of a funeral in South Africa. It was accompanied by a quote from a *Vorstand* member saying that the bank could not take a political position in South Africa as it would then have to take political stands everywhere, which is exactly the type of political involvement Haacke demands of everyone.

Beuys was just as politically motivated as Haacke, but after 1972, when he had his showdown with the Academy authorities, he was more concerned with building new structures than tearing down the old ones. His belief in art as a regenerative force was absolute. "Art alone makes life possible", was one of his dictums. He went further, maintaining "that without art man is inconceivable in physiological terms".[21]

Confrontation remained an important part of Beuys's work to the end, but always as part of a greater plan. He left the Staatliche Kunstakademie Düsseldorf as he felt that people had "lost sight of their intention to involve the whole of mankind in the process of education".[22] The following year he set up

the Free International University For Creativity and Interdisciplinary Research, the task of which was to make creativity as essential to society as economics.

Beuys was looking to heal society as he had been healed during the War. His Stuka was shot down in the Crimea in 1943. As he recalls, "I was completely buried in the snow. That's how the Tartars found me a few days later. I remember voices saying 'voda' (water), then the felt of their tents and the dense and pungent smell of cheese, grease, and milk. They covered my body with grease to help it regenerate warmth and wrapped me in felt as an insulator to keep the warmth in."[23]

Beuys was a true conceptual artist: "Thought is sculpture", he frequently proclaimed. But he was not content to leave the idea in the head. Action was required. He urged all around him to make more use of their innate faculties.

The fragility of Beuys's art was that it relied on him as a person, his charismatic ability as a preacher. Two key works of 1974, *Dead Hare* and *I like America and America likes me*, show his understanding of his own and man's limitations. His faith and enthusiasm in life was boundless, but he realized that he had to use all means possible of conveying this to an audience often far less receptive than the animals and plants he loved. As the cult of Beuys

mounted, his charismatic persona became his most effective tool. His image became part of his and other people's art. Warhol, after all, made some memorable icons of him.

There was a dramatic sense of a crusade at Beuys's Guggenheim New York retrospective in 1979. As Stefan Germer observed, "He was invited as a monument, and he intended to be venerated as such".[24] He felt he needed to be venerated to achieve the mindset change in his American audience. Thomas Messer, the Director of the Guggenheim, who had already had a showdown with Hans Haacke, was presented with an ultimatum by Beuys. The installation of the twenty tons of fat that formed *Tallow* meant the removal of walls from Frank Lloyd Wright's much vaunted American masterpiece. To underline the insult, when Beuys had previously installed *Tallow* in an ugly underpass in Münster in 1977 he had said it was intended to heal an "architectonic disaster". The implication was that America's architectural jewel was a disaster. Beuys was unyielding: "No *Tallow*, no show!". Unlike Haacke he got his way.

In professing his belief that everyone was an artist, Beuys was expressing his ambition to change the world. He thought that man should occupy a central place in the universe and has unlimited potentialities that have yet to be tapped. He had to change people to

Arnulf Rainer
Oak Leaf, from the
portfolio *For Joseph
Beuys*, 1986

Photo-etching and
etching on Hahnemühle
79.5×60 cm
(31 1/4×23 3/4 in.)
Edition: 31/90

change the world. In 1975 he performed
To Change Art, Change People at the Musée
Ixelles in Brussels. It was in this performance
that a former student of his, Katharina
Sieverding (born 1944), used her ex-professor
as target practice in a knife-throwing circus act.

While Art & Language feel uncomfortable
with the very idea of a story of art, Beuys was
simply trying to break the story open, to
expand it. If Beuys had had his way, history
and the history of art would become one. He
may not have succeeded in doing this, but his
impact was far greater than the accumulation
of the works of art that he left behind. His
influence was felt not just by his students but
by a wide spectrum of people.

Arnulf Rainer (born 1929), an Austrian con-
temporary, gave a touching indication of
Beuys's legacy in a work of tribute a year after
Beuys's death. Rainer had created a psychotic
style of painting and drawing over pictures.

In *Oak Leaf* (1986), he drew over a cycle of
French botanical engravings, *Histoire des
chênes de l'Amérique* (1801). In obliterating
the original images, which included oak
leaves, Rainer lets the oak emerge from his
frenetic scribbling, acknowledging that Beuys
had managed to reclaim the original notion of
the German oak out of the surrounding chaos.
Rainer was showing how his style of painting
over things, "mortification" as he termed
it, was in the regenerative spirit of Beuys.

Beuys told his pupils not to paint.
Intriguingly, the first attempts by his students
to create a new art were in abstract painting.
Both Blinky Palermo (1943–1977) and Imi
Knoebel (born 1940) studied under Beuys in
the 1960s. Palermo was a particularly well-
favoured master pupil. Yet in the 1970s both
were producing the coolest abstraction in
the tradition of the early twentieth-century
Russians. Knoebel's *Figure I & II* (1985) literally
shows the artist's examination of the found-
ation of paintings. It is made of tiles, planks
and metal supports. Knoebel and Palermo's
exploration of space led them to extend the
picture into space. Their paintings are meant
to be seen as part of the architecture, while
the architecture in return is meant to support
the picture.

There is a heavy conceptual base to
Palermo's work. He even took Sol LeWitt's

ideas one playful step further with *Blue Triangle* (1969), which was an editioned conceptual multiple. He produced fifty cardboard boxes, which contained the stencilling equipment to enable the owner to take their *Blue Triangle* home with them. The *Blue Triangle* was designed to go above any doorway.

An inverted echo of Mondrian's philosophy comes through in Beuys's teaching. Mondrian, whose work shows the most logical and clear evolution of abstraction, had created an art that was detached. Kitaj discusses this quality of Mondrian in his introductory essay to the *Human Clay* in 1976:

"The consequences of a detached art are very seductive … a very high act indeed is said to transpire there, an ultimate act or moment or feeling, so independent of anything else but its paint or shape, for instance, as to give that art its very value, an incredible purity. The idea took root in Mondrian's concept of art as a 'life substitute', something apart, detached from a life out of balance. Mondrian said, 'Art will disappear as life gains more equilibrium'."[25]

Though coming from the opposite direction to this, Beuys's merging of life and art was meant to have similar results. It needed someone like Kitaj, who is afloat in ideas, to give an alternative vision.

Ideas and idealism motivated the art scene of the 1960s and 1970s. This was the main reason why Pop faded away. Attempts to introduce intellect into Pop were doomed to failure, because a vital part of Pop's success had been its frivolous, shallow, transparent nature. There were those like Tom Phillips (born 1937) whose love of wordplay led him to create a hybrid art between late Pop and conceptual art, but no one in England managed the ever-shifting cocktail that Polke originally induced from Pop and neo-conceptualism. In the mid-1970s the division between Greenberg's legacy of abstraction and conceptualism dominated the art world. It was left to Kitaj to reveal that there were artists in London pursuing an alternative route.

Kitaj was not the first person to write about a 'School of London'. Back in 1949 Patrick Heron had written an article of that title for *The New Statesman & Nation*,[26] but it was the recoining of this phrase by Kitaj that highlighted the work of Francis Bacon, Lucian Freud, Frank Auerbach, Leon Kossoff, Michael Andrews (1928–1995) and Kitaj himself. As Kitaj has made it plain in his statement for this book, his School of London was a loose expansive group. This was borne out by the wide range of artists included in *The Human*

Imi Knoebel
Figure I and II, 1985
Mixed media on wood
253.8×173.8 cm
(99 1/4 ×68 in.) each

Clay. The brave act of the time was to ask about fifty artists to show figurative drawings. This was far more provocative than a red rag to the abstract bull of the art world. There were older painters such as William Roberts (1895–1980), William Scott and Robert Medley (1905–1995), and sculptors such as Henry Moore and William Turnbull, but the show was mainly composed of Kitaj's contemporaries, including several who had been linked, like him, to Pop: Blake, Caulfield, Hamilton, Hockney, Hodgkin, Allen Jones, Paolozzi and Colin Self.

It would be laughable to say that Kitaj lacks ambition, but his aims are far more realistic than those of Beuys, Mondrian or Greenberg. As he says in the catalogue to *The Human Clay* exhibition, "For myself, though Mondrian's dream of Arcadia has its attractions, I doubt either art will disappear or that life will achieve equilibrium … it has always seemed to me that maybe an even larger spiritual purity than an art of detachment may lie in the very direction

of sweating people in their unbalance rather than away from that life."[27] In describing himself as an "exegete" and also being unstinting in his praise of Modernists in the statement he made for this book, he supplies further keys to his work. While other Modernists have looked to the art of earlier civilization, he has looked back to the roots of his own people. Images were forbidden under Judaic law. Understanding of God did not come in one single revelation, as, for example, some Christians have believed. Truth was acquired by a continuous process of exegesis, a never-ending act of interpretation.

Despite Kitaj's realism, he shares the same regenerative urge with Beuys. He is perhaps the first Ultra-modernist. His writing of the *First Diasporist Manifesto* shows the impact that the Holocaust has had in terms of providing the chasm that has to be overcome. In the *First Diasporist Manifesto* he writes: "At odd moments I even suspect art can mend the world a little. No, I'm certain it can because

Tom Phillips
*Berlin Wall with German
Grass and Skies*, 1972
Acrylic and gouache on
paper
37×53 cm (14 1/2×20 3/4 in.)

Sigmar Polke
Rotation, 1979
Oil and acrylic on paper
230×200 cm
(89 1/2×78 in.)

I have the experience of its company – the healing effect of its company, just the two of us like pals alone in a room together."[28] He maintained that most of the major movements of the twentieth century, for instance the schools of New York and London, as well as the three schools of Paris, have depended heavily on outside blood, and particularly on migrant Jews. He had spent a couple of terms in Vienna and travelled in the merchant navy, so that he had a large vocabulary of images welling up inside him by the time he came to England to study at the Ruskin School of Drawing and Fine Arts in Oxford and the Royal College of Art in London.

One can rarely appreciate the full complexity of an artist by looking only at his works on paper, and this is true even of Kitaj, who organized *The Human Clay* to show the strength of out-of-favour draughtsmanship. His drawings do not usually contain quite as many layers of meaning or such an amalgam of sights as do his paintings. *Anne at Drancy Station* (1985) does, however, give an indication of the way his pictures are built to carry meaning. It appears to show a fairly straightforward image, a woman bundled up in a coat waiting for a train at one of Paris's suburban stations. The name of the station is given prominence:

Drancy was the station from which the Jews in France were sent to the camps. Those railway lines that supply the diagonal of the picture immediately possess more menace. We are also told in the title that the woman is called Anne. Anne Atik is a poet; she is married to the French-Israeli artist Avigdor Arikha (born 1929), who was in the camps as a child. Indeed, Arikha is a human symbol of draughtsmanship. As a thirteen-year-old he made some startling, grim images of life within the camps. A guard censored the ones that would certainly have led to his death. Later they were shown to a Red Cross Commission, which arranged for his release to Switzerland. Much later in life, when he was already a successful abstract painter, Arikha gave up painting for seven years in order to draw from life.

Kitaj's delight in interpretation is not shared by any of the other leading School of London painters. Francis Bacon, as his biographer Michael Peppiatt argues succinctly,[29] was a

Robert Medley
Figure in a Landscape,
c. 1954
Charcoal on paper
56×44 cm (22×17 ½ in.)

William Turnbull
Leaves II, from Series of
Leaves and Nudes, 1971
Etching and drypoint
60×47 cm (23 ½×18 ½ in.)
Edition: 9/30

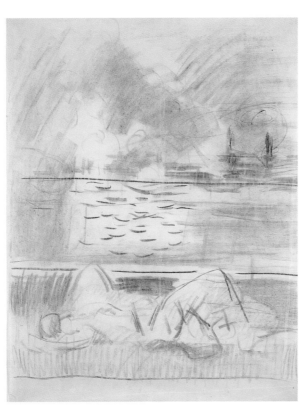

master of the presentation of his own image, but this did not extend to hours of discussion. Kitaj described the School of London as "a herd of loners", and Bacon enjoyed being the leader of the herd. He was a brilliant conversationalist, but as a reductionist he subscribed to the view that the pictures should talk for themselves. His basic image is of the isolated figure. He devised an arena on which his subjects could be tormented and dissected. The structure of the painting *Portrait of Isabel Rawsthorne Standing in a Street in Soho* (1967) in the Nationalgalerie in Berlin shows his friend from the Colony Club in London's Soho in much the same position as the bull in his bull-fighting paintings and prints.

Despite the many recent efforts to dwell on Bacon's works on paper, he was not that interested in working with the material. The lithographs in the bank's collection are little more than reproductions of his paintings.

They were often executed some time after the paintings. For instance, he painted *Study for Bullfight No. 1* in 1969, but the book of lithographs, *Miroir de la Tauromachie*, was made in 1990. The etchings by Lucian Freud, on the other hand, are an integral part of his work and reveal a great deal about the way Britain's most famous living painter pins down human flesh.

Woman with an Arm Tattoo (1996) was made two years after a glorious painting of the same subject, *Benefits Supervisor Resting* (1994). Though Freud could quite easily be described as the last great realist, he is interested in more than just representation. He adopts a gruelling schedule, working through the mornings and then follows this with a night session, usually on a different painting. With sheer will power he makes paintings that pierce through the mountains of theory generated in his lifetime. He is not

David Hockney
Gregory, 1974
Lithograph
91×71 cm (35¹/₂×27³/₄ in.)
Edition: 17/75

R.B. Kitaj
Anne at Drancy Station,
1985
Charcoal on paper
110.5×57 cm (44×22³/₄ in.)

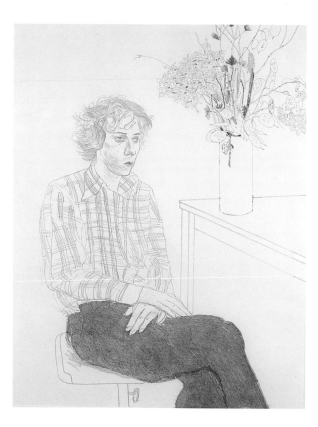

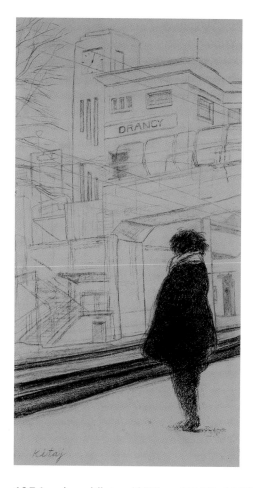

content with the idea that painting is just a two-dimensional flat surface of paint. For a painting of a person to succeed he has to feel he is working with flesh, not paint. "As far as I am concerned the paint is the person", says Freud; "I want it to work for me just as flesh does."[30] There is a sense that he has physically assembled the generous folds of flesh in such paintings as the *Benefits Supervisor Resting*. He has set about the capture of the body in a very different way with the etching. Here, with the laborious care of the Lilliputians tying down Gulliver, he has seized Big Sue's sleeping form.

In Michael Andrews's painting *The Colony Room I* (1962), Francis Bacon is sitting at his favourite stool at the bar of his drinking club, while Freud is standing on the far right, depicting the two poles of the School of London. Freud is associated with the Slade School of Art, as a visiting tutor from 1949 to

1954, when Victor Willing (1928–1988), Paula Rego (born 1935) and Michael Andrews himself were studying there. Yet no single art school dominated the School of London. After all, Bacon was self-taught. Freud went to the Central School of Art and Cedric Morris's East Anglian School of Painting and Drawing. Frank Auerbach's and Leon Kossoff's names are linked to Bomberg's because they attended his night classes at the Borough Polytechnic (and because of their use of thick paint), but they spent far longer together at St Martin's and the Royal College. Auerbach's and Kossoff's work ethic is even more legendary than Freud's. Victor Willing at the Slade was aware that somewhere Auerbach and Kossoff were working away day and night.

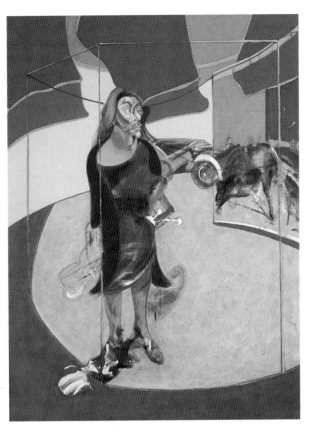

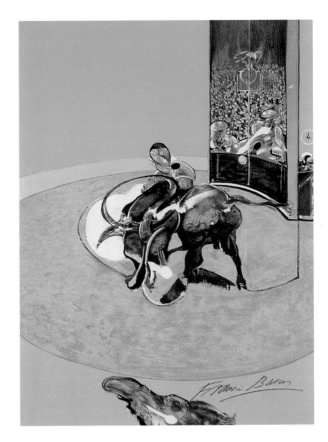

Frank Auerbach's aims are not too dissimilar to those of his friend Freud. They both left Berlin at an early age, but Auerbach left his family behind, so his method of working arose out of a greater sense of urgency. "Unless one was conscious of the fact life was short and one was going die, there would be no sense in making this sort of effort." He recalls:

"I began to realise what I wanted to do as a painter … after about five years of being a student. I was living with someone, who has the initials E.O.W. She was the most important person in my life at the time … The intensity of life with somebody and the sense of its passing has it own pathos and poignancy. There was a sense of futility about it all disappearing into the void and I just wanted to pin something down that would defy time, so it wouldn't all just go

off into thin air. This act of portraiture, pinning down something before it disappears seems to be the point of painting."[31]

Reclining Figure (1972; see p. 84) depicts J.Y.M., not E.O.W., but the point holds. Auerbach devised a Modernist technique to help catch the spontaneity. He may work on a painting for months or even years (his loyal models return regularly), but at the end of a day, if he has not finished the painting, he scrapes the oil off and starts again at the next sitting. Auerbach recognizes that painting needs revitalizing. He has created a structure to help him find the primitive feelings for which Alan Davie and other *Informel* painters searched. Primitive, though, is the wrong word with Auerbach. It is naked intimacy that he reveals in such works as *Reclining Figure*. One is immediately aware of the pent-up

overleaf:
Joseph Beuys
*In those days, Liverich
used to smell of grass*, 1981
Offset lithograph based
on a photograph
42×59.5 cm (16 1/2 × 23 1/4 in.)
Edition: 458/500

1 Nam June Paik, quoted in Caroline Tisdall, *Joseph Beuys: We Go This Way,* London (Violette Editions) 1998, p. 208.
2 *Idea Structures*, curated by Charles Harrison, London, Camden Arts Centre, 1970.
3 Sol LeWitt, 'Paragraphs on Conceptual Art', *Artforum,* Summer 1967, p. 79.
4 *Ibid.*, p. 80.
5 *Ibid.*
6 *Ibid.*
7 *Ibid.*, p. 83.
8 Jeffrey Kastner, 'Preface', in Jeffrey Kastner and Brian Wallis, *Land and Environmental Art*, London (Phaidon) 1998, p. 14.
9 *Ibid.*, p. 13.
10 Isamu Noguchi's work was included in *Painting and Sculpture of a Decade, 1954–64*, London, Tate Gallery, 22 April– 28 June 1964.
11 Richard Long, quoted in Anne Seymour, 'Walking in Circles', *Richard Long: Walking in Circles*, exhib. cat., ed. Susan Ferleger Brades, London, The South Bank Centre, 1991, pp. 12–16.
12 *Contemporary British Art in Print*, exhib. cat. by Patrick Elliot, Edinburgh, Scottish National Gallery of Modern Art, 1995, p. 86.
13 Richard Long, quoted in *Richard Long: Old World, New World,* exhib. cat. by Anne Seymour, London, Anthony d'Offay Gallery; Cologne, Walther König; 1988, p. 55.
14 Richard Long, quoted in Richard Cork, 'An Interview with Richard Long by Richard Cork', *Richard Long: Walking in Circles*, *op. cit.*, p. 252. The interview was originally broadcast on 'Third Ear', BBC Radio 3, Friday 28 October 1988.
15 Richard Long, quoted in Anne Seymour, 'Walking in Circles', *Richard Long: Walking in Circles*, p. 34.

16 Hamish Fulton, in *Contemporary British Art in Print*, *op. cit.*, pp. 92–93. Fulton made a special double-page-spread text piece for the catalogue ("Trees = Framed works of art on paper …").
17 Ulf Erdman Ziegler, 'Preface', in Marcus Rasp (ed.), *Contemporary German Photography*, Cologne (Taschen) 1997, unpaginated [p. 8].
18 Art & Language, 'Biography and Statement', *Live in Your Head,* exhib. cat. by Clive Phillpot and Andrea Tarsia, London, Whitechapel Art Gallery, 4 February–2 April 2000, p. 43.
19 *Ibid.*
20 Hans Haacke, quoted in *Documenta X*, exhib. short guide by Paul Sztulman, Kassel, various venues, 1997, p. 84.
21 Joseph Beuys, quoted in Michael Archer, *Art Since 1960,* London (Thames and Hudson) 1997, p. 110.
22 Joseph Beuys, quoted in Caroline Tisdall, *op. cit.,* p. 43.
23 Joseph Beuys, original source unclear, quoted in Lucrezia De Domizio Durini, *The Felt Hat: Joseph Beuys A Life Told*, 1st Italian edn, Rome (Edizioni Carte Segrete) 1997; 1st English edn, Milan (Edizioni Charta) 1997, p. 20.
24 Stefan Germer, 'Intersecting Visions, Shifting Perspectives: An Overview of German–American Artistic Relations', *The Froehlich Foundation: German and American Art from Beuys and Warhol*, exhib. cat., ed. Monique Beudert, London, Tate Gallery, 1996, p. 29.
25 *The Human Clay*, exhib. cat. by R.B. Kitaj, London, Hayward Gallery, 1976, unpaginated.
26 Patrick Heron, 'The School of London', *The New Statesman & Nation*, 9 April 1949, p. 351.
27 R.B. Kitaj, in *The Human Clay*, *op. cit.*, unpaginated.

28 R.B. Kitaj, *First Diasporist Manifesto*, London (Thames and Hudson) 1989, p. 15.
29 Michael Peppiatt, *Francis Bacon: Anatomy of an Enigma*, London (Weidenfeld and Nicolson) 1996.
30 Lucian Freud, quoted in Alistair Hicks, *The School of London*, Oxford (Phaidon) 1989, p. 12.
31 Frank Auerbach, quoted in Alistair Hicks, *op. cit.*, p. 28.
32 *Leon Kossoff*, exhib. cat. by Paul Moorhouse, London, Tate Gallery, 6 June–1 September 1996, p. 9.
33 Leon Kossoff, quoted in Alistair Hicks, *New British Art in the Saatchi Gallery*, London (Thames and Hudson) 1989, p. 60. In response to a letter from the author, Kossoff wrote to his then dealer, Anthony d'Offay. He is now represented in London by Annely Juda.

"My personal history is of interest only in so far as I have attempted to use my life and person as a tool and I think this was so from a very early age."

"When I was five years old, I had already developed a laboratory involved with physics, chemistry, botany, zoology and such things, for contemplation, meditation, and research into all kinds of systems. If I look back I find what I did as a child had a lot to do with the understanding of art that I developed later."

"It was quite impossible to understand why many of those books had been put on the index. Naturally I stole some from the bonfire, books I still have today, like *Systema naturae* by the Swedish naturalist Linnaeus."

"War, as Heraclitus says, is the father of everything, but this was naked parody of power. For me it meant coming into contact with other powers that forced me to survive – felt and tallow, in which I was wrapped to keep me warm … the impulse I felt to survive."

"For me they [fat and felt] are the right and effective tools for overcoming the wound in all of us."

"Art. Everyone an artist. Creativity equals capital."

"Everyone is a king, the value of people lies in their sovereignty. The longing of people for their inner good is destroyed in these materialist times."

"Economics is not only a money-making principle. It can be a way of production, to fulfil the demands of people all over the world. Capital is humankind's ability in work, not just money. True economics includes the creativity of people. Creativity equals capital."

"Christianity is on the same plane as Plato. In my opinion, true Christianity developed in science, philosophy, the concept of science, death, Immanuel Kant, the process of abstraction – all to free mankind from the old collective unit."

"The purpose of philosophy is to arrive at materialism. In other words, to move towards death: matter. In order to be able to say anything about life, one has to understand death: the methodology of reduction."

"Even in death the hare can understand more than man with stubborn rationalism."

"Can man contribute something new, something not of this world, something beyond the terrestrial and material world?"

"Death is the sharp edge, the blow that keeps us awake."

"The people have political power. But they do not know how to use it."

"All I do is inform people of their own possibilities."

These quotations from Joseph Beuys have kindly been supplied by Caroline Tisdall from her book *Joseph Beuys: We Go This Way*, London (Violette Editions) 1998. We should like to thank both Caroline Tisdall and Robert Violette for permission to reproduce these statements.

Anselm Kiefer
*Ways of Worldly Wisdom:
Arminius's Battle*, 1978
Collage with woodcut,
acrylic and varnish
215×340 cm (84×132 in.)

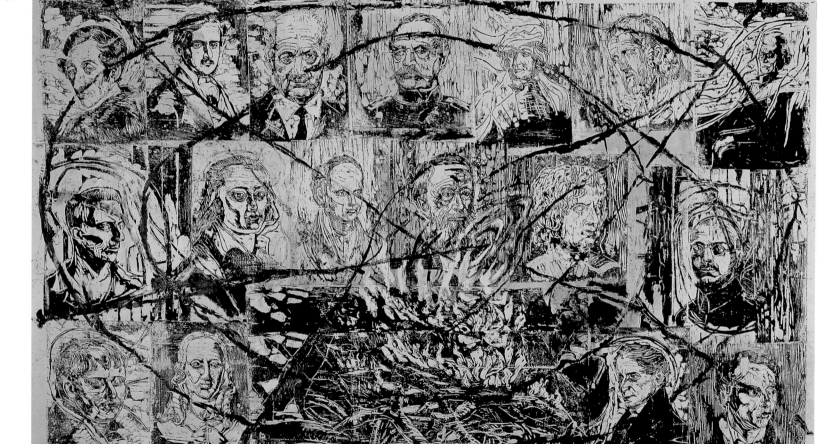

1980s: Zeitgeist

"To desire only the New is pitiful. That state of mind and heart breeds nervousness in the present and it easily distorts history."
Rudi Fuchs[1]

"The artists' studios are full of paint pots again and an abandoned easel in an art school has become a rare sight. Wherever you look in Europe or America you find artists who have rediscovered the sheer joy of painting",[2] began Christos Joachimides in the catalogue to the exhibition *A New Spirit in Painting*, held at the Royal Academy of Arts, London, in 1981. Not everyone was pleased. Critics, particularly Americans, raged against the new painting with the weasel voices of cornered zoo keepers. They saw the new violent painting for what it was – a glorious escape by artists from the cage of carefully nurtured, critical structure.

At the heart of this new spirit, this *Zeitgeist*, were groups of German painters, who had been told for years that they must not paint. Naturally they rebelled like naughty school-boys and painted in the most crude, obvious, in-your-face manner. Some of the names for these artists tell the story – *Neue Wilde* or *Nouveau Fauve* (The New Wild Ones) and *Heftige Malerei* (Violent Painting). Paint, often cheap and basic, was being splashed on to the canvas.

The critics would happily have ignored the pot of paint being thrown in the public's face that Ruskin and Whistler had famously fought over one hundred years earlier, but they could not tolerate being ignored themselves. In the Royal Academy catalogue Christos Joachimides continued, "In the studios, in the cafés and bars, wherever artists or students gather, you hear passionate debates and arguments about painting".[3] The critics had not been involved in the debate at the early stages.

The meteoric rise of the *Zeitgeist* painters was a result of a direct alliance between artists and curators. The careers of the Violent Painters in Berlin illustrate this perfectly. The term *Heftige Malerei* was invented as the title of an exhibition in 1980 at the Haus am Waldsee in Berlin. It included Luciano Castelli (born 1951), Rainer Fetting (born 1949), Helmut Middendorf (born 1953), Salomé (born 1954) and Bernd Zimmer (born 1948). All these artists had clubbed together some three years earlier to show their work at their own gallery, Galerie am Moritzplatz.[4] Only Fetting was selected for the London *New Spirit* exhibition, but so was K.H. Hödicke, the influential teacher of Middendorf and Salomé. Hödicke had introduced the group to house-painters' latex paint. The following year Fetting, Middendorf, Salomé and Hödicke

Salomé

Blind, 1984
Chalk and acrylic
on paper
69×99 cm (27×39 in.)

Rainer Fetting

Taxis (City Canyon), 1992
Screenprint
122×86 cm (46³/₄×33¹/₄ in.)
Edition: 9/50

were in *Zeitgeist*. By this time they were
having sell-out shows in New York.

Something had to give in the hothouse
climate of Berlin in the mid-1970s, and it might
as well be all the rules. Salomé, Fetting and
Castelli were openly homosexual and lived a
wild life. Middendorf and Zimmer were also
involved in the nightclub and musical scene.
They all found release in a direct depiction of
the life they led. Salomé is a transvestite and
many of his, and Fetting's, paintings dwell
on posing and strutting male bodies. Since
becoming established, Salomé has lived in
both Los Angeles and Berlin, while Fetting has
divided his time between Berlin and New York
– just one more layer to their double lives.
The Berlin scene they depicted had much in
common with that of Robert Mapplethorpe's
New York. Looking at Middendorf's crowded
nightclub scenes, such as those in *SO 36*, one
can almost hear the thump of the music beat
in the sea of cut-off heads.

The Berlin painters were far from being the
only new German painters. The *Mülheimer
Freiheit* painters from Cologne were repre-
sented in the *Zeitgeist* exhibition by Peter
Bömmels (born 1951), Walter Dahn (born 1954)
and Jiři Georg Dokoupil (born 1954). There is
more irony in these 'free-style' Cologne

painters. As Wolfgang Faust explained back
in 1981 in the American magazine *Artforum*,
"Their paintings are blasts of sheer joy of
contradiction".[5]

One of the problems for the American
critics was that this new figurative painting
was presented as an international movement.
Zeitgeist had a contingent from Austria in the
form of Siegfried Anzinger (born 1953) and
Erwin Bohatsch (born 1951), while Per Kirkeby
(born 1938) represented Denmark. The British
contribution was a bit of a muddle. The 'neo-
Expressionist' work of Bruce McLean was
dripping with intentional insincerity. The
adoption and adaptation of different styles by
Malcolm Morley was part of his endlessly
shifting œuvre. The hares of Barry Flanagan
were certainly in the mood of a new, young,
rejuvenated art, but they were no longer new
as Flanagan had been ahead in that particular

Peter Bömmels
Untitled (Self-Portrait),
1983
Mixed media
105×84 cm (41×32³/₄ cm)

Christopher Le Brun
Untitled (Horse), 1985
Watercolour, pencil and
pastel on paper
30×30 cm (11¹/₂×11¹/₂ in.)

game. Christopher Le Brun (born 1951), with his Wagnerian subject-matter, fitted superficially, but his gentler style highlighted the differences as much as the similarities between British and German painting.

It was the Italians who were most in tune with the German painters. Indeed, in the introduction to the standard book in English on the movement, *The New Image*, the author, Tony Godfrey, begins, "A few years ago, I was in conversation with an Italian art critic when out of the blue, and quite categorically, he asserted that painting had been reinvented in 1977 by the young Italian painter Sandro Chia".[6] Chia, Enzo Cucchi and Francesco Clemente were the flag-fliers of Achille Bonito Oliva's *Trans-avantgarde*. Oliva was most definitely one of the few critics who did champion and intellectualize the new painting.

It was not Oliva who alarmed the American critics, but rather the authority of the curators involved and the sheer economic success of

the artists in the New York galleries. This latter was facilitated greatly by the emergence of a genuine American participant in the larger-than-life form of Julian Schnabel (born 1951). Included in both major European shows, Schnabel was just what the American buying public had been waiting for. He burst on to the scene with all the iconoclastic, or at least plate-breaking, bombast of a Renaissance master. Schnabel's eventual autobiography was very much of the school of Benvenuto Cellini.

Schnabel was not afraid to needle the critics: "A lot of Americans still don't understand that it was Beuys who instigated this current shift in art", he wrote. "They think it came from reductivism and minimalism and painting being dead and then resurrected – but I'm talking about an involvement with materials … ."[7] With his show at the Guggenheim in 1979, Beuys had opened the floodgates for European art.

Many American critics attempted to dismiss the new painting as a commercial phenom-enon. Thomas Krens admitted this when he organized an exhibition entitled *Refigured*

Helmut Middendorf
The Embrace of the Night,
1983
Gouache, watercolour
and chalk
87.5×55 cm
(34¹/₂×21¹/₂ in.)

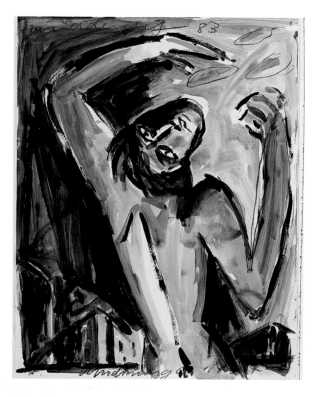

Painting at the Guggenheim in New York in 1989: "Artists have always wanted 1) to make history and 2) to make money", he maintained. "The contemporary appetite for art has upset the modernist axis that chose to emphasise the former and ignore the latter."[8] The argument that raged throughout the 1980s over these painters was basically Modernism versus Post-modernism. As Krens again pointed out, the major anxiety of the Modernist establishment was that "art criticism is on the very verge of surrendering to an entirely uncritical bias".[9]

Krens had a valid point about the economics of the art world in the 1970s. In a spirit of Marxist asceticism, it was extremely difficult for artists to make a living. Joachimides goes further: "Soon the avant-garde of the 1970s with its narrow, puritan approach devoid of all joy in the senses, lost its creative impetus and began to stagnate".[10] In the blunt words of one of the Violent Painters, Helmut

Middendorf, "painting is not justifiable in itself, and I find painting for the sake of painting totally boring".[11]

The critic Benjamin H.D. Buchloh put up the fiercest defence of the Modernist position against the baying Visigoths. In stark contrast to British Marxist critics such as John Berger and, of course, the Soviet and Eastern Bloc Communists, the American Buchloh equated the depiction of the human figure with Fascism. He also came up with the best excuse for the success of the new painters. He wrote in 1981 that "the collapse of the modernist paradigm is as much a cyclical phenomenon in the history of twentieth-century art as is the crisis of capitalist economics in twentieth-century political history".[12] Modernism has constantly changed, having been attacked and redefined again and again. Indeed, although Post-modernists have derided the conservatism of the tradition of Modernism, almost every Modernist, by definition, has had to redefine the term. The assault on the current structures of the day, followed by their rebuilding, is an essential part of being a Modernist.

Modernism was in crisis at the end of the 1970s as critics had brilliantly argued themselves into successive culs-de-sac. Greenberg and Fried were the most obvious examples, but then artists were also capable of achieving

these ends on their own account. Warhol did everything in his power to deliver hermetically sealed art, while Donald Judd certainly could not envisage an art beyond his own, a perfectly constructed full stop on art.

The Modernist critics were vulnerable because of the brittle nature of their critical structures. As Craig Owens proclaims indignantly, "the post-structuralist critique could not possibly be absorbed by art history without a significant reduction in its polemical force, or without a total transformation of art history itself".[13] Owens was prophetic. Art historians have tried to find a whole new form of art history. Twenty years later one has to start wondering whether these attempts have been successful.

One American critic stood up as the champion of the new painting. He was Donald Kuspit. He accused his fellow critics of self-interest, writing that, "These critics above all intend to deny its vanguard character, because to acknowledge its radicality would mean for them to deny their own".[14] He continued:

"The new German painting is a convenient whipping boy for ineffectual, directionless criticism – a criticality that no longer really knows its goals. Indeed, it is too impotent to imagine any future for art other than the same modernist missionary position of 'classical' negation … It was said to lack the critical character of modern art – as if Abstraction, with its tired strategies of negation, was still critical with respect to society and other art."[15]

The great contribution of the Modernism versus Post-modernism debate was that it highlighted the weakness in the naïve belief that Modernism should be equated with progress. This was not an essential prerequisite of early Modernists. One has only to look at Picasso and Bacon, apparently a straightforward Modernist line. Was Picasso really anti Classical art? No! To create his new art, he plundered Classical as well as African art. Bacon frequently admitted that he did not believe in progress, but this does not mean that his pictures can be looked at in the same way as Velázquez's. Bacon's screaming popes owe their existence to a postcard Bacon saw of Velázquez's *Portrait of Pope Innocent X*. There is a great debt in terms of composition, but the emotional power of the twentieth-century picture comes out of the gulf as much as the links.

Kuspit may have hinted at his fellow critics' greatest fear, but he did not underline it. This was left to the curators of *A New Spirit in Painting*, *Zeitgeist* and *Documenta VII*. The critics were not particularly afraid of the work

of the *Heftige Malerei*, the *Mülheimer Freiheit* or indeed the Italians from the *Trans-avant-garde*. These artists on their own did not pose the main threat. The shocking element of all these shows, as far as the likes of Buchloh were concerned, was the revisionist view of the recent past. Revisionism had been one of the great Marxist tools, but it had led to the massacre not only of ideas but also of those who had perpetrated them.

A New Spirit in Painting, curated by Christos Joachimides, Norman Rosenthal and Nicholas Serota,[16] strayed drastically from the accepted vision of the post-war years. For the Buchlohs of this world, the older painters included in the exhibition read like a rogues' gallery of dissidents and traitors. There was Phillip Guston (1913–1980), who, having been one of the heroes of Abstract Expression, brought the wrath of the New York art world upon his head by going figurative. The Nabokov of the painting world, Balthus (born 1908), was given prominence, as was Francis Bacon (with a pretty full School of London team: Freud, Auerbach, Kitaj, Hockney and Hodgkin). Then there were the eleven Germans.

The year before, in 1980, the German Pavilion at the Venice Bienniale had been filled with the works of two artists, Georg Baselitz and Anselm Kiefer. The German critics had panned it, which highlights just how crucial

the three events in London, Berlin and Kassel were in turning opinion around.

Anselm Kiefer is the pivotal figure to emerge in the 1980s. Born in 1945, he was five to ten years older than most of the *Heftige Malerei* or *Mülheimer Freiheit* painters. As a pupil of Beuys his early work was conceptual, but when he did break his tutor's edict against painting he did it in style. The original consternation at his paintings, both within Germany and outside, was caused by his choice of subject-matter. In the spirit of Beuys he confronted his country's past head on. He, too, wished to regenerate his culture, but the shock was perhaps even greater than with Beuys, as his large canvases with vivid images achieved the type of accessibility for which Beuys had worked.

Ironically, in one sense *Zeitgeist* was a glorious celebration of Beuys's teaching. Although he used to chide his students with the admonition "Still painting?", many of his ideas were most forcefully put over to the public by his painting pupils, in particular the figurative painters Kiefer and Immendorff. Beuys, who might have been the bogeyman of the new painting, was included in *Zeitgeist*.

Some of Kiefer's paintings speak literally of the purging of German soil. Unlike Uecker, who had gone out and painted the streets white, Kiefer made images of charred battle-

fields or, as Kiefer himself called them, "paintings of the scorched earth".[17] In such works as *Ways of Worldly Wisdom: Arminius's Battle* (1978) he adds an iconostasis or altarpiece of German heroes. The painting refers to a massacre in AD 9. Arminius (Hermann) ambushed Quintillus Varus and three legions while they were marching through the Teutoburg Forest.

The combination of fire and raised ranks of heroes has been subjected to several interpretations. Mark Rosenthal writes:

"… it is perhaps no coincidence that these German sources of wisdom are being subjected to the same treatment that many Jews were given by the National Socialists. Does Kiefer seek a sort of revenge? Is Kiefer in the same fashion as the Germans whose perverse idealism led them to slaughter humans in order to 'purify' their race and to acquire 'Lebensraum' (space for living), burning away the memory of these individuals in the hope that regeneration can occur? Kiefer seems to dare his German viewers to look with idealism at their past and to recall that the histories of these often admirable figures together formed a path leading to the holocaust. In this way, he implies that 'wisdom' is bankrupt."[18]

"Bankrupt" is not a word that leaps to mind when I stand in front of, and am usually dwarfed by, Kiefer's work. Power! Stark rejuvenation! New life! Certainly the artist is saying we should start again, but let us look at those faces he shows. They may be wooden, as Mark Rosenthal claims, but by presenting them to us and scribbling and scratching them out is the artist obliterating them? I don't believe so. They still have power. They were abused, but so were the ideas of Jewish Germans such as Marx and Freud. As Nicholas Serota wrote:

"The tragedy of two world wars now makes it almost impossible for a young German to establish connections with an earlier heritage, even in the most questioning way, without opening himself to the charge that he is interpreting history in the same way, and for the same purposes, as the National Socialists. And yet for Germans of Kiefer's generation, born after the war, the real lesson is surely that the past must be given an alternative reading and interpretation."[19]

Kiefer undoubtedly pushed the 'German history' question into the public's face, but, as much of his subsequent work has proved, he is very much concerned with universal issues, not just German ones. Indeed, he has

moved to Barjac in France. Kiefer's emergence was as relevant in America and world culture as in Germany. Kiefer refused to avoid the Modernist/Post-modernist division. In the 1980s he was interpreted as a Post-modernist, but the Post-modernist label does not fit well. His scorched-earth policy is the act of a Modernist. It is true that his rebuilding is open to interpretation, but I like to see the portrait heads as Cartesian bricks rather than bankrupt role models. His paintings are actually about the process of restructuring culture. In between the crossings out and the licking flames the artist weaves his way to find the building materials that will create a new Modernist structure.

Are the main curators who promoted the new painting Post-modernists? In looking back over the last twenty years it would be difficult to find a more powerful triumvirate of European museum directors than Nicholas Serota of the Tate Gallery, Rudi Fuchs of the Stedelijk, Amsterdam, and Norman Rosenthal of the Royal Academy of Arts. None of them is a Post-modernist, and none of them is a Modernist in the old style. As Bernard Smith points out in *Tate* magazine, the multiple meanings of Modernism arise out of its longevity; the different types of Modernism should have been given different names long ago:

"When will art historians take courage and give the Modernism of the first half of the twentieth century a period style name? … when it [an earlier style] reaches a use-by date historians gave it a period style name. The Abbot Suger's *'opus modernum'* at St Denis eventually became Gothic: Vasari described the styles of Leonardo and Giorgione as *'la maniera moderna*,' now it's High Renaissance; Winckelmann's modernism is now neo-classicism … ."[20]

In its questioning of the unthinking linear succession of artists, Post-modernism made a useful contribution to our understanding of history, but as this negative term has gone on being used well beyond its sell-by date it has introduced extraordinary contortions. For instance, Wieland Schmied puts Kiefer in his Post-modernist box by writing:

"A person dealing with Anselm Kiefer's work has to deal with a plethora of meanings, allusions, associations and references rare in contemporary art. Kiefer tries to charge his pictures with intellectual and visual meaning to the extreme, in a way which can only be fundamentally repulsive to an eye schooled on Matisse or Mondrian, on colour-field painting or minimal art."[21]

If Kiefer was a threat to Modernism, it was the late American Modernism, not the European one. There may well be a reaction against Minimalism in Kiefer's work, and his starting-point may be different from that of Matisse, Mondrian and the Modernist Expressionists such as Kirchner and Nolde, but there are decided overlaps. It took years for the German avant garde to recover from the victimization of the 'Degenerate artists'; there was a serious break between the Expressionism of Kirchner and the so-called 'neo-expressionism' of the new painting of the 1980s. Sometimes they might be going back to similar sources but they were looking for different things. Baselitz's interest in African art is a clear example.

As the Munich dealer Fred Jahn complains:

"Even back in the 70s critics attempted to present Baselitz as some kind of latter day Corinth, and also sought to somehow hang an expressionist label on him ... Baselitz considers the avoidance of expressionism as an important point in his efforts to create a figurative work. And the fact that African sculpture of all things – which has your 'average punter' immediately sensing something expressionist – enables you to use the appropriation of a different canon as a means of discovering how to produce moving figurative sculptures that are pre-

cisely not expressionist; that is Baselitz's quite remarkable achievement."[22]

A.R. Penck (born 1939) is another East German artist who collects African art. Largely self-taught, his use of earlier art has been highly original. Unlike most of his famous contemporaries, he opted to stay east of the wall until 1980, even though he was not allowed to exhibit at home. He was born Ralf Winkler in Dresden, but he invented several pseudonyms so that he could exhibit in the West. Although his reasons for changing his name were perhaps more urgent than most, he certainly was not the only one to do so. Baselitz was born Georg Kern but renamed himself after his birthplace, Deutschbaselitz; Peter Schwarze called himself Blinky Palermo after a Chicago gangster; Wolfgang Cilarz adopted the stage name Salomé for his transvestite performances; Knoebel was born Wolfgang, not Imi; and to demonstrate that it is not totally a German phenomenon there is the Anglo-American nomad Kitaj, who started life as Ron Brooks.

"Max Ernst once said that it was his greatest good fortune that he had never found himself. Ralf Winkler never even started to look for himself",[23] wrote Wieland Schmied to empha-size Penck's natural interest in identity. Penck is almost the opposite of Pollock, who worked

A.R. Penck
Delphi Heliotroph, 1992
Bronze
900×500×500 cm
(351 1/2 ×195 1/4 ×195 1/4 in.)
Deutsche Bank
Luxembourg S.A.

114

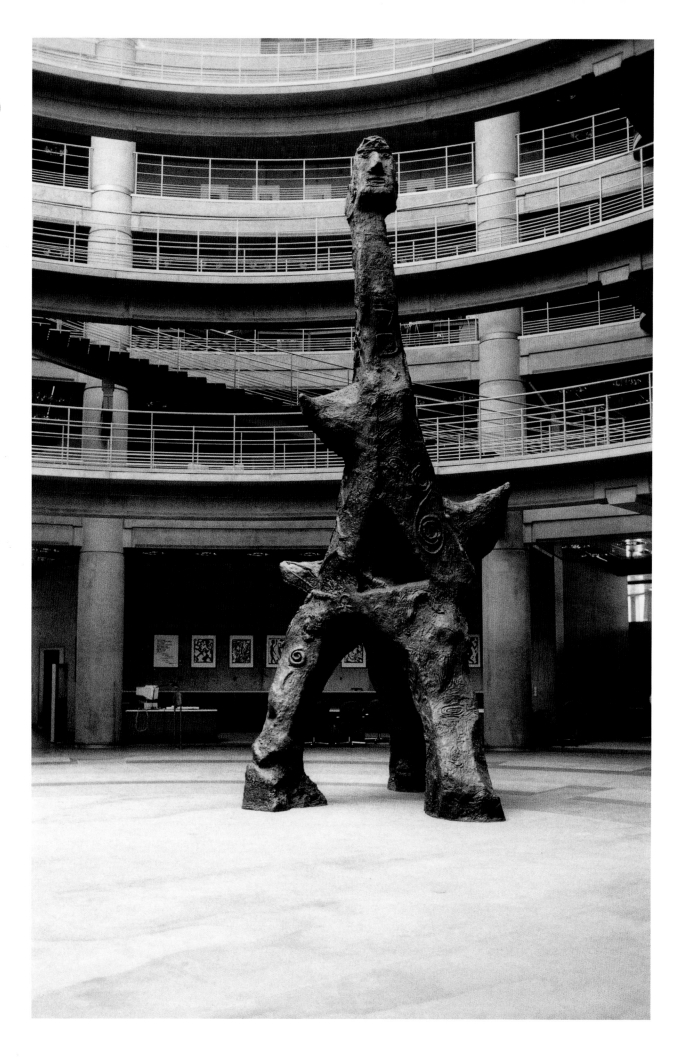

at the centre of his arena of his canvas. Not allowed to exert his identity, he subsumed it in his work and theories. "'I is for someone else,' says Rimbaud. 'I, that is a lot of other people,' Penck/Winkler could say."[24]

Rudi Fuchs gives a clear indication of Penck's existence before he left the East:

"By the time he became known in the West, in the late sixties, (after the dealer Michael Werner, via Baselitz, had found him and begun to smuggle work out of Dresden) he was effectively a non-person in the German Democratic Republic. I tried to obtain an exit visa for him in 1975 when I showed in the Van Abbe Museum in Eindhoven the exhibition that Johannes Gachnang had previously curated for the Kunsthalle in Berne. My museum enjoyed good relations with the East German Embassy in the Hague … I went to the Embassy with a few catalogues of previous Penck exhibitions. I showed the catalogues to the Ambassador and asked for the visa. He said there was no artist named Penck. When I said that Penck's real name was Ralf Winkler, the Ambassador replied that he had no knowledge of such a person either."[25]

Penck himself explains the origins of his own name, which came about as a result of his admiration for the systematic, objective working method of the ice-age scholar Albrecht Penck (1858–1945). "As regards painting, I can say that for me the name (A.R. Penck) stands for a concept which I had just developed at the time and which had to do with information", says Penck. "I saw a certain analogy between deposited inform-ation and geology. At that time, I had to work my way through numerous layers of information, through the entire history of art, and then I came across the ice age and cave paintings."[26] Prehistoric and pre-Christian work was also a source for Penck's sculpture. Bronzes such as *Woman* (1987), with their big, bulbous, fertile figures, have a strong echo of early Venus statuettes.

There are clear connections between very early art and Penck's painting and sculpture, but Penck's great ability was to use these sources to create the most contemporary of works. Penck's stick-like figures dramatically predate the New York graffiti art of Haring and Basquiat, yet have the same natural power. As Dieter Brunner comments, Penck's works seem to stem "from a different time and yet remain recognisable as relics of our own day".[27] *The New York Times* described his language as "pidgin-symbolical".[28]

Penck's concern for society and the way individuals relate to it kept him in East

A.R. Penck
Quo vadis Germania?,
1985
Aquatint and drypoint
109×187 cm (4 2³/₄×73 in.)

116

Germany for many years (he has a home there again now) and has also given his work its political edge. With such works as *Anti-Lenin* (1994) and Deutsche Bank Luxembourg's *Delphi Heliotroph*, he tries to revitalize the debased monumental sculpture tradition by concentrating on inherent human qualities rather than the public face of public figures.

The balance between scurrying little men and the fate of the human race is seen in such works as *Quo vadis Germania?* (1984), a massive painting that has the impact of Byzantine and Early Renaissance frescoes of the Last Judgement (illustrated is the bank's related aquatint of 1985). Which way Germany indeed? Back in 1962 Penck had painted *Divided Germany*, and it was this subject that cemented his friendship with Immendorff.

As Jörg Immendorff was born, in 1945, his country was being divided. The border practically went through his birthplace in Bleckede. In his most famous series of paintings and prints, Immendorff depicts Germany as a coffee-house. The artist acknowledges the debt to Renato Guttuso's *Caffè Greco* (1976),[29] but the actual setting was undoubtedly also influenced by his many meetings with Penck in the state-managed cafés of East Berlin and Dresden. In several versions of Immendorff's *Café Deutschland* there is a wall going down the middle of the

room through which Immendorff thrusts his arm to shake hands with his friend. The style is brutal, indeed it has been described as "ugly realism". Into this nightmarish scene he often throws art-world figures. "The inhabitants of Immendorff's restaurant theatre interiors had become the denizens of the art world", writes Michael Archer. "His one time associate and fellow artist A.R. Penck …, his teacher Beuys, his colleagues Lüpertz and Baselitz, the art dealers Michael Werner from Cologne and Mary Boone from New York, the American artists Schnabel, Salle and Fischl, the European curators Rudi Fuchs and Joachimides and many more curators, artists, collectors and critics all engaged in the niceties of the social dance."[30]

Immendorff is political. In the late 1960s he was an active protestor against the war in Vietnam. As one of Beuys's students he would not have resorted to painting unless he felt he needed such a direct medium, but there is an element of anti-painting. These images are meant to be ugly, not only to mirror the ugliness of the situation, but also as part of a drive to create a new aesthetic just as Beuys did. The image is crude in order to emphasize the message. Immendorff "envisions a place which exists only by force of artistic imagination, he cannot be said to approach reality so much through the sense of sight as on the

Jörg Immendorff
*Heuler from: Café
Deutschland Goods*, 1983
Coloured linocut on board
175.5×229 cm (69³/₄×90 in.)
Edition: 7/9

basis of a conception, an idea called *Café
Deutschland*".[31]

Baselitz, Richter, Polke, Penck, Lüpertz,
Hödicke and Koberling – these were the older
German artists that the revisionism of the
1980s brought into prominence. "Art is the
highest form of hope",[32] said Gerhard Richter,
but these artists, Baselitz's "fatherless
generation", had had, early on in their careers,
little more than hope on the international
stage. Their arguments were toughened by
years in opposition. So whereas Middendorf,
with a blast of youthful bravado, declared,
"painting for the sake of painting is totally
boring", Baselitz made a more considered
explanation for avoiding the route of abstrac-
tion. "It would be possible to do without the
motif", he admits, "but it would be
completely uninteresting to me, because
I still don't see why just for the sake of
identification you should forgo private
communication in the form of motifs".[33]
The same cry is taken up by Markus Lüpertz:
"The abstract forms are worn out", he said
in 1984. "The ones I make have a different
intensity, a different speed, I have given them
a different form and something quite new
has emerged…."[34]

Zeitgeist was a far from all-inclusive exhi-
bition. Though the two main centres of artists
in Germany, Berlin and the Cologne/
Düsseldorf area, were well represented, the
young Hamburg artists Martin Kippenberger
(1953–1997) and the Oehlen brothers (Albert,
born 1954, and Markus, born 1956) were
excluded, although their colleague Werner
Büttner (born 1954) was in the show. In one
sense this exclusion is understandable in
that the Hamburg painters were even more
full of ironic contradictions than those from
Cologne. In making an art out of the evasion
of being categorized, they, like their teacher
Polke, pointed the way forward to the 1990s.
Their catalogues read like a list of retractions.
Markus Oehlen played drums for the 'punk'
group *Mittagspause*, but

"his art never had anything to do with his
music … Markus' painting never had
anything to do with dilettantism and this
sort of charm. The man used many
methods in many fields and never broke
under the ambitious desire to unify his
artistic person through these mediums,
as so many modern fools *à la* Salomé or
Middendorf try to do. Because he was
always good, he could negate that which
in history always holds true: Everything is
connected to everything else."[35]

Markus Oehlen
Untitled, 1995
Oil on canvas
199.5×150 cm
(78×58 1/2 in.)

Martin Kippenberger
Pop Art D.B. (October),
1991
Calendar with twelve
collages
43.5×29 cm (17×11 1/4 in.)
Edition: 15/20

118

There is talk of the Oehlens rejecting the polarity of Modernism and Post-modernism, yet the overriding feeling one gets from their work (confirmed by their statements) is that it is a release of paint, the result of a build-up of frustration caused by a state of confusion. It was a cry of youth combined with a Nietzschean honesty that wanted to let the chaos they perceived overwhelm order. "In the history of abstract painting you find each artist setting up a framework to explain why any particular painting had to look this way and no others", observes Albert Oehlen. "By contrast, I am not interested in the autonomy of the artist or of his signature style. My concern, my project, is to produce an autonomy of the painting, so that each work no longer needs that legitimising framework."[36]

Sigmar Polke (born 1941) was still very much the master of this confusion and appropriation. As Christopher Schreier declares, "Polke's works retain a living quality that seems to be lost in many products of Post-

modern art today. Where Post-modern art is content to recycle art-historical facts, and cultivate the citation, Polke – the classical avantgarde artist – keeps his art open to possible discoveries, the new and different."[37]

At *Documenta VI* Gerhard Richter declared that "success used to involve having a style … we don't need one".[38] Until his early death in 1997 Martin Kippenberger was probably closest among his – the next – generation in fulfilling this. Though he was not in *Zeitgeist*, he was very much part of the Berlin scene as well as those of Hamburg and Cologne. He was part of several bands and was one of the co-founders of the nightclub SO36. In 1991 he made *Pop Art DB*, a work using Pop images that had appeared in Deutsche Bank calendars. He pasted printed collages over each month, so that the original Pop images can only be glimpsed through cut-outs.

Friedemann Hahn (born 1949) similarly distances the viewer from his appropriated images. His famous series on Van Gogh was started after he had seen one of Francis

Friedemann Hahn
Kirk Douglas in 'Lust for Life', 1983–85
Oil on canvas
120×90 cm
(47¼×35½ in.)

John Bellany
Untitled, 1987
Screenprint
75×57 cm
(29½×22¼ in.)
Edition: 2/10

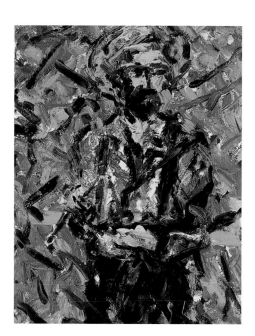

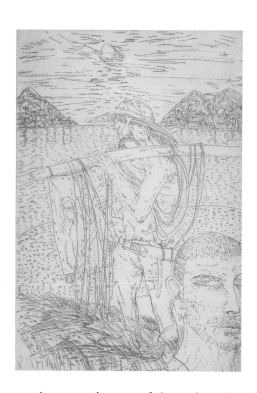

Bacon's 1950s' series, *Study for Portrait of Van Gogh*, in 1981.[39] Not only is his view competing with Bacon's vision of the father of modern painters, but he mocks his roots with the title *Kirk Douglas in 'Lust for Life'* (1983–85). The German painter is deliberately putting an extra layer of meaning in front of the viewer by making this reference to this deliciously bad film. He has subsequently painted other art and film icons such as Carole Lombard, Monet (1840–1926), Cézanne, Humphrey Bogart, Munch and Jane Russell. Once again, the images have been stolen from film stills and other photographs. Hahn is not presenting these famous figures in the totally straight and reductionist manner of Warhol. As Jürgen Schilling comments, "If he thinks a particular painting is too pretty he goes back to it in order to cover it with dabs or streaks of paint to the effect that the figures in the painting seem to be acting in some darkening blizzard or behind bars".[40]

Hahn is not trying to be evasive in his layering of images. He is not only revealing his sources in a very direct way, but also conjuring up the great image of the painter battling against the prevailing wind. Brian Kennedy sees a Classical descent into the underworld for inspiration in this use of the Van Gogh image: "The painter approaches the landscape imprisoned, as it were, by his own personality. Here after we have a descent into despair … ."[41]

Kennedy's words could equally be applied to the Scottish painter John Bellany (born 1942), who has also made work in tribute to Van Gogh, though slightly more disguised. His painting and screenprint of *Old Man with Sail* (1987) shows a seaman trudging up the shore with a sail over his shoulder in a pose that emulates Bacon's image of Van Gogh. Bellany has built his vision out of the hard life of his grandfather's fishing village, Eyemouth, which was wracked by Calvinist anxieties further stoked by a fishing tragedy in 1881, the year of his grandfather's birth, when half the male population was lost at sea.

Most comparisons between British and German painters are little more than

Markus Lüpertz
Legende-dithyrambish,
1975
Watercolour and Indian
ink on paper
43×61 cm (16³/₄×23³/₄ in.)

John Walker
Form in a Landscape,
1989
Monotype
55.9×76.2 cm (22×30 in.)

coincidental. Certainly Bellany and Hahn's reaction to Bacon was very different. Bellany admits that "Bacon had a huge effect on me, when I was younger".[42] The Scottish painter has certainly studied the way Bacon concentrated emotion into his pictures using simple frameworks. Hahn sees Bacon almost as an incidental challenge.

At first glance the Albas and dithyrambs of Markus Lüpertz and John Walker (born 1939) are very similar shapes, and both are designed for the artists to be able to show off their use of paint rather like a musician practising his scales. John Walker took his paintings back to a basic shape. It looked like a monolithic stone, but he called it an Alba after Goya's Duchess of Alba. By repeating a uniform shape, Walker was able to give full vent to the qualities of paint. This is a very public display of the desire to construct a new art. In works such as *Two Cultures* (1983–84) and *Oceania my dilemma* (1983) one begins to wonder whether the attempt to inject new life into modern art through Oceanic art is doomed by the overwhelming power of primitive sculptures and emotions. One can actually witness the tired formalism of the Western tradition dying in Walker's art.

Lüpertz's truncated pyramid shape, the dithyramb, came straight out of the artist's examination of Classical art. Rather like Bacon, he concentrates on the heavy emotional charge placed on the individual in the roots of Western art, found in Greek myths. "Lüpertz's dithyramb stands, on the one hand, for a new beginning in his work, and on the other, for the artist's initiation into the mysteries of the self. Dionysus, the god of the dithyramb, symbolises the wholeness of the artist's projected personality."[43]

Of all British artists, Maurice Cockrill was most caught up in the *Zeitgeist*. He certainly was not even considered for the exhibition: he was relatively unknown outside Liverpool and moved to London to live only in 1982, while the exhibition was on in Berlin. With its riots, Liverpool had been at the heart of the resistance to Thatcherism. Perhaps it was Cockrill's experience of divided Britain that led him mysteriously to echo the subject-matter of German artists, in particular Immendorff. His *Winged Maiden* may be closer to Baselitz, but with his burning-book series and the creation of a symbolic star form there is a startling proximity to Immendorff.

Cockrill and Walker (who has divided most of the last thirty years between America and

Australia) showed closer links to German artists than did most Londoners.[44] Despite the connection forged between Berlin and London by the curators Christos Joachimides and Norman Rosenthal, the new spirit in painting had not radically altered the lives of most of London's herd of loners: though London provides countless social opportunities, it also encourages its inhabitants to retreat into themselves. In this, London was slightly out of step with Berlin and Düsseldorf. Original new painting was still coming out of London painters' sense of being totally ignored.

Paula Rego, in her statement for this book, comments that she likes the sense of isolation of the London painter. She has spectacularly broken the taboo against story-telling. To Francis Bacon and many artists of the 1950s and 1960s, including her husband, Victor Willing, illustration of any kind was the ultimate crime. They looked to concentrate emotion and saw anything that might hint at a story as a distraction. Rego has recaptured this forbidden territory by a circuitous route. Unlike Bacon and Willing, she did not consciously take on abstraction. Rather, she felt that no one worried about her, that she was so marginalized that she could do what she had always done since she was an only child in the middle of a lonely nursery floor – draw. "I was only a girl",[45] she explains.

Although Rego's attack on the old establishment straightjacket vision may have been through "the back door", it has been just as devastating. Her overflowing vision, constantly checked by vicious barbs, struck a chord with a viewing public starved of such visual generosity.

In the 1970s, even in London, the systematic figurative painting of Ken Kiff (born 1935) stood out. Although he has never been confrontational, his stubborn refusal to bow to the conventions of the time needled some of his contemporaries. The abstract painter and one-time fellow tutor at Chelsea School of Art, John Hoyland (born 1934), held up Kiff as some kind of bogeyman: "But if you turn your back on all that understanding of what's gone on in modern art, you're going to end up doing some idiosyncratic little kind of painting that doesn't belong to anything, like an escape … like Ken Kiff or somebody, painting your own nightmares."[46] Hoyland turned on Kiff for precisely the same reason that the American

critics had attempted to bury the *Zeitgeist* painters under a pile of vitriol. If he was forced to take Kiff seriously he had to reassess his own formula for success – the current narrow interpretation of Modernism. It was a bleak prospect for artists such as Hoyland who had chosen to hurtle down a bobsleigh run only to find they had reached the bottom with a bump. It was galling to see other artists exploring the mountain.

The frightening aspect of Kiff for fellow artists such as Hoyland was his in-depth understanding of earlier European Modernism. In *Drawing the Curtain* (1980; see frontispiece) one can literally see Kiff pulling back the curtain of abstraction to reveal the forbidden life behind. Painting is not allowed to be a window, Greenberg had declared. One can see why. We humble viewers have to be protected. There is a whole zoo there! Yet the world Kiff gives us in this and other paintings is far from pure undiluted chaos. There may be blood spurting from goddesses' heads, flying creatures that play similar roles to Bacon's harpies, exploding volcanoes and walking hills, but there is a rigid structure in the colours and shapes – his composition and use of complementary colours. The structure of Modernism is not only in the purple curtain but behind it as well.

Kiff is more interested in building up the structures of painting than in tearing down the old ones. He does, however, question all his building blocks. He has obviously learnt from much that has happened since, but his essential starting-point is not far removed from that of Klee and Kandinsky. In his constant experimentation with the pushing around of the "stuff of paint", colour and its combination with images, he is close to Klee, but Kandinsky's insistence on the sanctity of inner beauty is Kiff's point of departure. Kandinsky wrote that "The 'beautiful' can be measured only by the yardstick of inner greatness and necessity which has so far always served us well. The beautiful is what springs from an inner psychic necessity."[47] One can almost hear Kiff saying "Yes and No" to this: "Yes" to the importance of this spiritual and psychological content in art; "No" to the fact that abstraction was the only way to show this.

Andrzej Jackowski was born in 1947 into a world that made him an Ultra-modernist. He spent his first eleven years in Doddington Camp, near Crewe , a 'temporary' home for refugees. His father, though he was to live for over thirty years in England, spoke only Polish at home. Living out of a Nissen-style hut, the young Jackowski learnt to carry his culture on his back. He studied film before retraining as a painter. At the Royal College of Art he learnt the technique of painting on half-ground chalk, which helps give the pictures their luminous,

Bernd Zimmer
Black Wall, 1979
Emulsion on canvas
180 × 180 cm
(70 ¹/₂ × 70 ¹/₂ in.)

dreamlike quality. He completed a series of paintings that referred to Copernicus, emphasizing his dramatic removal from his own Central European roots. Over the last twenty years Jackowski has gradually reduced his subject-matter, sometimes placing a few treasured objects on a table like an altar. It is as though he has been slowly distilling all links to the past. His work has evolved out of the dramatic break in our culture.

The exhibition *Zeitgeist* emphasized the figure in painting, but it made no attempt to end the ban on landscape painting, which for so long had been considered a tired and debased tradition. The contribution of Bernd Koberling and Per Kirkeby (born 1938) to landscape was more evident in the exhibition *A New Spirit in Painting*, but even there it was given hardly any prominence. Bernd Zimmer, the one *Heftige Malerei* painter who was making a serious attempt to look at landscape literally from a new perspective, was left out of *Zeitgeist*. Zimmer painted his Bavarian mountains as if from the air. At the same time,

he was breaking down nature, this forbidden subject, into its four elements: air, fire, water and earth.

"Since we no longer know what it is to be natural, nature is no longer a norm",[48] wrote Donald Kuspit, extolling the artificiality of the new painting. In the same catalogue, Siegfried Gohr concurs in writing about Baselitz: "His conception of painting has shown … that it is impossible for modern art to deal naively with nature".[49] It would be possible to take this line with Kiefer's work, too. His forests and scorched earth are almost like his other architectural settings – stage sets for emotional dilemmas. As Richard Calvocoressi concluded in the catalogue to the exhibition *The Romantic Spirit in German Art*:

"And yet the spectator cannot help experiencing a feeling of morbid fascination for this grandiose architecture, the doomed descendant of the Romantic Classicism of Schinkel and von Klenze. Kiefer would have been aware of the regret expressed by certain revisionist architects and historians in the early 1980s that many of the best examples of the style were blown up after the war. To assert the artist's right to allude to such politically emotive issues is an intrinsic part of Kiefer's art. It derives its peculiar force from the artist's ability

to hold in balance contrary emotions, such as repulsion and attraction."[50]

Landscape may be part of Kiefer's work, just as it is with Auerbach and Kossoff in England, but other painters in both Germany and Britain were looking for ways of making nature their main subject. Though it certainly cannot be described as a movement, there is a series of loose connections between those working in this area. Bernd Koberling was not only an influence on German artists such as Christa Näher (born 1947), but is also quoted by both Christopher Le Brun and Ian McKeever (born 1946) as an influential friend. Even before he had finished his postgraduate degree, Le Brun painted *Landscape* (1975–77), which had strong connections to the eighteenth- and nineteenth-century British landscape tradition. He also made a series of pictures with trees and clouds as the subject, yet the environment has never supplied the *raison d'être* of his work. McKeever, on the other hand, has fully engaged with the countryside.

Like Koberling and Kirkeby, McKeever has been intrigued by the landscape of the far north (in his case, particularly Iceland and Lapland). In Britain, sculptors and installation artists had had the monopoly of the land for some years. McKeever came out of this tradition, though it was articles by and about the American environmental artist Robert Smithson, not Long and Fulton, that first came to his attention around 1970. From the beginning he wanted to break through the 'refined' view of British landscape. Writing in tribute to Alan Davie, he wrote:

"Our roots, our real roots, the Celts, old blood, the bogs, the liquid and flow of our early history is lost, suffocated under the weight of the Academy. What an impoverished tradition of mediocrity we painters [in Britain] have to fight our way out of. Even Turner and Constable are soothed in this land of the pastoral. Schhh! lest we wake the monster in this beautiful land. It makes you want to scream out loud 'Let the land devour me down to mud and all, but do not placate me!'"[51]

In 1982 McKeever wrote, "About two years ago I said to a friend, 'I have some ideas for new works and I think they would work best as paintings.' He replied, 'but you are not a painter!'"[52] This did not deter McKeever. He was not tied to any one medium; his first paintings were mixed with photographs. McKeever has lived in Germany and has many German connections,[53] so he was fully aware of Richter's theories on photography and

125

painting, but his use of partially painted-over photographs is often closer to Kiefer's. The point, as Lewis Biggs noted, was that, "By incorporating photographic material into his work he distanced himself from formalist painting (to which his work had a superficial gestural similarity) and allied himself with the theoretical debate around photography and its 'objective' relation to the real world".[54] McKeever may have rejected a Modernism that had become equated with formalism, but over the years he has created his own fluid grid to assist him in his attempt to release the "land's monster".

Although Michael Porter (born 1948) also worked as a sculptor before turning to paint, his approach to the countryside has been far gentler than McKeever's. His interest in landscape originally revolved around the Shining Cliff Woods in the Derwent Valley in his native Derbyshire. For years he took photographs of this natural beauty spot, which nevertheless showed the effects of industrial contamination, and returned with them to his studio, which was then in the East End of London. Recently he has moved to Cornwall, from where he continues to use photographs of the Derbyshire woods as well as new ones of the local environment. He does not incorporate the photographs into his work like McKeever, but uses them as reminders of the land.

Porter is not content with representation. Rather like Lucian Freud, who has stated that he wants to paint with flesh, Porter wishes to give us the experience of walking through the woods. Coming out of a time of conceptual art, from the walks of Richard Long and Hamish Fulton, Porter uses details of a forest walk to trigger memories of experience. Whereas Long and Fulton give us words and maps, Porter paints incredibly detailed fungi and other organic matter. He does not attempt to conjure up the broad panoramas; rather, he shows us a puffball being buffeted in the wind, dry grass on a cliff face or a falling leaf.

Thérèse Oulton (born 1953) was hailed as the latest in the line of the Romantic landscape tradition, and violently objected. Indeed, she immediately reinvented herself. While Kiefer consciously evoked connections to Caspar David Friedrich (one of Kiefer's earliest works actually adapted Friedrich's *Wayfarer above the Sea of Fog* (*c.* 1818),[55] so that the hero is giving the Fascist salute to the Romantic past), the mention of Turner led Oulton to remove

any possible suggestion of landscape. She evolved a highly textured painting style similar to the late style of Richter.

Hughie O'Donoghue (born 1953) has periodically, like Kiefer and McKeever, used photographs. Since O'Donoghue's reputation has been built very much on his skill as a painter and his exploration of the human body and its relationship to the earth, the recurrent use of photography is surprising. Yet his first lifeline to the international art world, when he embarked on a career as a painter in Manchester, was through magazines. Artists of his generation were still very much looking at the Americans. Ian McKeever, for instance, declared his admiration for Barnett Newman and Clifford Still in describing his own *Waterfall* paintings: "I remember standing under a waterfall, framing it in the camera and thinking of a Barnett Newman painting".[56] Once again the introduction of photographs may well be part of the battle against formalism. As O'Donoghue says, "Formalism is a kind of artistic disease that you can get from reading the wrong art books or looking at the wrong artists or by just becoming lazy".[57]

O'Donoghue has compared the use of photographs to the academic habit of putting a quotation in quotation marks.[58] He wants to isolate his sources, to show what is his and what is not. The fact that the quotations are in

a different medium emphasizes his process of painting, which is extremely seductive as his paintings are built up with layer upon layer of paint and varnish, but it is not an end in itself. He encourages the viewer to look for meaning like an archaeologist digging for evidence. There is an extremely close relationship between man and earth. "One day sometime in 1983 or 1984", explains the artist, "I picked up a book and the pages fell open at a photograph of a man who was buried in a bog."[59] A leg literally slips out of a bank of earth. In a sense, the artist is trying to trap elusive intimate life like Auerbach, but he projects his ideas on a monumental scale.

While a few painters in both Germany and Britain were incorporating photography in their work, a powerful generation of artist photographers emerged. They were pupils of Bernd and Hill Becher, including Candida Höfer (born 1944), Thomas Struth (born 1954), Andreas Gursky (born 1955) and Thomas Ruff (born 1958). Struth and Höfer both made series of photographs of museum interiors. In showing cultural institutions in the manner of Vermeer's still interiors, Höfer is questioning their values, while Struth's depictions of similar scenes concentrate on the bizarre ways in which we look at art. Gursky is most famous for his similar work with the stock exchanges of the world, while Ruff turned

Thomas Ruff
Portrait (Elke Denda), 1988
Photograph
210×160 cm
(82 1/4×63 in.)
Edition: 2/4

Thomas Ruff
Portrait (Elke Denda), 1988

ordinary people into monuments. "While it once seemed that pictures had the function of interpreting reality, it now seems that they have usurped it",[60] wrote American critic Douglas Crimp. Ruff literally blew up passport-like photographs of unknown people. As he recalls, "In my first exhibition with large-size portraits some people actually thought they recognised the faces of famous personalities from the movies and television. Apparently they just couldn't imagine seeing ordinary people presented that way."[61]

Photography was one of many tools that was to be used by artists whose positioning required them not to be tied to any one medium. The British art schools, led by Goldsmiths' College, London, had made a seismic shift in their teaching of the Modernist position. Duchamp now occupied the mainstream pole position, and not Greenberg, Fried, Picasso, Mondrian or the Minimalists. This was to have its greatest effect on British sculptors.

Though the return of painting may have been making most of the art headlines at the end of the 1970s and the beginning of the 1980s, a third generation of sculptors from St Martin's School of Art was sweeping the international field. The idle name of the movement tells you that 'New British Sculpture' was not critic-led, either. Once again, it was an artists' rebellion against narrow Modernist and conceptual rules. It was backed mainly by curators rather than critics, but this time the powerful alliance was between artists and a dealer – Nicholas Logsdail of the Lisson Gallery, London. Right from the beginning of the 1980s Lisson has represented Tony Cragg (born 1949), Richard Deacon (born 1949), Bill Woodrow (born 1948), Anish Kapoor (born 1954), Shirazeh Houshiary (born 1955), Richard Wentworth (born 1947), Edward Allington (born 1951) and Julian Opie (born 1958). The main two names from this very loose group to slip the Lisson net were Antony Gormley (born 1950) and Alison Wilding (born 1948).

Jon Thompson gives the standard interpretation of 'New British Sculpture' in writing of Deacon as a Post-modernist:

"Deacon … is quintessentially the Post-modern artist. He belongs to no tendency or movements. He shares no stylistic concerns even with the British sculptors of his own generation: Tony Cragg, Anish Kapoor, Bill Woodrow, Richard Wentworth and the rest. It is intrinsic to the condition of Post-modernity that artists, freed from the progressive, programmatic aspect of Modernism, are at liberty to choose their own style."[62]

Tony Cragg
*Britain Seen from the
North*, 1981
Mixed media, found
plastic fragments

Figure: 170×58 cm
(65 3/4×22 1/4 in.)
Britain: 370×700 cm
(135×270 in.)
Courtesy of Tate Gallery,
London

At the beginning of the 1980s the Post-modern interpretation did seem to fit the 'New British Sculptors'. There was a glorious freedom in the way Bill Woodrow and Tony Cragg not only used new materials but also flaunted them with an apparent casual ease. Woodrow opened up everyday appliances as if with a can-opener, so that a washing-machine started strumming a guitar, a car door gave birth to a Native American headdress, a 40 mm artillery shell sprouted delicate chestnut leaves, and the edge of a cymbal curled into a snake.

In *Hoover Breakdown* (1979), Woodrow's vacuum cleaner literally deconstructed, spewing out a triangle of waste that actually consisted of its own component parts. This was very close to Cragg's wall and floor pieces of the late 1970s and early 1980s. Cragg's *Staubsauger* (1981) is a wall depiction of a vacuum cleaner, made of coloured debris. A more famous image is *Britain Seen from the North* (1981), in which a figure made of vividly coloured debris looks on at a map of Britain composed of equally colourful discarded scraps of life.

As Nicholas Serota has written, "Cragg and Woodrow brought the detritus of conspicuous consumption into the gallery, rearranging, re-classifying and transforming it into emblems of the post-industrial age, in which information comes to us not through direct experience but through the electronic media of the video and TV screen".[63] It was not only Cragg and Woodrow who indulged in a shop window of excess. Piles of fruits and vegetables flowed bounteously in Edward Allington's early work. Perhaps the most obviously Post-modern work was produced by the youngest artist of the group, Julian Opie. *Eat Dirt: Art History* (1982) was a construction of welded metal sheets showing the pages of art history literally blowing away. Beginning with a book open at an illustration of Stonehenge, it is a true magpie vision of art history: the Sphinx (*c.* 2500 BC), the Parthenon (448–432 BC), Donatello's *David* (*c.* 1430–32), *The Dying Slave* (1513–16) by Michelangelo, Ingres's *Odalisque* (1814), *The Fifer* (1866) by Manet, Rothko's *Earth and Green* (1955) and Carl Andre's *Equivalent VIII* (1966). This anodyne reading of history was not for him, but this type of Post-modernist protest could not satisfy him for long either. In 1985–86 he drastically changed style, closing down his generous

wild humour and producing works verging on the minimal. Indeed, in works such as *Painting of D/889 E* (1991) he made houses that could not exist – they were visual culs-de-sac.

There was a crisis in Opie's work, as there was among such painters as Oulton and Opie's wife of the time, Lisa Milroy (born 1959). Opie's repositioning of himself within the emerging canon of his former college, Goldsmiths', was a relatively instant transformation. Both Allington's and Woodrow's reassessment of their work took far longer; indeed, it still appears to be continuing. Woodrow, in particular, has not tried to hide his dramatic U-turn. Spectacular though his initial Post-modernist protest was, Woodrow was not content to reiterate it time and time again. He bravely set about reinventing himself.

Although, at the end of the 1970s, Woodrow's and Cragg's work looked fairly similar, there was a fundamental difference between them. With the benefit of hindsight one realizes that Cragg was never a Post-modernist. He always had an underlying critical structure behind his work that went beyond protest. Cragg might well have agreed with Woodrow back in 1981, when his friend declared, "What I find more interesting about the work, is that these items are material for me that is found in my environment, it's not recovered in any sense, it deals directly with my life and the majority of my experiences, whereas walks in the countryside and rural atmospherics don't play a very large part in my life".[64] Conceptual art was their point of departure. As Mary Jane Jacob recalls, "Recognizing the promise of his student, in September 1970 Ackling [Roger] introduced Cragg to Richard Long, whose work immediately became a point of reference for Cragg".[65]

A scientific background not only supplied Cragg with some of his most important subject-matter, but also undoubtedly led to his methodical approach to making art. He has always been fascinated by the creation of the world, how it is made. As Germano Celant relates, "The problem of the genesis of things and their component parts first seized Tony Cragg's attention while studying at Technical College and during his first experiences working in a laboratory at the Natural Rubber Producers Association, where he came into contact with atomic, and subatomic phenomena as well as with biochemistry".[66] Cragg is interested in nature, but he is more interested in the reality of nature in which we all live, a world where nature and the man-made rub shoulders and interact. As he says, "I am trying to make natural materials and man-made materials have equal value".[67] Elsewhere he wrote:

Richard Deacon
*Study for 'For Other
Men's Eyes No. 2'* (iv),
1986
Pencil on paper
25 × 30 cm (9³/₄ × 11³/₄ in.)

"There exists a very beautiful letter from Van Gogh to his brother that simply describes a walk through a fantastic land-scape full of strange objects, forms and colours. This is a description of him walking across the local rubbish dump. So for artists even at the end of the nineteenth century there was already an awareness that there was not just a natural world but there was a whole population of other objects. In fact, the products of the industrial society began to have an aesthetic impact."[68]

The label of Post-modernist simply does not work with Cragg. His choice of subject and his ordered method of working reveal his sophisticated critical structure. Jon Thompson's claims for Deacon as a Post-modernist can equally easily be turned on their head. Ultra-modernists are all naturally aware of Post-modernist concerns. Their strength of purpose is tested by their ability to react against "the progressive, programmatic aspect" of Marxist Modernism and yet still create a new art that is connected, not just in negative responses, to a greater critical web. Ultra-modernists can just as well be loners as work in a movement; they may work on the theme of isolation but their work is never isolated. Their new art evolves out of the questioning of earlier Modernists and others. Deacon is a prime example.

Deacon's work may not look like that of any of his contemporaries, and although he has a greater joy in new materials and is a more adept engineer, his debt to the early Modernist sculpture of Anthony Caro is clear for all to see. His achievement is in producing three-dimensional drawings of forms that are mysteriously both archetypal and ambiguous. There are a lot of references in the titles to the senses – in particular sight and hearing (*Tall Tree in the Ear*, 1983–84, and *For Other Men's Eyes No. 2*, 1986, for instance), yet the ears and eyes are never drawn too literally. It is the space in his work that encourages the dialogue between viewer and sculpture. The viewer is asked questions in the Socratic tradition. Despite his constant references to the senses, Deacon's art is conceptual – though it owes as much to Plato as to his immediate artist predecessors. Of course, he is not interested in making ideal ears and eyes, but his spare forms demand similar leaps in the viewer's mind. They induce you to talk to yourself. It is not surprising that "he chooses to link the making of sculpture with speaking rather than writing. In spoken

discourse meaning is always open to negotiation"[69] His works are open-ended frameworks.

In 1992 Deacon gave a brief history of his own thinking:

"Baudelaire's assumption ... was that sculpture was necessarily primitive and close to nature: that is to say, incapable of becoming civilised, as painting is, without losing necessity and virtue. A central plank of Rilke's interest in and writing about Rodin was puzzlement bordering on awe that something made as art could dispense with its maker and exist in the world of things. Judd in his text *Specific Objects* suggests the possibility of an art which borders on the ordinary and the matter of fact. This 'like 1,2,3' is a way of seeing the world."[70]

Deacon has departed from the harshness of Minimalism. Indeed, in Thompson's words, he has argued "that the Minimalists, far from solving the problems of meaning, had only postponed it".[71] Meaning is important to Deacon but the sculptures do not always yield the secrets as easily as the no-nonsense materials suggest. Poetry is a key to the work of Deacon, Kapoor and Houshiary. The early work activated ideas and memories in a similar way to poetry. As Stéphane Mallarmé said, "To name an object is to suppress three quarters of the enjoyment of the poem which comes from the delight of divining little by little: to suggest, that's the dream".[72]

Like Houshiary, Anish Kapoor has been accused of mysticism. While it is true that both artists have looked at the roots of cultures outside the linear Western tradition, they have also confronted Modernism full on. "I have no formal concerns", Kapoor claimed in 1981. "I don't wish to make sculpture about form – it doesn't really interest me. I wish to make sculpture about belief, or about passion, about experience, that is, outside of material concern."[73]

Order and chaos competed in Kapoor's work of the first half of the 1980s. His shapes, sprinkled with richly coloured pigment, emerged like the beginning of life. Like Cragg, Kapoor has a burning interest in the genesis of life. He may not have Cragg's scientific experience, and he certainly was interested in a wide spectrum of creation myths, but the ambitious sequential nature of the 1000 Names series, shows that, from the beginning in the late 1970s, he was prepared to embark on a thorough exploration of sculpture's properties.

Beuys's death in the mid-1980s left a yawning void. His regenerative ideas had been powered by his charismatic energy. Without him the task of creating a whole new aesthetic structure seemed far more daunting, if not

Anish Kapoor
Void Field, 1989
Cumbrian sandstone
and pigment
Sixteen parts, dimensions
variable

Courtesy of Fondazione
Prada Collection, Milan,
and Lisson Gallery,
London

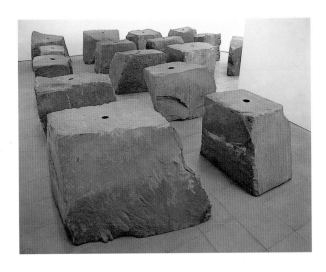

impossible. Beuys's aim had been to make art more accessible, but there was a danger that his legacy would actually alienate the public from sculpture. His refusal to give the public memorable images to compete with those of, say, Warhol meant that, to a certain extent, Beuys's art had remained in the minds only of a group of followers. In 1987, the year before he took up his post as a professor at Beuys's old Düsseldorf Kunstakademie, Cragg admitted that "For me a sculpture will only work if its form is right".[74] He is acknowledging the need to make art visibly accessible. He is refusing to divorce his work from Modernism.

In contrast, Beuys made Kapoor realize that the making of sculpture was not one smooth line of tradition. He himself supplied the break, the gap, the void. Kapoor was introduced to Beuys's work through his Romanian friend Paul Neàgu at the end of the 1970s. "There was someone I found very important to me then, Paul Neàgu", recalls Kapoor. "He really had a lot to do with the way my growth as a person occurred. He was a foreigner working in this context here, that had something to do with it. He opened my eyes to the idea that making art wasn't about making more or less beautiful things and that there was some

deeper purpose to it."[75] Yet it was ten years later that the full effect of Beuys's ideas entered Kapoor's work. The early void pieces resonate with Beuys – *Here and There* (1987), *Void Field* (1989), *The Healing of St Thomas* (1989) – but there is one big difference between these and Beuys's work. Kapoor is incapable of totally abandoning beauty. In creating essentially brutal works, little details such as weeds appear through the cracks. These works are almost like an inversion of Michel Leiris's remarks on beauty: the rogue element is now beauty.

Richard Wilson (born 1953) actually delights in altering our environment. His site-specific installations play tricks on the viewer's perceptions. *20:50* (1987), in the Saatchi Collection, London, is the most famous example. Here the visitor is allowed to walk down a near-submerged bridge into a room full of sump oil. The oil is in fact only a few centimetres deep, but the intruder is completely disorientated by the reflections and materials of this threatening lake. The mood of Wilson's sadly unfulfilled project to transform the Baltic Flour Mills in Gateshead into a windmill with beams of light for sails may be completely different, but they share an element of surprise.

David Nash (born 1945), who is sometimes included on the edge of the 'New British

Sculptors' group, makes very different site-specific works in the country. He, too, is prepared to alter the environment. Indeed, he fully engages with the land and trees around him, letting nature itself have its creeping way with his conceptions. At the start of his career he used found wood, but in 1977, the year he moved to Wales, he planted a circle of ash seedlings at Cae'n-y-Coed, near his studio at Blaenau Ffestiniog. *Fletched Over Ash Dome* is a work in progress. As the artist explains, the work consists of "a circle of young ash trees fletched and woven into a thirty foot dome fletched three times at ten year intervals then left alone. A silver sculpture in winter, a green canopy space in summer, a volcano of growing energy."[76] Nash is gently letting the real world undermine the ivory towers of critical structure.

Andy Goldsworthy (born 1956) also clearly acknowledges the power of nature. In one sense his work is close to that of Richard Long and Hamish Fulton, yet it can be read as a declaration of war. It proclaims the impossibility of keeping art purely in the head. Goldsworthy uses the landscape literally as his canvas, making fragile and temporary works of art out of ice, snow, sticks and leaves. Often the only evidence for these works is photographic. The Post-modernist label might seem fair enough in this clear celebration of

the senses over formalism, yet in his return to direct sources he shares an Ultra-modernist urge. He literally fulfils the declaration of the German Romantic poet Novalis (1772–1801) that "Nature has an artistic instinct – thus it is only empty words when a claim is made to distinguish between nature and art".[77]

Goldsworthy has certainly never been included among the 'New British Sculptors' – a grouping that looks even more diverse today than it did twenty years ago. Antony Gormley's idea of rigorously exploring the body, through recasting his own body, has very little to do with Richard Wentworth's nagging, incisive soul-searching. Wentworth has always had more in common with Jon Thompson and Michael Craig-Martin, fellow teachers at Goldsmiths' College, London. His subversive, disruptive discourse has been seen as Post-modernist, but it has more to do with the shift towards the Duchampian view of Modernism.

The natural German successors to Beuys failed to materialize in the field of sculpture in the 1980s, though some of the next generation, such as Rebecca Horn (born 1944), perhaps received more attention. Ironically, it was the sculpture of painters that was seen everywhere, with Baselitz, Lüpertz, Penck and Kiefer all making monumental three-dimensional work. The break in culture was even more obvious

David Nash
Ash Dome, Caen-y-Coed,
1983
Charcoal, pastel and
watercolour on paper
80.5 × 121.5 cm
(31³/₄ × 48 in.)

in their sculpture than in their paintings. As Michael Govan wrote, "'Degenerate Art' returns in Baselitz's work not as progressive, but psychotic, repressed and unfinished".[78] The figurative sculpture of Stephan Balkenhol (born 1957) evolved in this climate.

Balkenhol expresses a desire to reintroduce balance into art:

"What I saw in the seventies was the division of the arts by subject, the handling of them separate, as main fields – the creative process, the material, the concept, the colours, the exhibition site and so forth … like, for example in process art or conceptual art … When I turn out wood sculpture all of the elements are equally important: concept, process, material, arrangement, installation, spatial relatedness."[79]

"What I really want to do is to fill a whole room by one figure doing nothing",[80] says the British sculptor John Davies (born 1946), who also makes haunting figures that hover mysteriously between the modern world and our disjointed past. There was an element of quiet, peaceful performance in his work of the 1970s and early 1980s. Figures hid behind masks and other contortions, interacting with the drama of a Genet or Beckett play. Later he had figures climbing and swinging as though in a circus, men performing within an arena. It is not surprising, however, that after years of abstract and conceptual art it is the single, still figure that is waiting in the wings to reclaim its central position.

John Davies
Head – Reworked, 1985;
reworked 1988
Etching and mixed media
62×54 cm (24×21 in.)
Edition: 33/70

1 Rudi Fuchs, 'Introduction', *Documenta VII*, exhib. cat., ed. Rudi Fuchs, Kassel, various locations, 1982, vol. 1, pp. xiv–xv.
2 Christos Joachimides, 'A New Spirit in Painting', *A New Spirit in Painting*, exhib. cat., ed. Christos M. Joachimides, Norman Rosenthal and Nicholas Serota, London, Royal Academy of Arts, 1981, p. 14.
3 *Ibid.*
4 The exhibition programme of the Galerie am Moritzplatz included shows of Fetting (1977 and 1978), Middendorf (1977, 1978 and 1979), Salomé (1977, 1978 and 1981) and Zimmer (1977 and 1978).
5 Wolfgang Max Faust, '"*Du hast keine Chance. Nutze sie!*" With It and Against It: Tendencies in Recent German Art', *Artforum*, September 1981, p. 39.
6 Tony Godfrey, *The New Image*, Oxford (Phaidon) 1986, p. 7.
7 Julian Schnabel, quoted in Michael Archer, *Art Since 1960*, London (Thames and Hudson) 1997, p. 154.
8 Thomas Krens, 'German Painting: Paradox and Paradigm in Late Twentieth-Century Art', *Refigured Painting: The German Image 1960–88*, exhib. cat. by Thomas Krens, Michael Govan and Joseph Thompson, New York, Solomon R. Guggenheim Museum, 1989, p. 20.
9 *Ibid.*, p. 16.
10 Christos Joachimides, 'A New Spirit in Painting', *A New Spirit in Painting*, *op. cit.*, p. 15.
11 Helmut Middendorf, quoted in Joseph Thompson, 'Blasphemy on Our Side: Fates of the Figure in Postwar German Painting', *Refigured Painting*, *op. cit.*, p. 23.
12 Benjamin Buchloch, 'Figures of Authority, Ciphers of Regression: Notes on the Return of Representation in European Painting', *October*, no. 16, Spring 1981, p. 55.
13 Craig Owens, 'Representation, Appropriation and Power', *Art in America*, May 1982, p. 9.
14 Donald B. Kuspit, 'Flak from the "Radicals": The American Case Against Current German Painting', *Expressions: New Art from Germany*, exhib. cat. by Jack Cowart, Siegfried Gohr and Donald B. Kuspit, The St Louis Art Museum *et al.*, 1983, p. 43
15 *Ibid.*, pp. 43–44.
16 Norman Rosenthal has been Exhibitions Secretary at the Royal Academy of Arts since 1977. Nicholas Serota was Director of the Museum of Modern Art, Oxford, 1973–76, Director of the Whitechapel Art Gallery, London, 1976–88, and has been Director of the Tate Gallery since 1988. Christos Joachimides is a freelance curator.
17 Anselm Kiefer, quoted in Nicholas Serota, 'Anselm Kiefer: Les Plaintes d'un Icare (From the Poem by Baudelaire 1862)', *Anselm Kiefer*, exhib. cat. by Nicholas Serota, London, Whitechapel Art Gallery, 1981, p. 19.
18 *Anselm Kiefer: Eleven paintings 1976–1984*, exhib. cat. by Mark Rosenthal, Tokyo, Entwistle Japan, 1998, p. 13.
19 Nicholas Serota, *op. cit.*, p. 21.
20 Bernard Smith, 'Modernism in its Place', *Tate*, no. 21, pp. 81–82.
21 Wieland Schmied, 'The Painters: Standpoints of German Painting from Richter to Kiefer', *German Art: Aspekte deutscher Kunst 1964–1994*, exhib. cat., ed. Thaddaeus Ropac, Salzburg, Thaddaeus Ropac Gallery, 1994, p. 107.
22 Fred Jahn, 'Baselitz and Africa: A Conversation Between Fred Jahn and Siegfried Gohr in Munich on 21 July 1997', *Georg Baselitz: Deutsche Bank Collection*, exhib. cat. by Britta Färber, Ariane Grigoteit and Friedhelm Hütte, Moscow, Chemnitz and Johannesburg, 1997–99, p. 288.
23 Wieland Schmied, *op. cit.*, p. 71.
24 *Ibid.*, p. 72.
25 Rudi Fuchs, 'A.R. Penck: Penck's Passion', *German Art: Thirty Years of German Contemporary Art*, exhib. cat., ed. Dieter Ronte and Walter Smerling, Singapore Art Museum, 10 July–21 September 1997, pp. 81–82.
26 Christine Lutz, 'A.R. Penck: Painter and Sculptor', *A.R. Penck: Memory. Model. Memorial*, exhib. cat. by Dieter Brunner, Siegfried Gohr, Arie Hartog, Pamela Kort, Christine Lutz and Hans Jürgen Schwalm, Deutsche Bank Luxembourg *et al.*, 1999, p. 13.
27 Dieter Brunner, '"Reduction is concentration": A Group of Very Small Bronzes from the Early 1990s', *ibid.*, p. 127.
28 Original source not located; quoted in Arie Hartog, 'There Is No Such Thing as an Ironic Sculpture: On the Reception of A.R. Penck's Bronzes', *ibid.*, p. 111.
29 Renato Guttuso's *Caffè Greco* (1976) is in the Ludwig Museum, Cologne.
30 Michael Archer, *op. cit.*, p. 151.
31 Siegfried Gohr, 'The Difficulties of German Painting with Its Own Tradition', *Expressions: New Art From Germany*, *op. cit.*, p. 35.
32 Gerhard Richter, artist's statement, in *Documenta VII*, *op. cit.*, pp. 84–85 (English trans. p. 443).
33 Georg Baselitz, quoted in Wieland Schmied, *op. cit.*, p. 63.
34 Markus Lüpertz, quoted in Armin Zweite, 'Markus Lüpertz: Interpreting Painting', *German Art: Thirty Years of German Contemporary Art*, *op. cit.*, p. 65.
35 Diedrich Diedrichsen, 'Markus Oehlen … already since 1956', *Markus Oehlen*, exhib. cat., Cologne, Galerie Max Hetzler, 1985, p. 10.
36 Albert Oehlen, quoted in Diedrich Diedrichsen, 'The Rules of the Game', *Artforum*, November 1994, p. 69.
37 Christopher Schreier, 'Sigmar Polke: Irony and Experiment', *German Art: Thirty Years of German Contemporary Art*, *op. cit.*, p. 87.
38 Gerhard Richter, quoted in *Documenta VII*, *op. cit.*, pp. 84–85 (English trans. p. 443).
39 Hahn saw Bacon's work at Westkunst, Cologne, in 1981.
40 *Friedemann Hahn*, exhib. cat. by Jürgen Schilling, London, Flowers East, 1986, unpaginated.
41 Brian Kennedy, 'Friedemann Hahn and the "Reality" of Fiction', *Friedemann Hahn: The Eye of the Seaman*, exhib. cat. by Brian Kennedy, Belfast, Ulster Museum, 1996–97, p. 116.
42 John Bellany, quoted in Alistair Hicks, *The School of*

London, Oxford (Phaidon) 1989, p.70.

43 Siegfried Gohr, in *Expressions: New Art from Germany*, *op. cit*., p.33.

44 Cockrill has lived in London since 1982 so is a Londoner now.

45 Paula Rego, in her statement for this book, p.292.

46 John Hoyland, quoted in Timothy Hyman, 'The Meeting of Contrasted Elements', *Ken Kiff: Paintings 1965–85*, exhib. cat., ed. Alister Warman and Peggy Armstrong, London, Serpentine Gallery, *et al*., 1986, p.10.

47 Wassily Kandinsky, *Über das Geistige in der Kunst* [1910], 9th edn, intro. by Max Bill, Berne 1970, p.136.

48 Donald B. Kuspit, 'Flak from the "Radicals": The American Case Against Current German Painting', *Expressions: New Art from Germany*, *op. cit*., p.44.

49 Siegfried Gohr, in *Expressions: New Art from Germany*, *op. cit*., p.32.

50 Richard Calvocoressi, 'Anselm Kiefer', *The Romantic Spirit in German Art 1790–1990*, exhib. cat., ed. Keith Hartley, Henry Meyric Hughes, Peter-Klaus Schuster and William Vaughan, London, Hayward Gallery; Edinburgh, Royal Scottish Academy; 1994, p.466.

51 Ian McKeever, 'Strange Business', *Alan Davie: The Quest for the Miraculous,* exhib. cat., ed. Michael Tucker, London, Barbican Art Gallery, 1993, p.77.

52 *Ian McKeever: Black and White … or how to paint with a hammer*, exhib. cat. by Ian McKeever, London, Matt's Gallery, 1982.

53 In 1981 McKeever spent six months in Nuremberg, where he met his German wife, the critic/curator Gerlinde Gabriel, and has since spent further time in Germany.

54 Lewis Biggs, 'The Shape of Time', *Ian McKeever: Paintings 1978–1990*, exhib. cat., ed Catherine Lampert, London, Whitechapel Art Gallery, 12 October–2 December 1990, p.25.

55 Caspar David Friedrich's *Wayfarer above the Sea of Fog* is in the Hamburger Kunsthalle.

56 *Ian McKeever: Black and White … or how to paint with a hammer*, *op. cit*.

57 Hughie O'Donoghue, 'The Last Abstract Painting in Orpington', *Hughie O'Donoghue: Corp*, exhib. cat., ed. Sarah Glennie, Dublin, Irish Museum of Modern Art, 1998, p.13.

58 Hughie O'Donoghue, 'Myself and Jack Blanc: Proposals for a New History Painting', lecture, Oxford University, St John's College, 21 June 2000.

59 Hughie O'Donoghue, *op. cit.*, p.12.

60 Douglas Crimp, *Pictures*, exhib. cat., New York, Artists' Space, 1977, p.3.

61 Mary Louise Syring and Christian Vielhaber, 'Thomas Ruff' [interview], *Binationale: German Art of the late 80s*, exhib. cat. by Jürgen Harten, Rainer Crone, Ulrich Luckhardt and Jiří Svestka, Düsseldorf, Städtishe Kunsthalle, *et al*., 24 September– 27 November 1988, p.262.

62 Jon Thompson, 'Thinking Richard Deacon, Thinking Sculptor, Thinking Sculpture', in Jon Thompson, Pier Luigi Tazzi and Peter Schjeldahl, *Richard Deacon*, London (Phaidon) 1995, p.82.

63 Nicholas Serota, 'Introduction', *Transformations: New Sculpture from Britain. The XVII São Paulo Bienal*, exhib. cat. by Teresa Gleadowe, The British Council, 1983, p.8.

64 Bill Woodrow, in Iwona Blaszczyk, 'Bill Woodrow' [interview/statement], *Objects & Sculpture*, exhib. cat., ed. Lewis Biggs, Iwona Blaszczyk and Sandy Nairne, London, ICA; Bristol, Arnolfini; 1981, p.38.

65 Mary Jane Jacob, 'Tony Cragg: "First Order Experiences"', in Terry A. Neff (ed.), *A Quiet Revolution: British Sculpture since 1965*, London (Thames and Hudson) 1987, p.55.

66 Germano Celant, 'Tony Cragg: Material and its Shadow', *Tony Cragg*, London (Thames and Hudson) 1996, p.12.

67 Tony Cragg, quoted in Ludovico Pratesi, 'A Conversation with Tony Cragg', *Tony Cragg*, exhib. cat., Rome, Valentina Moncada, 1990, p.8.

68 *Tony Cragg: In Camera*, exhib. cat. by Tony Cragg, Eindhoven, Stedelijk van Abbe Museum, 1993, p.12.

69 Jon Thompson, *op. cit.*, p.44.

70 Richard Deacon on 17 April 1992, quoted in Richard Deacon and Lynne Cooke, *Richard Deacon*, Paris (Editions du Regard) 1992, p.87.

71 Jon Thompson, *Ibid.*, p.45. Thompson is referring to an interview with Marjetic Potrc, M'ARS, Ljubljana, vol. II, no. 4, 1990.

72 Stéphane Mallarmé, quoted in *Shirazeh Houshiary,* exhib. cat. by Lynne Cooke, London, Lisson Gallery, 9 October–3 November 1985, p.18.

73 Anish Kapoor, in Iwona Blaszczyk, 'Anish Kapoor' [interview/statement], *Objects & Sculpture*, *op. cit.*, p.20.

74 Tony Cragg, quoted in *Tony Cragg*, exhib cat. by Lynne Cooke, London, Arts Council of Great Britain, 1987, p.14.

75 Douglas Maxwell, 'Anish Kapoor', *Art Monthly*, May 1990, p.6.

76 David Nash, quoted in *Fletched Over Ash*, exhib. cat., London, Air Gallery, 1978, quoted in Graham Beal, 'David Nash: "Respecting the Wood"', in Terry Neff (ed.), *A Quiet Revolution: British Sculpture since 1965*, *op. cit.*, p.136.

77 Novalis, 'Fragment 1086', *Frammenti,* Milan (Istituto Editoriale Italiano) 1948.

78 Michael Govan, 'Meditations on A = B: Romanticism and Representation in New German Painting', *Refigured Painting*, *op. cit.*, p.37.

79 Stephan Balkenhol, quoted in Mary Louise Syring and Christine Vielhaber, 'Stephen Balkenhol' [interview], *Binationale*, *op. cit.*, p.17.

80 John Davies, talking to Nicholas Wadley in 1980, quoted in *John Davies*, exhib. cat. by Norbert Lynton, New York, Marlborough Gallery, 1989, p.3.

Maurice Cockrill
Burning Book, 1985
Oil on paper
55.5×75.5 cm
(21³/₄×29³/₄ in.)

"'The jaguar [priest] on the right, seized a heavy stone wedge and drove it into the victim's heart. One edge of it drove sharp through the breast bone. Kien closed his eyes, dazzled. He thought, the blood must spurt up to the very sky; he sternly disapproved of this medieval barbarism. He waited until he thought the blood must have ceased to flow, then he opened his eyes. Oh, horrible: from the cleft victim's wounded breast a book appeared, another, a third, many. There was no end to it, they fell to the ground, they were clutched at by viscous flames. The blood had set fire to the wood, the books were burning.' Elias Canetti, *Auto da Fé*.[1]

My series of paintings and drawings under the title Venus and Mars was begun in 1986. It used the male/female protagonists in their wild landscape settings to allude to the fragile relationship between civilization and barbarism. This extensive cycle of works was inspired in part by Rubens's *Horrors of War* in the Pitti Palace in Florence, a commissioned picture concerning a hope for concord in Europe. Restrained by Venus, the armoured Mars has his mailed foot implanted in an open book, evidence perhaps of this scorn for culture in general, literature in particular.

Several of the works in my series have books in their composition, both open and closed, and I was reminded of the significance of the book as an object, a body, and how by a kind of transubstantiation in times of strife or aggression the book is made to stand for the victim, person or race and persecuted, defaced, destroyed, often burned.

The watercolour *Mountain Ash* has a related theme in the sense that a tree, the rowan, among other supposedly mystical properties, could be seen to have characteristics often admired in humans – beauty, tenacity, solitariness, endurance – and may also stand for the (Christian) sacrificial tree, replacing the body represented only by hands and feet: the tree, of course, being the material from which the book is made.

These musings spawned a pendant group of images of burning books – works on paper, various paintings and, later, small bronzes, in which the book (or books), unconsumed, remains defiantly intact among the flames, phoenix-like, the unassailable spirit of literature.

In my consciousness the burning-book theme brings together two of the most potently fascinating agencies, fire and the book. Fire warms, purges, harms, illuminates, insatiability its foremost characteristic. The book is now under attack from other technologies also. The companionship of books is something I have known and valued since childhood; a book destroyed could be likened to a living thing leaving the world."

Maurice Cockrill, March 2000

1 Elias Canetti, *Auto da Fé* [1935], English trans., London (Pan Books) 1978, p. 34.

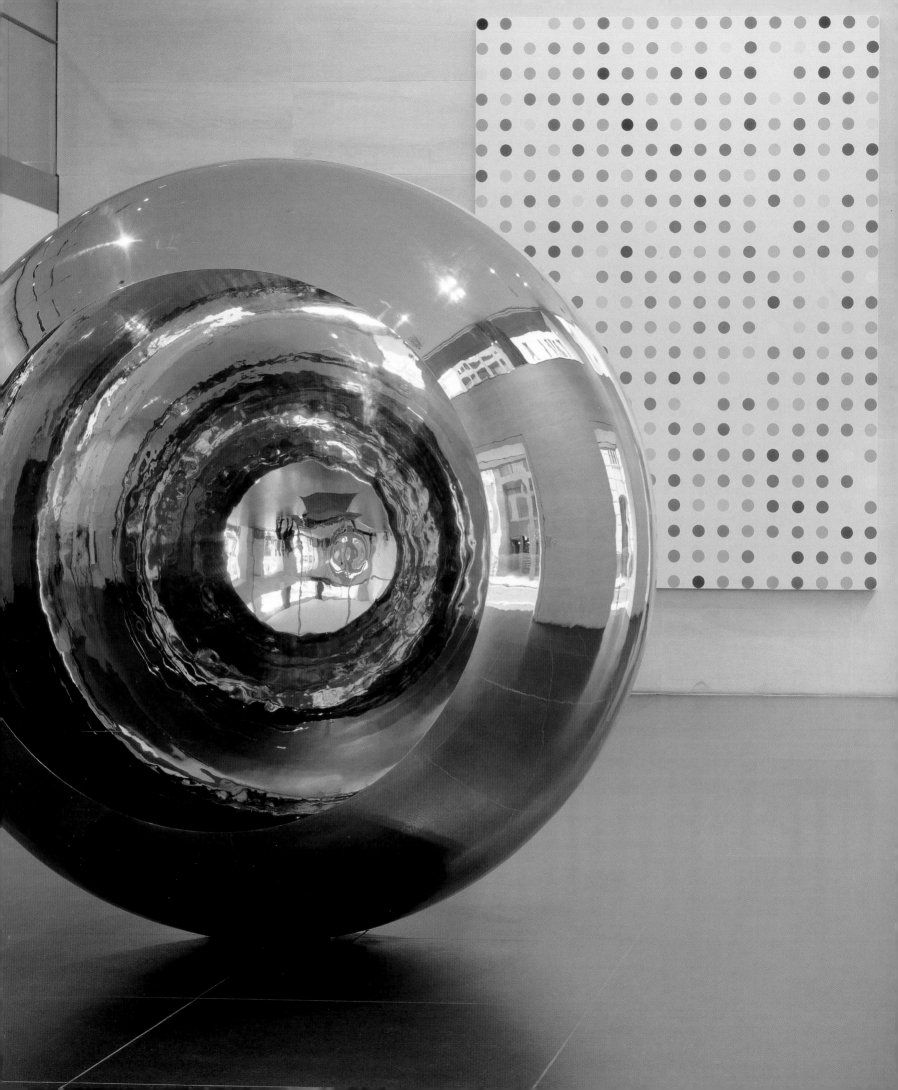

1990s: Pidgin- and Ultra-modernism

"Art is not just about making a vision; it is also imposing that vision on others."
Norman Rosenthal[1]

"I'd like to be able to order one over the 'phone. 'Could you deliver a shark in formaldehyde please?' That would be perfect." Damien Hirst[2]

"Renaissance art was a lot more like contemporary television than contemporary painting."
Bill Viola[3]

The YBA history can be neatly sensationalized into a simple ABC. YBAs (Young British Artists) have stolen the art headlines ever since Damien Hirst (born 1965) held the three-part warehouse show of his and his friends' work *Freeze* in 1988. The 1, 2, 3 history lesson refers back to Francis Bacon, "an acknowledged – sometimes the only acknowledged – influence"[4] on Hirst. Bacon frequently declared that he thought about death every morning. Hirst capped this with, "Every time I finish a cigarette I think about death".[5] But Hirst was not left with the last word. Up popped naughty girl Tracey Emin (born 1963) with the confession that the first cigarette of the day makes her want to shit.[6]

Young British Artists seized their opportunity and took their fate into their own hands. As the *Zeit* and the *Geist* ticked by for the *Zeitgeist* painters, the new aspirants noticed that the critical structure that had been blown away had been replaced by a network of stars. Hirst *et al.* behaved accordingly. Matthew Collings claims it was Schnabel who paved the way to Hollywood-like stardom for artists: "He [Schnabel] was Mister Smart in about 1978 and then Mister Huge. We don't talk about him so much in the nineties, because his particular brand of iconoclasm seems standard now. But he was the first monster superbrat of the eighties artworld, the model for Jeff Koons [born 1955], and then, later, Damien Hirst."[7]

Strictly speaking Hirst did not initiate the marketing of his and his friends' work. It was a fellow second-year student at Goldsmiths' College, London, Angus Fairhurst (born 1966), who organized a small exhibition of his own work alongside that of Mat Collishaw (born 1966), Abigail Lane (born 1967) and Hirst at the Bloomsbury Galleries, London, in 1988. By the time this was up and running in February, Hirst's plans for an event with four times the number of artists were well under away.

With *Freeze*, Hirst found a way of presenting the spirit of the art of the moment. In negotiating the loan of the Port of London Authority Building (Plough Way, London SE16), he found a big space out of the general run of the art world. Visitors almost felt they

Michael Craig-Martin
Portfolio, 1997
Screenprint: set of ten
double-page images
33×110.5 cm
(13×43 ½ in.)
Edition: 4/50

were being invited to the big moveable acid parties of the time. Yet, as Collings wrote, "… these first warehouse shows were not revolutionary or rebellious or anarchic or crazy or unbelievable, they were quite conventional in a way. The aim was not to buck the system but to get into it absolutely as soon as possible by showing how utterly system-friendly your art was."[8] Hirst did use common tactics to get people along. He sent out invitations from borrowed gallery lists, but he did not rely on this. He managed to round up such people as the godlike Exhibitions Secretary of the Royal Academy of Arts. As Norman Rosenthal recalls, "I for one managed to see it [*Freeze*] courtesy of the persistent young Hirst, who came to collect me early one morning in a rickety old car and drove me down to Docklands so that I might be able to be back at the Royal Academy by 10.30 am".[9] He also drove Rosenthal to see *Ghost* by Rachel Whiteread (born 1963), of whom Rosenthal had not heard at the time.

Hirst commissioned one of his teachers, Ian Jeffrey of the Art History Department of Goldsmiths' College, to contribute to a well-produced catalogue. Not often quoted by the YBA mythology machine, Jeffrey's largely inconsequential text has some revealing moments. "In FREEZE", he writes, "you might get the beauty of it pure, the essence of ART

NOW, for elsewhere, in the arithmetic establishment, NOW comes qualified by second thoughts and infiltrated by history. What history there is on show here is here by invitation, and is just enough."[10] What an extraordinary confession for an art history lecturer! There is a strong desire by the Young British Artists to detach, or at least semi-detach, themselves from historical structure – to present themselves as of the moment. They had been led to this by the Principal of Goldsmiths', Jon Thompson, and the other staff including Richard Wentworth, Michael Craig-Martin and Yehuda Safran, who in their teaching had shifted the focus of Modernism from Picasso, Malevich, Kandinsky and Mondrian to Duchamp. History has stressed the conceptualist element of teaching, but abstract painters such as Albert Irvin (born 1922) and Basil Beattie (born 1935) were also teaching there during this time and Safran is quoted by other former students as having been inspirational.

Michael Craig-Martin is most often quoted as *the* influence on the YBAs. His legacy to them has been primarily in the field of presentation. Known in the 1970s for highly conceptual works such as *An Oak Tree* (1973), in which he claims to have transformed a glass of water on a shelf into a tree merely by calling it one, he reinvented himself as a neo-

Lisa Milroy
Giraffe (1), 1997
Lithographic monoprint
101×54 cm (39½ × 21 in.)

conceptualist, showing reduced diagrams of simple objects on brightly coloured backgrounds. Like Warhol and Caulfield, he never gives more information than is strictly necessary. His art is cool and yet deceptively approachable. As Jeffrey says in the *Freeze* catalogue, "The '80s would as soon as give you the threshold, and rely on connotation to do the rest, as if its sign was *sotto voce* and irony its mode".[11]

The Goldsmiths' thinking sometimes led to Post-modernism being replaced by Pidgin-modernism. As Jeffrey says in *Freeze*, the young artists wanted to be seen "Only in terms of genius, originality, and the fresh start".[12] The serious endeavour to answer the criticisms of Post-modernism by refocusing Modernism on the shifting sands of Duchampian thought was not fully carried through by the Goldsmiths' students. Jeffrey admits this in his explanation of Hirst's work in *Freeze*: "But what framework does he use?" he asks, before answering,

"One which asserts control, one which acts as if dispassionately, from that Modernist discovery of a universal order".[13]

So what of the art? Hirst's main contribution to *Freeze* was not the finished article: consisting of a colony of coloured boxes on the wall, it could have been mistaken for work from the transitional period of Julian Opie in 1986, when he was in the process of retreating from Post-modernism to his own version of Minimalism. Opie, Lisa Milroy, Grenville Davey (born 1961) and Mark Wallinger (born 1959) had all recently left Goldsmiths' and their rapid success was admired. Milroy and Opie had, in surfing parlance, got too early on to the wave that was to form the YBAs. Both of them picked themselves up and reinvented themselves. In the late 1990s Milroy refound her sense of mischief by travelling and bringing back a safari load of animals and studies of human beings. In contrast, Wallinger is an absolute classic Pidgin-modernist, stealing wholesale from such artists as Duchamp. Is he trying to do a Duchamp on Duchamp with jockey jackets? If so, it is a pity that these works are little more than pale imitations of Duchamp's *Jacket* (1956).

Wallinger borrows like a Post-modernist. Hirst's relationship with Duchamp is more complicated; he has partly digested earlier

Damien Hirst
Biotin-Malemide, 1995
Gloss household paint
on canvas
432 × 317 cm (172 × 126 in.)

ideas before regurgitating them. His spin paintings may literally be spin-offs from Duchamp's *Optical Disks* (1923), the *Anaemic Cinema* (1925–26) and *Rotary Demispheres* (1925), but Hirst developed a clever democratic twist in inviting visitors to his spin drawings exhibitions, such as the one at Bruno Brunnet in Berlin in 1994, to make their own drawings. "We have to keep everything simple, anyone can do it, anyone can make beautiful drawings. It's as simple as that: making beautiful drawings",[14] he declared. This is a classic example of him repackaging the 1970s' conceptual ideas of, say, Sol LeWitt and Beuys, and putting them into practice.

Hirst's distinctive style did not take long to emerge. After all, he had made a spot painting for *Freeze*, but his spot paintings are really little more than decorative Sol LeWitts. True, Hirst does not entrust just anyone to make his

spots; he has his assistants to manufacture the bright patterns. However, in a warehouse show, *Gambler*, at Building One in 1990 (this time not curated by Hirst but by his friends Billee Sellman and Carl Freedman, with whom he had earlier curated *Modern Medicine*, also in 1990), Hirst's vitrine art appeared. The immediate impulse for showcase art like this was Jeff Koons, whose work Hirst would have seen in the Saatchi Gallery's *New York Art Now* in 1987–88. In this exhibition, not only did Koons present vacuum cleaners and other domestic appliances in showcases, but he also suspended balls in equilibrium tanks. Hovering ping-pong balls, indicating the fragility of life, and showcases, were to become two Hirst hallmarks. The theme of the vitrine in *Gambler*, *A Hundred Years* (1990), was life and death, showing flies living off a cow's head.

"We get put into boxes when we die because it's clean, and we get put into a box when we are born. We live in boxes",[15] says Hirst to explain his packaging. There is a neatness in his best concepts, which is very much in the spirit of Duchamp, Christo and Beuys. Gordon Burn describes how Hirst organized his most famous image:

"When he decided to make a sculpture whose title would be *The Physical*

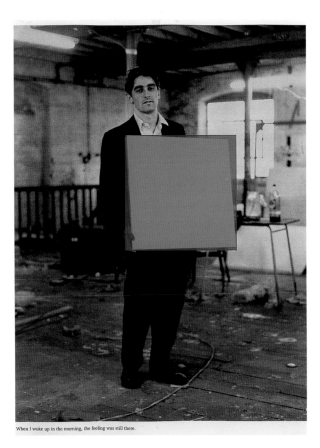

145

When I woke up in the morning, the feeling was still there.

Impossibility of Death in the Mind of Someone Living [1991], Damien Hirst lifted the phone and placed an order for an adult shark with a shark hunter who was unknown to him and who lived in a town he had never visited, ten thousand miles away in southern Australia. When the commission had been completed, cash in advance, the shark was crated and air-freighted, unpacked and filled full of formalin by masked and dry-suited assistants, then floated by a team of experienced art-transporters in a formalin solution in a tank that had been factored for it by specialist craftsmen in London … as dedicated an example of the Duchampian refusal to let the hand meddle in the mind's work as you were likely to encounter in the post-object, neo-Swinging, post-postmodern world."[16]

"I like ideas of trying to understand the world by taking things out of the world. You kill things to look at them",[17] says Hirst. Anthony Everitt in *The Guardian* added, "We take a holiday from our ethics into a world created from death and violence about which we are invited not to care – a world where bad taste is driven to the point of elegance, and disgust filtered into delight".[18]

In their profusion of ideas, either Angus Fairhurst or Mat Collishaw could have been the leader of the pack. Fairhurst's adaption of Magritte's businessmen provides one of the funniest YBA images. Men, naked except for bowler hats, are seen jumping like lemmings as if out of the window. He also confronted the predicament of his generation of artists in *When I Woke Up in the Morning the Feeling was Still There* (1996). In a series of four images one sees a square of colour slipping from the artist's hand.[19] The structure that artists have relied on for so long is escaping.

Mat Collishaw has made several photographic images of fairies, including *Catching Fairies* (1994). He admits that these fantasy pictures are "an attempt to make a play on what making pictures is about. A desire to believe in something other than the real world which we inhabit. What kind of extraordinary creature is man that he needs these

semi-translucent four inch high figures that fly around with little wings? Why do we need these ideas, where do they come from?"[20]

The title of the exhibition *Freeze* came from Mat Collishaw's light-boxes. He exhibited an image of a bullet wound, and the term "Freeze" refers to the moment of impact, a freeze-frame. Collishaw shares Hirst's interest in blood, flesh and decomposition. He has made a series on infectious diseases that, like Hirst's work, harks back to Francis Bacon's fascination with slaughterhouses and "a second-hand book which had beautiful hand-coloured plates of diseases of the mouth".[21] There are also strong echoes of Bacon in Collishaw's declaration: "I'm mourning the loss of humanism. There's nothing didactic about it. It's more a curiosity. I'm not taking a moral stance. I'm side stepping all that and saying look at the incredible richness, beauty and texture of this fucked up world we live in."[22]

Opinion is divided as to whether Hirst's position at the head of the YBAs originated from his generous nature in promoting his friends or a cynical understanding that to achieve fame one needs to be marketed as a gang leader. Whatever the reason, it was not Fairhurst or Collishaw that shot to superstardom. Hirst's apologist Gordon Burn is the first to acknowledge this:

"But top-drawer allusions, however intended or unintended, have never been the vehicle for crossover success. For that to happen – in order to become a celebrity artist, one of those remembered names – history has shown that you have to become known for being known, even among people who have no idea why what you are known for matters."[23]

Straight out of the Warhol manual!

Like Warhol, Hirst understands the world of advertising in which we all live. It is no coincidence that the shows and events that have portrayed the YBAs in the best light have invariably been organized and presented by Hirst or by the art and advertising mogul Charles Saatchi, who was buying all their work at a very early stage. When control went out of their hands things invariably went wrong, as in the production of the book *Technique Anglaise* (1991), which even Matthew Collings recognized as being "fatuous and empty".[24] This publication is worth looking at simply to underline the complete collapse of any critical framework. 'Edited' by Andrew Renton and the artist Liam Gillick, it consisted of little more than incestuous art-world chat. As the concluding remarks by Gillick demonstrate, it read just as if the art world sit around all day discussing the main chance:

Mat Collishaw
Catching Fairies, 1994
Colour photograph
41×51 cm (16×20 in.)

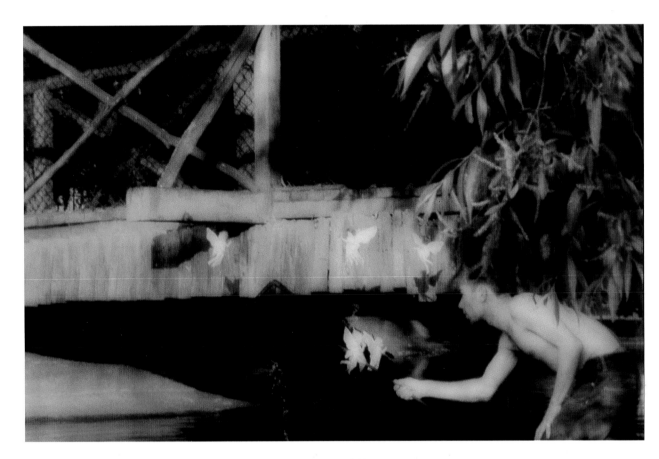

"Why be alternative when the alternative has already become the mainstream, and when everything's turned on its head, and it doesn't make any sense? There's no motivation to act in that way. It doesn't mean anything any more. None of those terms mean anything, so you might as well go ahead and just do it for real. It was just a group of people thinking Well, I'll make the art instead, seeing as nobody else seems to be doing it. Or not even thinking about doing it. So it's no good waking up in the morning and thinking, History will sort it out."[25]

By linking up with fellow Leeds-born celebrity chef Marco Pierre White for a joint venture in the London restaurant Quo Vadis, Hirst found another way of taking his curatorial skills out of the gallery. In naming his own controversial restaurant he was acknowledging his links to Duchamp. *Pharmacy* (1914) was a key work by Duchamp, in which he took an anonymous artist's mass-produced print and turned it into his own work of art. In describing this work, Arturo Schwarz, author of *The Complete Works of Marcel Duchamp*, underlines Hirst's blueprint for appropriation:

"*Pharmacy* was manufactured only to a certain degree. It was made by some unknown artist who did a series of landscapes as models for art schools. A winter landscape at night. It was a commercial print reproduced in thousands of copies, and thus it had the same character as a manufactured object …

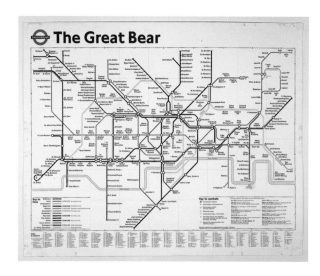

148

there were a great number of them, in
the same way that there are a great number
of snow shovels in the world."[26]

Hirst's involvement with restaurants and
his frequent visits to the Groucho Club,
literally a stone's throw from Bacon's Colony
Club in London's Soho, brings his lifestyle into
focus.[27] "Because his art is idea art", writes
Gordon Burn, "– art drawn on the back of
cigarette packets and beer mats, roughed out
in airport departure lounges and the backs of
taxis, usually delegated to and carried out by
others – this leaves Damien a lot of time for
what might loosely be called socialising.
Hanging around."[28] This is only part of the
story. It is quite possible to see the main
significance of the YBAs as a social
phenomenon. They have created a self-
perpetuating network of friends and fellow
celebrities.

The Great Bear (1992), Simon Patterson's
remake of the London Underground map, is
all about fame and connections. Patterson
(born 1967), who was one of the original team
– the Freeze XVI – has replaced the stations'
names on the map so that "the lines and their

stops are now memorials to comedians,
footballers, scientists and kings: names
familiar from television, newspapers and half-
remembered history lessons at school".[29] It is
the term "half-remembered" that is crucial.
Patterson was supplied with his ready-made
by Harry Beck's classic design of the Tube
map of 1931. As Marco Livingstone writes,
this is a "diagram still relied upon every day
by millions of Tube passengers because it
smoothed out and made such sense of the
capital's complex network of interpenetrating
rail lines. We all accept that it takes great
liberties with the truth – with the actual
distances between stations and their relative
geographical placement – but we are happy
to go along with the fiction because it makes
it so much easier for us to find our
bearings."[30] Patterson exploits our mind's
ability to accept this subversion by further
subverting it. "Retitling this map after a
constellation and redesignating the stations
with names of a motley crowd of
philosophers, saints, footballers, explorers,
politicians, journalists, Italian artists, film
actors and even planets, among others,
Patterson throws the whole system into
absurd disarray."[31] Again, it is the word
"motley" that provides the key.

By supplying a map to the way our minds
work, it might be assumed that Patterson is

showing us a carefully constructed critical structure. No, this diagram shows his mind hurtling down very bumpy and haphazard lines of history, only to branch off suddenly just because another line supplies the opportunity. Man's linear thinking is being subjected to Post-modernist questioning. There is no system, the map is telling us, just a pathetic attempt to impose order on the confusion of our brains. A Modernist or an Ultra-modernist would have to construct more intellectually consistent histories and systems, but Patterson's YBA training tells him to leave it as a one-line joke. Any attempt to build an intelligent system, even though it is going to be disrupted, might show too much of his brain. The idea is to show as little commitment as possible, as commitment is dangerous, exposing its author to criticism.

"Art allows you to go off on the wrong track",[32] says Damien Hirst, revealing an important ingredient in the YBA make-up – calculated incoherence. In an interview with Andrew Graham-Dixon, Hirst admits that he likes "long, clumsy titles, which try to explain something but make matters worse, leaving huge holes for interpretation".[33] Clarity of purpose was never a YBA trademark, yet the only serious challenge to Hirst's leadership has come from someone who expresses her incoherence rather more lucidly than Hirst.

"Assonance is getting the rhyme wrong",[34] declares Rita in *Educating Rita*. Tracey Emin emerged on the art scene with all the cutting edge of Rita.

Carl Freedman was in the best position to describe Emin's impact on the YBA scene in the mid-1990s. Freedman, who had curated many of the most talked-about shows, writes how, "in a way it was *The Shop* experience which inspired me to make this exhibition. I had lost a lot of interest in art since Building One and Tracey and Sarah brought me back to life."[35] Emin came into the public eye when, as well as having a very public affair with Sarah Lucas (born 1962), one of the *Freeze* frontrunners, she literally set up shop with her, selling multiples and her old knickers.

It was Emin's inclusion in *Minky Manky*, Carl Freedman's exhibition at the South London Gallery in 1995, that propelled her to international fame. Richard Gott in *The Guardian* recalls the event: "Carl had said 'If I'm going to put you in the show, and I'm having a relationship with you, you'd better make a good piece of work. You've got to make something totally outstanding to justify your situation in that show." She didn't disappoint him. She erected a tent in the exhibition, which was called *Everyone I've Ever Slept With 1963–1995* (1995). She transformed the space into a patchwork notice-board with her lovers'

Gary Hume
Francis Bacon, from the
portfolio *Portraits*, 1998
Screenprint
109×85 cm (42×23³/₄ in.)
Edition: 12/36

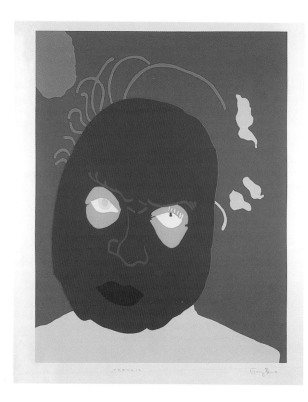

names writ large in coloured letters. As Gott continued, "In a way, it was quite cheeky. It was almost like saying to Carl, 'You asked for something big, well here you are – *Everyone I've Ever Slept With* – with the curator's name on the tent flap."[36]

Everyone I've Ever Slept With may have surpassed Patterson's *Great Bear* as the defining YBA connections piece, as it explains how the YBAs were linked, but it also announced the end of the repressed, give-nothing-away Goldsmiths' thinking. It was Emin's charismatic openness and her willingness to tell forbidden stories that had the art world gawping open-mouthed. The painter/critic Adrian Searle wrote that "her vulnerability and her self-confidence – bordering on monomania – are of a piece, and one can't have the one without the other ... The best thing about her work is the way she deals with what most of us would keep to ourselves."[37]

Among the touching things Tracey Emin broadcast to the world were her early failures as an artist. Gordon Burn has written of Hirst, "He isn't dismissive of solitary studio practice (he tried it himself, and failed)",[38] but Emin went far further, describing how she had given up art before she met Sarah Lucas. "I felt a complete failure – a failure as a painter, a failure as an artist, and a failure as a human being. So I stopped making art."[39] In the *Minky Manky* catalogue she continues on the same theme: "I had the idea to make something beautiful. And I'd go to the studio everyday with that ambition and I'd leave every day feeling depressed and feeling a failure. I couldn't live up to my ideas of what I truly believed art to be. I was just a loser, full stop. I had this regressive attitude towards art. I thought it was more important the way things looked."[40]

Emin's art relies heavily on her own strong presence. She declares that "artists are too content with making things which look nice. There should be something revelationary about it. It should be totally new and creative, and it should open doors for new thoughts and new experiences." The novelist Will Self sees a touch of the Beuys flame but qualifies this by adding, "Where Beuys used dialectics, Emin employs her sexuality".[41] She opens doors with the sheer force of personality. She

Gavin Turk
*Study for Unoriginal
Sculpture*, 1996
Photocopy and pen
on paper
19.5×73 cm
(7³/₄×28¹/₂ in.)

touches a nerve with most of us who fear failure and are frustrated with life.

The Doors by Gary Hume (born 1962) will never open; they are well and truly stuck up with enamel and other factory paints. Hirst may have realized that he was only ever going to be able to re-present conceptual art in an appealing way through the anti-painting style of the *Spins* and *Spots*, but Hume definitely feels that with slick materials he has found the ultimate dumb surface. The content is equally dumb. There may be references in his Door paintings to Duchamp's doors and blocked-up windows, for example *Fresh Widow* (1920) and *Brawl at Austerlitz* (1921), but it is doing nothing more than reaffirming a full stop made three generations earlier. In his portrait of Bacon he reduces the life in the painter's face, so magically displayed by Freud and others, to dead paint.

The exhibition *Sensation: Young British Artists from the Saatchi Collection* opened at the Royal Academy of Arts, London, in September 1997, some nine years after *Freeze*. While building on the mythology of the original Brit Pack, Charles Saatchi and Norman Rosenthal not only ensured that the network of stars had the new blood it needed to support it, but also inserted some serious ballast. Emin was well and truly assimilated into the YBAs in this show. Gavin Turk (born 1967) had been running with the pack for some time, too, though he had gone to the wrong art school. He had mastered one-liner art at an early age, and was thrown out of the Royal College of Art for submitting an imitation blue heritage plaque for his degree show. It read simply, "Gavin Turk Sculptor Worked Here 1989–1991". He developed into a brilliant one liner neo-Pop, neo-Dada artist. He painted his own signature, he made a waxwork of himself as a Sex Pistol (sub Elvis through Warhol). He parodied and glorified the position of the artist as a star.

Works by two sculptors stood out in *Sensation* like beached whales – those of Rachel Whiteread and Mona Hatoum (born 1952). It is possible to describe them both as neo-conceptualists but it is misleading. True, they both come out of conceptual art. Whiteread's use of neglected space is a development of the conceptual ideas of Christo, Beuys and Bruce Nauman (born 1941) – particularly Nauman's *A Cast of the Space under my Chair* (1965).

Hatoum started her career as a performance and video artist. Yet any attempt to

overemphasize the conceptual side of her own and Whiteread's work diminishes it. They are not just conceptually based – their art has its roots in many other areas of Modernism, and indeed, in Hatoum's case, in other cultures. Hatoum acknowledges her departure-point in talking about a specific work, *Light at the End* (1989): "I adopt a 'minimal' aesthetic, but unlike minimal sculpture, the piece is referential and reverberates with meaning and associations".[42]

While Whiteread is interested in the formal qualities of Minimalist sculpture, she is not interested in formalist sculpture without meaning. To find her meaning she has literally turned art inside out. Fellow British sculptor Edward Allington introduced her to casting. Her most famous cast was that of *House* (1993), for which she used a condemned Victorian terraced corner house (at the junction of Grove Road and Roman Road, London E3) as a mould. The inside of the house sat in a cleared field as a memorial to the life that the house had contained. When her sculpture was pulled down in 1994 – at almost exactly the same time that she was being awarded the Turner Prize – it high-lighted the problems of housing and waste.

"I am a socialist – it's very much part of my life", declares Whiteread in her 1992 Eindhoven exhibition catalogue. "You can't help it, living somewhere like London where you're seeing things crumble around you and you're seemingly helpless to do anything … But I am a sculptor not a politician. I am involved in the making of sculpture, of explor-ing formal questions about how a work sits on the floor, or about the space surrounding it."[43] She has built up a coherent, consistent critique of the way we live. Her art is broad-based. She attracts comparisons with older contemporaries – Boltanski's missing house or Beuys's *Plight*, for instance – but she has also looked at Renaissance artist Piero della Francesca and Etruscan sarcophagi. Her work evokes the same still aura, underpinned by mathematical precision, created by Piero. Her interest in funerary sculpture was fanned by her time working at Highgate Cemetery in north London. Of the crypts and coffins she recalls, "I had a sense of something being inside. Although I didn't want to look, I was curious. Peering through the cracks was, and remains, so compelling."[44] Aware of the weight of history, one has to look through every crack and crevice to find the empty spaces in which to make new art.

Whiteread's thorough approach is closer to that of many artists working on the Continent than it is to that of most of the other artists included in *Sensation*, so it was not surprising that she was included in a *Documenta* early

on in her career. For *Documenta IX* in 1992 she cast mortuary slabs and the exhibition hall's floorboards. However, perhaps because they were about to be 'tainted' by their association with the overlapping *Sensation*, neither Whiteread nor Hatoum were included in *Documenta X*, which can be seen as the complete antidote to the Saatchi exhibition at the Royal Academy.

Hatoum was included in *Global Art*, held in Cologne in 1999–2000, and the very title of her subsequent exhibition at Tate Britain, *The Entire World as a Foreign Land*, indicates her concerns as an exile in London. Included in it was *Continental Drift* (2000), which consisted of a map etched on a glass table. The continents are made of metal filings, and under the table a magnetic arm swings backwards and forwards. The volatile nature of the world's surface is illustrated by the jumping filings. It is as though the various political and artistic movements are in deadly opposition beneath the surface like the tectonic plates that grind against one another beneath the earth's surface. Hatoum can see that collision is not only inevitable but also necessary. A great deal of her work has revolved around her own body. Though she was born a British citizen, she has long internalized the exile of the Palestinian people, and this has led her to tackle the problems of the world in a similar fashion. She is looking for a universal language.

"In private you feel as if you are the subject of everything", says Olafur Eliasson, who was born in 1967 in Copenhagen but now lives in Berlin. "That's why isolation and segregation (why not call it apartheid) is very bad for most artists. Among others you realise your objectivity. You realise your interrelatedness and/or dependence, whether you like it or not. You realise that culture is not just this sweet, warm, noble thing but a constant ongoing struggle between people."[45] Eliasson uses light and modern techniques to explore the relationship between man and man-made, and man and nature. He creates rain in galleries and controls rooms with light. He was included in the exhibition *Greenhouse Effect* at the Serpentine Gallery, London, in

153

Olafur Eliasson
Untitled, from the series
Iceland, 1997
Cibachrome print
61.5×91.5 cm
(24×35¾ in.)

154

2000, which, following on from the *Global Art* at the Ludwig Museum, Cologne, showed a new willingness by young artists to incorporate nature into their art – with living animals, plants and other natural phenomena.

When *Sensation* went to Berlin it did not take the city by storm. It was less shockable than New York later proved to be. Germany was divided in its opinion of the YBAs, as revealed clearly by the organizers of the 1999–2000 *German Open* at Wolfsburg:

"Since the mid-Nineties, two types of contemporary art have been shown at exhibitions: British art and international art. For over five years – 'The Saatchi Decade' – the art scene was dominated by young British artists who monopolised the trademarks fresh, bold and shocking, and

provoked the so-called crossover debate, making London the place to be …The conventional practice of perceiving and naming artistic attitudes above all as trends reached its extreme form with the young British artists. Critical discussion had given way to the catchy label, marketing was guaranteed, and not only did it result in lively sales, but publicity throughout the various life-style media."[46]

Some German artists competed in the "fresh, bold and shocking" stakes and appeared in many of the shows around Europe alongside the YBAs, such as the sculptors Andreas Slominski (born 1959) and Stefan Kern (born 1966), and the painters Michel Majerus (born 1967) and Daniel Richter (born 1962). Slominski, who describes himself

155

as "more of a trapper than an enlightener",[47] sometimes makes constructions reminiscent of those by Rebecca Horn, but there is quite often a savage side to them. He tries literally to trap his audience, once leaving harmless-looking bananas injected with urine on the windowsill. Although Daniel Richter is almost two generations removed, in that he was Albert Oehlen's assistant, Polke's presence can be felt in both his and Majerus's work. In Richter's dense, highly packed pictures, "the fight against confusion attains exemplary status", writes Rudolf Schmitz. "Daniel Richter has decided to look up the skirts of Lady Painting from under a sheet of glass, simultaneously reacting with many hands to what he sees."[48]

Polke set the mood of the 1990s. As Wieland Schmied wryly observes, "He is interested in everything. But he believes in nothing", before continuing to say that "Sigmar Polke is an astute diagnostician of the times, but one who has no therapy to suggest, because he knows that there is no help for us, after all. His cause is not social criticism, but comprehensive criticism of life. As he may not hope to make any effect, he presents it light-footedly, playfully, makes it seem like a joke that we needn't take seriously."[49]

In the late 1990s, however, one of Germany's main contributions was that it supplied a forum for a serious questioning of the direction art, and indeed the world, was taking. Catherine David's *Documenta X* highlighted two main areas of concern, which she linked because one of her priorities is to repoliticize art. The political agenda of *Documenta* was to focus attention on the dangers of globalization, and in the process try to break up the control of the art world by so few Western countries. Hand-in-hand with this went an anxiety over the sheer irresponsibility of the art being produced. Sadly, the selected art did not always fulfil her arguments.

One of the high points of *Documenta X* was a long argument that ran intermittently through the largely impenetrable text of the main catalogue. It was between Catherine David, Jean-François Chevrier and the old defender of Marxist Modernism, Benjamin H.D. Buchloh. Since his stalwart defence of

Katharina Fritsch
The Bremen Town Band,
1996
Linocut on paper
100×52 cm (39½×20½ in.)
Edition: 4/30

Modernism against the savagery of the *Zeitgeist* painters, Buchloh's position had evolved in its attempt to maintain an intellectual framework for art at all costs. He has become a great questioner. The year before *Documenta X*, in 1996, in his introduction to *The Duchamp Effect*, Buchloh wrote, "First there is the question of whether we have finally reached that stage where all attempts at writing art history as a history of authors (and anti-authors, of whom Duchamp is, of course, the exemplar and model) appear utterly futile and methodologically unacceptable from the outset".[50] This does not stop him from rapidly getting into full stride in seeing Duchamp's great unseen masterpiece as the key to the future. *Etants donnés*

"could also point the way out of the *cul de sac* of contemporary artistic production sustained in a false opposition between a return to traditional humanist models and a gradual disappearance in the shallow derivations of obsolete or misunderstood Duchampian paradigms, just as it could also point a way out of the stale opposition between a poststructuralist orthodoxy and an increasingly instrumentalized rationality of social art history, more evidently incapable of recognizing the complex circumscriptions of aesthetic objects".

In the catalogue to *Documenta X*, Buchloh refers to Duchamp, but not as the sole saviour. He is now at his best in his dire warnings of the alternative to the maintenance of a universal critical structure:

"When people in New York can propose a collaboration with David Bowie for the upcoming Damien Hirst exhibition – and it's serious, nobody laughs – then you know it's over. You've lost your territory! … There's nothing left to protect. There's not a single voice of resistance. At least not in America. So you see that the first part of my argument, which says that the museum still functions as a locus of self-reference and self-criticism for the formation of

bourgeois consciousness, is already a dream, the nostalgia of an intellectual on the left! But fortunately the situation is still different in Europe."[51]

Katharina Fritsch (born 1956) is one German artist who has a clear agenda, and it follows a very different route from that of the YBAs. "I find precision to be the best possible contribution one can make to art",[52] she declares. She makes objects and repeats them in a pattern. Her most famous work is *Company at Table* (1988), which is in fact owned by another bank.[53] Thirty-two identical polyester men are sitting in two rows either side of a table on which there is a patterned tablecloth. There is a frightening sense of *déjà vu*. We are on the treadmill of history, which is in the process of repeating itself, again and again. Is it our fate to sit and stare at our clone?

One result of the collapse of critical structure was a crisis in confidence. Curators such as Serota, Fuchs and Rosenthal may have detonated a necessary bomb twenty years ago, but not many of their successors have been capable of picking up the pieces. Writing in the catalogue to the exhibition *NowHere*, held at the Louisiana Museum of Modern Art, Denmark, and considered a key European group show, Lars Nittve admits that "I was frightened, but also tempted" at the curatorial prospect. "How to organise an exhibition that would acknowledge the changes of the last few decades, that would recognise an absence of structure, and that would work with small stories, with local language games and contexts?"[54]

Despite its negative title, one of the bravest attempts to make sense of recent developments was the exhibition *Distemper: Dissonant Themes in the Art of the 1990s*, held at the Hirschhorn Museum in Washington, D.C. It was a show of ten artists, including Whiteread, Hatoum, the German sculptor Thomas Schütte (born 1954) and the powerful South African/Dutch painter Marlene Dumas (born 1953).[55] Neal Benezra and Olga Viso developed the exhibition around three themes, all of which are typical Ultra-modernist concerns. First, they noted that their selected artists had a shared interest in time and memory: "Registering moments of rupture between the past and the present, time is often rendered by the artists as if in a state of collision or suspension".[56] Secondly, they actually dared to use the near-taboo term "beauty" in discussing artists' willingness to bring in more content to balance form. Thirdly, they perceive a new, more open relationship between public debate and private lives.

158

Cornelia Parker (born 1956) would have made an interesting addition to the British contingent in this Washington exhibition, but then she has been left out of many mixed shows in which Whiteread and Hatoum have been included. Her art is certainly more fragile, her ideas more awkward. At first sight she takes Post-modernism to its logical conclusion. She blows up history. In placing a bomb inside a garden shed, exploding it and suspending the reassembled pieces it is almost as if she is showing us the end of history. As we walk around *Cold Dark Matter: An Exploded View* (1991), the original light-bulb casts shadows around the room. One is tempted to see this as the Big Bang of the art world. It is all over, the male preserve has been reduced to distorted fragments. She shows her scorn for linear history by referring to Edward de Bono's lateral thinking: "You're less likely to dig an original hole if you're an expert who is already at the bottom of a very deep hole",[57] she says. For a free thinker she makes a great deal of use of institutions and the structures for which they stand. The British

Army helped her explode the bomb inside the garden shed. In other projects she has collaborated with British Customs, the Royal Mint, NASA and the Daughters of the Republic of Texas. Our mental structures are a vital part of her work as she wants to mend them from the inside. Her approach is in fact very down-to-earth. She does not want her work to be seen in relation to other art; her ideas come off the street. "I get my inspiration from reading about science in the newspaper, or perusing objects in a street market. I've learned more about sculptural space or technique in the real world than in sculpture class."[58]

One can quite understand why Parker was not included in *Sensation*, as her work reveals too much about the nature of fame. When in *The Maybe* she put that institution of avant-garde cinema, Tilda Swinton, inside a showcase in the Serpentine Gallery, London, she was showing how fame kills. The other exhibits in the show were all relics from famous dead people. The strain for Swinton of staying for eight consecutive hours in a showcase, sleeping or pretending to sleep, was numbing, cramping, deadening.

Parker's work is bound up with our way of thinking – our faulty, dysfunctional brains and the channels down which they veer. We want to celebrate people's success by putting them in our cabinet of curiosities. Parker is not far

Thomas Schütte
Preparatory drawing,
1995
Watercolour, ink and
pencil on paper
28 × 19.8 cm (11 × 7 ¾ in.)

29.1.95

removed from the seventeenth-century connoisseur. She admits that "very often the sculpture is just a flimsy excuse for me to get my hands on these things that change the face of history".[59] History! Structure! She makes work out of history, our memories, particularly the forbidden ones. In *Avoided Object* (1999) she shows us a photograph of the sky, much like those we have by Gerhard Richter. The caption reads *Photograph of the sky above the Imperial War Museum taken with the camera that belonged to Hoess, commandant of Auschwitz.*

American curator Neal Benezra brings to our attention the difficulty German artists had in emerging from Beuys's shadow: "Younger artists, Schütte among them, were struggling to establish an idealistic position, one that might be distinct from the cult of personality

that still surrounded Beuys".[60] The spirit of Beuys was in Schütte's earlier work, such as his contribution in 1987 to *Documenta VIII*, where he created *Ice-cream*, a brick ice-cream kiosk modelled on an upturned ice-bucket from which ice-cream was served throughout the exhibition. His point of departure was with the American Minimalists. He admits that "It was this generation that established the grammar, the training and the language. They address the fundamental problems of lighting, material, meaning, and space."[61] Since 1988 Schütte has worked with the figure, often as part of monuments. The public monuments are hardly heroic, as their human inhabitants are often contorted until they are grotesque. Several of his figures, as with the central three in *Larger Respect* (1993–94), are bound. There is an obvious reference to Prometheus, the idea that the artist has been tied down by the 'gods' of theory, but there is more than a hint of scepticism. If we really are as ugly and twisted as Schütte portrays us, perhaps Zeus was right to wish to destroy us and start again.

Larger Respect combined Schütte's interest in the figure with an even older theme of his: architecture. "For me [architecture] simply crops up as one motif among others, as a nature substitute so to speak, because I find it difficult to work with nature",[62] Schütte confesses.

159

Günther Förg
Untitled, 1990
Gold leaf, pigment and
acrylic on wood
200×315 cm
(78 3/4 × 126 in.)

Thérèse Oulton
Untitled, 1994
Monoprint
77×111 cm (30×42 3/4 in.)

It was not fear of nature that made Günther Förg (born 1952) take the theme of Modernist architecture (and our relationship to it) as his subject. Indeed, he mockingly shows us the siren coast outside the window in his interior photographs of Villa Malaparte. "The whole of Förg's project [*i.e.* his œuvre] uses an evaluating and appropriating strategy, seeking out, reproducing, taking in and reflecting upon the works of modernism. In other words, he is very aware of his own historical position in relationship to the early modernists, and unlike the modernists, there is no optimism or Utopian thinking in Förg, no hymn to technology here."[63] Unlike Schütte, who seems to be attempting to reclaim a sense of commitment from irony, Förg considers ridicule an essential tool. He is a transitional artist. His art is not coming out of a thorough analysis of the history of art; rather, "the great narrative of history is filtered through a personal life-story".[64] He makes photographs of the women in his life as though they were great Modernist monuments. He shows the forbidden life through the windows at the Villa Malaparte, but in paintings such as *Untitled* (1990; see illustration), he is taking heed of Greenberg's dictum that a painting should not be a window (in this case he does everything to exaggerate

its flatness), while at the same time teasing the viewer with the idea that art might be nothing more than part of a decorative scheme. Förg is a "stroller through Modernism".[65]

Förg used painting in the same manner as, say, Damien Hirst – as just part of the armoury of the artist. There was a feeling at the beginning of the 1990s that artists should not be too tied to one medium; they should flit from one to another. Painting was not an integral part of the YBA movement. Gary Hume, Ian Davenport (born 1966) and Fiona Rae (born 1963) just happened to run with the pack. When it came to *Sensation*, the painting element was bolstered, just as the sculpture had been by Whiteread, Hatoum and the extraordinarily life-like models of Ron Mueck (born 1958). Works by the main painters recruited into the Saatchi show were the giant figure paintings of Jenny Saville (born 1970), the combed surfaces of Jason Martin (born 1970) and the large abstracted 'sperm' paintings of Mark Francis (born 1962).

As Förg and Hirst had demonstrated by their frequent jokes at its expense, abstract painting had become almost forbidden territory for serious artists. For too long it had been the preserve of the Modernist theoret-

Gerhard Richter
Abstract 26.5.92, 1992
Oil on photograph
mounted on board
12.8×17.6 cm (5×7 in.)

Mark Francis
Untitled, 1999
Oil on paper
86×65 cm
(33¾×25¾ in.)

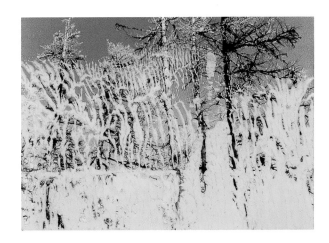

icians. The difficulty of making meaningful abstract paintings was demonstrated by the early career of Thérèse Oulton. In fleeing the connotations of landscape art she was happy to acknowledge the influence of Gerhard Richter's pure abstract paintings, which he had been developing since the mid-1970s alongside other work. Built up in three layers, Richter's paintings are seductive. "Art is the highest form of hope",[66] he declared back in 1982. Coming out of the artist's highly charged lifelong work, these canvases can balance on the knife-edge between painting and anti-painting. They are very painterly, but without knowledge of the artist's work they would appear to be form without content.

Shortly after coming out of Chelsea School of Art in 1986, Mark Francis started to distance himself from the art that had first interested him – that exploring landscape by Ian McKeever, Michael Porter and Christopher Le Brun. He saw a crisis in painting and looked back to the high renaissance of abstraction – to Mark Rothko and Brice Marden (born 1938) as his restarting-point. He was not interested in painting empty landscapes, but in questioning himself – under a microscope, as it were – he found possibilities for painting inside himself. Sperms, the seeds of life,

became his subject-matter. These 'sperm' paintings appear to comment on the world's population problem. In his Growth series there are so many black dots that they begin to merge. He called one orange painting like this *Partition*. One half of the canvas is an almost solid block of sperms smothering each other, and as he comes from Ulster it seems to be a direct reference to his home country divided by religion and ideas on birth control. Questioned about it, though, he claims *Partition* was a reference to Rothko, not Ireland.[67] Pushed further on the subject of one half of the picture being orange and the other overcrowded with uncontrolled sperm, he replied with a story about the mobile telephone company Orange. Apparently it was only at the last minute that they pulled their normal advertising campaign in Eire. "The future is Orange" might have been a counterproductive slogan.

As Francis's painting grew in confidence through the 1990s, his own interior landscape began to overlap with his interest in mushrooms and other small organic life forms. He has studied mushrooms and scientific

Sean Scully
Shoji, 1992
Woodblock
55.8×56.5 cm
(21³/₄×22¹/₄ in.)
Edition: 3/30

Felim Egan
Untitled (Blue), 1998
Watercolour on paper
79×66 cm (31×26 in.)

books, and this has led to ideas about "mapping, communication systems and networks within nature".[68]

Part of Francis's desire to make meaningful abstract paintings probably came from his Irish heritage. Until recently, Irish artists had to go abroad if they were ambitious, but the Irish boom of the 1990s, both financial and cultural, has meant that young artists are able to make their name in Dublin. Indeed, although he trained in London, Mark Francis has had a Dublin dealer from an early stage in his career. Perhaps more importantly, however, there is an Irish tradition of highly human abstract art.

In her book *Modern Art in Ireland*, Dorothy Walker maintains that Sean Scully's Celtic roots show in his early art. Born in 1945 in Dublin but now living in New York and London, "his early 'grid' paintings of the seventies seem to me to be direct descendants of Celtic interlacing, layered linearity in a dynamic large-scale version of Early Christian Irish graphic art".[69] Scully has a direct approach to art; his importance lies in his attempt to "subvert the art-for-art's sake syndrome and endow geometry with a human aspect", as Armin Zweite observes. He continues: "… the artist has repeatedly emphasised his wish to liberate abstract painting from the

ghetto of noncommittalism and hermetic isolation, and to incorporate in his pictures a reaction, albeit of a highly indirect kind, to the realities of the city of nature, of the individual and society".[70]

Scully's internationalism proved vital to his success. His commitment to abstract art at one of its darkest hours found support in both Germany and his adopted country, America. Scully was not the only abstract Irish artist looking to "humanise abstract painting".[71] In writing about Felim Egan (born 1952), Rudi Fuchs elaborates on a new practicality being discovered in art:

"Abstract art is not just an alternative to figurative painting. Sometimes the supposed antithesis is thus described in ideologically motivated theory, in that absurd debate on the 'right' and 'wrong' work of art. Happily, artists are of a more practical nature: they hang on to what they've got. Of course there was something extraordinarily determined in the way abstract painting was first formulated –

Fionnuala Ní Chiosáin
Untitled, 1999
Watercolour and sumi ink
on paper on wood
107×137 cm (41 1/4 × 54 in.)

Estelle Thompson
Untitled, 1999
Monoprint
45×60 cm (17 3/4 × 23 3/4 in.)

by Mondrian for example. In order to take that step, he must have briefly thought that it was the only possible one. Later, abstract art went its own way. It developed a repertory of its own to which all the old beauty could return: all the lovely colours, all the decorative nuances of light. That's what I meant when I said that artists hang on to what they've got."[72]

The scale in Egan's work evokes man's relationship to nature. There are invariably small squares, triangles or associated geometric shapes set in a wider space. Viewers can identify with his pictures in that the balance between forms and background is similar to that of a man in the country, such as the artist himself on the beach outside his house – on Sandymount Strand in Dublin. Egan, too, has undoubtedly found sources in Celtic art, but, as Alistair Smith asserts, "While investigating the primitive, Egan has not turned his back on the contemporary. Rather, the mark-making of primitive man is seen to be one and the same as that of the contemporary artist. Egan's primitive ancestor cast spells with marks; Egan casts emotions."[73]

In true Modernist fashion, Egan and Scully may have found ways of reviving abstraction by looking and listening to 'primitive sources'; among many others, Fionnuala Ní Chiosáin (born 1966) has taken a route closer to Mark Francis. She signed on at the Botany Department at University College Dublin to study plants under a microscope. She had found that her drawings had a tendency to look like magnified plant structures. She was not looking to copy the plants, but to capture the excitement of discovering another world. "There is this basic thing of human perception", she says, "that when your brain, aided by the eye, goes into a new environment, it scans it. It tries to make some context of the new environment it walks into, and looks immediately for particular patterns. Your brain is predisposed to looking for patterns."[74] Now there's a warning to Post-modernist historians!

Irish artists have not monopolized the efforts to humanize abstraction. When Gillian Ayres said she wanted her "paintings to have the same effect as Chartres",[75] she was referring, in part, to her admiration of all the countless craftsmen that worked in the creation of a cathedral. One can experience this accumulation of human endeavour when one sees the west façade of Wells Cathedral with the sun shining on it: no individual figures

or sculptures can be seen but the onlooker knows they are there.

While at art school in Newcastle, Scully came under the influence of Bridget Riley, who, using optical illusions, was able to break through the formalism of abstract painting of the time. Estelle Thompson (born 1960) has systematically looked for ways to break the formal, flat surface of abstract painting, so key to Greenberg's understanding of art. Thompson may present a well-ordered vision, but there is always a way through it. This led her to stripes, which she sees as the logical answer for those wishing to lay down colour. In her large paintings she makes optics work for her so that the stripes hover dizzily in front, pushing us away, whereas in her smaller pieces she entices us to peer into the picture as if we can see the picture the other side. There is no longer any hard edge; colours fuse into each other, encouraging the viewer to fuse with the painting.

In 1960 abstract painting was almost an artist's easy option. Today, artists such as David Austen (born 1960), Libby Raynham (born 1952) and Melanie Comber (born 1970) are exploring new forms of abstraction, but the innovative abstract painter is almost as isolated as the lonely figures made by the German sculptors Stephan Balkenol (born 1957) and Thomas Schütte, and by Ana Maria Pacheco (born 1943) and John Davies (born 1946) in Britain. Schütte's subject-matter strangely coincides with that of a small group of painters on both sides of the North Sea producing startling figures and Schütte's "nature substitute" – our city environment. This group is so loose that it makes Kitaj's "herd of loners" look positively sociable. It is the antithesis of Damien Hirst's YBAs, yet virtually every member has one influence in common with Hirst – the powerful memory of Francis Bacon's paintings. This is not surprising to Marlene Dumas, who was born in 1953 in South Africa but now lives in Holland. She divulges, "I don't know of anyone of the generation after the Second World War, who ever wanted to paint a portrait or a human figure (whatever their intentions) who could escape Francis Bacon".[76]

Drawings and paintings of the female body, often ripe with racial and sexual overtones, have been interpreted as an attempt to reclaim the image of the body for feminism. There is no question that Dumas has strong feminist (and anti-colonial) feelings, but ultimately she has decided to stand her ground and compete on the same aesthetic footing as male painters. She is making art within a critical structure. She may complain at the use and abuse the structure has had at the hands of both sexes, but, like Bacon, she wants to appeal directly to our nervous system, and she knows she

Tony Bevan
*Self-Portrait: Back
with Doors*, 1990
Acrylic on paper
105 × 102 cm
(40½ × 39¼ in.)

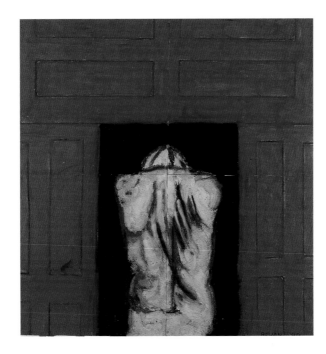

has to use the quickest and most direct route to it. She is prepared to talk about 'beauty' because it is only by redressing this concept that she can make us truly look afresh at ourselves. Neal Benezra writes of her Magdalena series of 1995: "With each painting devoted to a tall, slender, and quite aggressive woman, the series conflates the idealised, media-derived 'beauty' of the fashion model with the confrontational, socially unacceptable 'beauty' of prostitutes, all the while referring to the role of women in Western tradition".[77]

In Britain, the Ultra-modernist resistance in painting germinated in the studios of three artists, whose alternative visions had been hardened by studying at the seat of YBA learning – Goldsmiths' College, London. Tony Bevan (born 1951), Hughie O'Donoghue and Arturo Di Stefano (born 1955) all spent time at Goldsmiths' in the early to mid-1970s, though Di Stefano went on to the Royal College of Art and Bevan to the Slade. An important part of their work has been a confrontation with the human body and memory.

"As an artist you have to be aware that you are part of a history", says Bevan. "You can deny it all you like, but there is a whole sophisticated language behind you."[78] His art has concentrated on the head, the container of this information, and he has shown it from a succession of awkward, obtuse angles, almost as if our ability to depict ourselves was slipping away like our memories. The artist, who usually uses himself as a model, is determined to pin down both body and mind with a web of big bold strokes. In his paintings and drawings he leaves the traces of the explosive art of creation. His paintings of corridors, which he began in 1987, let us see inside his mind. According to Marco Livingstone, the artist "reflects that he was probably attracted to the motif of the corridor as a physical entry into the space of the imagination".[79] It is a vision of a dead end, a space remarkably similarly to Mona Hatoum's *The Light at the End* (1989), but whereas Hatoum installs a grid of lights, Bevan paints feverishly out of this cul-de-sac.

Like Katharina Fritsch, Arturo Di Stefano sees the need for precision in art. After a fire destroyed his studio in 1987, he set about re-creating his world. In embarking on a series of portraits of writers, artists and places, he painted the framework of his existence. His style and technique were determined by his

**Alice Stepanek and
Steven Maslin**
P.7., 1996
Oil on paper
41.5×42.5 cm
(16×16 1/2 in.)

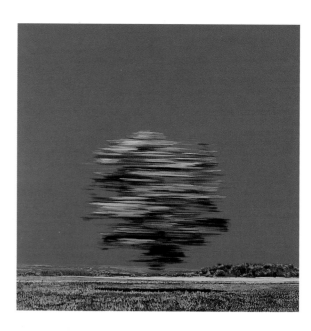

belief that there was no longer any point in realism. He devised a method of making paintings that act like our memories. Memory is a filter of the past, so it needs holes to function. It is these gaps in our memory on which Di Stefano plays with his counterproof technique.[80] He forces the viewer to complete the picture in a form of mental Impressionism.

"Paintings just stop time", claims Katrin Zschirnt, writing about Ralph Fleck (born 1951). She continues by maintaining that paintings are timeless, "not a document in the traditional sense, such as a photograph, but an indication to something absent".[81] Another German painter, Michael Bach (born 1953), elaborates on this sense of time within paintings. He sees the length of time taken to make a painting as an advantage over more instantaneous media in "that one doesn't have to react to every single flash. The television screen is always flickering but there is nothing to look at. I want to be independent."[82] There is also a stubborn sense of resistance to the accepted way of perceiving nature in the work of Alice Stepanek and Steven Maslin (born 1954 and 1959). They are a German-British couple who have worked exclusively together since the mid-1980s, and they benefit from the impartiality of their combined work. Beyond this, Hans Irrek believes their steady gaze on nature "gains from the recent boom in the appli-

cation of artificial reality which strays between the poles of the genuine and the fictitious".[83]

At first it seems surprising to learn that Bach was one of Richter's pupils, but then his relationship to realism is not far removed from his teacher's apparent adoption of abstraction. Just as we know that Richter is more than an abstract painter, so we doubt Bach's attachment to realism. He uses buildings and cityscapes merely as accessible components of his paintings.

While it can be argued that Bach shares Schütte's preference for the city over the country, the same cannot be said of Fleck, who applies his roving eye to cities, fields, mountains and the sea with equal vigour. Ralph Fleck's paintings reflect that the "claimed order of things has become obsolete", writes Hans-Joachim Müller. "The painter in the post-idealistic epoch is discovered to be homeless and uprooted in a world of things and experiences without hierarchical order, quality or priority."[84] Perhaps, but this prompts in Fleck the most positive of responses. He paints whole series of pictures in quick

Hannah Collins
True Stories 8, 2000
Cibachrome print
50.8 × 65.3 cm
(20 × 25 ³/₄ in.)
Edition: 3/50

succession. He reproduces his vision of the world time and again.

Stepanek and Maslin's entire work could almost be seen as a reaction to Schütte's fear of nature. "In the early eighties one had the feeling that no one was looking at nature in an engaged or, dare one say, emotional way",[85] they say in their statement for this book. They live in Cologne, at the heart of industrial Germany, and yet the tree has supplied their main subject-matter. Though they have studied the Romantic and idealistic landscape artists of the past, their interest in nature is more straightforward. They paint it like scientists. They are much closer to Tony Cragg than to Poussin. There is, however, some of the joy of those seventeenth- and eighteenth-century part-time Dutch painters, who often went out into the country but painted a landscape with the spires of their urban existence in the distance. In some pictures they twist perspective to make the viewer look afresh; in others there is an element of implied motion. They paint just as trees grow in a hostile environment – naturally and persistently, with their roots twisting and turning to find the necessary support.

Stepanek and Maslin's mastery of small brushes has meant that their paintings are sometimes mistaken for photographs. Fleck claims that his pictures' verisimilitude even fooled a dog; it cocked its leg on a painting of a tree! Certainly the borders between photography and other media are becoming increasingly blurred.

The aims of the Deutsche Bank concept, allied with practical considerations, have meant that the collection has bypassed video, which is a shame for the story of the emergence of Ultra-modernism. There was a time when it was thought that all other art forms were going to be swept aside by video and other installation art, yet it has proved just as difficult a medium to work in as all the others. The screen is noted for its delivery of quick messages, so it was assumed that the medium would appeal to a gallery-going public who, in their working day, want information as fast as possible. The irony is that video art needs an incredibly strong structure to find the balance between catching and keeping the viewer's attention. It is not a medium for one-liner art, but it has yielded great rewards to such American artists as Bill Viola, Tony Oursler (born 1957), Shirin Neshat and Diana Thater (born 1962), who have been prepared to work to its strengths. Viola particularly has capitalized on revitalizing ideas used throughout the history of art and adapting them to the

Katharina Sieverding
Viewing the Sun at Midnight, 1988
Colour photograph
187 × 71.5 cm
(72¹/₄ × 27³/₄ in.)
Edition: 12/15

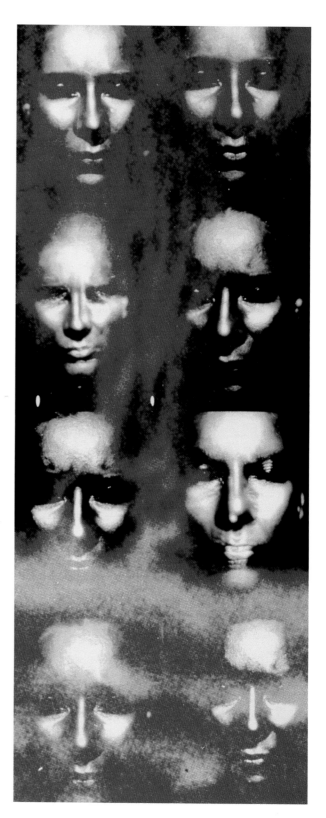

new medium. The triptych has new life in his hands, as have had the compositional skills of Goya, Velázquez, Pontormo, Vermeer and many others. Viola states:

"I consider myself to be part of a long tradition of art-making, a tradition that includes my own cultural background of Europe, as well as the late twentieth century's expanded range of Oriental and ancient Eurasian culture, and even embraces our current nineteenth century French model of the postacademy avant garde and its rejection of tradition. I do feel that there are serious problems with the conclusions of a 150 year long evolution of the rejection of traditions, as necessary as it was in the first place."[86]

By admitting that Modernism was necessary in the first place, Viola is also aware of the break, of the earthquake that severed the neat lines of art history once and for all. However much inspired by *The Visitation* by Pontormo (*c.* 1528), Viola's video of *The Greeting* (1995) does not rely on the old Mannerist structure. He has remade the image in a new form. The early Modernists refused to waste so much early art that had been pushed aside by the classical canon. Similarly, Ultra-modernists such as Viola, Cornelia

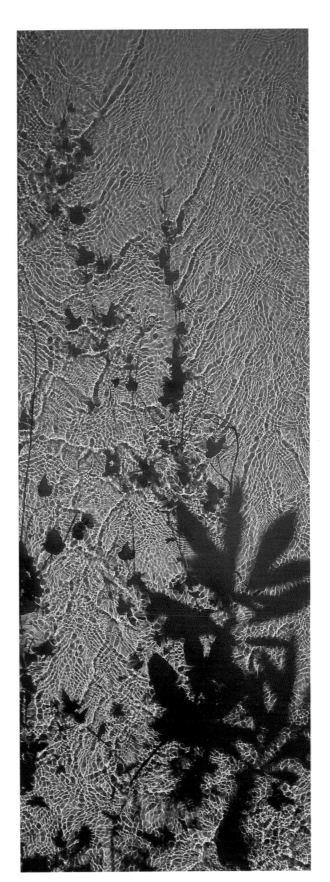

Susan Derges
Stream, 1996
Unique Cibachrome
photograph
168×60 cm (66×23¾ in.)

Parker and Hannah Collins (born 1956), with their direct approach to history, show their refusal to waste the vast structures of thought raised by previous men and women.

Given the amount of important work made in response to the division of Germany, one might have assumed that the reunification would bring with it an avalanche of new art. The death of political polarity actually saw a release of tension that had driven artists for decades. The collapse of Communism also witnessed the lingering demise of Marxist history and art history and the profusion of end-of-history theories. One artist to confront the fall of the Wall was Hannah Collins.

Collins, born in London, lives in Barcelona but travels a good deal, especially through Eastern Europe, Turkey and India, as one of the themes of her work is concerned with frontiers and identities. Her camera has a nomadic existence in the spirit of film director Wim Wenders, who illustrates that there is no home other than in the head. There is no lack of polarity in Collins's work. Her pictures show the burden of history, picking out traces of the past, as a means of reflecting on the present. She manages to show the terrifying ability of Capitalism to flatten all the past to a smooth homogenous sameness. When she places several photographs in a vertical row, she is parodying the billboard culture that is filling

Catherine Yass
Bankside: Cherrypicker,
2000
Photographic
transparency
68×50.8 cm (26³/₄×20 in.)
Edition: 3/50

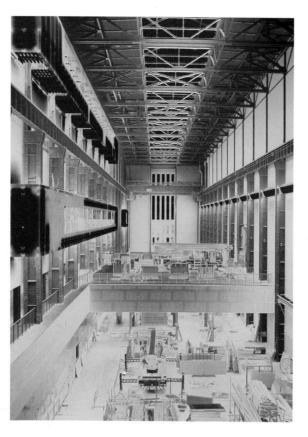

every corner and cranny of our suburban sprawl.

Collins came out of video and is increasingly involved in film. The last time we heard of Katharina Sieverding (born 1944), she was throwing darts at her former professor, Joseph Beuys. Her experience as a performance artist and student of sculpture has certainly influenced her use of photographs in her recent work. Her installation *View the Sun at Midnight* (1988) is like an iconostasis. With her gold face, she has presented herself for worship like the beautiful Nefertiti that resides in Berlin, but the gold speaks of death, of the death mask, of the death that would result from totally painting oneself with toxic gold paint. This is an alter-piece but not an altarpiece to herself. It is about the transformation of the self and of Germany. It is lamenting lost identity.

The focus of Deutsche Bank's holdings in young British photography is provided by a group of sculptor-photographers, all of whom use film but not a camera: Susan Derges (born 1955), Christopher Bucklow (born 1957), Garry Fabian Miller (born 1957), Daro Montag (born 1959) and Adam Fuss (born England 1961; moved to America). Their work follows on from that of the pioneering German artist in this field, Floris Neusüss (born 1937).

The group's work comes as a blast of fresh air in the dusty corridors of the art world. Its direct appeal to nature is like a return to primary sources after being lost in an argument over semantic detail. In an extraordinarily wide-ranging essay in his book on Derges, Martin Kemp, a scholar known for his work on Leonardo da Vinci, effectively sees her reviving early Modernist explorations of science and nature:

"Only with some of the more overtly nature-derived abstractionism of the early twentieth century, epitomised at the highest level by Mondrian, did the basic fields of force underlying appearance become the primary subject of the representation. Where the patterns of standing waves in a Monet seascape were but a component of the visual texture of the scene, in Mondrian's pictorial field the conjunction of

Christian Müller
Untitled, 1999
Lambda print
145×126 cm
(56³/₄×49¹/₄ in.)
Edition: 2/3

Mat Collishaw
Infectious Flowers II –
Melanomic Orchid, 1997
Wood and glass light-box
with photographic
transparency

18×29 cm
(7¹/₄×11¹/₂ in.)
Edition: 3/3

the co-ordinates of vertical and horizontal forces became the prime organisational elements. This move was in part related to an interest in non-Western and pre-historic art, but it was more profoundly driven by the direct or indirect impact of the abstract orders being revealed by new modes of scientific examination. Atomic physics, in particular, was disclosing a world of dynamics on such a small scale as to have no readily apparent connection with the optically visible realities of earlier science, even when using such aids as microscopes and telescopes."[87]

Derges needed no microscope for her River Taw series. She literally gives us sections of the Taw. "At night the river is used as a long transparency or negative and the landscape as a large dark room", she writes. "Photographic paper held in an aluminium slide submerged just below the water's surface and exposed to a microsecond of flashlight that prints the flow of the river directly onto the light sensitive paper."[88] With the Shoreline series, executed near the mouth of the river, the paper is even more exposed to the open sky, and is not protected by the shadows of trees – rowan, willow, oak, hawthorn, elder, alder, hazel and birch. The size and glow of the moon determine the colour, but at the coast there is also the baleful influence of the neighbouring towns' street lamps.

The city at night is the territory of Rut Blees Luxemburg. Though born in the Moselle region in 1967, she moved to London to take on the city. People never actually appear in her views of her nocturnal travels. Whether the photographs are taken of dual-carriageways or isolated steps that go down to the River Thames, the human presence is felt on the long-exposed film as sources of golden light.

It is hoped that this book will have given some idea of the divergent paths of British and German art, but there are an increasing number of links between artists. The opening of Tate Modern, which is intended to act as a centre of European rather than just British culture, will certainly increase the artistic exchanges between the two countries.

The art produced during the last forty years in Britain and Germany encourages

Maik and Dirk Löbbert
San Gimignano II, 1996
Black-and-white
photograph with
graphic foil
77 × 56 cm (30 × 21³/₄ in.)
Edition: 3/3

many comparisons to be made, but often the apparent similarities are arrived at for different reasons and with different intentions at different times. Zero was not Pop, which was not *Fluxus*, which was not Land art. There were few shared aims between Beuys and the School of London, and very few genuine British contributors to *Zeitgeist*.

One or two comparisons spring to mind with young photographers. The flower paintings of Mat Collishaw and Christian Müller are superficially very similar. They have both made photographs manipulated by computer. As Müller explains, "Parts of the photos were digitally reflected and then placed back into the picture. The faces, masks of features, that seems to consist of blossoms, fruits, leaves or branches are only caused by this reflection."[89] Collishaw's diseased plants are more sinister still. There is a direct link to Bacon's fascination with diseases of the mouth and Hirst's obsession with decomposing meat. "Despite the immense variety

of flowers that we have, there still isn't enough to satisfy our appetites, our greed, for more and more different types", says Collishaw. "There's a basic human hunger to transform nature and elaborate it for our own ends."[90]

The playfulness of another YBA, Angus Fairhurst, also finds the vaguest of echoes in the work of Maik and Dirk Löbbert (born 1958). In *When I Woke up in the Morning the Feeling Was Still There* (1996), (illustrated on p. 145) it looks as if the artist is losing control of his work. In *San Gimignano II* (1996), the Löbberts are amending one of the small jewels of Italian city-state architecture by extending one of the famous towers. In another of their touched-up photographs, *Galleria* (1998), they have transformed the semicircular hole of a train tunnel into a full black circle. Are the artists implying that we should distrust what we see or just playing with us?

The void created by the collapse of Communism has still not been filled. There was probably more effort to fill this gap in the ten years before the fall of the Wall than in the tens year after. There has been no successful attempt to create a universal critical structure. Many people do not want one, but in a world filled with an ever-increasing amount of information, the lack of a shared language makes the Tower of Babel parable more and more significant. Artists have had to create

their own individual structures and supply their own tensions, the North and South poles of their own debates.

Ironically, given that far too many artists in the 1980s and 1990s have been unbalanced by Duchamp's influence (placing too much focus on just one thread of Modernism), perhaps the most balanced of all artists of the 1990s attributes his equilibrium to the master of Dada. "One artist who was very important to me was Duchamp", says Anish Kapoor. "Not the Duchamp of the readymade but the Duchamp of *The Large Glass (The Bride Stripped Bare by Her Bachelors, Even)* and *Etant Donnés*, the Duchamp of Alchemy … a perfect kind of oppositeness. I made quite a lot of work that had to do with this polarity."[91] Looking into the bowl of *Turning the World Upside Down*, one can reflect on Duchamp's verdict on his own art, "A little game between 'I' and 'me'".[92] The chasm between them drives us all.

1 Norman Rosenthal, 'The Blood Must Continue to Flow', *Sensation: Young British Artists from the Saatchi Collection*, exhib. cat., London, Royal Academy of Arts, 1997, p. 9.
2 Damien Hirst, in Damien Hirst and Gordon Burn, *Damien Hirst: I Want to Spend the Rest of My Life Everywhere, With Everyone, One to One, Always, Forever, Now*, London (Booth-Clibborn Editions) 1997, p. 289.
3 Bill Viola, quoted in Jörg Zutter, 'Interview with Bill Viola', *Bill Viola: Unseen Images*, exhib. cat. by Rolf Lauter, Marie Louise Syring and Jörg Zutter, London,

Whitechapel Art Gallery, *et al.*, 10 December 1993–13 February 1994, p. 100.
4 Gordon Burn, 'Is Mr Death in?', in Damien Hirst and Gordon Burn, *op. cit.*, p. 9.
5 Damien Hirst, quoted in Andrew Graham-Dixon, 'Damien Hirst, trader in sharks, entrails and butterflies, is ONE STRANGE FISH in the art market' [interview], *Vogue*, March 1992, p. 212.
6 Tracey's Emin confession was written on a painting included in the exhibition *Tracey Emin: I Need Art Like I Need God*, London, South London Art Gallery, 16 April–18 May 1997. Reported in Adrian Searle, 'Me, me, me, me' [exhib. review], *The Guardian*, 22 April 1997, p. 13.
7 Matthew Collings, *Blimey! From Bohemia to Britpop: The London Artworld from Francis Bacon to Damien Hirst*, London (Twenty-One) 1997, p. 12.
8 *Ibid.*, p. 31.
9 Norman Rosenthal, in *Sensation, op. cit.*, p. 9.
10 *Freeze*, exhib. cat., intro. by Ian Jeffrey, London, Port of London Authority Building, 1988, unpaginated.
11 *Ibid.*
12 *Ibid.*
13 *Ibid.*
14 *Damien Hirst making beautiful drawings*, exhib. cat., Berlin, Bruno Brunnet Fine Arts, 1994, unpaginated.
15 Damien Hirst, in Damien Hirst and Gordon Burn, *op. cit*, p. 292.
16 *Ibid.*, p. 7.
17 *Ibid.*
18 Anthony Everitt, in *The Guardian*, quoted in Gordon Burn, *ibid*.
19 The man seen in the photographs is actually not the artist in reality but a model.
20 Mat Collishaw, quoted in *Minky Manky,* exhib. cat., ed.

Carl Freedman, London, South London Gallery, 1995, unpaginated.
21 Francis Bacon, quoted in David Sylvester, *Interviews with Francis Bacon, 1962-1979*, 2nd edn, London (Thames and Hudson) 1987, p. 35.
22 Mat Collishaw, *op. cit.*, unpaginated.
23 Gordon Burn, *op. cit.*, p. 7.
24 Matthew Collings, in *City Limits,* 6–13 June, 1991.
25 Liam Gillick and Andrew Renton (eds.)*, Technique Anglaise: Current Trends in British Art*, London (Thames and Hudson) 1991, p. 40.
26 Marcel Duchamp, quoted in Arturo Schwarz, *The Complete Works of Marcel Duchamp*, rev. edn, London (Thames and Hudson) 1997, p. 597 [taken from unpublished interviews, 1959–68].
27 Since Hirst became a father he has made politician-style statements that he is spending more time with his family in Devon.
28 Gordon Burn, *op. cit.*, p. 10.
29 *High Fidelity, Low Frequency*, exhib. cat. by James Roberts, Nagoya, Kohji Ogura Gallery, 1993, p. 7.
30 *Signature Pieces*, exhib. cat. by Marco Livingstone, London, Alan Cristea Gallery, 5 January–6 February 1999, p. 28.
31 *Ibid.*
32 Damien Hirst, quoted in Sarah Barruso, 'Artist's Statement from an Interview with Damien Hirst', *Hot Wired*, 11 June 1996, reproduced in Damien Hirst and Gordon Burn, *op. cit*, p. 15.
33 Damien Hirst, quoted in Andrew Graham-Dixon, *op. cit.*, p. 212.
34 Willy Russell, *Educating Rita*, a film directed by Lewis Gilbert, 1983.

174

35 *Minky Manky*, *op. cit.*, unpaginated.
36 Richard Gott, 'Sexual in-tent', *Guardian Weekend* [London], 5 April 1997, p. 33.
37 Adrian Searle, *op. cit.*, p. 13.
38 Gordon Burn, *op cit.*, p. 11.
39 Tracey Emin, quoted in Richard Gott, *op. cit.*, p. 27.
40 Tracey Emin, quoted in *Minky Manky*, *op. cit.*, unpaginated.
41 Will Self, 'Tracy Emin: A Slave to Truth', *The Independent on Sunday*, 21 February 1999, p. 8.
42 Mona Hatoum, 'The Light at the End' [statement], *The British Art Show*, exhib. cat., ed. Caroline Collier, Andrew Nairne and David Ward, London, South Bank Centre, *et. al.*, 1990, p. 62.
43 Rachel Whiteread, in Iwona Blazwick, 'Rachel Whiteread in Conversation with Iwona Blazwick' [interview], *Rachel Whiteread*, exhib. cat., ed. Jan Debbaut and Selma Klein Essink, Eindhoven, Stedelijk Van Abbe Museum, 1992, p. 15.
44 *Ibid.*, p. 10.
45 Olafur Eliasson, statement made at the press conference on 22 March 1996 and included in *Manifesta 1*, exhib. cat., ed. Rosa Martinez, Viktor Misiano, Katalin Néray, Hans-Ulrich Obrist and Andrew Renton, Rotterdam, 9 June–19 August 1996, p. 11.
46 Andrea Brodbeck and Veit Görner, 'Now's the time', *German Open*, exhib. cat., ed. Veit Görner and Annelie Lütgens, Wolfsburg, Kunstmuseum Wolfsburg, 1999, unpaginated.
47 Mary Louise Syring and Christine Vielhaber, 'Andreas Slominski' [interview], *Binationale: German Art of the late 80s*, exhib. cat. by Jürgen Harten, Rainer Crone, Ulrich Luckhardt and Jiří Svestka, Düsseldorf, Städtishe Kunsthalle, *et al.*, 24 September–

27 November 1988, p. 269.
48 Rudolf Schmitz, 'Daniel Richter: Crash Course in Painting', *German Open*, *op. cit.*, 1999 unpaginated.
49 *German Art: Aspekte deutscher Kunst 1964–1994*, exhib. cat. by Wieland Schmied, Salzburg, Thaddaeus Ropac Gallery, 1994, pp. 90, 92.
50 Benjamin H.D. Buchloh, 'Introduction', *The Duchamp Effect*, ed. Martha Buskirk and Mignon Nixon, Cambridge MA (An October Book, MIT Press) 1996, p. 3.
51 Benjamin H.D. Buchloh, 'The Political Potential of Art', *Documenta X*, exhib. cat., ed. Catherine David and Jean-François Chevrier, Kassel, 1997, p. 640.
52 Mary Louise Syring and Christine Vielhaber, 'Katharina Fritsch' [interview], *Binationale*, *op. cit.*, p. 117.
53 The Museum für Moderne Kunst, Frankfurt, has Fritsch's *Company at Table* (1988) on loan from Dresdener Bank.
54 Lars Nittve, 'Nowhere but NowHere', *NowHere*, exhib. cat., ed. Henning Steen Hansen, Denmark, Louisiana Museum of Modern Art, 15 May–8 September 1996, p. 11.
55 The other artists in the show were Miroslaw Balka, Robert Gober, Mike Kelley, Guillermo Kuitca, Charles Ray and Doris Salcedo.
56 *Distemper: Dissonant Themes in the Art of the 1990s*, exhib. cat., ed. Neal Benezra and Olga M. Viso, Washington, D.C., Hirshhorn, 1996, p. 10.
57 Bruce Ferguson, 'Cornelia Parker interviewed by Bruce Ferguson', *Cornelia Parker*, exhib. cat., ed. Jessica Morgan, Boston, The Institute of Contemporary Art, 2 February–9 April 2000, p. 51.

58 *Ibid.*
59 *Ibid.*, p. 58.
60 Neal Benezra, 'Thomas Schütte: A Path towards that Goal', *Distemper*, *op. cit.*, p. 96.
61 Thomas Schütte, 'Thomas Schütte', *Possible Worlds: Sculpture from Europe*, exhib. cat. by Iwona Blazwick and Andrea Schlieker, London, ICA and Serpentine Gallery, 1990, p. 70.
62 Paul Sztulman, 'Thomas Schütte', *Documenta X*, exhib. short guide, Kassel, various locations, 1997, p. 204.
63 Rune Gade, 'Space – Surface – Frame – on Günther Förg's Art', *Günther Förg*, exhib. cat. by Christain Gether and Rune Gade, Ishøj, Arken Museum for Moderne Kunst, January–June 2000, p. 75.
64 *Ibid.*
65 Raimar Stange, 'Günther Förg', in Burkhard Riemschneider and Uta Grosenick (eds.), *Art at the Turn of the Millennium*, Cologne (Taschen) 1999, p. 158.
66 Gerhard Richter, artist's statement, in *Documenta VII*, exhib. cat., ed. Rudi Fuchs, Kassel, various locations, vol. 1, pp. 84–85 (English trans. p. 443).
67 On a visit by the author to the artist's studio, 5 May 1999.
68 Mark Francis, in his statement for this book, 25 May 2000; see p. 175.
69 Dorothy Walker, *Modern Art in Ireland*, Dublin (Lilliput Press) 1997, p. 102.
70 Armin Zweite, 'To Humanize Abstract Painting: Reflections on Sean Scully's "Stone Light"', *Sean Scully: Twenty Years, 1976–1995*, exhib. cat. by Ned Rifkin, Atlanta, High Museum of Art, *et al.*, October 1995–January 1996, p. 22.
71 *Ibid.*, p. 21.
72 Rudi Fuchs, in *Felim Egan*,

exhib. cat., ed. Jan Hein Sassen, Amsterdam, Stedelijk Museum, 1998, p. 5.
73 *Felim Egan*, exhib. cat. by Alistair Smith, Dublin, Kerlin Gallery, 1990, unpaginated.
74 Fionnuala Ní Chiosáin [in a conversation with Martin Steer], quoted in *Fionnuala Ní Chiosáin*, exhib. cat., Dublin, Kerlin Gallery, November 1999–January 2000, p. 4.
75 Gillian Ayres, quoted in Alistair Hicks, *The School of London*, Oxford (Phaidon) 1989, p. 64.
76 Marlene Dumas, 'Bacon and Dumas – or The discomfort of being "coupled"', *Marlene Dumas/Francis Bacon*, exhib. cat., ed. Marente Bloemheuvel, Jan Mot and Sune Nordgren, Malmö, Konsthall, 18 March–14 May 1995, p. 31.
77 Neal Benezra, 'Marlene Dumas: On beauty', *Distemper*, *op. cit.*, p. 39.
78 Tony Bevan, quoted in Marco Livingstone, *Tony Bevan*, London (Michael Hue-Williams) 1998, p. 12.
79 *Ibid.*, p. 11.
80 Once Di Stefano has taken his pictures to a high realist finish, he attacks the paintings with an acidic varnish. He then places a sheet of Japanese paper over the surface, and when he rips this off it removes not only the corrosive varnish but also some patches of paint as well. He calls the paper with the impregnated image a "counterproof".
81 Katrin Zschirnt, 'Somewhere down there the road continues', *Ralph Fleck*, exhib. cat., ed. Axel Zimmerman, Munich, Galerie von Braunbehrens, 1997, p. 8 [amended translation].
82 Michael Bach, in his statement for this book, March 2000; see p. 184.
83 Hans Irrek, 'Passage', *Alice

Stepanek/Steven Maslin*, exhib. cat., Cologne, Johnen & Schottle; Amsterdam, Torch; 1997, unpaginated.
84 Hans-Joachim Müller, 'Informel with Order', *Ralph Fleck*, *op. cit.*, p. 6.
85 Alice Stepanek and Steven Maslin, in their statement for this book, March 2000; see p. 270.
86 Bill Viola, quoted in Jörg Zutter, *op. cit.*, p. 101.
87 Martin Kemp, *Susan Derges: Liquid Form*, London (Michael Hue-Williams) 1999, p. 12.
88 Susan Derges, quoted in Martin Kemp, *ibid.*, 1999, p. 140.
89 Christian Müller, in a letter to the curators at Deutsche Bank London, 5 May 2000.
90 Mat Collishaw, *op. cit.*, unpaginated.
91 Douglas Maxwell, 'Anish Kapoor', *Art Monthly*, May 1990, p. 6.
92 Marcel Duchamp talking about the Large Glass, quoted in Kaharin Kuh, *Marcel Duchamp, The Artist's Voice: Talks with Seventeen Artists*, New York and Evanston (Harper and Row) 1962, p. 83.

"Towards the end of the eighties my preoccupation with landscape had begun to tire. It no longer seemed relevant to me in its present form. Landscape had already been incredibly well explored within the tradition of painting. I felt I was suffering from a hangover from a period of romantic landscape painting which had been popular in British art of the mid-1980s. It was at this point that I embarked on a series of monoprints. This process gave me the freedom to explore new imagery that had emerged through looking at line diagrams of dissected botanical images and biological forms.

This new imagery, for me, seemed to involve landscape and nature, but in a more internalized way. Here were images of forms not visible to the naked eye. Through the aid of a microscope a fascinating and beautiful world was revealed. Images were recalled from memory, then mutated to evolve a language. Deutsche Bank has some of these early prints in their collection.

Paintings in the early 1990s had a stronger literal association with particular ideas, whereas later paintings went through a process of reduction to create a language of rigorous minimal abstraction. The images in some cases were metaphors for other concerns, which ranged from notions of creation to ideas of intimacy and isolation. Most recently, the focus within my painting has been informed by ideas dealing with mapping, communications systems and networks within nature."

Mark Francis, May 2000

Robert Adams

Untitled, 1960
Ink and coloured paper
collage
37 × 34.5 cm
(14 ½ × 13 ½ in.)

Robert Adams was a
pioneering British abstract
sculptor. He is linked to
Henry Moore and Victor
Pasmore, but his quiet
voice was highly individ-
ual. Though understated,
he was insistent that a
"good non-figurative work
is a thing complete in
itself, with its own laws
and life, and takes its
place naturally and com-
pletely when placed in a
suitable environment".[1]

1 Robert Adams, in Lawrence
Alloway, 'Robert Adams'
[interview], *Nine Abstract Artists*,
exhib. cat., ed. Lawrence
Alloway, London, Redfern Gallery,
1954, p. 22.

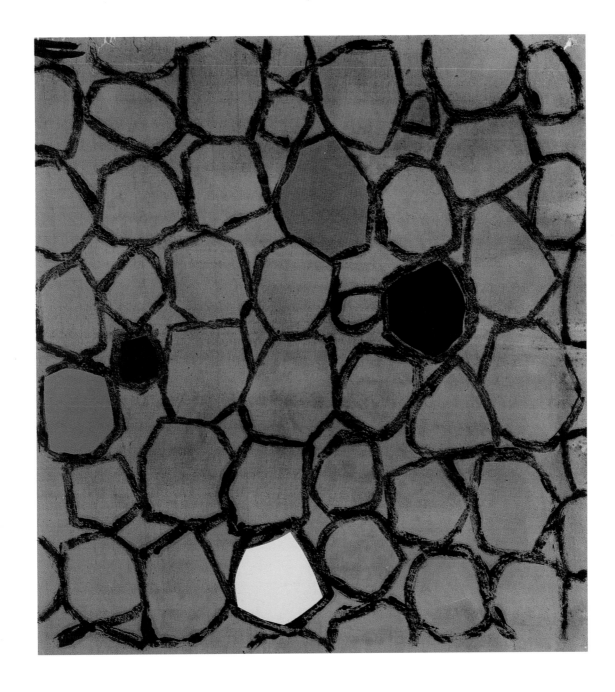

Craigie Aitchison

Magpie (from Nine
London Birds series), 1994
Lithograph
46×36 cm (18×14 in.)
Edition: 58/80

Craigie Aitchison's highly
individual vision was
launched at the Beaux
Arts Gallery, London, in
1959 by Helen Lessore,
who was also responsible
for the early promotion
of Francis Bacon, Frank
Auerbach and many other
artists.

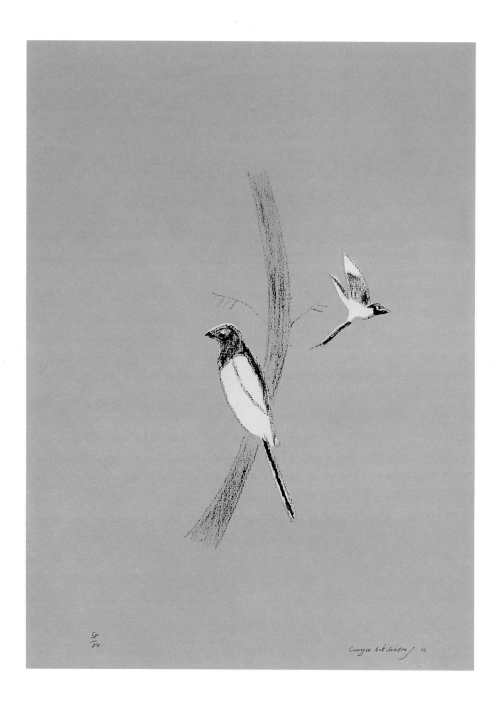

Michael Andrews

Untitled (Scottish Landscape) 1, 1980
Watercolour on paper
21×57.5 cm (9³/₄×22¹/₂ in.)

Andrews did not visit
Scotland until 1975, but
apart from his memorable
paintings of Ayers Rock
in Australia, Scotland
supplied one of his richest
subjects during the last
twenty years of his life.
He was fascinated by
stalking, perhaps because
it corresponded so closely
to his meticulous, care-
fully planned approach
to painting.

Art & Language

Study for Index: Incident in a Museum II, 1985
Gouache, acrylic and pencil on paper
105 × 154 cm
(45 ¼ × 60 ½ in.)

As their name implies, Art & Language, a changing group of artists, were adamant that art took place in the head. Words are their main tools.

David Austen

Untitled, 17 August, 1995
Gouache on paper
58.5×46 cm (23×18 in.)

Austen very consciously
explores colour – its
emotive power and the
relationships set up
between juxtaposed
tones. One is never quite
sure how serious this
endeavour is, as he is
happy to give irony its full
corrosive powers.

Charles Avery

Avery's work entices the viewer into the world of his imagination, and in his portrait series The Life and Lineage of Nancy Haselswon, Avery constructed a family that exists only in his head. The lineage spans one hundred years and four generations – and *Uncle Eugene's Funeral* is a major event in the evolution of this fictitious family.

182

Gillian Ayres

Untitled, 1993
Gouache on paper
78.8×78.8 cm (31×31 in.)

Ayres's first round picture dates from 1979–81, while she was still Head of Painting at Winchester School of Art. She visited Florence in 1979 and came back wanting to paint tondi. The round form proved important to her in the way it encouraged the energy to come out of the picture rather like a spinning Catherine Wheel.

"When I am most critical of my work, I look at it and say that I am still painting just buildings. I have reservations about being a realist painter. I am happy to paint buildings that people can recognize, but it is the formal properties in the painting that concern me.

I see no reason why one cannot paint figuratively in the modern tradition. It is the everyday that I depict in my painting. The world consists of more than castles and prize-winning architecture. I want to give people a good feeling about the world in which we live. It is not one-off representation that I am after; rather, I want the painting to continue to work – to give up more each time it is looked at. That means I want to shift people's vision.

I would like people to feel that they are moving around in my pictures. I don't want them to think that this is Berlin, this is Frankfurt, this is London, but ideally I would like to enable them to switch back and forth between form and content. In every picture I want there to be a sense of, say, Berlin, Frankfurt and London. The person seeing the picture could mix it up, so he or she doesn't stay in just one atmosphere.

One of the advantages painting has over other more instant media such as film, video or photography is that one doesn't have to react to every single flash. The television screen is always flickering but there is nothing to look at. I want to be independent.

I was attracted to Blackfriars Bridge by the large red pillars that jut out of the Thames. They were part of the old bridge but now they have no function. They don't serve any purpose. Art serves no practical service, and yet with this picture I wanted to return some energy. The way the river hits the pillars triggers memories for me – in particular an early memory of examining the water at the edge of a swimming pool. I am interested in the way we perceive one substance shifting into another."

Michael Bach, March 2000

Michael Bach *Blackfriars Bridge*, 1992
Oil on canvas
140.5×240 cm
(55×93³/₄ in.)

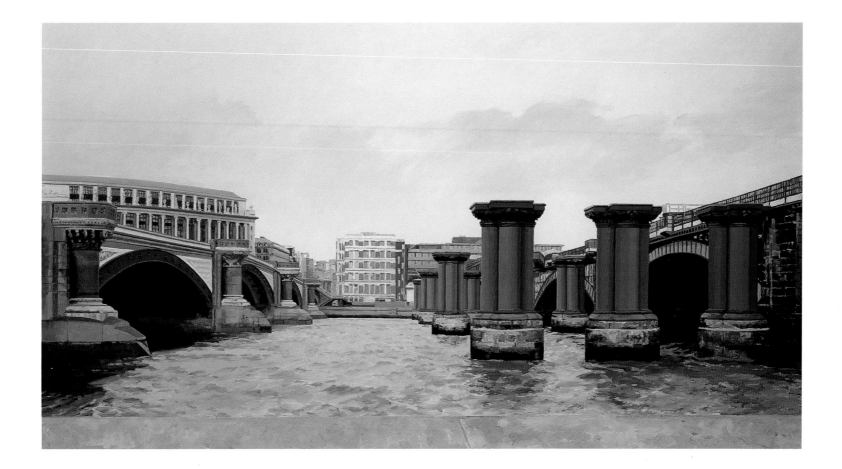

Stephen Balkenhol

Untitled (Motiv IV), 1993
Lithograph
20.1 × 29.8 cm
(8 × 11¾ in.)

Balkenhol's choice to make the human figure the central focus of his sculpture was brave and has been carried out systematically. Seen from a British perspective, one assumes this amusing print is making fun of Operation Sea Lion, the planned invasion of Britain, which Kiefer had mocked in similar fashion ten years earlier.

186

**Wilhelmina
Barns-Graham**

Scorpio Series 2 # 47,
1997
Acrylic on arches paper
15 × 21 cm (6 × 8¼ in.)

In 1940 Barns-Graham arrived in St Ives, Cornwall, where she worked alongside Ben Nicholson, Barbara Hepworth and Naum Gabo, though she has also long maintained a studio in Scotland. She takes inspiration from the surrounding land-scape. As the title of this works suggests, she sees in nature the heat and intensity that she gener-ates in her own work.

Basil Beattie

Untitled 3, 2000
Acrylic on paper
28 × 38 cm (11 × 14 ³/₄ in.)

Basil Beattie, who taught painting at Goldsmiths' College, London, has forged his abstract language out of hieroglyphic shapes.

188

John Bellany

Conversation Piece, 1991
Watercolour on paper
75.5×56.5 cm
(29 1/2×22 1/4 in.)

Bellany's wives and the
sea have been constant
subjects in the artist's
work.

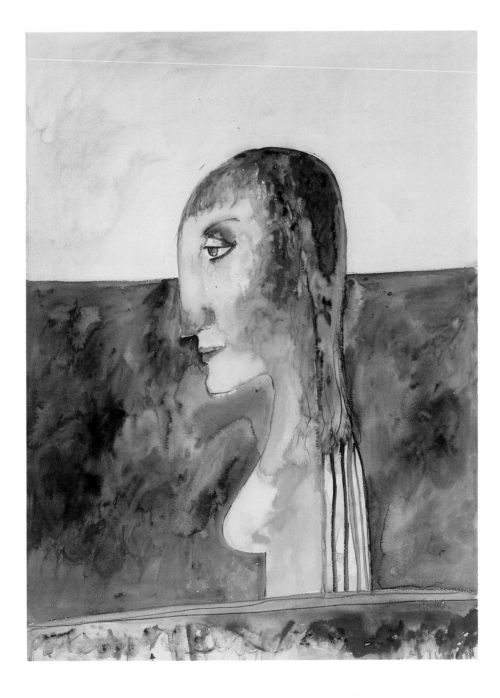

Kate Belton

Beguile, 1996
Cibachrome photograph
110×80 cm (43¼×31½ in.)

Belton examines our perception of reality by inserting painted stage-sets into natural settings and photographing them. She trained as a painter. Here we see a cardboard cutout girl placed in a sand-pit. Through Belton's manipulation of reality, in this image the scale of childhood adventures on the beach appears to have gone alarmingly awry.

Elizabeth Blackadder

Mexican Fan, 1969
Watercolour on paper
62.4×93.6 cm
(24½×37 in.)

Blackadder is best known for her flower paintings, particularly irises, many of which she grows in her own garden. The narrow confines of her chosen subject-matter should not disguise the serious endeavour in developing still life along tight new lines.

Peter Blake

I for Idols, 1991
Screenprint
103×77.5 cm
(40 1/2 ×30 1/2 in.)
Edition: 40/95

Peter Blake trained not only as a painter, but also as a commercial artist and illustrator. In 1991 he compiled the Alphabet print set, which illustrated twenty-six images of everyday representations from popular culture, including *F for Football*, *K for King (Elvis)*, and *I for Idols*. In *I for Idols* Blake

takes images of thirty-six of the century's popular idols to create a montage that sandwiches a picture of a near-naked Marilyn Monroe between the Beatles and Francis Bacon.

Christine Borland

*The Velocity of Drops:
City Park – Turning and
Kneeling*, detail, 1995
Set of six photographs
25.5 × 25.5 cm
(10 × 10 in.) each
Edition: 3/3

Christine Borland, who
was shortlisted for the
Turner Prize in 1997, here
uses watermelons to look
as if they were smashed
heads bursting open on to
the snow in the German
winter. Borland received
a DAAD scholarship to
Berlin in 1996.

Johannes Brus

Untitled, 1988
Coloured photograph
mounted on canvas
91 × 128 cm
(35 ¾ × 50 ½ in.)

Johannes Brus has
explored the combination
of paint and photography,
among many other
materials.

196

Christopher Bucklow

Guest. 1.15 pm,
1 August, 1996
Unique colour
photograph
98×76 cm (38 1/2×30 in.)

Bucklow's luminous
figures are constructed
with a hand-made
contraption, which
involves the photographic
process and also makes
use of the more ancient
tradition of silhouette
manufacturers.

Rachel Budd

Fruits of the Sea I, 2000
Oil on paper
59×91.5 cm (23¼×36 in.)

Rachel Budd has a great facility for finding colour and form in her immediate environment. The markets around her studio provide an endless supply of flowers, vegetables and fish for her to draw upon.

198

Lynn Chadwick

Two Seated Figures, 1972
Screenprint
56 × 76 cm (22 × 30 in.)
Edition: AP/75

As Henry Moore had his
Mother and Child,
Chadwick has Seated
Figures, but Chadwick's
sculpture is more angular
than Moore's.

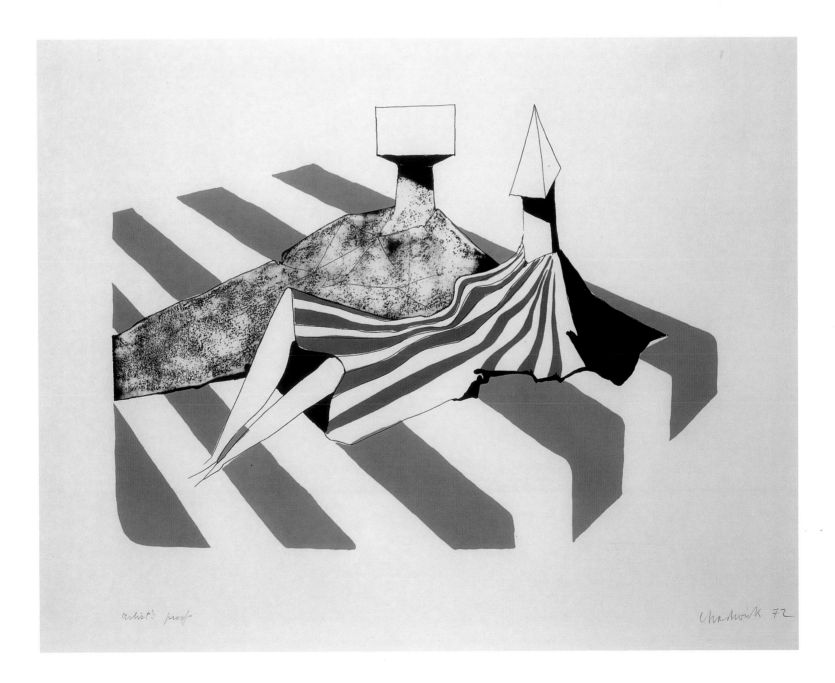

artist's proof

Chadwick 72

Stephen Chambers

Down There Somewhere,
1997
Oil on canvas
91.5×107 cm (36×42 in.)

"My paintings are not of specific people or specific activities", Chambers maintains, "but of states of mind, attitudes and sensibilities."[1]

1 Stephen Chambers, quoted in Judith Bumpus, 'Stephen Chambers', *Jerwood Painting Prize*, exhib. cat., London, Jerwood Charitable Foundation, 1999, unpaginated.

Prunella Clough

Counters, 1998
Acrylic and pigment
on paper
53.3×62 cm (21×24 ½ in.)

"I feel able to act more
radically about form than
I do about colour which,
within my context, is
muffled, tonal and murky.
But one of the licences
given by twentieth-
century art, which is still
valid for me, is many
ways of dealing with a flat
twentieth-century surface
and much preoccupation
with its integrity, but in
the face of theory of this
sort, I am essentially
an 'eye' person, totally
affected by visual facts."[1]

1 Prunella Clough, in Bryan
Robertson, 'Introduction' [essay
and interview], *Prunella Clough:
New Paintings 1979–82*, exhib.
cat., London, Warwick Arts Trust,
8 April–14 May 1982.

Prunella Clough

Tree, 1989
Watercolour on paper
78 × 52 cm
(30³/₄ × 20¹/₂ in.)

202

Maurice Cockrill

Study for Mountain Ash, 1987
Watercolour on paper
76×56 cm (30×22 in.)

"The rowan, among other supposedly mystical properties, could be seen to have characteristics often admired in humans", says Cockrill in his statement on p. 139, "– beauty, tenacity, solitariness, endurance and may also stand for the (Christian) sacrificial tree, replacing the body represented only by hands and feet."

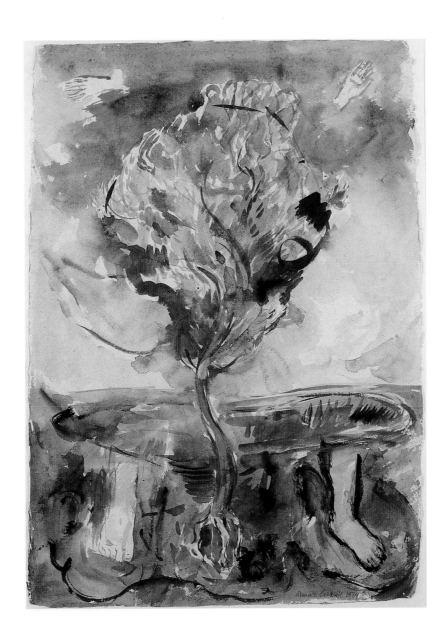

Melanie Comber

Untitled, 1996
Mixed media on paper
60×41.7 cm
(23 ³/₄ × 16 ¹/₄ in.)

Comber evokes land-
scape by literally
incorporating the land in
her pictures. The ribbed
surface is built up with
chalk, sand, paint and
natural pigments, so that
the work becomes almost
three-dimensional.

204

Stephen Cox

Study for Hymn,
set of eight, 1989
Ink and pencil
29.5×21 cm
(11½×8¼ in.) each

These drawings illustrate
the thoughts the sculptor
had on his way to making
Hymn (1991), which
has been constructed in
black Indian granite and
oil and can be seen at
the University of Kent,
Canterbury. Starting
with a female torso, he
works his way to a more
minimal form.

 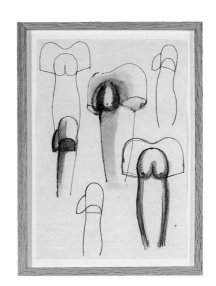 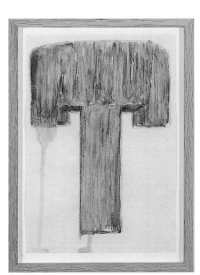

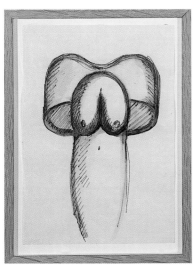 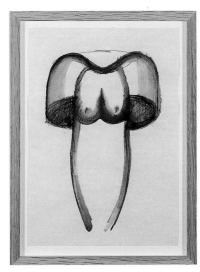 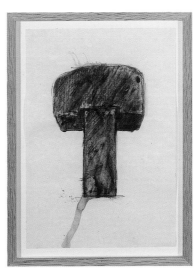 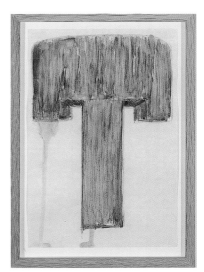

"I started making work with dice as I was looking for a surface that had its own artificial value. Prior to this, I had been drawing numbers and figures on the forms. On one level, the use of dice refers to the discourse between Lukasiewicz and his theory of Indeterminability and Einstein's desire to disprove it. Almost out of his frustration at being unable to measure the quantum, he made his famous pronouncement that 'At any rate, I am convinced that *He* [God] does not play dice'.[1]

Thirty years ago they were producing big, heavy, stick-like models of molecules, which are very different from the views we have of molecules today. I was interested in a new way of showing molecules. The study of prebiotic chemistry[2] has been important for my thoughts on this subject. I like to imagine millions of complicated molecules hanging around in puddles. The influence of one molecule upon its neighbours is the only way that change can come about, forcing it into another substance, eventually creating transformations.

The dice themselves are made of a transformed material. Plastic is a substitute for a natural material as it was invented as a result of a competition to find a substitute for ivory to make billiard balls.

I believe that in the future it will become increasingly important to make visible the huge amount of imperceptible information that is related to the perceptible. As with the world of molecules, energy waves or the like, it will become necessary to find a language to describe the invisible, the inaudible, the unsmellable or the untouchable. That could be a function of sculpture."

Tony Cragg, May 2000

1 Albert Einstein, in a letter to Max Born dated 4 December 1926, *The Born–Einstein Letters: Correspondence between Albert Einstein and Hedwig Born, with commentaries by Max Born*, English trans. by Irene Horn, London (Macmillan) 1971, p. 19. Einstein actually wrote, "at any rate, I am convinced that *He* does not play with dice", but it has most often been quoted as "*Gott würfelt nicht*".
2 Prebiotic chemistry is the study of chemistry before life forms and is based on inorganic compounds and carbon change.

Tony Cragg

Secretions, 1998
Thermoplastic (dice)
and fibreglass
235×330×395 cm
(92×129×154 in.)

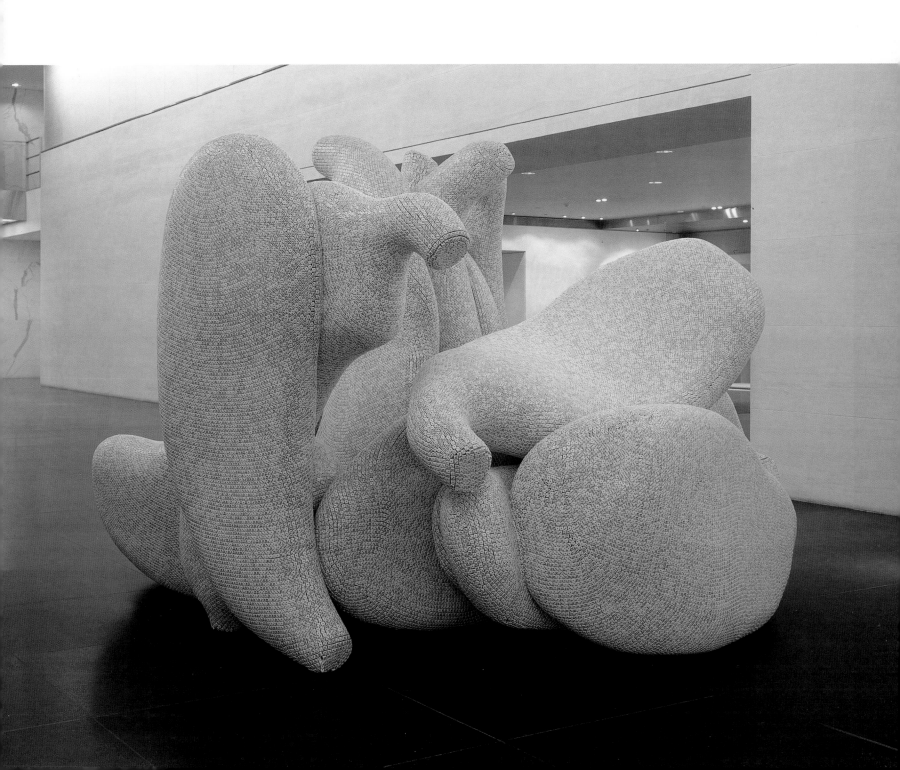

Colin Crumplin

Salmon, 1992
Acrylic and pencil
on paper
50×70 cm (19³/₄×27¹/₂ in.)

Crumplin gives two highly
contrasting images of
the salmon, one highly
realistic, the other more
abstract.

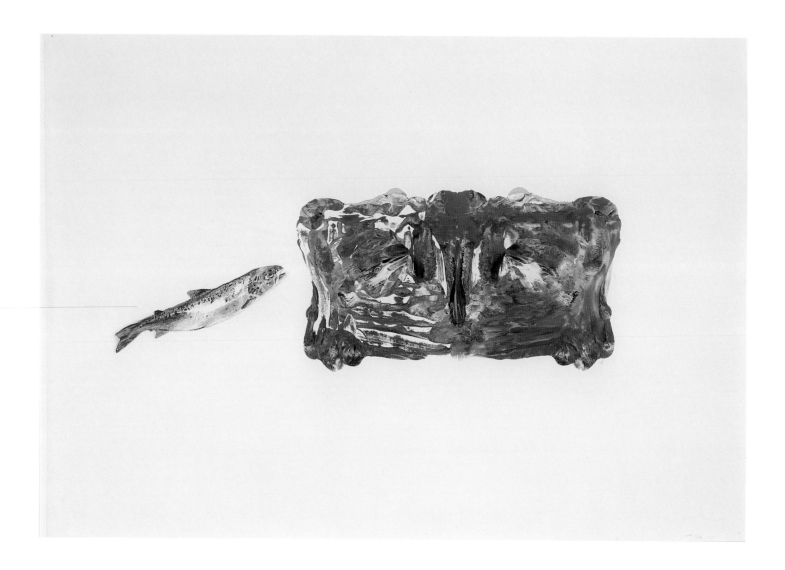

Grenville Davey

Eye, 1996
Sugar-lift aquatint
75.7×57.2 cm
(30×22 ½ in.)
Edition: 1/40

Grenville Davey, who won
the Turner Prize in 1992,
plays with eyes. The tool
for seeing becomes an
object and is arranged
à la Lisa Milroy or Warhol.

Alan Davie

Celtic Landscape No. 2,
1996
Gouache on paper
66×56 cm (26×22 in.)

The emergence of land-scape in the work of Davie, who was once the most abstract of British painters, is largely due to the repetition of certain forms that recur in many of the early cultures that the artist has studied over the years.

Celtic Landscape No. 2,
1996
Gouache on paper
66×56 cm (26×22 in.)

Jonathan Delafield Cook

Hackberry Butterfly, 2000
Oil on board
35.5×35.5 cm (14×14 in.)

Delafield Cook has never
faltered in his interest
in nature. *Hackberry
Butterfly* demonstrates
his Australian roots with
its similarities to
Aboriginal work, but
above all it shows his
direct study of the
butterfly's wings.

"The River Taw flows downwards from the high ground of North Dartmoor to where it meets the North Devon coast near Barnstaple. It is alive and constantly changing, and at the same time could be seen as one long transparency through which an infinite number of images might be printed by treating the landscape as a darkroom, and working at night. Submerging light-sensitive paper just below the water's surface and exposing it to a brief flash of light, flow forms, trailing branches, cascades and gravel are all exposed directly on to the paper. Once processed, such transient events become visible memory traces within the print – as complex as thinking itself. Both arise out of a flowing movement – creating forms, containing and dissolving them in an endless succession of changing states."

Susan Derges , May 2000

214

Susan Derges

Shoreline, 4.9, 1997
Panel of four unique
Cibachrome photograms
178×104.5 cm (71×41 in.)
each panel

Blaise Drummond

A House in the Woods,
1995
Pencil on paper
56×56 cm (22×22 in.)

"In general terms, it is my
ambition to make work
that is at once accessible,
thought provoking and
conceptually rigorous …
Primarily, the work is
prompted by concerns of
the wider world and how
we occupy it … I hope the
work is also quite funny
and sort of sad."[1]

1 Blaise Drummond, 'Blaise
Drummond', *Art Review*, LII,
March 2000, p. 47.

Garry Fabian Miller

Sections of England:
The Sea Horizon, No. 6,
1976–77
Cibachrome photograph
48.5×48.5 cm (19×19 in.)

Sections of England:
The Sea Horizon were
taken from Fabian Miller's
window overlooking the
Severn Estuary with a
Hasslebad camera. Later,
in 1984, he abandoned
the Hasslebad and simply
placed a beech leaf in
the head of his enlarger
and printed the results.

Stephen Farthing

Queen Margarita of Austria, 1996
Gouache on paper
67×61.5 cm
(26 1/2 × 24 1/4 in.)

The analogy between the state of the monarchy and painting is a dangerous one, but Farthing demonstrates that the figure can survive compositionally even after beheading. Just as Baselitz turned the image upside down, Farthing attacks the natural focal point, to force the viewer to concentrate on the picture as a whole.

218

Barry Flanagan

Monday, June 12, 1989
Ink on paper
55.5×76.2 cm
(22¼×30 in.)

Flanagan's work has
ranged from soft sculpture
in the style of *Arte Povera*
to his bronze hares.
Whether it depicts
Oblomov or Bacchus, this
Kitaj-esque drawing
shows Flanagan's refusal
to be pigeon-holed.

"I resist too much theory about my work, as I know it would make a jail for me. My only concept is one of painting. I am not interested in what a painting shows, but how it is done. I constantly expand my subject-matter, because I do not wish to be dominated by the subject, but when confronted with any one subject I am so consumed with the need to show that subject's properties that I often continue into a series. Sometimes I am interested in showing different aspects of one location or object, while at other times I am working again to show more of the same essence. When painting a garlic, for instance, I want those seeing the picture to be able to sense the touch of the thin silvery skin. You must feel the garlic.

I paint in series like a writer might make a diary. My reason for repeating an image is far removed from that of advertising or Warhol. I wish to reveal the spirit, not close it down.

When I come to a city I bring my fantasies with me. That is why I like to gain a high vantage-point of a city. It is easier to maintain one's dreams of a city when one is looking down from a good height. When I first came to London I arrived with ideas from films – Hitchcock, for instance – crime stories. In taking photographs from a tower or high point one is able to preserve this inner nostalgic preconceived vision of a city, which is warmer than other people's photographs.

I have recently done a series of London from the river. I came armed with the silvery bridges of Constable, but one is ripe for surprises. I found a bridge that I remembered from Sisley. I had thought it was on the Seine but it was in London. I took lots of photographs. I should have known because in my imagination both Paris and London are silvery but London is grey-silver while Paris is whiter.

I need to paint with a lot of freedom, but there is order within painting and order in nature and my other subject-matter. If I had to describe my method of work, it would be as *Informel* with order."

Ralph Fleck, March 2000

Ralph Fleck

Darmstadt 1/1, 1996
Oil on paper
100 × 75 cm (39 × 29 ½ in.)

Lucian Freud

Woman with an Arm Tattoo, 1996
Etching
59×81.2 cm (23 1/4×32 in.)
Edition: 37/40

Etchings reveal Freud's desire to pin down life. His two key models of the 1990s were the generous figures of the late performance artist Leigh Bowery and social worker Sue Tilley. In *Woman with an Arm Tattoo*, he attacks the mountainous flesh of Big Sue with all the relish of a spider who has caught a new juicy fly in its web.

Terry Frost

Olives for Aphrodite, 1996
Monotype
80 × 120 cm (31 1/2 × 47 1/4 in.)

"I try to give
expression to my
total experience."[1]

1 Terry Frost, quoted in *Spotlight on Terry Frost*, press release, London, South Bank Centre, 1998.

The Changing Shape of Clouds (1992)

In June of 1992 I walked from the south coast to the north coast of France in twenty-one days (from Narbonne-Plage on the Mediterranean Sea, 692 miles on roads north to Boulogne-sur-Mer by the English Channel).

The challenge of this particular walk was to attempt to finish on the day of the summer solstice – having started on the first day of June.

The first few days in the South were very wet, resulting in some flooding. This uncontrollable situation made it difficult to keep up with the required daily distances. (My average distance was about thirty-two miles per day for twenty-one consecutive days.)

Somewhere in the middle of France I was able to divide the remaining number of days into the remaining calculated distance – suddenly I had a precise plan. The daily objectives were now clear.

Walking through the grain belt of France in June, the main problem was dehydration, not rain. As navigation was minimal, my attention shifted from the constructed agricultural environment to the drifting clouds. The body chemistry of constant walking opened me up to absorbing – *The Changing Shape of Clouds*. (The road became peripheral.)

Although the atmosphere was filled with midsummer light, my lasting memory of 21 June was not sunlight, but car headlights strongly reflected on the wet roads leading to the sea."

Hamish Fulton, May 2000

Hamish Fulton

The Changing Shape of Clouds, 1992
Photograph with text
107×128 cm (42×50½ in.)

THE CHANGING SHAPE OF CLOUDS

A 20½ DAY 692 MILE ROAD WALKING JOURNEY FROM THE MEDITERRANEAN SEA TO THE ENGLISH CHANNEL

NARBONNE-PLAGE TO BOULOGNE-SUR-MER FRANCE 1-21 JUNE 1992

Anya Gallacio

Untitled from *SCREEN* portfolio, 1997
Screenprint
67×88 cm (34¾×26¾ in.)
Edition: 33/45

The original installation, from which this screen-print is derived, was composed of a massive pool of developing photographs. True to the Brit-Pack theme of connections, like Simon Patterson's Tube map and Tracy Emin's tent, it could have been called *Narcissi* as the art world peered in to see whether they could see their reflection. The dealer Anthony d'Offay, whose stare was given pole position, has not as yet taken the hint.

226

Andreas Gursky

Gardasee, Panorama, 1986–93
Cibachrome photograph
80×150cm (31¼×58½ in.)
Edition of five

Like Bernd and Hilla Becher, Gursky maintains a detachment from his subjects, but the scale of his vision reacts with this objectivity to demand a different response. Sweeping landscapes, trading floors, harbours and hotels dwarf the viewer.

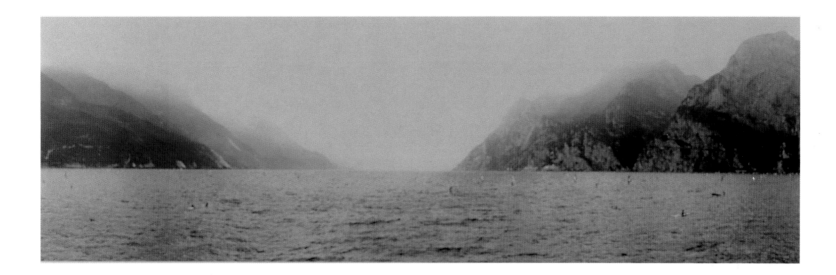

Richard Hamilton

I'm dreaming of a black Christmas, 1971
Screenprint on collotype
with collage
74.7×100 cm
(29 ¹/₂ × 39 ¹/₂ in.)
Edition: 124/150

I'm dreaming of a black Christmas is a neat inversion of *I'm dreaming of a white Christmas*, which was initially a simple enlargement of a colour negative of Bing Crosby.

228

Susie Hamilton

Figure LVIII, 1999
Acrylic on paper
75×57 cm (29 1/2 × 22 1/2 in.)

The single, rather threatening man provides Susie Hamilton's current subject-matter. With single-colour backgrounds enclosing the men in their environment, there is a strong echo of Francis Bacon.

Tom Hammick

Window, 1998
Oil on canvas
41×61 cm (16 ¼ × 24 in.)

Hammick's pictures, whether populated or not, usually concentrate on the lonely corners in modern life – a window, a staircase or even a urinal. In today's climate, flaunting the picture as a window, so breaking the laws on which modern American painting was built, is far more daring than the ironic reference to Duchamp and his portrayal of the urinal as a work of art.

Tom Hammick
Two Men in a Field, 1999
Oil on canvas
107×137 cm (42×53 ½ in.)

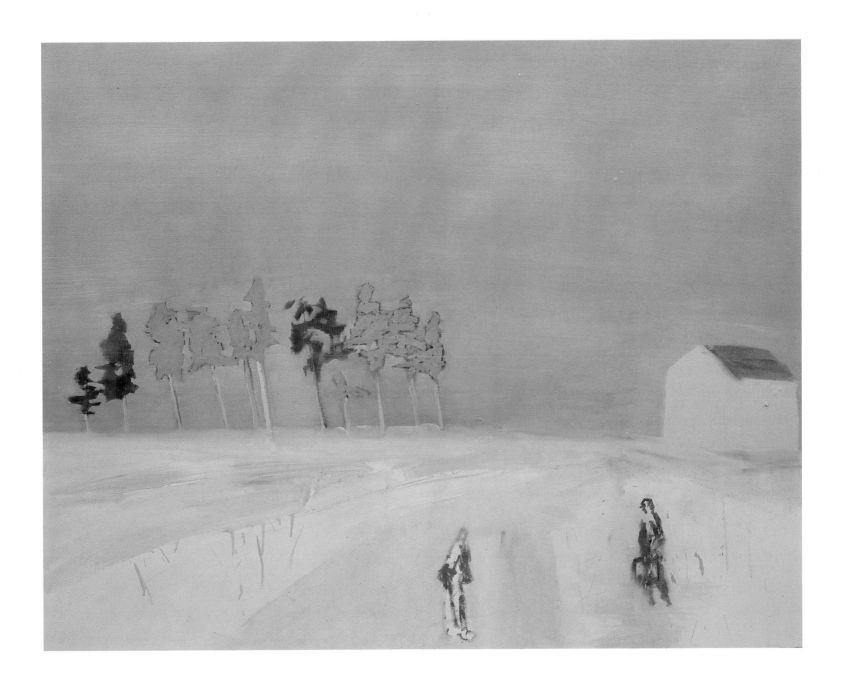

Claude Heath

Head, 1996
Ballpoint pen on
acid-free paper
68×48 cm (27¼×19¼ in.)

Heath works blindfolded
and feels his subject as
he draws – he simultan-
eously traces the object
with one hand while
drawing his responses to
it with the other. Keeping
his subject out of sight
ensures that he is not
influenced by any prior
knowledge about the
objects.

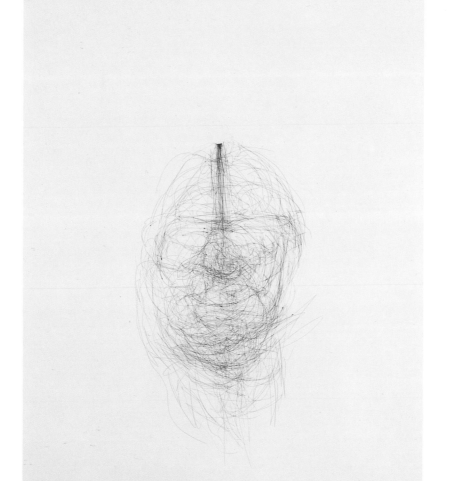

Tim Hemington

Untitled, 1995
Oil on paper
53.5 × 39.5 cm
(21 × 15 ½ in.)

Tim Hemington, who
lived and worked in Berlin
between 1991 and 1995,
is one of several young
British artists whose
abstraction is ultimately
based on the human
figure.

Barbara Hepworth

Three Forms, from the
portfolio *Opposing Forms*,
1969
Screenprint
78×58 cm (30¾×22¾ in.)
Edition: AP/60

This late print by
Hepworth shows how she
found a clear, vigorous
voice out of the debates
of Hampstead and St Ives.
She responded to Naum
Gabo's belief that one
should try to erase the
influence of the human
hand.

234

Patrick Heron

May 14, 1987
Gouache on paper
31.1×40 cm (12 1/4×15 3/4 in.)

Heron was one of the first
Europeans to champion
American Abstract
Expressionism, and he
became deeply embroiled
in the debate over the
British contribution
to the new abstraction.

Roger Hilton

Untitled, 1973
Gouache and charcoal
on paper
34.5 × 43 cm (13 ½ × 17 in.)

Untitled was painted in Hilton's last years, when he was ill. Many drawings at this stage were actually executed in bed, but this did not detract from their energy, and, if anything, added to it. Even at this stage he was drinking a great deal and was abrasively funny. As Frances Spalding writes, "Humour entered his late work when, confined to bed during the last two-and-a-half years of his life, he found emotional release through the painting of gouaches in which hectic colours and childlike drawing combined with his aesthetic cunning and immense zest for life".[1]

1 Frances Spalding, *Dictionary of British Art, VI: Twentieth-Century Painters and Sculptors*, Woodbridge (Antique Collectors' Club) 1991, p. 239.

236

David Hiscock

Stroke (Grass), 1997
Iris print
84 × 114 cm (33 × 45 in.)
Edition of ten

Hiscock has proved that Cubism comes more naturally to photography than to painting. By mechanically moving the camera over a long exposure, it scrolls across the chosen subject, in this case grass, to give a many-sided image.

Ivon Hitchens

Storm Cloud over a River,
1963
Oil on board
46 × 112 cm (18 × 44 in.)

Hitchens evolved a
formula style for his
abstracted landscapes.
By the time he painted
Storm Cloud over a River,
at the age of seventy, he
had long been a forceful
figure in the British art
world. At this time of his
life he lived in 'Turner
country' near Petworth
in Sussex.

238

David Hockney

Lithograph of Water Made of Thick and Thin Lines and Two Light Blue Washes, 1978–80
Lithograph
57×76.3 cm (22 ½ × 30 in.)
Edition: 17/40

From the mid-1960s Hockney has helped turn the Hollywood swimming pool into one of the icons of the twentieth century, yet he made no prints of the subject until 1978. By giving a "cumbersome but literal accurate title" to this work and others of the same series, Hockney was, according to Marco Livingstone, directing the viewer to "the artifice by which such a convincing picture of the world has been produced".[1]

1 Marco Livingstone, 'David Hockney', *Signature Pieces*, exhib. cat., ed. Alan Cristea and Kathleen Dempsey, London, Alan Cristea Gallery, 5 January– 6 February 1999, p. 18.

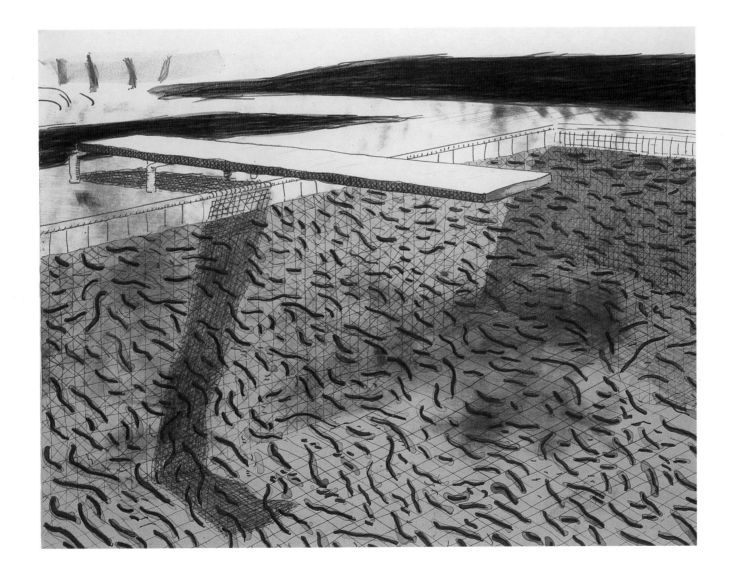

Howard Hodgkin

Venice, Evening, 1995
Sixteen-part hand-painted
etching and aquatint with
carborundum printed
from five plates
160 × 196.5 cm
(62 1/2 × 76 3/4 in.)
Edition: 44/60

Venice has triggered a
number of Hodgkin's
paintings and prints. The
artist has always claimed
that he is not an abstract
artist as his work refers
to a specific event or
location. *Venice, Evening*
is one of four large
etchings that illustrate the
same view of Venice at
different times of the day.
Andrew Graham-Dixon
says Hodgkin's Venice
paintings are "a painter's
way of talking about the
sad inevitable passage of
time and the change-
ability of all things".[1]

1 Andrew Graham-Dixon,
Howard Hodgkin, London
(Thames and Hudson) 1994, p. 62.

240

K.H. Hödicke

Untitled, 1985
Gouache on paper
100×70 cm (39×27½ in.)

Hödicke's response to
living in a divided Berlin
was to paint with simple,
cheap colours and recall
the life around him. He
was a catalyst of *Zeitgeist*.

Shirazeh Houshiary

*Count me not one of
these men; recognize a
phantom circling; If I'm
not a phantom, o should,
why do I circle about the
secrets? Rumi*, 1990
Mixed media on paper
127.5×111 cm
(50¹/₄×43³/₄ in.)

242

John Houston

Evening Sky over the Sea,
1998
Watercolour on paper
64×101.5 cm (26×40 in.)

The recurring theme in
John Houston's work is
the sea's horizon. At
different times of day and
at different locations
around Scotland, he
returns again and again to
the same subject-matter.
He is obsessed with the
effect that light and water
have on each other.

Paul Huxley

Untitled, 1989
Screenprint
53×46 cm (21×18 in.)
Edition: 18/20

Paul Huxley was
Professor of Painting at
the Royal College from
1986 to 1998.

244

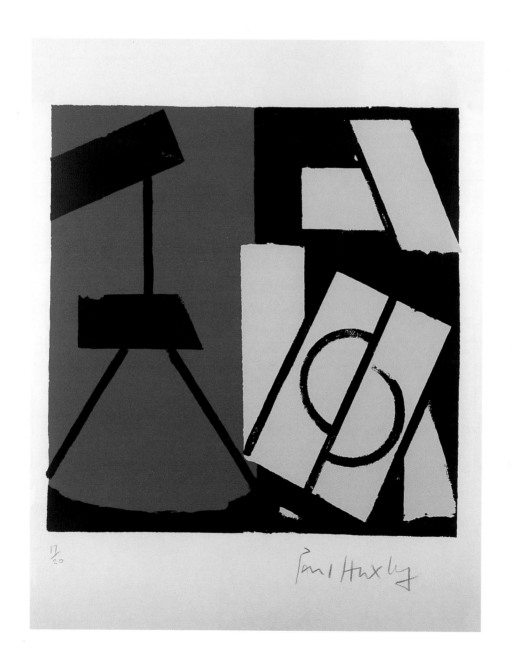

Jörg Immendorff

245

EINSAM + DOOF der Unbesiegbare Jörch, dein Notenschlüssel (LONELY + DUMB the Unbeatable Jörg, your Treble Clef), 1995
Pencil and watercolour on paper
29.6×21 cm (11³/₄×8¹/₄ in.)

Immendorff pays homage to his former teacher, the felt-hatted Joseph Beuys. In an act of self-depreca-tion he depicts himself as a dumb and lonely but impish child dragging a forbidden paintbrush behind him. Beuys has shown the way forward but the raised eyes of the young Immendorff are looking for excuses, ways of avoiding doing as his father figure instructed.

Bill Jacklin

Benches, Coney Island,
1991
Conté crayon on paper
22.8 × 29.2 cm
(9 × 11½ in.)

"My paintings are all about things in flux", says Jacklin. "When I was a student I wrote my thesis on Rauschenberg because I was interested in the fragmentary nature of the phenomenological world as it comes to you, and how can you make sense of that … In that respect, it's about an interest in questioning the nature of what is real. I'm specifically interested in rhythm and motion. How do you paint motion? How do you paint flux, change and transition?"

1 Bill Jacklin, quoted in Phoebe Hoban, 'The Connected Image', *New York City, The Connected Image 1997–99*, exhib. cat., New York, Marlborough Gallery, 1999, p. 2.

246

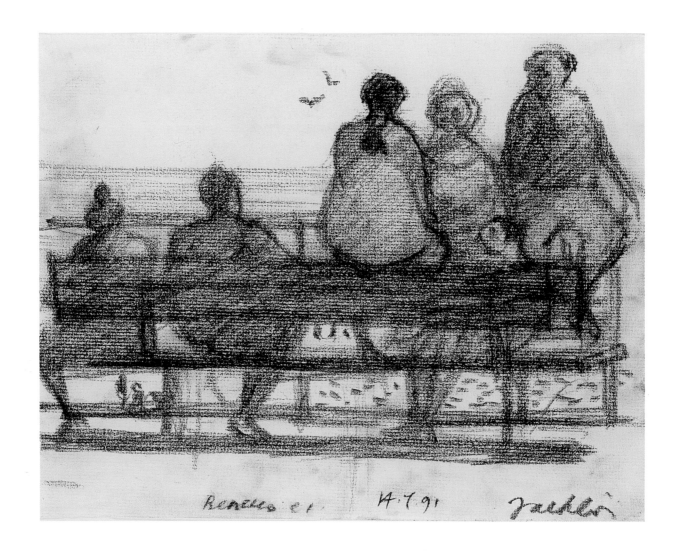

Bill Jacklin

Coney Island Incident,
1992
Softground etching
and aquatint
44 × 54.5 cm
(17 1/4 × 21 1/2 in.)
Edition: 1/2

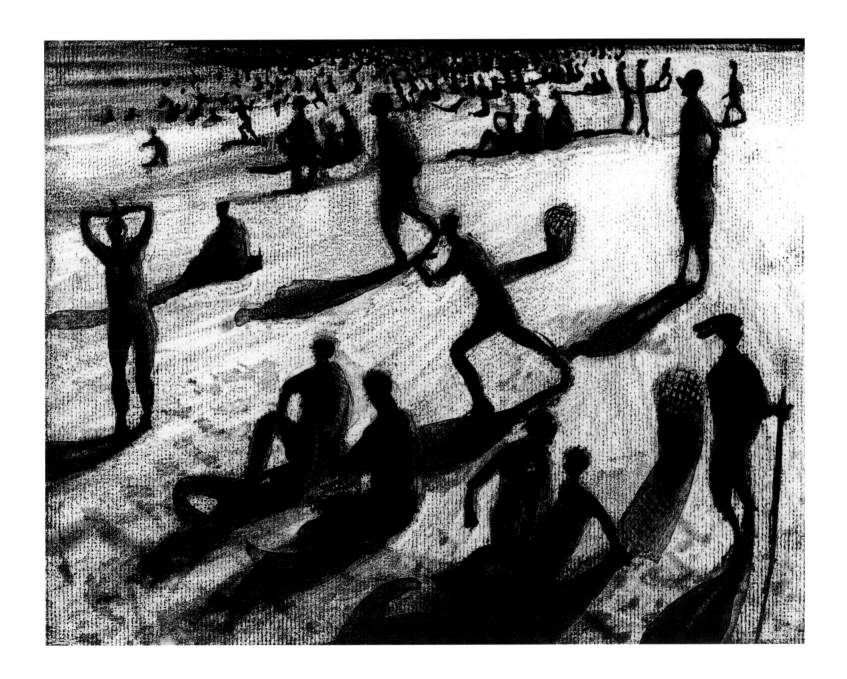

Andrzej Jackowski

Two Narrow Beds, 1999
Oil on canvas
152.2 × 193 cm
(60¾ × 75½ in.)

As soon as Andrzej Jackowski's father settled in a place he would plant a garden. It was his way of attempting to put down roots. In this painting one uprooted tree lies next to a bed of radishes. There appears to be a stark choice between an old and new culture, but neither would sustain us for long. In the same series of work the artist shows a mother and son on a single bed. Jackowski's work is about using the break in our culture for regeneration.

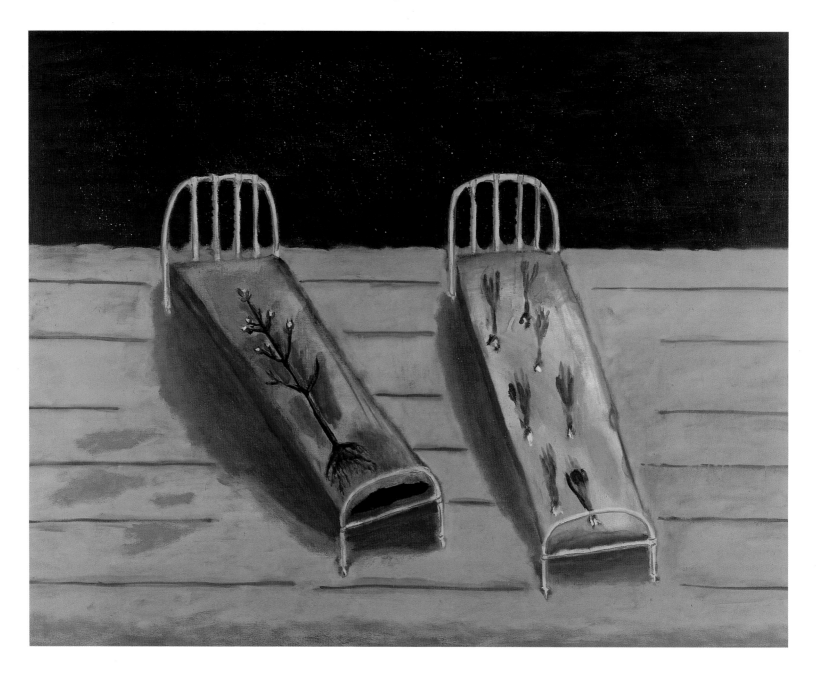

Glenys Johnson

Tree, 1999
Acrylic on canvas
140×97 cm (54³/₄×38 in.)

Glenys Johnson's study
of the vegetation at Point
Hill in Surrey continues
her fascination with trees,
most memorably demon-
strated at her exhibition
Forest, in which she
installed twenty-four
vertical paintings at the
Staatsgalerie Moderner
Kunst in Munich.

Glenys Johnson

Crowd, 1993
Watercolour and acrylic
on paper
120×86 cm
(46 1/2×33 1/2 in.)

250

Lucy Jones

Pink Walk, 1996
Oil on canvas
174.5 × 213 cm
(68 1/4 × 83 1/4 in.)

"The main difference between the self-portraits and the cityscapes is that I am not looking directly at myself", says Lucy Jones in comparing her two main subjects. "With the cityscape I am looking out on the world that is common to everyone, but my experience of the world is of course different – chaotic and difficult. It is this difference that is reflected in the cityscape paintings … I have hardly ever put figures in the landscapes as this would suggest a narrative."[1]

1 Lucy Jones, quoted in Judith Collins, 'Extracts from an Interview between Lucy Jones and Judith Collins', *Lucy Jones*, exhib. cat., ed. Sarah Howgate, London, Flowers East, 24 January –23 February 1997, p. 6.

251

"Deep space is one of the things we associate with the sublime. The eye is drawn into the distance, as with Caspar David Friedrich. The viewer is invited out of himself, to gaze in a moment of wonder. I want to bring this experience home, to make it as intimate as possible, as physical and bodily as possible. It is as if the sublime is an internal experience and not an external one. Many of the works that I have made use concave form and deep, dark colour. I wondered if a mirrored surface could do the same thing by returning the gaze – and in so doing, include the reflected image of the viewer. Could a mirrored volume speak of something akin to the deep space of the traditional sublime? I find that it can. This is perhaps a modern sublime. The gaze returned. *Turning the World Upside Down III* is a work made with these thoughts in mind. It is simultaneously full and empty, a real sculptural volume and a hole in the space. It is physically present and yet camouflages itself in the surrounding space."

Anish Kapoor, June 2000

Anish Kapoor

*Turning the World
Upside Down III*, 1996
Stainless steel
250×250×225 cm
(97³/₄×97³/₄×87³/₄ in.)

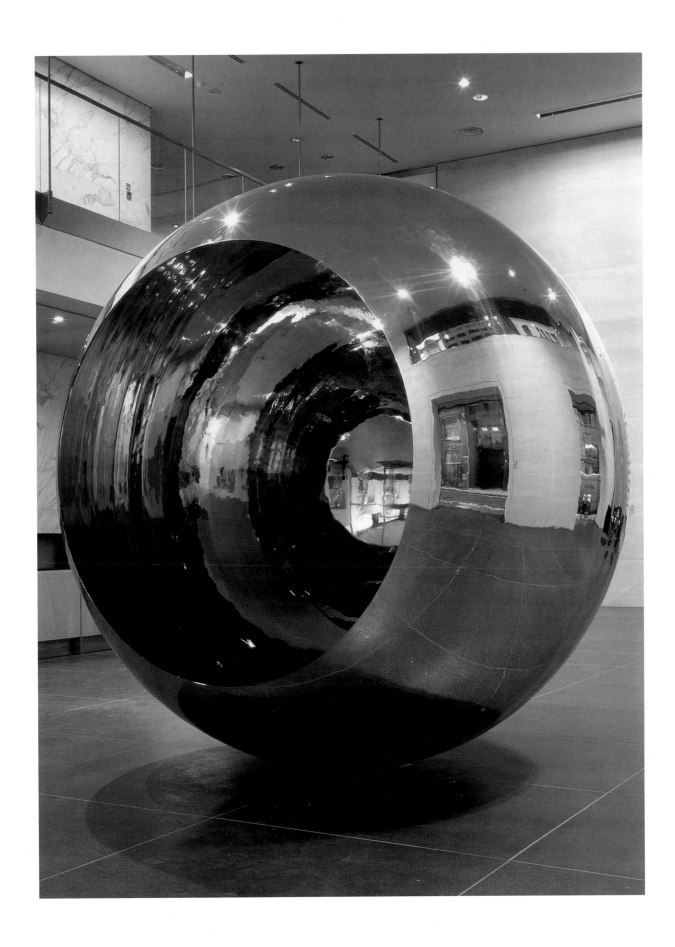

Michael Kenna

*Ratcliffe Power Station,
No. 12*, 1986
Black-and-white
photograph
18 × 25.5 cm (7 × 10 in.)

The Ratcliffe towers in
Oxford were the subject
of one of the most famous
of Kenna's images, but
since his move to
America, he has found
similar industrial scenery
in Michigan.

Stefan Kern

Untitled, 1996
Colour pencil and pencil
on transparent paper
45×65.2 cm
(17³/₄×25³/₄ in.)

"Stefan Kern is a maniac.
On Saturdays he gets up
at four in the morning, on
Sundays he sleeps in until
half past six. It could be
an inner restlessness –
or unbridled energy – that
denies him the suppos-
edly so healthy eight
hours' sleep. In any case,
few artists are as uncom-
promising and ruthless
with themselves and
their own resources as
Stefan Kern."[1]

1 Jan Winkelmann, 'Stefan Kern
– Sculpture as Catharsis', German
Open, exhib. cat., ed. Veit Görner
and Annelie Lütgens,
Kunstmuseum Wolfsburg, 2000,
unpaginated.

"It was a labour at art school, a big effort in learning – not that the art school as a whole was encouraging or sympathetic to this – to explore what had happened in the twentieth century. Then it was just a matter of finding one's feet, but looking back it appears I was trying to get to the roots and basic elements of painting. I believed that this had not happened enough in British painting.

Cubism seemed the most crucial thing of all. But then, out of these signs or elements come differentiations, which we call imagery. Klee became one of the most central of all artists to me. He still is and is close to my mind when I look at Kiefer and Polke. As for the Americans, there seemed something profound in Abstract Expressionism, and, following Pollock, in the radiance of independent colour in works by Helen Frankenthaler and Sam Francis and others. Not that I feel able to respond to a great deal of their work, but when the singing of colour happens, it seems so deep and important.

Yet isn't it a contradiction to be so admiring of the singing quality of colour and still be involved with imagery and all the baggage it caries? Yes, it's a weird mingling of forces that each carry their own meaning. Yet painting without imagery has its problems also.

All the same, if there were a battle between colour-in-itself, or shape-in-itself, and on the other hand colour-as-subordinate-to-storytelling, or shape-as-subordinate-to-the-shape-things-'really'-are – and if only one side could survive, it would have to be colour-in-itself and shape-in-itself – and Kandinsky's position in *Concerning the Spiritual in Art* would seem to me the right one. But that isn't the situation, so Klee matters more to me than Kandinsky.

Storytelling might indeed weaken and contradict the singing and meaning of colour, but I don't see paintings as storytelling, not now, not after the twentieth century. With Polke, for example, it is so obvious that colour is important, imagery is, and that it is in a modern context. If my own efforts have to be rather quiet, and not very large, it's difficult for me to know whether that is a sign of weakness; because if it is genuine it could be a kind of strength."

Ken Kiff, March 2000

Ken Kiff

*Volcano and Quiet
Colours*, 1999
Watercolour on paper
28 × 29.2 cm (11 × 11½ in.)

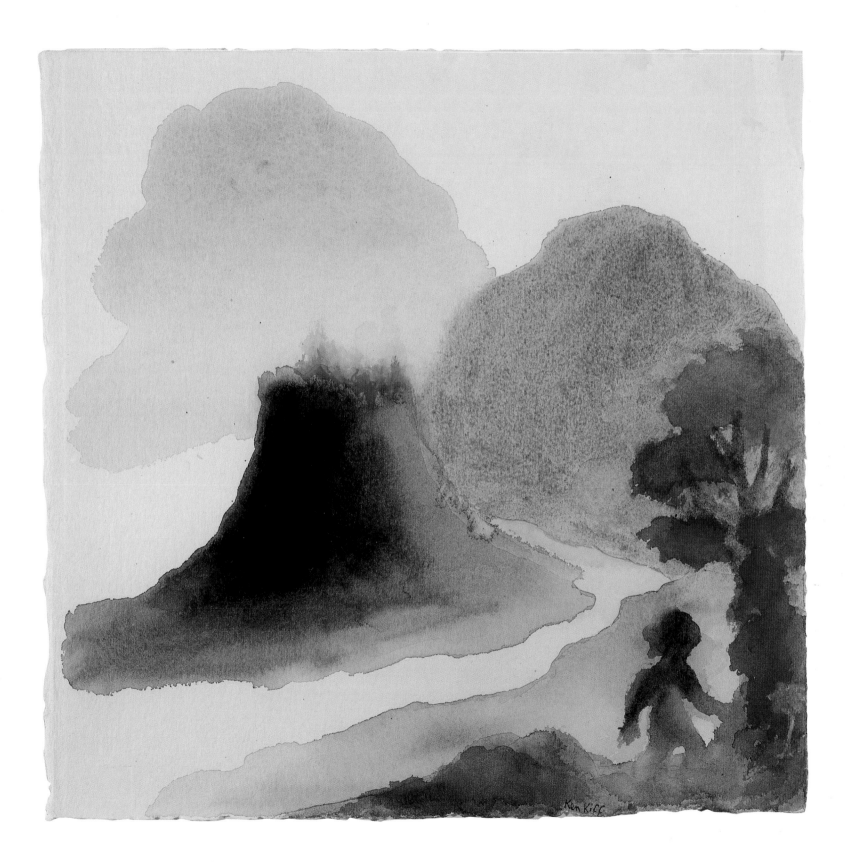

Oskar Kokoschka

Battersea Power Station,
1967
Lithograph
63.5×90.8 cm (25×36 in.)
Edition: 65/75

Born in Austria in 1886
into a family of Prague
goldsmiths, Kokoschka
spent much of his life in
exile. His presence in
Britain helped shake the
country out of its artis-
tically provincial state.

Leon Kossoff

Fidelma No. 2, 1982
Charcoal and coloured
chalk on paper
115.6 × 80 cm
(45³/₄ × 31¹/₂ in.)

"The subject, person or
landscape, reverberate,
in my head unleashing
a compelling need to
destroy and restate.
Drawing is a springing
to life in the presence of
the friend in the studio or
in the sunlight summer
streets of London from
this excavated state and

painting is a deepening of
this process until, moved
by unpremeditated visual
excitement, the painting,
like a flame, flares up
in spite of oneself, and,
when the sparks begin
to fly, you let it be."[1]

1 Leon Kossoff, quoted in
an untitled statement of Spring
1986, in *Leon Kossoff*, exhib. cat.,
London, Anthony d'Offay Gallery,
9 September–8 October 1988,
unpaginated.

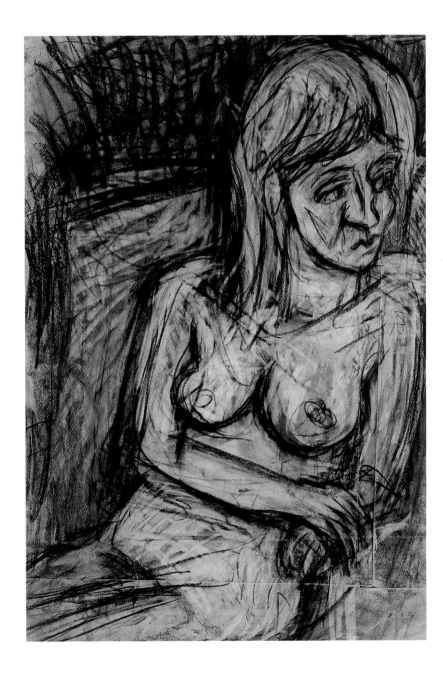

Christopher Le Brun

Brünnhilde, 1994
Monoprint
189 × 216 cm
(75 1/2 × 86 1/2 in.)

In 1994 a private collector commissioned Le Brun to make four large paintings on the theme of Wagner's *Ring* cycle. The artist continued this theme into the Wagner print portfolio. This large monoprint is one example.

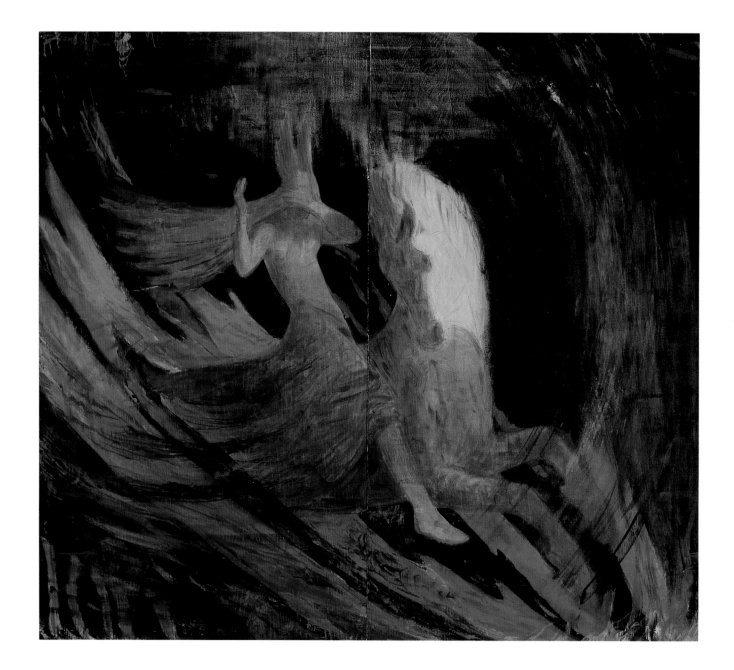

Sol LeWitt

Wall Drawings #580.
Tilted Forms, 1988
Double drawing with
colour ink washes
superimposed and
black grid
1212×572 cm
(473 1/2 × 111 3/4 in.)

Sol LeWitt's drawings in
1 Appold Street, London,
were erected as part of
the Broadgate Estate's
artistic programme. They
were applied in strict
adherence to the artist's
wishes. LeWitt explains
that "the idea or concept
is the most important
aspect of the work. When
an artist uses a concep-
tual form of art, it means

that all of the planning
and decisions are made
beforehand and the exe-
cution is a perfunctory
affair".[1] It was an impor-
tant aspect of the work
that the panels were
painted according to the
artist's instructions, but
not actually by him.

1 Sol LeWitt, 'Paragraphs on
Conceptual Art', *Artforum*,
Summer 1967, p. 80.

Art as a formal and holistic description of the real space and experience of landscape and its most elemental materials

"Nature has always been recorded by artists, from prehistoric cave paintings to twentieth-century landscape photography. I, too, wanted to make nature the subject of my work, but in new ways. I started working outside, using natural materials such as grass and water, and this evolved into the idea of making a sculpture by walking.

Walking itself has a cultural history, from pilgrims to the wandering Japanese poets, the English Romantics and contemporary long-distance walkers. My first work made by walking, in 1967, was a straight line in a grass field, which was also my own path, going 'nowhere'. In the subsequent early map works, recording very simple but precise walks on Exmoor and Dartmoor, my intention was to make a new art that was also a new way of walking: walking as art. Each walk followed my own unique, formal route, for an original reason, which was different from other categories of walking, like travelling. Each walk, though not by definition conceptual, realized a particular idea. Thus walking – as art – provided an ideal means for me to explore relationships between time, distance, geography and measurement. These walks are recorded or described in my work in three ways: in maps, photographs or text works, using whichever form is the most appropriate for each different idea. All these forms feed the imagination, they are the distillation of experience.

Walking also enabled me to extend the boundaries of sculpture, which now had the potential to be deconstructed in the space and time of walking long distances. Sculpture could now be about place as well as material and form.

I consider that my landscape sculptures inhabit the rich territory between two ideological positions, namely that of making 'monuments' or, conversely, of 'leaving only footprints'.

Over the years these sculptures have explored some of the variables of transience, permanence, visibility or recognition. A sculpture may be moved, dispersed, carried. Stones can be used as markers of time or distance, or exist as parts of a huge, yet anonymous, sculpture. On a mountain walk a sculpture could be made above the clouds, perhaps in a remote region, bringing an imaginative freedom about how, or where, art can be made in the world."

Richard Long, January 2000

Richard Long

Wind Stones, 1986
Offset lithograph and silk
screen on white board
60×80 cm (24×31 in.)
Edition: 31/90

WIND STONES

LONG POINTED STONES

SCATTERED ALONG A 15 DAY WALK IN LAPPLAND
207 STONES TURNED TO POINT INTO THE WIND

1985

A QUIET DRY DARK REST OUT OF THE WIND

"... tracking the poetic entry-points into the psyche of the city.

Sartre warned in *Nausea* that one is not always prepared for the moment. 'I have gone out of range of the street lamp; I enter the black hole. Seeing my shadow at my feet melt into the darkness, I have the impression of plunging into icy water.'[1]

In my earlier work, *A Modern Project,* the city was the site for the pleasures and terrors of vertiginous sensations, the urgency of being thrown, *geworfen*. In my current work, *Liebeslied*, these hard urges give way to a slow immersion, conceiving a different encounter with the urban space.

Liebeslied concentrates on the liquid, the fluid incontinences within the city. As in *Die Ziehende Tiefe/The Wandering Depth*, where a slip of translation occurs, when the German word *ziehen* reveals its double meaning in relation to the river: wandering and pulling. The camera's long exposure liquidizes the columns of the bridge. These columns are important with their obtuse relationship to reality, reflected in the solid surface of the water. The journey of the river is the experience of itinerancy, of 'being-in-the-unhomelike', the importance of the migration.

In *Das Offene Schauen/Seeing the Open*, time zones collide. This empty place, an *Abgrund*, still bears traces of remembrance as well as potential. The glinting puddles reflecting a future for this site. The home/the impossible dwelling is liquidized.

Through the *Liebeslied* series resonates an apparent absence – only the footprints on the muddy steps of *Nach Innen/In Deeper* are left of the encounter. This emptiness is there to be inhabited by the viewer. The public sphere is taken on and understood as a place of concealment and disclosure. Sometimes, as in *Versuch der Betörung/The Attempt of Seduction*, there is literally a window open"

Rut Blees Luxemburg, March 2000

1 Jean-Paul Sartre, *Nausea* [1938], London (Penguin Books) 1988, p. 42.

Rut Blees Luxemburg *A Modern Project*, 1996
Cibachrome print
mounted on aluminium
91.5×114.5 cm (36×45 in.)
Edition: 3/5

Tim Macguire

Peach, 1995
Lithograph
49×49 cm (19 1/4 × 19 1/4 in.)

In the mid-1990s
overblown fruit was
Macguire's signature.

266

David Mach

Train-Rustic, 1997
Drawing and collage
on paper
81×117 cm (32×46 in.)

The brick train was com-
missioned as a landmark
for Darlington in 1994.
It sits on the edge of the
A66 heading into
Darlington, the home
of the railway. Mach
developed this collage
format, where he cuts out
images from magazines,
to demonstrate to
potential patrons how
his sculptures might look
in the 'real world'.

Alice Maher

Dance, 1997
Etching
43×34 cm (17×13¼ in.)
Edition: 4/25

The main thread running through Irish artist Alice Maher's work is hair. She makes installations of hair, large drawings of hair, but in this etching of an Irish dancer the head of hair is largely, teasingly, hidden.

4/25 'dancer' Alice Maher

**Alice Stepanek and
Steven Maslin**

The World Around I, 1991
Gouache on lightweight
board
25×31 cm (9³/₄×12 in.)

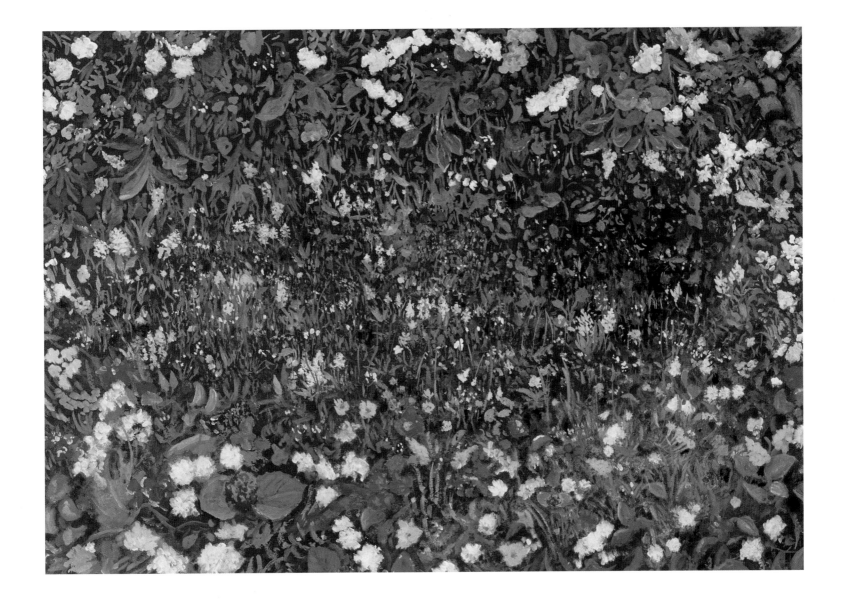

Alice Stepanek: Nature is our starting-point …

Steven Maslin: … and trees have become our central theme. In the early eighties one had the feeling that no-one was looking at nature in an engaged or, dare one say, emotional way.

Alice Stepanek: Nature, and the 'wellness' it instils, were simply unwished or overlooked in the art world after the fifties. We are rebelling against the artefact, the indoors …

Steven Maslin: … and went outside, to the outward form of nature. We involved ourselves in a form of representation that otherwise was being taken over by photography and began studying the 'surface' of Nature …

Alice Stepanek: … but this didn't result in a preoccupation with the materiality of painting. It was, and still is, the 'face' of the natural world, rather than the surface of the painting, or photographic source, that is the key subject for us.

Steven Maslin: Nature was a forbidden territory. Somewhere I heard Greenberg even forbade green because it was the colour of landscapes.

Alice Stepanek: Our fascination with painting and nature led us to look closely at naturalistic artworks in our Western culture, beginning in the fifteenth century and running through to the late Romantic movements. We are less interested in art that glorifies the artist-hero, a picture of the artist that still seems so popular … through collaborating we are too aware of our different talents and inabilities, the 'genial artist' is rather foreign to us. We are more involved in a democratic learning process, our main emphasis is on the subject.

Alice Stepanek: Using our common interest but different cultural backgrounds, we introduced each other to a wide spectrum of work and influences. But somehow the focus remained on nature rather than art for art's sake. I would much rather go for a walk in the wood than go to a gallery.

Alice Stepanek: But we live in the city, the lack of nature gives us the urge to fill our indoor environment with natural images. In rural surroundings we would probably be just too content, or spend our time nurturing nature; perhaps in the future …

Steven Maslin: If I lived in the country I could imagine spending the whole day making portraits of trees, but we would lose the confrontation with our culture. I like to compare the way we work to a tree. First there is the trunk of an idea, but the image will be taken up, ideas develop just as the branches unfold, splitting right down to the smallest twig, and as it grows …

Alice Stepanek: … our ideas fuse …

Steven Maslin: … melt, but also diversify.

Alice Stepanek: Nature is so diverse and we apppropriated it as our third-person imagination.

Steven Maslin: We were thinking about abstract problems of composition and decided to solve them by going back into nature – using the outside world rather than abstract concepts.

Alice Stepanek: We wanted to be more like scientists – observing nature …

Steven Maslin: … After a period of working outside we started to play with the images, to re-form our material, a process of manipulation that painters have been using long before the invention of the computer.

Alice Stepanek: The advantage we have over the scientific work process is using our association and fantasy …

Steven Maslin: And in this process we find a fascinating repetition, both microscopically and macroscopically.

Alice Stepanek: Our paintings are collages of these different forms of nature, which themselves become artefacts. Our more recent work refers to modern phenomena such as speeding through the environment, the cloning of individuals, or simply setting artificial light into the darkness …

Alice Stepanek and Steven Maslin, March 2000

Katharina Mayer

Séance, 1998/2000
Cibachrome photograph,
Diasec
165×125 cm
(65 ½ × 45 ½ in.)
Edition: 2/3

Katharina Mayer studied
under Bernd Becher, as
well as Nan Hoover, at
the Staatliche Kunst-
akademie Düsseldorf.
Her most recent series
show women looking
away from the camera
with their hair plaited.
The presence of the
women is emphasized by
their averted gaze.

272

Ian McKenzie Smith

Matsuri, 1997
Watercolour on paper
64×99.8 cm
(25¼×39¼ in.)

Like his fellow Scottish
painter, Alan Davie,
McKenzie Smith has
found inspiration for his
mainstream twentieth-
century abstract vision
from other cultures, in his
case those of the Far East.

Bruce McLean

Spotlight on the Horse,
1985
Acrylic on photographic
paper
160×122 cm (63×48 in.)

McLean made his repu-
tation as a performance
artist, but however
ironical his neo-
Expressionist phase
was, it meant he was
included in *Zeitgeist*.

Bernard Meadows

6 drawings for Sculpture (Cockerels), 1952
Pencil, watercolour and gouache
57.5 × 66 cm (22 ½ × 26 in.)

Meadows was a studio assistant to Henry Moore in the 1930s and 1940s. He was Professor of Sculpture at the Royal College of Art (1960–80) and later Director of The Henry Moore Foundation (1983–88).

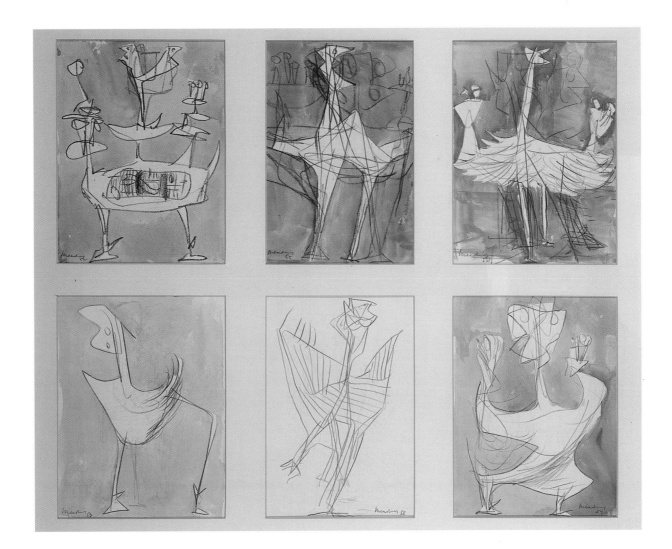

Matthias Meyer

Untitled, 1993
Oil on laminated
cardboard
20.4×26.3 cm (7³/₄×10 in.)

Meyer, a pupil of Richter,
paints "objective,
representational works
into which he introduces
the expressive abstract
gesture. Meyer's small oil
sketches, in particular
Untitled, 1993, are made
up of a few, often rather

broad brushstrokes,
which – for all their
spontaneity, and the runs
of paint caused by his use
of high-gloss cardboard
as a support – come
together every time to
form landscapes of
astonishing beauty."¹

1 Friedhelm Hütte, '"Constable
on Opium": Aspects of
Contemporary Landscape
Painting', *Contemporary Art at
Deutsche Bank, London*,
Frankfurt (Deutsche Bank) 1996,
p. 86.

276

Lisa Milroy

Sky 1, 1997
Monotype
68.5×50 cm (27×19½ in.)

Milroy's visit to Africa
resulted in her bursting
out from the restriction of
her earlier style. *Giraffe*
and *Sky 1, 4, 5* and *6* (all
1997) broke free from
her previous regimented
rows.

Daro Montag

Yew, 1997
20 framed Ilfochrome
prints
Overall size 165×172 cm
(64 1/2 × 67 in.)

Montag subverts the
normal photographic
process. He starts with an
already-exposed film. In
this work he placed yew
berries on old film and
buried them both
together. Digging the
work up, the transparen-
cies reveal the chemical
reaction between the
berries and film over a
varied period of time.
His images are the result
of the activity of micro-
organisms as they attack
the emulsion on the film's
surface.

278

Christa Näher

Untitled, 1982
Watercolour on paper
28×44 cm (11×17 ¼ in.)

Figures are half-
concealed by layers of
paint, and only emerge as
if reluctantly from the
pictures.

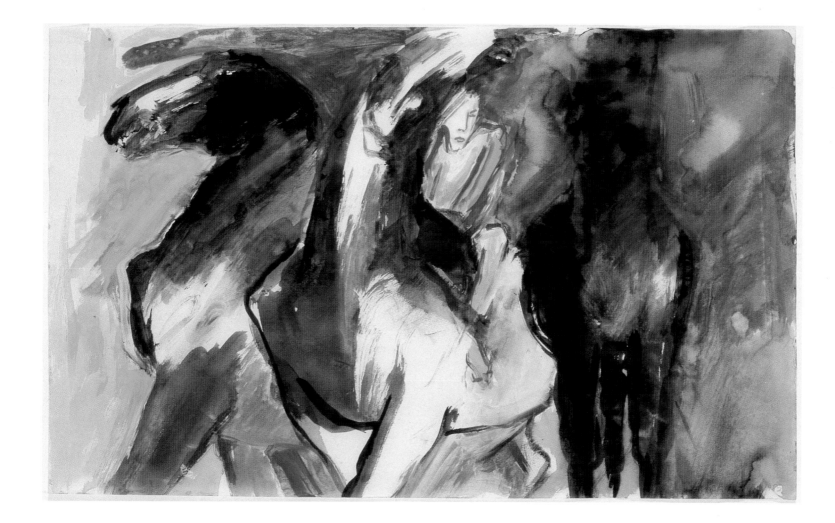

"Voltaire wrote that 'nothing is better known than the Siege of Malta'. This is no longer true, but something in the story at one time dominated the imaginations of men.

I have recently been preoccupied with the themes of history and memory and the selective way in which events are recorded and memorialized. The painter tries to represent the world in a true way, and this process involves excavations down towards that which is essential, an attempt to get beyond the surface veneer.

The small pictures in the *Great Siege of Malta* sequence were among the first attempts I made to introduce historical subject-matter into my work. It is done in a narrative, sequential form. I had become fascinated with the story after visiting the island and looking at the immense stone fortresses of the Knights of the Order of St John at Valetta.

One of the functions of these pictures, as well as giving pleasure to the eye, is perhaps to arouse our curiosity, to point a finger, so that we might wonder what exactly was 'the lesson in humanity' the Grand Master, Jean Valette, thought he was teaching to the besiegers of St Angelo when he ordered that the heads of his hundreds of prisoners should be removed, loaded into the fortress canons and fired into the enemy camp."

Hughie O'Donoghue, June 2000

Hughie O'Donoghue *The Great Siege of Malta,*
1997
Watercolour on paper
116×235 cm (45³/₄×93 in.)

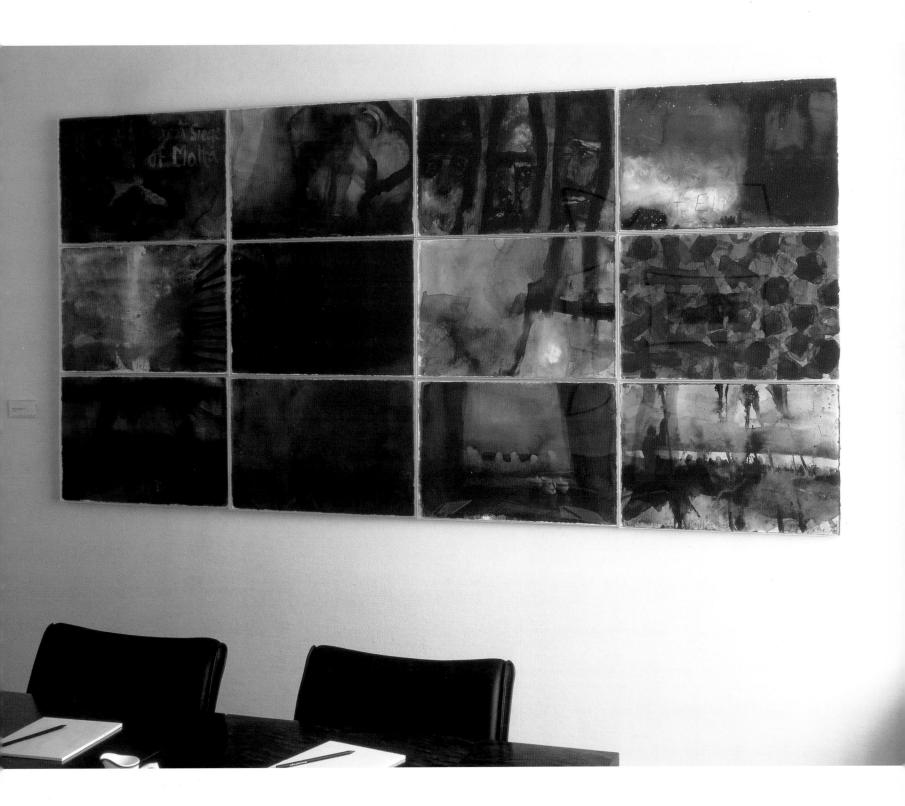

Julian Opie

Imagine You Are Driving,
1999
Screenprint
61×86 cm (23¾×33¾ in.)
Edition: 40/40

Opie made a painting of
the same title in 1993.
"I started the road
painting just after I got
back from driving 3,000
miles around Europe", he
explains. "I had also been
playing video games
quite a lot before that.
When you are driving
there is a feeling that you
are on a racetrack, which
is a simulation in a certain
sense because you are
behind a wide screen …

I'm interested in the
feelings created by very
functional spaces, where
there is a sense of alien-
ation and self-disgust
involved in being obliged
to give up your individ-
uality and power of
decision making. But
there is also something
I find very seductive and
charged about these
spaces."[1]

1 Julian Opie, quoted in
James Roberts, 'Tunnel Vision'
[interview], *Frieze*, 10, May 1993,
pp. 31–33.

282

Thérèse Oulton

New York No. 5, 1991
Watercolour on paper
24.4×18 cm (9×6¾ in.)

"Where the telescope ends, the microscope begins. Which of the two has the grander view?"[1] In quoting Victor Hugo in an Oulton catalogue, John Slyce was acknowledging that she was one of the first painters to turn away from the broad sweeping panorama and look to develop her own brand of abstraction in the spirit of the patterns found in the microcosm.

1 Victor Hugo, *Les Misérables. Saint-Denis*, Book III, Chapter 3, quoted in John Slyce, 'Thérèse Oulton: Stillness Follows', *Thérèse Oulton: Slow Motion*, exhib. cat., London, Marlborough Fine Art, 12 April–15 May 2000, unpaginated.

Ana Maria Pacheco

Transformations (V),
1998–99
Oil pastel on paper
147×150 cm (58×59 in.)

This large pastel is a
result of Ana Maria
Pacheco's time at the
National Gallery, London,
as Associate Artist
(1997–2000). Her Tales of
Transformations fuse
Brazilian myths and
Ovid's *Metamorphoses*.
The specific reference of
Transformations (V) is to
Ovid's sad story of
Cyparissus killing his
favourite stag by accident.

In his grief he turned into
a tree. The way the deer
sits on the ground is very
similar to that of the white
hart (Richard II's emblem)
on the reverse side of the
Wilton Diptych (1395–99)
in the National Gallery,
London.

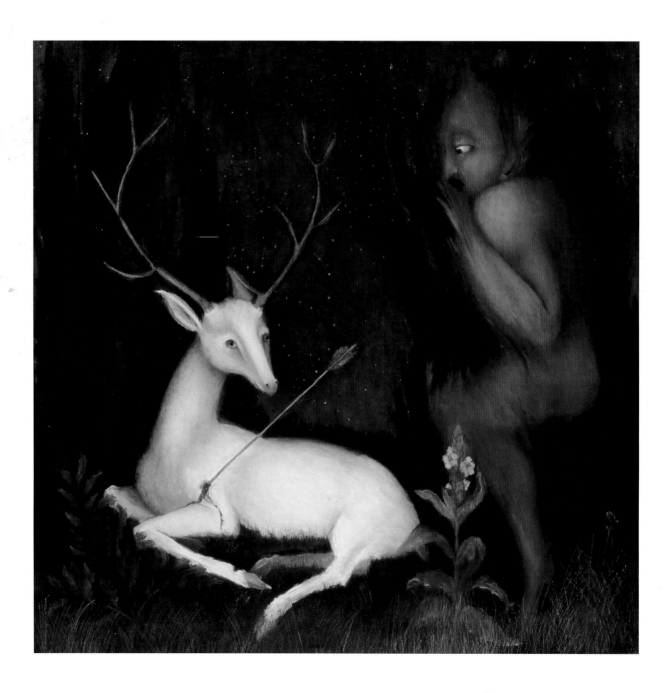

Cornelia Parker

Political Abstract.
Photomicrograph of the
surface and handle of
the Chancellor's Budget
Bag. With thanks to
H.M. Treasury, 1999
Set of 5 iris prints
76 × 56.5 cm
(30 × 22¼ in.) each
Edition: 1/5

Cornelia Parker is intrigued by power – its use and abuse. These photographically enlarged details of the Chancellor of the Exchequer's Budget case were taken as a commission for Arts & Business for their annual report. The Budget Box was made for William Gladstone, when he was Chancellor between 1859 and 1866, and, with due economy, has been repaired and used ever since by every Chancellor except James Callaghan and Gordon Brown.

Victor Pasmore

The Pulse, 1986
Etching and aquatint
105 × 249 cm (40 ½ × 99 in.)
Edition: AP10/90

When Pasmore took up abstract art in the late 1940s it was seen as an act of desertion by those both on the right and left of the art world, yet Pasmore's clear, clean abstraction was to become highly popular, as judged by the success of his 191 prints.

286

Celia Paul

Kate, 1995
Ink and pastel on paper
51.5×51 cm (20 1/4 × 20 in.)

Celia Paul's portraits
always illustrate people
that are close to her – her
immediate family and
close friends. Kate is one
of her four sisters, all of
whom sit for her and let
her reveal the haunting
intimacy between them.

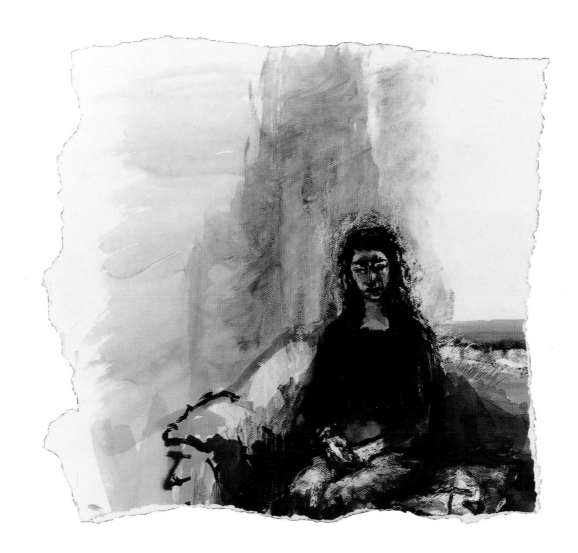

John Piper

Dorset Cliffs, 1948
Pen and black ink,
gouache and coloured
crayon
33.6×48 cm (13×19 in.)

John Piper's passion for
heritage led him away
from abstraction to an
almost encyclopaedic
record of Britain's
endangered landscape
and buildings. This dark
lowering view of Dorset
prompts the much-told
story of George V's
encounter with Piper and
his paintings of Windsor
Castle. Examining the
dark clouds above his
home in the paintings,
the king apologized for
the weather.

Michael Porter

Earth Tongues, 1992
Gouache on paper
34×30 cm (13 3/4 ×12 in.)

Michael Porter evokes the
idea of walking through
the country by catching
our eye with details.

Peter Randall-Page

Pitcher Plant, 1996
Charcoal on paper
76.1×56.8 cm
(29 3/4 × 22 1/4 in.)

"Drawing from nature, my own interest is less in accurate representation than in the embodiment of an emotional response."[1]

1 Peter Randall-Page, 'In Mind of Botany', *In Mind of Botany*, exhib. cat., ed. Contemporary Art Society, London, Royal Botanic Gardens, Kew Gardens Gallery, *et al.*, 13 September–28 October 1996, p. 3.

Libby Raynham

As Shadows Do, 1996
Watercolour on paper
52×73 cm (20¼×28½ in.)

"These are quiet paintings which at first glance may be overlooked."[1]

1 Libby Raynham, statement to the editors, 1999.

"There was a great advantage in painting in England as artists are left alone. There is more interest in art today, but when I was first here there were only a few people who really cared. I was living with one of them [her husband, the painter Victor Willing] – and there were his friends. I have never felt part of any movement. At the Slade you were supposed to practise figure drawing, but after the big American show at the Tate most people wanted to be abstract. You practically weren't allowed to be figurative, but the Slade was very good to me. I like stories, and although illustration was a dirty word at the time, my tutors didn't condemn narrative painting. They just advised me to paint what I knew about.

I was isolated after I left the Slade. I lived with Vic. He painted in one room and I painted in the other, and there were the children. We lived in Portugal for a while and it was during the end of this time that I discovered Dubuffet and Outsider art. It was like coming home.

As a woman I felt marginal to what was happening. I was only a girl. It suited me being marginal. I could be subversive. It was alright to come in the back door. I stood watching from the kitchen door. Just as I had earlier stood watching from the nursery door. I was only ever brought into the adults' rooms to perform. It was playing that was real to me. It is the ability to play that counts."

Paula Rego, May 2000

Paula Rego

Old Mother Hubbard (2),
1994
Unique handcoloured
etching
52×38 cm (20¹/₄×15 in.)
Edition: 2/5

Unique proof Paula Rego

Gerhard Richter

Untitled (Candle II), 1989
Oil on offset lithograph
59.3×62.5 cm
(23 1/4 × 24 1/2 in.)
Edition: 14/30

The fragile candle burns
brightly as if bearing
witness to Richter's
declaration that art is the
highest form of hope.

294

Bridget Riley

Study for Paean, BRB to RBR, 1973
Gouache on graph paper
23×52.5 cm (9×20½ in.)

Riley has carved out a position in the abstract world that is so clear that it has become almost unapproachable.

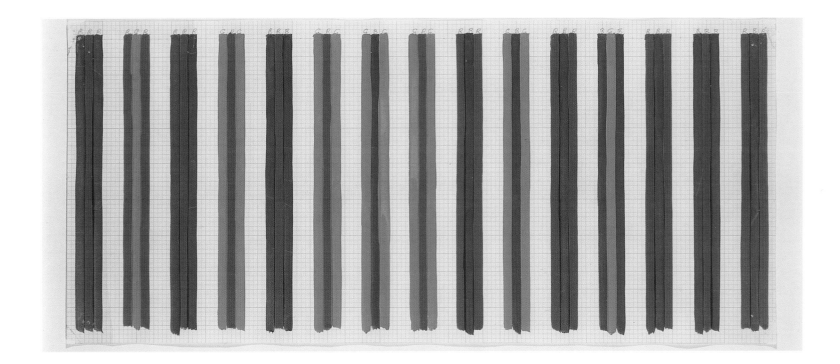

James Rosenquist

Swimmer in the Econo-mist (Painting 3), 1997–98
Oil on canvas
350×2750 cm
(136³⁄₄×1074¹⁄₄ in.)
Commissioned by
Deutsche Bank in
consultation with the
Solomon R. Guggenheim
Foundation for the
Deutsche Guggenheim
Berlin.

Commissioned for the
Deutsche Guggenheim
Berlin, this large canvas is
only one of three that were
designed to be shown
together as a 'wrap-
around'. The picture is
meant literally to engulf
you. The *Swimmer in the
Econo-mist* was designed
as a riotous reflection on
unchecked post-Cold
War consumerism.
Through this commission
Rosenquist wanted to
create paintings that
would reflect the Berlin

of today, not the divided
city of the past. Yet the
canvas is most certainly
split in two between the
black-and-white ghosts
of the past (shown, partly,
by Picasso's anti-war
painting *Guernica*) on the
left, and the brash exterior
of the present on the right.

296

Thomas Schütte

Untitled (Margerit in the Mountains, Switzerland), 1989
Watercolour and crayon on paper
49.5×64.5 cm
(19 1/2×25 1/4 in.)

"For some months now, I have been painting watercolours – for myself – while at the same time trying to develop ideas for major projects and exhibitions, with a view to getting a handle on the very few, maybe ten or so, basic problems, such as light-space, surface and structure, idea and material, etc. The repertoire concept is one I consider important. I'm constantly extending it. The backdrop to all this is a bid to create or design as complete a space as possible, one informed by a quality of experience, not just an intellectual punchline."[1]

1 Thomas Schütte, 1984, quoted in Ariane Grigoteit, 'Faszination der Berge', *Landschaften eines Jahrhunderts aus der Sammlung Deutsche Bank*, exhib. cat., ed. Ariane Grigoteit, Frankfurt, Deutsche Bank, 1999, p. 295. Translated from German by Steven Elford.

298

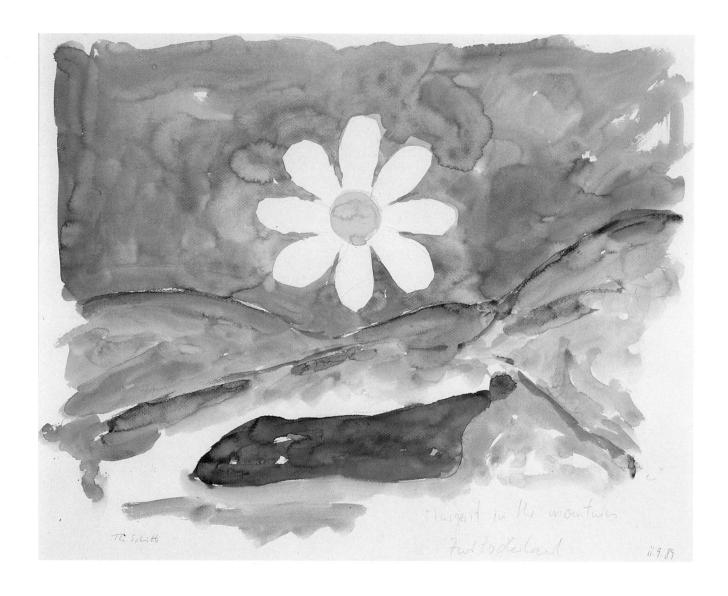

Colin Self

Peacock, from the Power
and Beauty series, 1971
Screenprint
67×99 cm (26×38¾ in.)
Edition: AP3/75

Colin Self's Power and
Beauty series might
appear to be a celebration
of the good life under
capitalism, but Self only
participated in Pop
because he saw it as a
working-class affront to
traditional fine-art élitism.

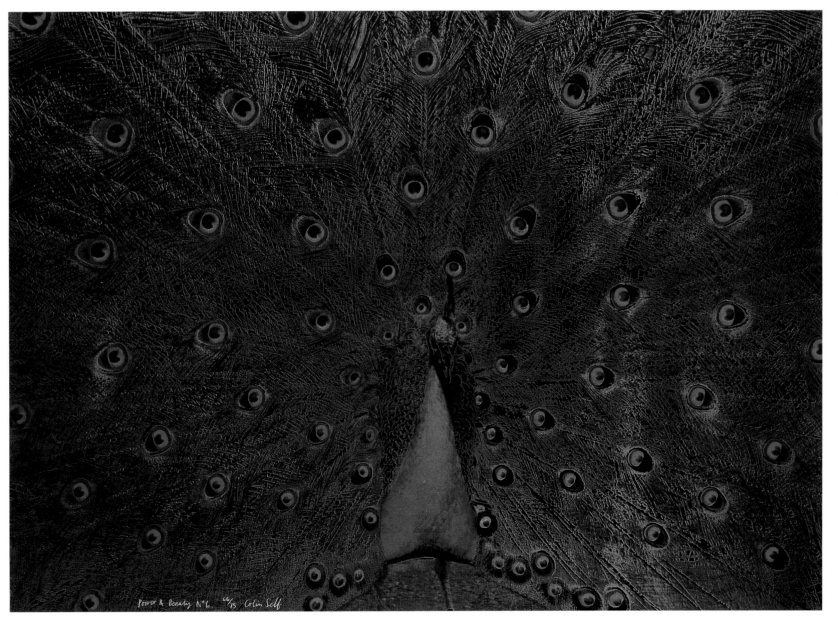

Power & Beauty N°6. ⁶⁶/75 Colin Self

"I believe in the art of painting, in its capacity as a medium of transport and as a vehicle for meaning.

A painting should be indifferent to the viewer's gaze. It should reflect and absorb light, illumine.

I use a linen support, sometimes with an *imprimatura*, paint fat over lean, wet into wet, with silence, exile and cunning; for, as the great *Künstler* Max Beckmann said: 'Genuine art just cannot be made effective through the hurly-burly and propaganda in a journalistic sense. Everything essential happens apart from everyday noise, only to attain a more far-reaching effect. The weak and unoriginal try to obtain a shabby fame for one day, and should get it. But this is not for us. One has to wait patiently for things to happen – most important is the silent show in your rooms.'"[1]

Arturo Di Stefano, May 2000

1 Max Beckmann, from a letter dated 29 January 1938 from Beckmann in Rotterdam to Stephan Lachner, quoted in Stephan Lachner, 'Shared Exile: My Friendship with Max Beckmann, 1933–1950', *Beckmann in Exile*, exhib. cat., ed. Matthew Drutt, New York, Guggenheim SoHo, 1996, p. 110.

Arturo Di Stefano

Crucifix Lane, SE1, 1996
Oil on linen
148.6×200 cm
(58 1/2×78 3/4 in.)

Thomas Struth

Gasse mit Platanen, Wuhan [Narrow street with plane trees, Wuhan], 1997
Cibachrome photograph
42×58 cm (16¼×22¼ in.)

The objective sense of structure that Struth applies time and again to his street scenes forces the eye to look for its own interest, making us inhabit his works.

302

Wolf Vostell

He That is Without Sin,
1990
Screenprint on offset
95×65 cm (37¹/₄×25¹/₂ in.)
Edition: 28/100

The collapse of the Wall in
Berlin, where Vostell lives
and works, supplied an
ideal subject for the artist.
The title focuses our
attention away from the
milling crowd to the stone
coming out of the blood-
red stain. Who was guilty
of dividing the city?

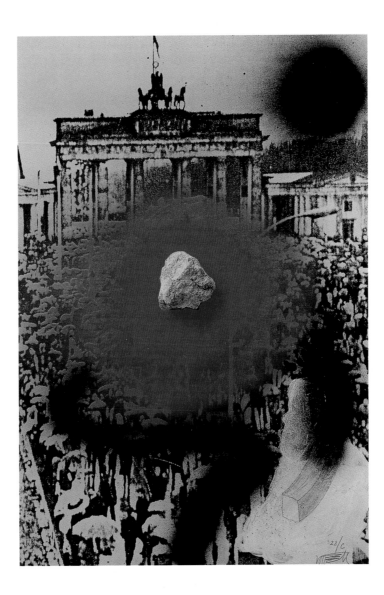

The Joint's Jumping

"In 1996, I was invited by Locus +, a publicly funded arts commissioning agency, to produce a sculptural proposal for the then disused Baltic Flour Mills, Gateshead, as part of the Year of Visual Arts in the North East.

The scheme was, however, co-opted as part of the building's planned conversion into a new museum of contemporary art, to open in 2001. The proposal was to become a permanent artwork overlooking the Tyne and the city of Newcastle from the Gateshead side.

It was architecture itself that was being offered as the subject-matter for the art statement.

I proposed outlining the external geometry of the river face of the Baltic Flour Mills in red neon. This was to be done twice. One was to fit the building's chosen verticals and horizontals on the exact façade. The other identical linear repeat was to be fitted 'skew-whiff' on the same façade but about 5 degrees off vertical and shunted 5 metres up river. Each architectural delineation was to flick on and off randomly, oscillating between one and the other, thereby giving the spectacular impression at night of the building in motion – an illusion that was to make the 'joint' – the Baltic – literally appear to 'jump'.

According to publicity released at that time, the Baltic aimed to be a vibrant and lively centre for cultural dialogue and inclusion. The neon drawing was to signal this in an accessible and popular way, hinting at the desire to become kinetic rather than static.

In mid-1998, on the appointment of the first director of the Baltic Centre for Contemporary Art, it was decided not to realize the work."

Richard Wilson, May 2000

Richard Wilson

*Baltic Flour Mills –
Newcastle, Year of Visual
Arts Proposal*, 1996
Pencil, ink, plastic film
and photograph
25.5×32.5 cm
(10×12 ³/₄ in.)

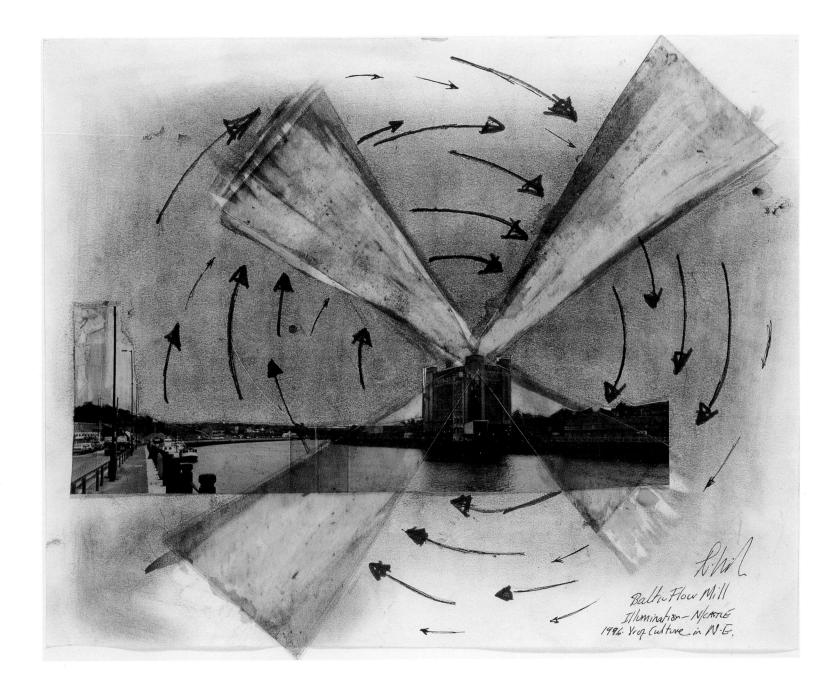

Baltic Flour Mill
Illumination – N/CASTLE
1996. Yrop Culture in N·E.

Bill Woodrow

The Beekeeper. From the Beekeeper series, 2000
Linocut
92×60.5 cm
(36³/₄×23³/₄ in.)
Edition: 14/20

Woodrow, one of the leaders of the New British Sculptors at the beginning of the 1980s, has totally reinvented his art over the last ten years.

310

Mark Wright

Untitled, 1996
Oil on paper
61×51 cm (23¾×20 in.)

"I don't think there is any area of life nowadays that isn't mediated by the photographic image, still or moving. So, for the last nine years I have attempted to deal with this, ... using microscopic imagery depicting the cell structure of natural materials".[1]

1 Mark Wright, quoted in 'Mark Wright: An Artist's Diary', *Art Review*, September 1996, p. 28.

Artists

In the Deutsche Bank collection, on every floor and in every conference room named after an artist there is a small plaque with a paragraph or two about the artist. This information, which was not originally intended for publication, varies from artist to artist – sometimes it is entirely biographical, sometimes almost purely about the work. It is simply meant to supply an opening into the artist's work.

313

Edward Allington
(born Troutbeck Bridge, Westmorland, 1951)
Studied at Lancaster College of Art (1967–71), Central School of Art, London (1971–74)

"My strongest objection to Plato is that he was always trying to bury … the cult of Dionysus", says Allington. "Reading about it or gazing at dislocated fragments in museums, we can catch a glimpse of another way of living which was orgiastic and physical, even almost bestial. What we need now is a new understanding of what was lost then."[1]

Edward Allington was one of the youngest members of the New British Sculptors. His work highlights polarities, such as the chaos behind the mathematical precision of the Greek façade, or the waste behind excessive consumerism. He underlines our accountability in our ordinary, everyday choices by drawing on already-used account books.
See p. 27

Michael Andrews
(born Norwich, Norfolk, 1928; died London, 1995)
Studied at Slade School of Art, London (1949–53)

Michael Andrews made the definitive painting of his fellow School of London artists when he depicted them in *The Colony Room* (1962), the Soho drinking club. The picture shows Francis Bacon sitting on his favourite stool on the right, with Lucian Freud standing on the other side of the room. Though Andrews admired Bacon more than any other fellow artist, his training at the Slade drew him more towards Freud. His later subject-matter varied from a series of pictures on Ayers Rock in Australia to his Scottish paintings, which came out of his obsession with stalking wild deer.
See pp. 99, 179

Frank Auerbach
(born Berlin, Germany, 1931)
Studied at Borough Polytechnic, London (1947), St Martin's School of Art, London (1948–52), Royal College of Art, London (1952–55)

In 1939, at the age of eight, Auerbach was sent from Berlin to England, never to see his parents again, which partly explains his highly personalized technique of painting, devised to harness his desperate desire to capture life. "Pinning down something before it disappears seems to be the point of painting",[2] he says. Yet he had not always intended to become an artist. Before studying with Leon Kossoff under Bomberg he had thought of becoming an actor.

Auerbach's drawings reveal a great deal about his method of painting. Though he often works on a painting for months, he scrapes away the oil after each day's work because he feels the painting has to be held together by the urgent need of making a picture. See pp. 18, 84

David Austen
(born Harlow, Essex, 1960)
Studied at Maidstone College of Art, Kent (1978–81), Royal College of Art, London (1982–85)

Austen has mastered the modern technique of evasion. He does not let himself be pinned down by style, form or medium. Ruth Charity and Amanda Daly point out that he approaches his art "like a fictional character". Each style or technique is an example of his adopting a role. It is as if he were asking himself, "If I were a figurative painter, how would I paint the human form? … If I were an abstract painter, how would I deal with form and colour?"[3]
See p. 181

Gillian Ayres
(born London, 1930)
Studied at Camberwell School of Art, London (1946–50)

Although Ayres was at the heart of the avant-garde London art scene in the 1950s and 1960s, she came into her own when she gave up teaching in 1981. She moved from London, first to Wales and then to Cornwall, where she still lives. She is one of Britain's leading abstract painters.

She took up painting circular pictures after seeing Renaissance tondos on a visit to Florence. Much to her family's horror, she painted her first tondo, *Ah my Heart* (1979–81) by using a round Georgian table-top as the panel. "It was worth far more than the painting at the time",[4] she admitted.
See pp. 6, 10, 183

Michael Bach
(born Sehma, Germany, 1953)
Studied at the Staatliche Kunstakademie Düsseldorf (Münster Department) (1975–79), Staatliche Kunstakademie Düsseldorf (1979–83)

Michael Bach was a pupil of Gerhard Richter, so his paintings should not be read as straightforwardly representational. "As a child, I once spent a long time looking at a knife on the kitchen table", says Bach. "The longer I did this, the more the word 'knife' took on an alien, unfamiliar sound and

314 detached itself from the object on the table, which became – for me at that moment – just a thing with a particular shape. Instead of belonging together with a fork and a place setting, it was now an isolated thing, or one that might equally well belong anywhere else. When the word was once more reunited with the object, the join remained detectable."[5]

Bach's painting questions the way we so readily accept mass-produced images. See p. 185

Francis Bacon
(born Dublin, Ireland, 1909; died Madrid, Spain, 1993)
Self-taught

Some attribute Bacon's violent imagery to the cruelty of his horse-trainer father. He himself always thought his pictures mild compared to Greek tragedy and everyday events in the newspapers and on television. He ran away from home to explore the high and low life of London, Paris and Berlin

as a manservant, furniture designer and interior decorator. He began painting in 1929. By the time of his first retrospective at the Tate Gallery, London, in 1962 he was one of the world's leading painters. Not only did he depict the isolation of man, but as a figurative painter he also appeared a lonely individual in the face of the current artistic trends of abstraction and subsequently conceptualism and minimalism.

Along with frequent self-portraits his most favoured models were his drinking companions Muriel Belcher and Isabel Rawsthorne, and his boyfriends – Peter Lacy, George Dyer and John Edwards. See pp. 13, 41, 98

Georg Baselitz
(born Deutschbaselitz, Saxony, Germany, 1938)
Studied at Hochschule für Bildende und Angewandte Kunst, East Berlin (1956–57), Hochschule der Künste, West Berlin (1957–64)

Baselitz has dismissed landscape pictures as

mere "travelogues", yet he was depicting his East German home town, Deutschbaselitz, as early as 1959, two years after he had left it to live in West Berlin, and even before he had adopted and adapted its name as his own. He was born Hans-Georg Kern. He has fixed his identity firmly in his native soil to counter his "rootedness dilemma".

Having abandoned his own roots in East Germany, Baselitz turned the image on its head in 1969. This was a way of making the viewer look at the composition afresh, as well as being a sign of the radical break with the past that history had forced him to make.
See p. 30

John Bellany
(born Port Seton, Scotland, 1942)
Studied at Edinburgh College of Art (1960–65), Royal College of Art, London (1965–68)

Bellany, the son of a fisherman, spent much of his childhood in his mother's village of

Eyemouth. In 1881, the year of his grandfather's birth, the village lost half of its male population in a fishing disaster. His inherited Calvinist fear of death and demons was heightened by a visit to Buchenwald in 1967. In 1985 he nearly died from a drink-related disease. Since coming down to the Royal College in 1965, Bellany has based himself in London. See pp. 119, 189

Kate Belton
(born Wrexham, Wales, 1972)
Studied at Central St Martin's School of Art, London (1991–94), Royal College of Art, London (1994–96)

Kate Belton produces personal stage sets. She creates her own world to share with her audience, but the found objects that she inserts into our vision have a universal relevance. Her studio environment invariably looks part real, part fabricated. In painting backgrounds she uses the debate between painting and photography to underline her questioning of reality.

In 1995 Belton went on an Erasmus exchange to the Hochschule der Künste, Berlin. She won a Burston Award in 1996.
See p. 190

Ann Bergson
(born Stockholm, Sweden, 1928)
Studied at Royal Academy of Arts, Stockholm (1945–48), Scuola Renato Guttuso, Rome (1948–51)

Bergson, who has been based in London since the 1960s, paints almost exclusively in watercolour, but her work is far removed from the British amateur tradition. She paints with the sparing, reductionist vision of Cézanne. Much of the thick, absorbent paper is left bare. Bergson works direct from landscape; she likes to travel to find her subject.

Born in Sweden, she has lived in both Italy and France. From her time in Sweden, when she worked on the stage sets for the Royal Opera House in Stockholm, she has been closely involved

with both musicians and writers.

See p. 191

Joseph Beuys
(born Krefeld, Germany, 1921; died Düsseldorf, Germany, 1986)
Studied at Staatliche Kunstakademie Düsseldorf (1947–51)

Joseph Beuys was brought up in Cleves, where his father ran a store. In a time of censorship he remembered a book burning in which most of his school library's books went up in flames. He rescued some. He ran away from home and joined a circus. He developed talents as a stunt man, particularly as an escapologist.

The turning-point in his life was when the Stuka in which he was the radio operator was shot down over the Crimea. After the Tartars had rescued him and healed him by wrapping him in fat and felt, these two materials became the key to his plan to heal the world through art. One simple symbol of this belief in felt sat on his head for the rest of his life – a felt trilby hat from the shop Lock's of St James's, London.

See pp. 38, 102–03

Tony Bevan
(born Bradford, Yorkshire, 1951)
Studied at Bradford School of Art (1968–71), Goldsmiths' College, London (1971–74), Slade School of Art, London (1974–76)

Although Tony Bevan is English, living and working in London, he is almost better known in Germany than in his homeland. The high number of museum shows in Germany can be partly explained by his pan-European vision. His study of a solitary figure pays obvious tribute to Francis Bacon, Giacometti and Munch, but also to the more obsessive works and thinking of Antonin Artaud, Arnulf Rainer and the eighteenth-century Austrian sculptor Franz Xaver Messerschmidt, on whom he wrote his Goldsmiths' dissertation. This interest in how psychological content was introduced into portraiture is clearly revealed in his own work, which concentrates on the framework of the head.

See pp. 165, 192

Elizabeth Blackadder
(born Falkirk, Scotland, 1931)
Studied at Edinburgh University and Edinburgh College of Art (1949–54)

Blackadder has long been one of the best-known Scottish artists, and she has an international following, but her work is quiet, contemplative and lacks the aggression expected of modern painting. As she is the first to admit, she is not the kind of painter who is going to cover heroic themes or make social comment. Her father died when she was ten, but she was soon demonstrating her steely determination. She was Head Girl of Falkirk High School and went on to get a first-class degree at Edinburgh University. She is married to the artist John Houston.

See p. 193

Peter Blake
(born Dartford, Kent, 1932)
Studied at Gravesend Technical College and School of Art (1946–51), Royal College of Art, London (1950–56)

Peter Blake – a natural populist – was a key founder of the Pop movement. He simply opened up the obsessive, lonely hearts of teenagers around the world. He made art like posters. He understood the culture of the fan. His reputation was greatly enhanced by his design for the front cover of the Beatles' *Sergeant Pepper's Lonely Heart's Club Band* album.

In the 1970s Blake moved from London to the country and with his wife formed the Brotherhood of Ruralists, but returned to his more popular print works in the 1980s.

See p. 194

Christopher Bucklow
(born Manchester, 1957)
Self-taught

Bucklow is a key member of the group of British artists who use photographic processes but not a conventional camera. Michael Auping, a curator at the Modern Art Museum, Forth Worth, describes the technique:

"Bucklow creates life-size Cibachrome silhouettes that have been described as 'futuristic,' although they are the result of working with a primitive, homemade pinhole camera built from a discarded crate. The artist's process involves making a silhouette drawing of a three-quarter-length figure on a large sheet of silver foil, then puncturing the outline and interior of the form with thousands of pinholes that function as tiny apertures. Positioning a full-size sheet of Cibachrome paper inside the camera and covering the front with the punctured foil, Bucklow takes his contraption to the roof of his studio building, exposing the pinholes to available light, thus producing a solar image on the Cibachrome paper. The result is an eerie, glowing portrait made of what

appears to be molecular beads of light."[6] See p. 197

Rachel Budd
(born Norwich, Norfolk, 1960)
Studied at the University of Newcastle upon Tyne (1978–82), Royal College of Art, London (1983–86), Kingston Polytechnic, Surrey (1986–87)

Budd's paintings have been described as being like "Constable on opium". David Lillington, who coined this expression, was trying to convey Budd's "quintessential Englishness". There are links to British artists, most obviously Gillian Ayres, but like Ayres before her, Budd was influenced by the tradition of the American Abstract Expressionists and European artists of the mid-twentieth century. As Budd's paintings are undeniably optimistic, she has at times appeared to be bucking the trend of recent art, but she simply paints what she sees. Whether travelling in Africa or simply looking out of her studio window on to the flower market in

Columbia Road, London, she naturally spills the colours she sees on to the canvas. See p. 198

Patrick Caulfield
(born London, 1935)
Studied at Chelsea School of Art, London (1956–60), Royal College of Art, London (1960–63)

"In advertising you have to project or you don't make a sale",[7] says Caulfield. Even when he was a Pop artist he was developing a deliberately anonymous style. It is this reduction to design that has made some of the Young British Artists look at his work. His impersonal interiors with their brave use of colour made him famous, but it is his habit of adopting several styles in one picture, his constant running from his own signature, that has been emulated. See p. 68

Lynn Chadwick
(born Barnes, London, 1914)
Self-taught

On a visit to Paris in 1932 Lynn Chadwick, the son of an engineer, was struck

by Epstein's tomb for Oscar Wilde in the Père Lachaise Cemetery. He trained as a draughtsman in textile design and then in several architectural practices, including that of the Eugen Kaufmann. He emerged as a sculptor around the time of the Festival of Britain in 1951. By 1956 he was an international name and won the prize for sculpture at the Venice Biennale. His beautiful house in Gloucestershire is a personal sculpture park. See p. 199

Prunella Clough
(born London, 1919; died London, 1999)
Studied at Chelsea School of Art, London (1938–39)

Clough was taught by Ceri Richards at Chelsea School of Art. In the 1950s her work developed industrial and urban overtones. In her desire to achieve an impersonal quality in her work she was a forerunner of the Young British Artists, yet her ethos and presentation could not have been more different. As Sacha Craddock says,

"Clough never chose the narrow alley of personal expression. Perhaps her background, upbringing and fact that she is a woman of her time, have all helped to ensure that the language remains private, held at arm's length."[8]

Clough refused to conform to the normal practices of the modern art world. She didn't talk about her work. She didn't work through a subject in series. She wanted to keep her prices down. Her art, produced in a rich range of media, was unpredictable in size, form and content.
See pp. 201, 202

Maurice Cockrill
(born Hartlepool, Cleveland, 1936)
Studied at Wrexham Art School (1960–62), University of Reading (1962–64)

In 1952 a probation officer informed Cockrill that he hadn't the religious background to be an artist, but at the age of twenty-four, after working as a builder and in an aircraft factory,

he finally went to art school. From 1964 to 1982 he lived in Liverpool before coming to London. In 1968 he burnt most of his work. He developed a Super Realist style, but like Malcolm Morley's, this loosened dramatically at the end of the 1970s until, in the 1980s, he was using strong expressionist brushstrokes.

Cockrill was one of the few British artists to have links with the German revival of the figure. Though not considered for either of the early 1980s' exhibitions *Zeitgeist* or *A New Spirit in Painting*, he was to show extensively in Germany from the mid-1980s. See pp. 121, 138, 203

Hannah Collins
(born London, 1956)
Studied at Somerset College of Art (1973–74), Portsmouth Polytechnic (1974–77), Royal College of Art, London (1978–81)

Hannah Collins is a traveller. Photography is her prime medium today, though she has used video, installation and

317

318

painting in the past and is now working in film. She lives in Barcelona. She won the 1991 European Photography Award in Berlin and was shortlisted for the 1993 Turner Prize. The harsh gaze of her camera questions today's values. As Catherine Legallais writes, she is very much in the European tradition:

"She identifies with Bernd and Hilla Becher and their depiction of industrial architecture, as with Thomas Struth and his images of China, by isolating portions of the world in a direct manner, without narration, harshly, focusing on the representation, and the progressive erosion of the modernist doctrine that a work of art transcends the chaos of modern life"[9]

See p. 167

Melanie Comber
(born Maidstone, Kent, 1970)
Studied at Wimbledon School of Art, London (1990–93), Chelsea College of Art, London (1993–94)

In 1997 Melanie Comber was a prize-winner at the NatWest Art Awards. Her most recent work is the result of a trip to Iceland, during which she taught at the Icelandic School of Arts and Crafts at Reykjavik. The paintings are not literal landscapes, but are usually triggered by an event or place.

These pictures are the result of a desire to create a sense of distance, which she experienced when standing on the East Anglian coast. She realised that the water stretched for 5000 miles to the Arctic. "I made a series of paintings looking 'out' into that space and then travelled to the Arctic circle to look 'back' at my created space." All her pictures have raised surfaces, which help build up "perversions of the traditional picture plane".[10] See p. 204

Stephen Cox
(born Bristol, 1946)
Self-taught

Although Stephen Cox lives in England, he has built his reputation abroad, particularly in India, Egypt and Italy. For over twenty years he has been interested in the traditional techniques of stonework. In 1979 he learned to cut and carve stone in Italy and in 1999 he was back again in Carrara. In the intervening years he has explored the mystical symbolism of Indian sculpture. See p. 205

Tony Cragg
(born Liverpool, Merseyside, 1949)
Studied at Gloucestershire College of Art (1969–70), Wimbledon School of Art, London (1970–73), Royal College of Art, London (1973–77)

Tony Cragg, the son of an electrical designer for aircraft, is the accepted leader of a group of artists who emerged at the very beginning of the 1980s, called the New British Sculptors. He came to art through the unusual route of a science training. From 1966 to 1968 he was a laboratory technician at the National Rubber Producers Research Association. After receiving his MA from the Royal College he married Ute Uberste-Lehn and moved to Wuppertal in Germany. In 1979 he started teaching at the Staatliche Kunstakademie Düsseldorf and was made a professor there in 1988, the same year that he won the Turner Prize and represented Britain at the Venice Biennale. See pp. 10, 129, 207

Michael Craig-Martin
(born Dublin, Ireland, 1941)
Studied fine art at Yale University, New Haven, Connecticut (1961–66)

Michael Craig-Martin grew up in the United States before moving to London in 1966. As a conceptual artist he is most famous for *An Oak Tree* (1973), which, while consisting of a glass of water, purported to be an oak tree. More recently as the father of neo-conceptualism, he makes neo-Platonic drawings of plain objects.

From 1974 to 1988 he taught at Goldsmiths' College, London, and he returned there as Millard Professor of Fine Art in 1993. Among his successful students are Damien Hirst, Julian Opie, Sarah Lucas and Gary Hume. See p. 142

Alan Davie
(born Grangemouth, Scotland, 1920)
Studied at Edinburgh College of Art (1937–41)

Alan Davie is the son of a painter and etcher. Although he has lived most of his life in England, he is Scotland's most famous painter. In 1946 he saw African sculpture at the Berkeley Galleries, which stimulated a life-long interest in 'primitive art'. In 1947 he worked briefly as a jazz pianist and married the artist-potter Janet Gaul. His painting invariably has the vitality of jazz. He has studied Zen Buddhism. He took up gliding in 1960. His wide-ranging, passionate interests feed his art. See pp. 53, 210

John Davies
(born Macclesfield, Cheshire, 1946)
Studied at Hull and Manchester Colleges

of Art (1963–64), Slade School of Art, London (1964–66), Gloucester College of Art (1966–67)

John Davies's subject is the figure. Though he has constructed groups of figures, some early examples with a strange, almost surreal selection of masks, others cavorting on ladders, swings and ropes, ultimately it is the single still figure that supplies the essential John Davies image. His larger-than-life heads have the aura of Buddhas.

John Davies found early success after leaving College with two one-man shows in the Whitechapel Art Gallery in 1972 and 1975. The Sainsbury Centre in Norwich has a large collection of his work.
See pp. 10, 136, 211

Richard Deacon
(born Bangor, Wales, 1949)
Studied at St Martin's School of Art, London (1969–72), Royal College of Art, London (1974–77), Chelsea School of Art, London (1977–78)

While in New York in 1978–79 with his wife, the ceramicist Jacqui Poncelet, Richard Deacon began to make pots and drawings based on the *Sonnets to Orpheus* by Raine Maria Rilke. On his return to London, he made a group of works that employed the swelling, curvilinear forms (fabricated at first from laminated wood) that have characterized much of his work since then. Though closely associated with Tony Cragg, Bill Woodrow and other New British Sculptors, Deacon has built up a visual language that is very much his own. He draws in space with the assurance of the son of an engineer. He won the Turner Prize in 1987.
See p. 131

Jonathan Delafield Cook
(born London, 1966)
Studied history at Royal Holloway and Bedford College, London University (1985–88), Royal College of Art, London (1994–95)

Delafield Cook declared that he was prepared to tread a different path from his contemporaries at his degree show at the Royal College. He displayed a highly detailed life-size pencil drawing of a fully-grown rhinoceros. A second version of this can be seen at the Chelsea and Westminster Hospital, London. His interest in nature, however, stems back a great deal further than his college days, because as a child he used to travel into the Bush with his father, Australian artist William Delafield Cook, on landscape-painting trips.
See p. 213

Susan Derges
(born London, 1955)
Studied at Chelsea College of Art, London (1973–76), DAAD Scholarship Berlin (1976–77), Slade School of Art, London (1977–79)

Susan Derges has followed the traditional route to artistic success in Britain, having been recognized abroad first. She had several solo exhibitions in Berlin, Japan and Poland before her first one-person show in Britain. She lives in Devon and has become associated with the River Taw, as she has used it for her most famous series of photograms (photographs made without a camera). "They are made at night", she explains, "when the landscape is dark enough to take light sensitive paper to the river in order to submerge it beneath the surface of the water. The traces of my own presence and of others involved in the making, along with ambient moonlight and other illuminations, merge with the many imprints carried in the water, forming a kind of collective memory … ."[11]
See pp. 169, 214–15

Felim Egan
(born Strabane, Ireland, 1952)
Studied at Ulster Polytechnic, Belfast (1971–72), Portsmouth Polytechnic (1972–75), Slade School of Art, London (1975–77), Rome Scholarship, British School at Rome (1979–90)

The key to the scale of Felim Egan's abstract paintings is on his doorstep. He lives by Dublin's Sandymount Strand. Every day he walks his dogs on this constantly varying open beach. The small, hand-drawn, geometric shapes have a similar relationship to their backgrounds to that of figures on the beach. This ensures that his highly pared-down, pure abstraction has a very human feel to it. The texture of his oil paintings also echoes the sand of the Strand. The paint seems to have been moved and smoothed by forces as natural as the sea. His carborundum prints are actually made out of metallic grit embedded into paper. He extracts a simple poetry from nature with the same apparent ease as Seamus Heaney, with whom he has often collaborated.
See p. 162

Stephen Farthing
(born Leeds, Yorkshire, 1950)
Studied at St Martin's School of Art, London (1969–73), Royal College of Art, London (1973–76)

Stephen Farthing is one of the country's leading teachers and art theoreticians. Since 1990 he has been the Ruskin Master and Professorial Fellow at St Edmund Hall, Oxford University. Previously he was a tutor at the Royal College before becoming head of painting at West Surrey College of Art and Design, Farnham.

Since his own student days at the Royal College, Farthing has been constantly fighting the theory that painting is dead. His first variation on a portrait of a monarch, a reworking of Rigaud's *Louis XV*, was done in 1975 during his final year at the Royal College. See p. 218

Rainer Fetting
(born Wilhelmshaven, Germany, 1949)
Studied at the Hochschule der Künste, Berlin
(1972–78)

Fetting was one of the leaders of the *Heftige Malerei* (violent painting), and the wildest of the *Zeitgeist* figurative painters. They ran their own gallery, Galerie am Moritzplatz, where they had frequent exhibitions, but they came to the fore at the beginning of the 1980s with the exhibitions *A New Spirit in Painting* (1981) and *Zeitgeist* (1982).

Fetting's art gave full vent to the hothouse mentality of Berlin in the last days of the divided city. After winning a DAAD Scholarship to New York in 1978 he has divided his time between America and Germany. It is the vibrancy of Berlin and New York that has supplied the energy of his pictures. See pp. 19, 106

Ralph Fleck
(born Freiburg, Germany, 1951)
Studied at Staatliche Akademie der Bildenden Künste, Karlsruhe
(1973–81)

We are bombarded with electronically controlled imagery. Much of what we see gets changed and distorted at the flick of a button. The message the eye receives is not necessarily the same as originally dispatched. There is often a time lapse. Ralph Fleck is highly aware of the dangers in the supply of information. His process of painting may echo the process that gives us images on the screen, as his paintings are based on photographs he has taken himself. Time elapses between the taking of the photographs and the painting of the pictures. Memory exerts itself. The artist is giving a human response. A realist depiction is not his goal, but he often paints his vision of the place not just once, but several times over. He paints cities, fields and the sea in series as he works his way through the subject. See p. 221

Günther Förg
(born Fussen, Germany, 1952)
Studied at Akademie der Bildenen Künste, Munich
(1973–79)

"The painter, photographer and sculptor Günther Förg sprints through the ideas of Modernism in art at a fair lick, while at the same time giving them a workover", writes Raimar Stange. "Piet Mondrian, the Bauhaus and the Russian avant garde at the beginning of this century, but also more contemporary figures such as Barnett Newman, Jean Fautrier and the legendary film-maker Jean-Luc Godard, are as it were the 'ancestors' of his art, which often takes the form of closely related installations."[12]

Much of Förg's work has been site-specific and almost all aims to change the space in which it is seen. His art walks a narrow line between the ironic and poetic. There is a mocking awareness of earlier art and its role, but in contrast the reduction of the work, the straight colours and forms, give a sense of escape. His art is an integral part of the permanent installation at Museum für Moderne Kunst in Frankfurt. See p. 160

Mark Francis
(born Newtownards, County Down, Northern Ireland, 1962)
Studied at St Martin's School of Art, London (1980–85), Chelsea School of Art, London (1985–86)

Mark Francis is a strong new abstract voice. Although he was included in *Sensation* at the Royal Academy he is not really part of the Young British Artist social set-up, but he is certainly one of the most successful young British painters. In his recent interest in mapping and communication, he does superficially share concerns with Simon Patterson and other YBAs, but unlike Patterson he is prepared to use Modernist structures and work through his ideas in a systematic manner. His success has been underpinned by dealers in both London and Dublin and recently Mary Boone in New York.

Francis's art comes out of the landscape, but he has made a break from tradition. He has looked to the microcosm rather than the macrocosm for inspiration. See pp. 161, 175

Lucian Freud
(born Berlin, Germany, 1922)

Studied at Central School of Art, London (1938–39), East Anglian School of Painting and Drawing, Dedham (1939–42), Goldsmiths' College, London (1942–43)

Grandson of Sigmund, the young Lucian Freud came to England at the age of ten. Though he started painting at an early age it was not totally obvious from his school career that he was going to be an artist. At Dartington he rode instead of studying art. He was expelled from Bryanston for "his disruptive influence in the community". He rapidly assimilated the English neo-Romantic trends of the time before injecting some vigorous realism into the English School. As Richard Calvocoressi observes, "It is clear that by 1945 Freud had found his own individual voice: tough, direct, unsettling".[13] He is now the best-known living figurative painter. See p. 222

Terry Frost
(born Leamington Spa, Warwickshire, 1915)

Studied at St Ives School of Painting, Cornwall (1946–47), Camberwell School of Art, London (1947–50)

Adrian Heath taught Frost to draw. As a commando captured in Crete, they were prisoners of war together between 1941 and 1945. It was Heath who encouraged him, when he was ill after the War, to move to Cornwall and study painting. Frost has lived intermittently in Cornwall since that time and is a key St Ives Group painter. Roger Hilton was a close friend. In 1951, the same year he met Hilton, he briefly worked as Barbara Hepworth's assistant.

Frost has been an active teacher for much of his career (Professor of Painting at Reading University from 1977 to 1981). He was knighted in 1998. See p. 223

Hamish Fulton
(born London, 1946)
Studied at Hammersmith College of Art, London (1964–65), St Martin's School of Art, London (1966–68), Royal College of Art, London (1968–69)

Hamish Fulton is a conceptual artist. Since 1969 his work has specifically recalled his walks. Words are the main component of his work, but they are often accompanied by black-and-white photographs. The text is sometimes dry, sometimes poetic. In working so directly with his memory he evokes many connections with earlier civilizations, particularly those that primarily relied on the oral tradition, such as those of the Native American and Australian Aborigines. Patrick Elliott, though, emphasizes the parallels with the Japanese Shinto religion, "which stresses the primitive, fundamental relation between man and natural phenomena".[14] See p. 225

Andy Goldsworthy
(born Sale, Cheshire, 1956)
Studied at Bradford Art College (1974–75), Preston Polytechnic (1975–78)

"On the rudest surface of English earth there is seen the effect of centuries of civilization so that you do not quite get at naked nature anywhere",[15] wrote the American writer Nathaniel Hawthorne as he travelled by stagecoach in the foothills of Cumbria in 1855. This recognition that even the remotest nature is rarely untouched by human influence is one of Goldsworthy's starting-points. His interaction with nature could not be more direct, and he invariably shows a lay audience scientific truths in a poetic manner, but the act of interfering with nature is an important part of his work. See p. 25

Friedemann Hahn
(born Singen, Germany, 1949)
Studied at Staatliche Akademie der Bildenden Künste, Karlsruhe (1970–74), Staatliche Kunstakademie Düsseldorf (1974–76)

Hahn's portrayal of artists gives an obvious insight into his artistic heroes. His technique of building up images out of fragmented paint has evolved out of the history of Impressionism, Post-Impressionism and Expressionism. Van Gogh, who more than any other man has come to epitomize the struggles of the artist, recurs in Hahn's work. While Francis Bacon and John Bellany have concentrated on the figure of Van Gogh (or in Bellany's case the fisherman echoing Van Gogh) trudging across the landscape carrying the burdens of the world on his shoulders, Hahn has repeatedly reworked the Post-Impressionist's head.

Artists are not the only stars in Hahn's repertoire. He portrays film stars in an obviously painterly fashion, almost as if he were reclaiming them from the clinical clutches of Warhol and the film industry. See p. 119

Richard Hamilton
(born London, 1922)
Studied at Royal Academy Schools, London (1938–40), Slade School of Fine Art, London (1948–51)

322 Hamilton left school at fourteen to work in advertising. He was the intellectual pioneer of the British Pop movement. Indeed, the poster he made for *This is Tomorrow*, a 1956 exhibition, is accepted by many as the first definitive Pop image. He designed the *White Album* for the Beatles. Very much in the spirit of Pop he has borrowed images from newsprint, film and television in the screenprints of the 1960s and 1970s. His concern for the way society works has been more lasting than that of most of his contemporaries. He has strong international ties, including many with Germany. He was one of the few British artists to be included in *Documenta X* in 1997, Europe's most important four-yearly art event, and he often collaborated with the artist Dieter Roth. See pp. 63, 64, 67, 228

Tom Hammick
(born Tidworth, Wiltshire, 1963)
Studied fine art and printmaking at Camberwell College of Art, London (1987–92)

Until recently almost all of Hammick's paintings were spectacularly empty. The dominant image was of a world split in two by the horizon. It was time for the figure's entrance. Taking the figure as subject-matter has not meant that Hammick has abandoned the isolated world. Indeed, he seems to pursue it. Since graduating from Camberwell he has made a number of voyages to remote parts of the world – the most recent on a bulk carrier to the Arctic Circle. This isolation is now found in the corners of his pictures, much as in the work of the Belgian artist Luc Tuymans.
See pp. 230, 231

Adrian Henri
(born Birkenhead, Cheshire, 1932)
Studied fine art at King's College, Newcastle upon Tyne (1951–55), King's College, University of Durham (1955)

Adrian Henri is probably best known in London as one of the 'Liverpool poets', along with his friend Roger McGough,

yet he was also Liverpool's Pop artist. He was at the very centre of the Liverpool scene when Liverpool was one of the liveliest of cultural centres.

There is direct confrontation with American culture in Henri's work. The use of flags and targets can be linked to Jasper Johns and Kenneth Noland; his assimilation of poster-like images of consumerism compares to that of Rosenquist and Rauschenberg; but he makes greater aesthetic sacrifices in his desire to obliterate the excesses of the Capitalist system.
See p. 71

Patrick Heron
(born Leeds, Yorkshire, 1920; died St Ives, Cornwall, 1999)
Studied at Slade School of Art, London (1937–39)

Heron was encouraged in his art from an early age by his father, who was a textile tycoon (Cresta). He admits happily to the influence of Matisse and Bonnard, but his connections with Rothko and

other New York artists of the 1950s and 1960s are more hotly debated, not least by himself. From 1947 to 1950 he was art critic for the *New Statesman* and long laid claim to having been one of the pioneers of the denial of the picture plane that proved so crucial in the development of American and international art. Many of his pictures exaggerate the flatness of the picture with simple shapes of colour floating on the surface.
See p. 235

Roger Hilton
(born Northwood, Middlesex, 1911; died 1975)
Studied at Slade School of Art, London (1929–31)

Hilton escaped the parochialism that dogged some of his contemporaries in the St Ives Group. He did not move to Cornwall permanently until 1965. After his scholarship to the Slade he studied under Roger Bissière (1888–1964) at the Académie Ranson in

Paris. In the 1950s, through connections with the Cobra group, and after studying the work of Mondrian, he turned to abstraction, but in the end he did not totally abandon the figure, as proved by the running Matisse-like creature exploding out of the drawing *Untitled* (*c*.1970). Many of his last drawings were made while he was ill in bed.
See pp. 48, 236

David Hiscock
(born Fordingbridge, Hampshire, 1956)
Studied at Salisbury School of Art, Wiltshire (1975–76), St Martin's School of Art, London (1976–79), Royal College of Art, London (1983–85)

Hiscock, who taught at the Royal College of Art, has developed Cubist photography. He has used this technique for still life and for advertisements. By moving the camera periodically in a long-exposure shot, the photographer creates a smooth, extended form of Cubism. Earlier Hiscock worked innovatively to combine paint and photo-

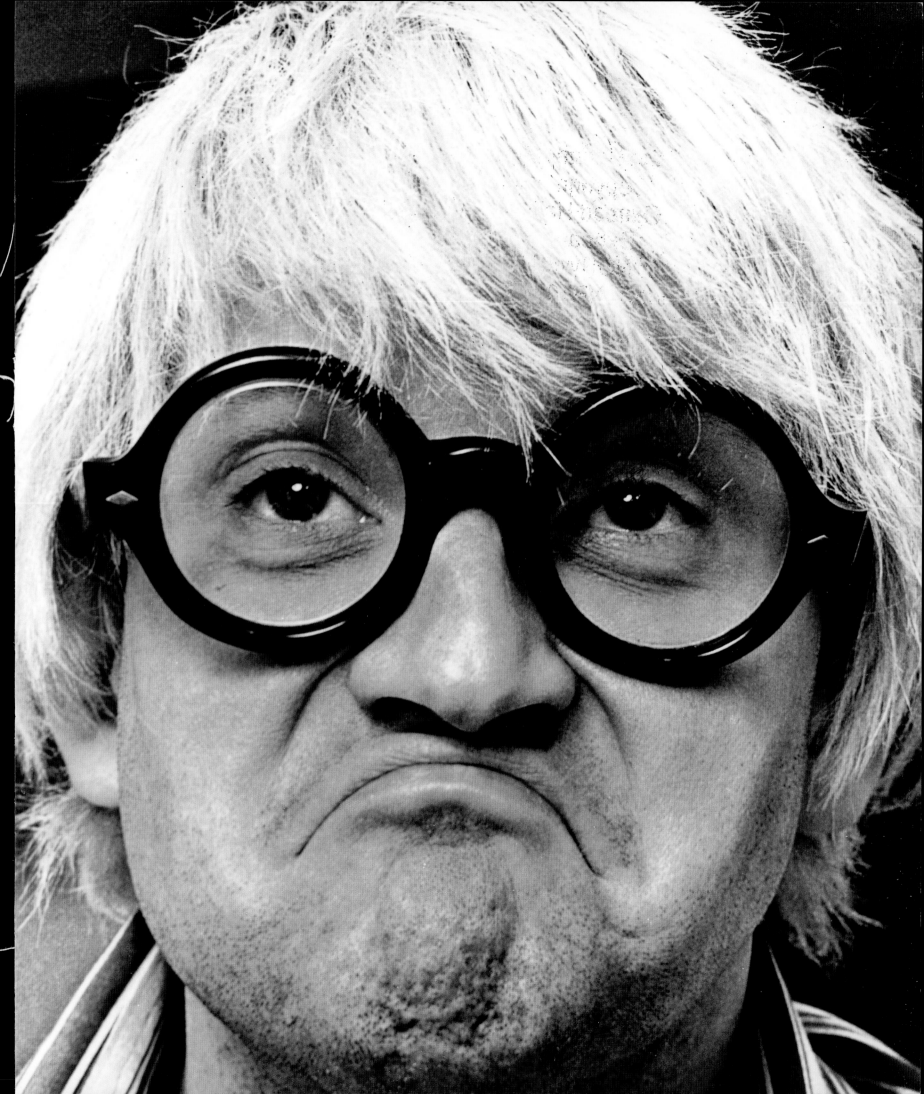

graphy. He was the Official British Olympic Artist at the Barcelona games (1992). See p. 237

David Hockney
(born Bradford, Yorkshire, 1937)
Studied at Bradford College of Art (1953–57), Royal College of Art, London (1959–62)

As a conscientious objector, Hockney did his National Service as a hospital orderly. He was inspired by an Alan Davie exhibition in Wakefield. At the Royal College, his friend R.B. Kitaj, excited by the young artist's draughtsmanship, persuaded him to move away from abstraction. Hockney was part of the Pop culture, but never let it squash his own personality and natural desire to tell his own story. On the proceeds of his etchings series A Rake's Progress he moved in 1963 to Los Angeles, where he has lived ever since. His ability as a draughtsman has not curbed his interest in experimenting with machinery. Photographs, photocopies and computers have all played an important part in his work. See pp. 70, 71, 97, 239

Howard Hodgkin
(born London, 1932)
Studied at Camberwell School of Art, London (1949–50), Bath Academy of Art (1950–53)

Sir Howard Hodgkin (he was knighted in 1992) decided he wanted to be a painter at the age of five. Though very English, from inventive Quaker stock, he lived in New York when he was very young. In 1949, in his mid-teens, he painted Memoirs, an image of two figures in an interior. Though his work soon became more abstracted, this early picture set the tone. He has always denied he is an abstract painter, as the starting-point of his pictures is invariably a specific memory of an encounter with people or a place. See p. 240

K.H. Hödicke
(born Nuremberg, Germany, 1938)
Studied at Hochschule der Künste, Berlin (1959–64)

Hödicke is just as well known as a teacher as he is a painter. He taught most of the Wild Ones, including Fetting, Salomé and Middendorff. Since 1974 he has been a professor at the Hochschule der Künste in Berlin. Earlier, his influence had been felt through Größgörschen 35, a co-operative that he founded along with Markus Lüpertz, Bernd Koberling and eleven other figurative artists.

Hödicke came to prominence in Berlin when the divisive effects of the Wall were very much in evidence. The city he portrayed was rough but often brightly coloured. His figures and creatures were often stiff and awkward, as though they were crying out for contact with the outside world. See pp. 28, 241

John Houston
(born Buckhaven, Scotland, 1930)
Studied at Edinburgh College of Art (1948–54)

John Houston has linked his painting life with the Bass Rock. Sometimes it is little more than a bump on the horizon in the Firth of Forth, but in other paintings it juts out of the North Sea more forcefully. It has been a constant in his work, just as Mont Sainte-Victoire was for Cézanne. In Houston's case the island is almost a steadying influence against the wild range of colours he finds in the sea and skies around it.

Houston spent much of his career teaching at Edinburgh College. He has been married to the artist Elizabeth Blackadder since 1956. He played football for Scotland's Under 21 team. See p. 243

Paul Huxley
(born London, 1938)
Studied at Harrow School of Art, Middlesex (1953–56), Royal Academy Schools, London (1956–60)

Paul Huxley was Professor of Painting at the Royal College of Art, London, from 1986 to 1998, and has been a trustee of the Tate Gallery (1975–82). After studying in Britain he lived in New York from 1965 to 1967. He was visiting Professor at Cooper Union in 1974. Cubism and Surrealism are seen by Huxley as the most important movements of the twentieth century, and he makes continual references to them in his work. See p. 244

Jörg Immendorff
(born Bleckede, Germany, 1945)
Studied at Staatliche Kunstakademie Düsseldorf (1963–64)

Immendorff was a student activist, campaigning in the late 1960s against the war in Vietnam and the environmental damage that he blamed on a consumerist society. This activity had been fanned by studying first under the stage designer Teo Otto and then in Beuys's class at the Staatliche Kunstakademie Düsseldorf. In trying to develop a highly political art he produced nightmarish visions of Germany's suffering, but out of these grim

depictions there was meant to be hope. In his famous Café Deutschland series his arm is thrust through the Wall to his friend A.R. Penck, who lived in East Berlin. He declared, "I conceive of myself as a political painter, because the political engagement is the central theme in my life and work".[16]
See pp. 117, 245

Bill Jacklin
(born Hampstead, London, 1943)
Studied graphics at Walthamstow School of Art, London (1962–64); studied painting at Walthamstow School of Art, London (1962–64), Royal College of Art, London (1964–67)

Jacklin, who lives and breathes crowds, moved to New York in 1985. He began his career as "a Systems *Wunderkind*" back in England's heady, avant-garde, Carnaby Street days. He likes to be at the hub of activity. He worked for Yoko Ono.

Jacklin's images often become more disturbing the fewer people they contain. This dates back to his earliest drawings of his father in a mental hospital. He would sit for hours by his father's bedside, contemplating this elusive shadow of a man. One senses the artist is more at ease losing himself in the crowds of Coney Island, Grand Central and the Ice Rink.
See pp. 246, 247

Andrzej Jackowski
(born Penley, North Wales, 1947)
Studied at Camberwell School of Art, London (1966–67), Falmouth School of Art, Cornwall (1967–69, 1972–73), Royal College of Art, London (1974–77)

Most of Jackowski's work refers back to his childhood. He was born in North Wales and spent the first eleven years of his life with his parents in a refugee camp on the English/Welsh borders. They spoke Polish in the camp. His father lived in Britain for thirty years, but his mind never left Poland. The figures in Jackowski's work carry their culture with them, some literally hanging their home city around their neck. In the same spirit, the artist also arranges 'sacred' items on a table, as though it were an altar. The images lie somewhere between dreams and reality. They work as triggers on the viewer, waking up his or her past. See pp. 10, 248

Glenys Johnson
(born Ulnes Walton, Lancashire, 1952)
Studied at Gloucestershire College of Art and Design (1970–71), Slade School of Art, London (1971–74)

Glenys Johnson is best known for her depictions of crowds and forests. Though she is aware of the symbolism of forests and crowds as places of safety, places in which to hide, she has been equally interested in finding out about her subject-matter through repetition. It is a way of capturing the constantly shifting nature of the world.

Johnson's most spectacular work to date was probably her exhibition *Forest* (1996), an installation of twenty-four vertical paintings at the Staatsgalerie Moderner Kunst in Munich. The striking achievement of *Tree* (1999) is that, though much has been made of the single iconic birch, it paradoxically shimmers with the same hovering uncertainty of the multiple images.
See pp. 249, 250

Allen Jones
(born Southampton, 1937)
Studied at Hornsey College of Art, London (1955–59), Royal College of Art, London (1959–60)

Allen Jones's sexist pictures and furniture have made him such a hate figure that he has been omitted from the standard *Dictionary of British Art*.[17] His most outrageous invention was a chair made out of a naked woman. He was a contemporary of Patrick Caulfield, David Hockney and R.B. Kitaj at the Royal College of Art and in the 1960s was almost as famous. He was controversial from the start; he was asked to leave the college at the end of his first year. See p. 70

Anish Kapoor
(born Bombay, India, 1954)
Studied at Hornsey College of Art, London (1973–77), Chelsea School of Art, London (1977–78)

Anish Kapoor's art encourages questions about the origins of the world. His recent recurrent theme of the void has made this clear. *Turning the World Upside Down III* (1996) is like a great beached scientific model of the void and the world. It stands almost as a warning of the fragility of ideas. Man will constantly ask himself how he began, but his theories, whether theological, scientific or philosophical, will come and go.

Turning the World Upside Down III was shown at the São Paulo Bienal, Brazil, in 1997. Kapoor has won his fair share of prizes, including the Premio Duemila, when he represented Britain at the Venice Biennale in 1990, and

the Turner Prize in 1991.
See pp. 32, 133, 140, 253

Michael Kenna
(born Widnes,
Lancashire, 1953)
Studied at Banbury
School of Art, Oxfordshire
(1972–73), London College
of Printing (1973–76)

Since 1980 Michael Kenna
has lived in San Francisco.
He has had many more
exhibitions in the United
States than in Europe. Yet
the Britain of his child-
hood, training and early
career still influences his
steady gaze. His inclusion
of industrial scenes in his
work has an overlap with
Bernd and Hilla Becher,
but his handling, despite
being equally direct,
is less systematic. The
relics of the Industrial
Revolution abound in his
native Lancashire, but
he finds similar subjects
in America. As Peter
Bunnell observes, he
"clothes the architecture
in a mood that suggests
an environment that has
collapsed".[18] See p. 254

Ken Kiff
(born Dagenham,
Essex, 1935)

Studied at Hornsey
School of Art, London
(1955–61)

At first sight one might
think Ken Kiff was part of
the great English eccentric
tradition of William Blake,
Stanley Spencer and
Lowry. Certainly, although
a teacher at Chelsea
College of Art and then
the Royal College of Art,
he was viewed with
suspicion by many of his
contemporaries in the
1960s and 1970s for
breaking all the taboos of
painting of the time. As
if to back up his critics
he underwent psycho-
therapy. Yet Kiff's work
comes out of the heart
of European twentieth-
century picture-making,
with direct links to Paul
Klee, Miró and Chagall.

From 1992 to 1994 he
was Associate Artist at
the National Gallery in
London. See pp. 2, 33, 257

R.B. Kitaj
(born Cleveland,
Ohio, 1932)
Studied at Cooper Union,
New York (1950–52),
Ruskin School of Drawing
and Fine Art, Oxford

(1958–59), Royal College
of Art, London (1960–62)

Kitaj was born Ronald
Brooks, and though he
has not changed his name
as much as the East
German A.R. Penck, it is
possible to claim that
much of his nomadic exis-
tence has been taken up
in the pursuit of identity.
After being a merchant
seaman and GI he settled
in England, where he
lived from 1958 to 1998.
He was involved in the
Pop movement in the
1960s and has been a
close friend of David
Hockney since Royal
College days. In 1976 he
organized *The Human
Clay* exhibition at the
Hayward Gallery, London,
which celebrated the
depth of figurative
painting in London. It was
then that he coined the
phrase "The School of
London", a label that has
come, misleadingly, to
refer to a hard core of
figurative painters –
Francis Bacon, Lucian
Freud, Frank Auerbach,
Leon Kossoff, Michael
Andrews and Kitaj himself.
His willingness to interpret
his own paintings led

him to be branded as an
intellectual. See pp. 56, 97

Imi Knoebel
(born Dessau, Germany,
1940)
Studied at Werkkunst-
schule Darmstadt
(1962–64), Staatliche
Kunstakademie
Düsseldorf (1964–71)

Born Klaus Wolf Knoebel,
he adopted the name of
Imi when he and Imi
Goese had their first solo
exhibition together at the
Charlottenborg gallery
in Copenhagen in 1968.
Ever since he came out
of Beuys's class he has
been looking to justify an
art of geometry.

Barnett Newman declared
that geometry had
become a moral crisis.
Few people have
attempted to resolve this
crisis with the determi-
nation and dedication of
Knoebel. He has pursued
geometric forms with
the vigour of Malevich
and other Russian
Constructivists. His
attempts to break down
the traditional window
vision of the picture has
led him to paper cuts that

have quite literally fallen
off the wall. He has also
built wooden plank con-
structions, the triangles
of which often echo the
shape of a top-floor
window through which
he saw Dresden in flames
as a child at the end of the
War. See pp. 13, 94

Leon Kossoff
(born London, 1926)
Studied at St Martin's
School of Art, London
(1949–53), Borough
Polytechnic, London
(1950–52), Royal College
of Art, London (1953–56)

Kossoff's father and
family built up a small
chain of bakeries across
the north-east of London,
the area that Kossoff has
painted again and again.
At Borough Polytechnic
he studied alongside
Frank Auerbach under
David Bomberg. In these
two artists Kossoff found
kindred spirits in devel-
oping his persistent, near-
obsessive method of
working and reworking a
subject. Kossoff's world,
like Lucian Freud's and
Auerbach's, is made up of
people and places.
See pp. 100, 259

Christopher Le Brun
(born Portsmouth, Hampshire, 1951)
Studied at Slade School of Art, London (1970–74), Chelsea School of Art, London (1974–75)

Le Brun was one of the few British artists included in *Zeitgeist*, the exhibition in Berlin in 1982 that announced the international revival of figurative painting. His use of German Romantic mythology and Wagner made him an obvious choice. He worked with strong images that have recurred since then – wings, trees and horsemen. Like Georg Baselitz and Markus Lüpertz, he works through themes that have traditional connotations, though his lyrical style is closer to that of his German friend Bernd Koberling. With both style and subject-matter the artist is insisting on the right of the modern artist to choose paths considered taboo by other artists and critics.

Le Brun is married to the artist Charlotte Verity.
See pp. 107, 260

Markus Lüpertz
(born Liberec, Czech Republic, 1941)
Studied at Werkunst-schule Krefeld (1956–61), Staatliche Kunstakademie Düsseldorf (1961–63)

Lüpertz moved with his family to the West in 1948, but their move did not result in instant riches. He was repeatedly expelled from schools. Before he was able to make a living as an artist he did stints down coal-mines and building roads. With Hödicke and Koberling, Lüpertz founded the self-help gallery Großgörschen 35. They were forerunners of the figurative revival. In the 1970s Lüpertz's use of specifically 'German' motifs – steel helmets and officers' caps, spades, ears of corn and rusting army equipment – led critics to accuse him of promoting the Fascist aesthetic of the 1930s, but by doing this Lüpertz helped retrieve Germany's recent past rather than ignoring it. He literally re-built a figurative style out of abstraction.
See pp. 75, 120

Rut Blees Luxemburg
(born Moselle, Germany, 1967)
Studied at University of Duisburg (1988–90), London College of Printing (1990–93), University of Westminster, London (1994–96)

Rut Blees Luxemburg was born and brought up in the Moselle region, where her parents have a vine-yard. Far from her rural roots, she trained in London and has made the city her subject. She believes that contem-porary life is defined by the city, and to find the clash of modernity you have to take it on. Her work is on the cusp of harsh reality and roman-ticism, but neither fully describe the strange corners and angles her camera unearths. She does not attempt to adjust the golden hues achieved by long exposure.
See pp. 28, 265

Alice Maher
(born Cahir, County Tipperary, Ireland, 1956)
Studied at National Institute for Higher Education, Limerick (1974–78), Crawford College of Art, Cork (1981–85), University of Ulster, Belfast (1985–86), San Francisco Art Institute (1986–87)

Maher walks the narrow line of being able to plunder Irish folklore and national traditions while maintaining the radical inquisitiveness that seems so natural to the line of great twentieth-century Irish artists in all media.

Maher has made some exciting large-scale installations. Much of her work has involved hair and thorns. She built a huge ball out of brambles and installed it in a cell in Kilmainham Gaol in Dublin. She works with hair in a similar way, but has also made massive drawings of rear views of hair cascading to the ground. See p. 268

Ian McKeever
(born Withernsea, Yorkshire, 1946)
Self-taught

McKeever, the son of Irish immigrants, was brought up in East Yorkshire in a home that was "devoid of any kind of culture".[19] His most powerful memories are of the Catholic Mass and the sea. He says, "To have religious beliefs and to believe in painting both necessitate an act of faith".[20] On a scholarship to Nuremberg in 1981–82 he met his German wife, and he has since shown widely in Germany and Britain.

McKeever is one of a handful of British painters to have tackled landscape in an innovative way. He has travelled extensively in Lapland, Greenland, Tasmania, New Guinea, Lebanon and Siberia.
See p. 24

Ian McKenzie Smith
(born Montrose, Scotland, 1935)
Studied at Gray's School of Art, Aberdeen (1953–59)

As well as being one of Scotland's leading abstract painters, McKenzie Smith, who has been the President of the Royal Scottish Academy since 1998, was the lively Director of Aberdeen Art

328 Galleries and Museums for over twenty years. His early work strongly responded to Abstract Expressionism, but over the years this has been modified by an interest in Oriental art and calligraphy. See p. 273

Lisa Milroy
(born Vancouver, Canada, 1959)
Studied at Sorbonne, Paris (1977–78), St Martin's School of Art, London (1978–79), Goldsmiths' College, London (1979–82)

Lisa Milroy made her name with paintings featuring repeated images. In a strong echo of Andy Warhol's work, she arranged rows of often mundane objects such as lightbulbs, tyres and shoes, although there were forays into more exotic items such as Greek vases and butterflies. Unlike Warhol's, the objects were meticulously painted. Her early success as an artist is often quoted as an example to the YBAs (Young British Artists) who followed in her footsteps from Goldsmiths'.

Recently she has broken away from her trademark repetition to a freer style. See pp. 143, 277

Henry Moore
(born Castleford, Yorkshire, 1898; died Much Hadham, Hertfordshire, 1986)
Studied at Leeds School of Art (1919–21), Royal College of Art, London (1921–24)

Henry Moore was the seventh of eight children of a coalmining engineer. He was a teacher before studying sculpture. He had a great interest in sculpture from non-Western cultures. As Moore explained, the mother and child and the reclining figure were to recur in his work again and again: "Sometimes an artist has a set theme that he takes over and over again – Cézanne and his bathers are a case in point – and the theme frees him to try out all sorts of things that he doesn't quite know or isn't quite sure of. With me, the reclining figure offers that kind of chance."[21] He had two retrospectives

at the Tate Gallery, in 1951 and 1968. See p. 34

Christa Näher
(born Lindau, Germany, 1947)
Studied at Hochschule der Künste, Berlin (1971–80)

Stories surround Christa Näher and her work. Though she is not interested in anecdote or illustration, she uses in her art reworked myths that are in that zone of half-consciousness. She is looking for the mood that binds storyteller and listener together. Figures are half-concealed by layers of paint, so that they emerge only slowly from the pictures.

Since 1987 Näher has held a professorship at the Städelsches Kunstinstitut, Frankfurt, but she can be teasingly enigmatic in talking about her own work. "When I paint pigs, I paint pigs", she declared in 1991. "When I paint dogs, I paint dogs. When I paint horses, I paint something of myself."[22]
See p. 279

David Nash
(born Weybridge, Surrey, 1945)
Studied at Kingston College of Art, Surrey (1963–64, 1965–67), Brighton College of Art, Sussex (1964–65)

Nash moved to Wales after completing his studies. "Moving to Blaenau was economically possible for me. I could buy a house and studio for £300 – no rent, no mortgage, very low overheads – which gave me more time to find my way."[23]

Nash, who was occasionally loosely linked with the New British Sculptors, is one of the pioneers of working directly with nature. He comes out of the conceptual school, but wood, whether carved or still living, has been his main material. His ecological concerns were manifest in his project in Barcelona in 1995. "Barcelona city has a tree hospital in the suburbs – ailing trees are hard pruned and moved to this site to be nurtured back to health. Eighty per cent recover and eventu-

ally are returned to the city. The other twenty per cent were available to resurrect as sculpture."[24]
See p. 135

Hughie O'Donoghue
(born Manchester, 1953)
Studied at Goldsmiths' College, London (1980–82)

O'Donoghue, born into the Irish community in Manchester, now lives near Kilkenny in Ireland. He spent the first fifteen years of his career in London. In 1984 he was the Artist-in-Residence at the National Gallery, London. At around the same time he began work on a commission for a massive series of paintings on the Passion. In reviving history painting, which for many years has been taboo and decadent, O'Donoghue, like Anselm Kiefer, directly works on our memories and how we use our past. See p. 281

Markus Oehlen
(born Krefeld, Germany, 1956)
Studied at Staatliche Kunstakademie Düsseldorf (1976–81)

Markus Oehlen completed his training as a technical draughtsman in 1973 and went on to study design in 1976. In the early 1980s he joined with his brother Albert and their friends Werner Büttner and Martin Kippenberger to form the Hetzler Boys, but he soon parted company with them.

Oehlen likes to use a multi-tier structure, in the vein of Polke, who actually taught his brother. He quotes the formal vocabulary of diverse art styles, thereby emphasizing that the styles and their motifs can be substituted at will. He tries repeatedly to strike a balance between simple technique and careful pictorial composition. He loves dirty colours to give his pictures an alien appearance. See p. 118

Thérèse Oulton
(born Shrewsbury, Shropshire, 1953)
Studied at St Martin's School of Art, London (1975–79), Royal College of Art, London (1980–83)

Rare among painters, Thérèse Oulton achieved early success. Only a few years out of the Royal College she was hailed as a star. Right-wing critics were pleased to find a British Romantic Neo-Expressionist landscape painter, a label she tried to resist from the beginning. Much of her subsequent work sees her carefully repositioning her work in order that it cannot be interpreted in this way. In that she produces work difficult to pin down, she was a forerunner of the Brit Pack. In 1987 she was shortlisted for the Turner Prize. Oulton delights in the texture of paint, sometimes literally manipulating it, putting down her brushes and using her hands.
See pp. 160, 283

Ana Maria Pacheco
(born Goias, Brazil, 1943)
Studied sculpture and music at University of Goias, Brazil (1960–64); studied music and education at University of Brazil (1965); British Council Scholarship to Slade School of Art, London (1973–75)

"Although not an exile, more accurately an émigré, her experience of the very different cultures of England and Brazil, each a compound of many cultural ingredients, echoes in the many references the work draws upon: classical myth, Brazilian folktale, mystical catholicism, the fashion catwalk, medieval satire. The work reflects the experience of the outsider, not of the excluded, but of one who can choose or refuse the right to belong. If the entire world is now a foreign land it is, as Theodore Adorno ironically observed, 'part of morality not to be at home in one's home'."[25]

Ana Maria Pacheco came to study at the Slade School of Art on a British Council Scholarship in 1973. She was head of fine art at Norwich School of Art from 1985 to 1998 and was the first sculptor to be Associate Artist at the National Gallery, London.
See p. 284

Eduardo Paolozzi
(born Leith, Scotland, 1924)
Studied at Edinburgh College of Art (1943–44), Slade School of Fine Art, London (1944–47)

Paolozzi was brought up in a suburb of Edinburgh. "His parents ran an ice cream shop in Leith", relates Judith Collins, "and they used to display in the shop, week by week, the posters for the cinema. In return the cinema provided the family with a supply of free tickets. At the end of the year the cinema would also give away a book of photographs of film stars and Paolozzi collected these."[26] His interest in collage started early.

From 1953, when he was commissioned to make a fountain for Hamburg Park, Paolozzi has had close links with Germany. He was included in *Documenta II, III* and *IV* and has had as many major shows in Germany as Britain. He has been visiting professor in Hamburg and Munich as well as the Royal College of Art, London, and Edinburgh College of Art. A gallery has been devoted to him at the Dean Centre in Edinburgh. He was knighted in 1989.
See pp. 62, 77

Cornelia Parker
(born Crewe, Cheshire 1956)
Studied at Gloucestershire College of Art and Design (1974–75), Wolverhampton Polytechnic (1975–78), Reading University (1980–82)

Cornelia Parker was always curious. When young she was forever referring to a children's encyclopaedia, and years later this was to provide a title for one of her works, *Matter and What it Means*. She enjoys asking herself big questions and her responses have a childlike freshness. This is demonstrated in her explanation for *Thirty Pieces of Silver* (1989):

"Silver is commemorative, the objects are landmarks in people's lives. I wanted to change their meaning, their visibility, their worth, that is why

I flattened them, consigning them all to the same fate … As a child I used to crush coins on a railway track. You couldn't spend your pocket money afterwards but kept the metal slivers for their own sake, as an imaginary currency and as physical proof of the destructive powers of the worlds."[27] She steamrollered the silver and hung it on strings under spotlights. Her starting-point may have been provided by the work of Tony Cragg and Bill Woodrow, but as they have come out of conceptual art she has gone in the opposite direction.
See pp. 158, 285

Victor Pasmore
(born Chelsham, Surrey, 1903; died Malta, 1998)
Attended evening classes at Central School of Arts and Crafts, London (1927–30)

The sudden death of his father led Pasmore to postpone his planned artistic training and take a job as a clerk in the Public Health Department of the London County Council. In 1938 Kenneth Clark,

then Director of the National Gallery, helped him take up painting full-time. One of the founders of the Euston Road School, he was a figurative painter until the late 1940s, when he became concerned with the crisis of modern painting. He was an influential teacher at Camberwell, Central and King's College, Durham, and was highly interested in art's potential role in the environment. In 1955 he helped design Peterlee New Town in County Durham.
See pp. 45, 286

Celia Paul
(born Trivandrum, India, 1959)
Studied at Slade School of Art, London (1976–81)

Celia Paul is a London painter in the spirit of Frank Auerbach, Leon Kossoff and Lucian Freud. In her studio, opposite the British Museum, London, she has painted those who are close to her, especially her mother and her sisters Kate, Jane, Lucy and Mandy. The original impetus to paint came when she was first

separated from her family. Sent to boarding school, she bitterly missed her mother, so began to draw and paint, as if it were to bring them closer.

Paul's most famous work was entitled *Family Group* (1984–86) and showed her family sitting on a bed, mourning the loss of the artist's father, a bishop. She is concerned with intimate worlds, so it is not surprising that she admires Charlotte Brontë, George Eliot and Nabokov.
See p. 287

A.R. Penck
(born Nuremberg, Germany, 1938)
Self-taught

Penck has made one of the defining images of twentieth-century man. His stick-like creatures, while recalling cave paintings, conjure up the insect-like existence of a world with too many people. It has a more personal meaning to the artist, who was forced constantly to create new identities for himself in order to exhibit his work

on the Western side of the Iron Curtain and not be prosecuted. He stayed in East Berlin when the Wall was built and was not allowed to exhibit. It was then that he chose the pseudonym Albrecht R. Penck, and from 1969 onwards he showed and sold in the West under that name and others. Keith Haring and other Graffiti artists later echoed the anonymity of his skeletal human figures.
See pp. 114, 116

Sigmar Polke
(born Oels, Germany, 1941)
Studied at Staatliche Kunstakademie Düsseldorf (1961–67)

Polke left the GDR in 1953 to come to the West, but has never totally left the mindset required to survive in the shifting sands of a repressive political system. He has never lost his scepticism. While studying at the Staatliche Kunstakademie Düsseldorf under Hoehme and Götz he was influenced by Joseph Beuys, but though some of his fragmented romanticism

may stem from Beuys, Polke lards everything with irony. His constant reinvention of himself means that it would be quite possible to give an informative history of the last forty years through his work alone – from his version of Pop through Romantic Irony and into his seamless, shifting position of the 1990s.
See pp. 10, 74, 95

Michael Porter
(born Holbrook, Derbyshire, 1948)
Studied at Nottingham College of Art (1963–66), Chelsea School of Art, London (1968–71)

Porter moved recently to Newlyn, Cornwall but for nearly thirty years he worked in a studio in the heart of the city on the edge of London Fields, where for much of the time he persisted in painting a threatened wood from his native rural Derbyshire. He works on the floor, as did the American Jackson Pollock. Pollock created his paintings literally standing in the centre of them and saw himself as

part of the picture, even declaring himself to be nature. Porter takes a more tangential approach than Pollock. He does not dominate his paintings. They literally grow in pools of mixed-media liquid. He was given an exhibition by the Botanic Gardens in Edinburgh because botanists admire the accuracy of his depictions of fungi.
See pp. 125, 289

Arnulf Rainer
(born Baden, Austria, 1929)
Self-taught

Rainer is an obsessive perfectionist. His pictures reflect a search for an ideal beauty, his inability to achieve it and the resulting destructive urge. He bases his own judgement not on the picture itself but on a pre-existent, neo-Platonic idea of perfection, which acts as a permanent challenge to him. He complains that his pictures lack the full vitality of living creatures and belong to a world of make-believe.

Lines fill the paper in his drawings, a result of his

need to meet his own personal challenge. He has made 'overpaintings' where he has literally applied layers of paint over previous works, both his own and other people's. In 1981 he was made a professor at the Akademie der Bildenden Künste, Vienna, and his influence has been felt on many younger German and some British artists.
See p. 92

Libby Raynham
(born Lenham, Kent, 1952)
Studied at Slade School of Art, London (1970–74)

Raynham quotes Emily Dickinson to introduce her own delicate abstract work: "Exultation is the going/ Of an inland soul to sea,/ Past the house – past the headlands – / Into deep Eternity".[28]

Though born and trained in England, Raynham lives in Zürich. As she admits, her chosen "format is small and intimate … I work by daylight. I work on paper, a sensitive receptive surface." Against the mood of the day, she

relies on contemplation.
See p. 291

Paula Rego
(born Lisbon, Portugal, 1935)
Studied at Slade School of Art, London (1952–56)

From her arrival as the youngest student at the Slade School of Art, Rego spectacularly broke the rules of modern British painting. She told stories in pictures, which was strictly forbidden. Her crime was not so much the subversive content of the pictures, but that they flaunted their disregard for the way her teachers and fellow pupils made pictures.

Though Rego made a six-month study of fairy stories in later life, many of her pictures stem back to her early memories of storytelling, to a time when alternate weeks were spent between her happy grandparents and a gloomy aunt. As she recalls:

"The greatest problem all my life has been the

inability to speak my mind – to speak the truth. Adults were always right, never answer back. To answer back felt like death, like being in a sudden huge void. I'll never get over this fear: so I've hidden in childish guises – or female guises. Little girl, pretty girl, attractive woman. Therefore the flight into storytelling. You paint to fight injustice." [29]
See p. 293

Gerhard Richter
(born Dresden, Germany, 1932)
Studied at Hochschule für Bildende Künste, Dresden (1952–56), Staatliche Kunstakademie Düsseldorf (1961–63)

In 1961, two months before the Wall was raised, Richter left his native Dresden to settle in Düsseldorf, to escape the social realism that reigned in the name of the proletarian masses. However, he found that the centre of the Western German art world showed little more tolerance for freedom of choice. His fellow artists seemed interested

only in Tachism and Abstract Expressionism.

Photographs have long played a crucial role in Richter's work, and much of his installation and preparatory work is photographic, but he has always been regarded as a painter. Indeed, he is considered by many as one of painting's foremost exponents. As he explained on 28 February 1985, he uses photographs because he prefers to "let something come into being rather than to create. That is, no declarations, no constructions, nothing supplied, no ideologies – in this way to achieve something real, richer, more alive, something that is beyond my understanding." [30]
See pp. 81, 161, 294

Bridget Riley
(born London, 1931)
Studied at Goldsmiths' College, London (1949–52), Royal College of Art, London (1952–55)

Riley is the most ordered of artists, experimenting with a scientific precision

334

on the way of seeing. Her early work came out of an understanding of Seurat and Pointillism, but in the 1960s she soon developed her own style, indeed her own label, Op art, in contrast to the Pop art prevalent at the time.

Images, though stationary on the canvas, visually move within the eye's retina. Famous for vertical stripes, Riley has developed diagonals and curves; she is very much still experimenting. Given her fascination with space, particularly the area between the viewer and the picture, it is appropriate that she is also known for her work as one of the key founders of SPACE, a scheme for organizing artists' studios. See p. 295

Dieter Roth
(born Hanover, Germany, 1930; died Hanover, 1999)
Studied at Studio Friedrich Wüthrich, Berne (1947)

Dieter Roth (born Karl-Dietrich Roth), as an active member of *Fluxus*,

came as close to Pop as any German artist. Indeed over the years he collaborated with one of its British exponents, Richard Hamilton. They shared an interest in the technological process of making prints. Roth trained as a graphic artist before working in Copenhagen as a textile designer. In the 1960s he explored organic processes by incorporating food into his work – silkscreen prints with chocolate, etchings with bananas and chocolate, food portraits and spice pictures. See p. 76

Eugen Schönebeck
(born Heidenau, Germany, 1936)
Studied at Hochschule der Künste, Berlin (1955–61)

Schönebeck met Georg Baselitz at art school and they worked together intensively. Their art was rooted in the figurative tradition, though Baselitz was later literally to uproot it. They had a joint exhibition in 1961 and created the *Pandemonium Manifesto*.

Schönebeck gave up painting after his second solo exhibition when he was thirty years old, by which time (between 1957 and 1966) he had produced about twenty-seven paintings and between five hundred and one thousand drawings. See p. 74

Sean Scully
(born Dublin, Ireland, 1945)
Studied at Croydon College, Surrey (1965–68), Newcastle University (1968–72), Harvard University, Cambridge, Massachusetts (1972–73)

The knowledge that Scully is a black belt in Judo has encouraged critics to call his abstract art muscular. Certainly the large three-dimensional constructions of the 1980s needed a strong builder; their stretchers looked like scaffolding. Indeed the building analogy may be taken further as he works with blocks of colour. Born in Dublin, Scully moved to London when he was three years old. Britain was not able to

contain him for long, however, for he moved to the United States in 1975, although he has maintained a studio in London for over ten years. Claimed by the Irish, British and Americans, his has been a truly international career. See p. 162

Katharina Sieverding
(born Prague, 1944)
Studied at Hochschule für Bildende Künste, Hamburg (1963–64), Staatliche Kunstakademie Düsseldorf (1967–74)

"Images have gone haywire … We the observers are left only with a sense of vertigo – a dizzying sense of having the ground pulled out from under our feet",[31] writes Rudolf Schmitz in explaining the way Katharina Sieverding dissects our new-found ambivalence to photographic images. She builds up walls of direct images in a way reminiscent of Warhol: she puts up the images as objects of worship, but at the same time fans our mistrust of such belief.

At the Staatliche Kunstakademie Düsseldorf, Sieverding was taught by Teo Otto and then Joseph Beuys. In 1975 she helped Beuys in the performance *To Change art, Change People* at the Musée Ixelles in Brussels. She threw knives at him in a circus act. See p. 168

Arturo Di Stefano
(born Huddersfield, Yorkshire, 1955)
Studied at Liverpool Polytechnic (1973), Goldsmiths' College, London (1974–77), Royal College of Art, London (1978–81), Accademia Albertina, Turin (1985–86)

Since Di Stefano's scholarship in Turin and his visit to the Shroud, he has developed a technique that goes beyond mere representation. He wants his images to have a certain distance, so that they work on the brain in the same way as the memory. He produces meticulous pictures, only to savagely attack his own creation by applying an acidic varnish to the surface. He consciously risks

damage to his hard-won image. To remove the varnish he applies Japanese paper. The risk comes in pulling off the paper in one flowing gesture. A mirror image impregnates itself on the Japanese paper. These counter-proofs give another side to his vision. See p. 301

Walter Stöhrer
(born Stuttgart, Germany, 1937)
Studied at Staatliche Akademie der Bildenden Künste, Karlsruhe (1957–62)

Stöhrer works in the German Expressionist tradition. His loose drawing and painting style unleashes his demons. Christian Rathke sees Stöhrer setting free a hellish multitude of evil spirits and fiends in wild sexual fantasies. He paints mainly large pictures and sucks the viewer into a whirlpool of colours. See p. 42

Thomas Struth
(born Geldern, Germany, 1954)
Studied at Staatliche

Kunstakademie Düsseldorf (1973–80)

Thomas Struth, a student of Bernd and Hilla Becher, has taken their objectivity in a new direction. He is perhaps best known for his interiors of museums. From early on in his career he decided his views of streets should have a strict linear perspective. In aligning façades he looked for the same basic structure in order to diminish the photographer's subjective focus. The standardization of the view forces the viewer to find his own interest. As the Berne curator Ulrich Loock observes, "this kind of photography demands from the observer that he create a world for himself from the inventory, knowing very well that it will inevitably be purely personal. With such a claim, Thomas Struth's photographic work does not only offer an archive of the already constructed world, it also guarantees that the world of our life is still waiting for us to construct it."[32] See p. 302

Graham Sutherland
(born London, 1903; died London, 1980)
Studied at Goldsmiths' College, London (1921–26)

Sutherland was originally destined to be an engineer. Indeed, in 1920 he was apprenticed to the Midland Railway Works at Derby. His second career change was forced on him by the Wall Street Crash of 1929. Up to that point he had specialized in etchings redolent of the nineteenth-century British Romantic Samuel Palmer, but the collapse of the print market made him expand the range of media he used. The debate on his influence on Francis Bacon is still unresolved, but the two artists were undoubtedly close. The general consensus is that Sutherland supplied kind encouragement at a vital moment, but was quickly overshadowed. See pp. 13, 303

Estelle Thompson
(born West Bromwich, 1960)
Studied at Sheffield City Polytechnic (1979–82),

Royal College of Art, London (1983–86)

It is possible to see Estelle Thompson's career since her first one-person show in 1989 as one steady Modernist march that leads inevitably to the Fuse Paintings. Stripes are the logical answer for those interested in laying down colour; the colours escape association with any form. This merging of colours, while not compromising the integrity of abstraction, makes the work more human.

Thompson has been a Senior Research Fellow in Fine Art at De Montfort University, Leicester, since 1995. See p. 163

Günther Uecker
(born Wendorf, Germany, 1930)
Studied at Hochschule für Bildende und Angewandte Kunst, East Berlin (1949–53), Staatliche Kunstakademie Düsseldorf (1955–57)

Uecker was a leader of the Zero movement. Interpretations of his nail paintings are usually

linked to his departure from the GDR in 1954. He began a new life as one of the first 'squatters' in West Berlin, but it was in Düsseldorf under the tuition of Otto Pankok that he developed his nail paintings, an attempt, like Fontana's slashes, to break and expand the traditional painting surface. The injuries Uecker inflicts on his canvas have been compared to those caused by the Third Reich. In 1969 Uecker began his Nail Campaign, which he described as a "battlefield" through a landscape. He drew a line to the horizon. He literally planted this line with nails. He called himself "the nailer" and everything was nailed down by him: cars, plants and many everyday objects such as telephones, glasses and clothes. He even admitted to a manic condition, which led him to the point where the nailer considered driving nails through his own shoes and so nailing himself down. There are strong echoes of theological redemption, as Christ was pinned to the Cross by nails. See p. 58

Charlotte Verity
(born Wegberg,
Germany, 1954)
Studied at Slade School
of Art, London (1973–77)

Charlotte Verity's still-life
painting is in the main-
stream of British art
favoured by the Slade
School of Art, which she
attended. Yet while at the
Slade she worked from
the figure and developed
her interest in landscape.
Her path to still life was
not as direct as it appears.

After leaving the Slade,
Verity lived and worked
on the Boise Travelling
Scholarship in Italy, where
she particularly admired
three of the founders of
modern Western painting,
Giotto, Masaccio and
Piero della Francesca. She
became more aware of
the values of Northern
European painting after
a year in West Berlin in
1987 and 1988 when her
husband, the artist
Christopher Le Brun, was
on a DAAD Scholarship.
See p. 306

Wolf Vostell
(born Leverkusen,
Germany, 1932)

Studied at
Werkkunstschule,
Wuppertal (1954–55),
École Nationale
Supérieure des Beaux-
Arts, Paris (1955–56),
Staatliche Kunstakademie
Düsseldorf (1956–57)

Like Richard Hamilton,
Vostell uses photographic
and film images, but
Vostell exploits them to
highlight the technologi-
cal destruction of the
environment. Since his
central role in the *Fluxus*
movement his work has
contained a heady mix of
consumerism, political
upheaval, chaos and
destruction, invariably
augmented with a topical
touch. The collapse of the
Wall in Berlin, where
Vostell lives and works,
supplied an ideal subject
for the artist.
See p. 307

John Walker
(born Birmingham, 1939)
Studied at Birmingham
College of Art (1956–60),
Académie de la Grande
Chaumière, Paris
(1961–63)

John Walker lived in
London from 1964 to 1970.

In 1972 he represented
Britain in the Venice
Biennale, but by then he
was dividing most of his
time between Australia
and the United States.

To defend Walker's
distrust of content, Dore
Ashton quotes Delacroix:
"Painting doesn't always
need a subject".[33] He has
devised a rather dull
monolithic form, which
he repeats endlessly. On
this he demonstrates the
richness of paint and
printing techniques. The
work resembles a brilliant
pianist playing scales in
public so that the listener
is reminded of the full
ability of the piano. His
German contemporary,
Baselitz, turns the image
upside down to make the
viewer reappraise what
he is seeing. Walker
reduces the work to
process and technique.
See p. 120

Richard Wilson
(born London, 1953)
Studied at London
College of Printmaking
(1970–71), Hornsey
College of Art, London
(1971–74), Reading
University (1974–76)

Richard Wilson is a site-
specific artist, who forces
visitors to his installations
to re-examine spaces.
His most famous work is
20:50 (1987), a lake of oil
within the Saatchi Gallery,
London. In describing
Deep End (1994), which
he made for the Museum
of Contemporary Art in
Los Angeles, Wilson
reveals how he literally
inverts our vision, in this
case by turning a swim-
ming pool upside down
and forcing us to look up
a drain pipe to see the
polluted California sky.

"The idea of the pool
came about while flying
into LA International
Airport, looking down,
seeing all these sixties'
Modernist shapes of sky
blue, and recognizing that
there were these peculiar
lifestyles being lived out
in the hills of Los Angeles
… When you look through
the pipe in Deep End,
you see the blue sky of
Los Angeles – the reality
of the world as opposed
to the artifice of the
Bahamas blue, the par-
adise blue of the swim-
ming pool. The artificiality
of the pool is supposed to

represent an ideal life-
style – paradise. Yet in
Deep End, reality appears,
as it were, up a drain
pipe."[34] See p. 309

Catherine Yass
(born London, 1963)
Studied at Slade School
of Art, London (1982–86),
Hochschule der Künste,
Berlin (1984–85),
Goldsmiths' College,
London (1989–90)

Catherine Yass's work is
produced to be shown
back-lit on a light-box.
Institutional buildings
such as hospitals and
factories are her natural
hunting-ground, though
she has made an effective
series out of the rich
lettering and sculptural
forms of a graveyard. The
luminous spreading of
acidic colours has become
her trademark.
See p. 170

Bernd Zimmer
(born Planegg,
Germany, 1948)
Studied philosophy and
religion, Freie Universität,
Berlin (1973–79); was
taught painting by K.H.
Hödicke and Bernd
Koberling

Bernd Zimmer began his career as an artist in 1975. With a few notable exceptions, the professors and rest of the art world were united in their advice as to the kind of work he should produce: "The censors told me don't paint, so I painted".[35] His desire to paint coincided with a public thirst for painting. He and the other *Neue Wilde* (Wild Ones), such as Fetting, Salomé and Middendorf, were instant international successes.

Realism has never been enough for Zimmer. His mountain paintings were the first to explore the idea of double vision, two viewpoints, two readings. Since then he has pursued this sense of aerial vision. It is as though one is looking down at the world through the clouds, and yet one can make different-angled readings as well. See p. 123

1 Edward Allington, interviewed by Stuart Morgan, in *Edward Allington: In Pursuit of Savage Luxury*, exhib. cat. by Stuart Morgan and Jacqueline Ford, Nottingham, Midland Group Art Centre, 1984, p. 27.
2 Frank Auerbach, quoted in Alistair Hicks, *The School of London*, Oxford (Phaidon) 1989, p. 28.
3 Ruth Charity and Amanda Daly, *David Austen: Paintings and Works on Paper*, exhib. cat., University of Warwick, Mead Gallery, Warwick Arts Centre, 27 September–27 October 1997, p. 5.
4 Gillian Ayres, quoted in Alistair Hicks, *op. cit.*, p. 64.
5 Michael Bach, quoted in artist's statement, *Der zerbrochene Spiegel: Positionen zur Malerei*, exhib. cat., ed. Kaspar König and Hans-Ulrich Obrist, Vienna, Museumsquartier Messepalast and Kunsthalle; Hamburg, Deichtorhallen; 1993, p. 150.
6 Michael Auping, in *Modern Art Museum Forth Worth Journal*, July–September 1998, pp. 1–7
7 Patrick Caulfield, quoted in Marco Livingstone, 'Patrick Caulfield', *Patrick Caulfield*, exhib. cat, ed. Timothy Stevens, London, Tate Gallery; Liverpool, Walker Art Gallery; 1981, p. 13.
8 Sacha Craddock, 'Prunella Clough: Paintings', *Prunella Clough*, exhib. cat., ed. Jenni Lomax and Elaine Marshall, London, Camden Arts Centre, 1996, p. 22.
9 Catherine Legallais, 'A Worldwide Homesickness', *Hannah Collins: In the Course of Time*, exhib. cat., ed. Manuel Muñoz Ibáñez, Sala Parpalló, Centre Cultural La Beneficència, p. 100.
10 Melanie Comber, personal

statement to the editors, December 1999.
11 Susan Derges, 'River Taw', *Susan Derges: River Taw*, exhib. cat., ed. Richard Bright and Michael Hue-Williams, London, Michael Hue-Williams Gallery, 19 October–22 November 1997, p. 3.
12 Raimar Stange, 'Gunther Forg', in Buckhard Riemschenedier and Uta Grosenick (eds.), *Art at the Turn of the Millennium*, Cologne (Taschen) 1999, p. 158.
13 Richard Calvocoressi, 'Foreword', *Early Work: Lucian Freud*, exhib. cat., ed. Richard Calvocoressi, Edinburgh, Scottish National Gallery of Modern Art, 18 January–13 April 1997, p. 7.
14 Patrick Elliott, 'Hamish Fulton: Fourteen Works 1982–89', *Contemporary British Art in Print*, exhib. cat., ed. Patrick Elliott, Edinburgh, Scottish National Gallery of Modern Art, 1995, p. 86.
15 Nathaniel Hawthorne, quoted in Andrew Humphries, 'Folds in the Landscape', in Michael Hue-Williams (eds.), *Andy Goldsworthy: Sheepfolds*, London (Michael Hue-Williams) 1996, p. 66.
16 Jörg Immendorff, in Jörg Huber, 'Situation–Position', *Immendorff*, exhib. cat., ed. Johannes Gachnang, Jörg Immendorff, Toni Stooss and Harald Szeeman, Zurich, Kunsthaus, 1983, p. 38.
17 Frances Spalding, *Dictionary of British Art, VI: 20th-Century Painters and Sculptors*, Woodbridge (Antique Collectors' Club) 1991.
18 Peter C. Bunnell, *Michael Kenna: A Twenty-Year Retrospective*, San Francisco (Ram) 1994.
19 Ian McKeever, taped conversation with Pat Gilmour,

recorded in London on 22 November 1996 and transcribed in Pat Gilmour, 'Introduction', *Ian McKeever: Colour Etching*, exhib. cat., ed. Alan Cristea and Kathleen Dempsey, London, Alan Cristea Gallery, 1997, unpaginated.
20 *Ibid.*
21 Henry Moore, quoted in John Russell, *Henry Moore*, London (Penguin Books) 1968, p. 189.
22 Christa Näher, quoted in Johann-Karl Schmidt, 'An Introduction', *Christa Näher. Schacht*, exhib. cat., ed. Johann-Karl Schmidt, Stuttgart, Galerie der Stadt, 1991, p. 13.
23 David Nash, quoted in Julian Andrews, 'Chronology', *The Sculpture of David Nash*, London (Lund Humphries in association with the Henry Moore Foundation) 1996, p. 165.
24 *Ibid.*, p. 173.
25 Simon Wilmoth, 'Circumnavigation: The Poetics of Exploration in the Work of Ana Maria Pacheco', *Ana Maria Pacheco: Twenty Years of Printmaking*, Sevenoaks (Pratt Contemporary Art) 1994, p. 15.
26 Judith Collins, 'Eduardo Paolozzi: Works on Paper 1946–1995', *Eduardo Paolozzi: Artificial Horizons and Eccentric Ladders*, exhib. cat., ed. Richard Riley, London, British Council, 1996, p. 13.
27 Cornelia Parker, quoted in Jessica Morgan, 'Matter and What it Means', *Cornelia Parker*, exhib. cat., ed. Jessica Morgan, Boston, ICA, 2 February–9 April 2000, p. 16.
28 Emily Dickinson, quoted in Libby Raynham, statement to the editors, 1999.
29 Paula Rego, quoted in John McEwen, *Paula Rego*, London (Phaidon) 1992, p. 17.

30 Gerhard Richter, *Gerhard Richter – werken on papier 1983–1986, notities 1982–1986*, exhib. cat., Amsterdam, Museum Overholland, 1987, p. 8; translated by Jill Lloyd; quoted in Jill Lloyd, 'Gerhard Richter: The London Paintings', *Gerhard Richter: The London Paintings*, exhib. cat., London, Anthony d'Offay Gallery, 11 March–16 April 1988, unpaginated.
31 Rudolf Schmitz, 'Terrestial Things', *Katharina Sieverding: Biennale di Venezia, 1997*, exhib. cat., ed. Klaus Mettig, Stuttgart, Cantz, 1997, unpaginated.
32 Ulrich Loock, 'Photos of the Metropolis', *Thomas Struth*, exhib. cat., ed. Thomas Struth and Ulrich Loock, Berne, Kunsthalle Berne, 1987, p. 79.
33 Eugene Delacroix, quoted in Dore Ashton, 'Introduction', *John Walker*, exhib. cat., ed. Catherine Lampert, London, Hayward Gallery, 1985, p. 6.
34 Richard Wilson, quoted in Paul Schimmel, 'Interview with Richard Wilson', *Richard Wilson: Deep End*, exhib. cat., Los Angeles, Museum of Contemporary Art, 1995, pp. 13 and 15.
35 Bernd Zimmer, from a conversation with the author, October 1997.

Selected Bibliography

General Books

Michael Archer, *Art Since 1960*, London (Thames and Hudson) 1997

Matthew Collings, *Blimey! From Bohemia to Britpop: The London Artworld from Francis Bacon to Damien Hirst*, London (Twenty-One) 1997

Margaret Garlake, *New Art, New World: British Art in Post-War Society*, New Haven CT and London (Yale University Press) 1998

Liam Gillick and Andrew Renton (eds.), *Technique Anglaise: Current Trends in British Art*, London (Thames and Hudson) 1991

Tony Godfrey, *The New Image: Painting in the 1980s*, Oxford (Phaidon) 1986

Charles Harrison, *Modernism,* London (Tate Publishing) 1997

Alistair Hicks, *The School of London,* Oxford (Phaidon) 1989

Alistair Hicks, *British Art in the Saatchi Gallery*, London (Thames and Hudson) 1989

Dieter Honisch and Jens Christian Jensen, *Amerikanische Kunst von 1945 bis Heute,* Cologne (Dumont Buchverlag) 1976

Jeffrey Kastner and Brian Wallis, *Land and Environmental Art*, London (Phaidon) 1998

Kaharin Kuh, *The Artist's Voice: Talk with Seventeen Artists*, New York, (Harper and Row) 1962

Marco Livingstone, *Pop Art: A Continuing History,* New York (Abrams) 1990

Norbert Lynton, *The Story of Modern Art* [1980], 2nd edn, Oxford (Phaidon) 1989

Marcus Rasp, *Contemporary German Photography*, Cologne (Taschen) 1997

Burkhard Riemschneider and Uta Grosenick (eds.), *Art at the Turn of the Millennium*, Cologne (Taschen) 1999

Bryan Robertson and John Russell, with photographs by Lord Snowdon, *Private View*, London (Thomas Nelson and Sons), 1965

Frances Spalding, *British Art Since 1900*, London (Thames and Hudson) 1986

Frances Spalding, *Dictionary of British Art, VI: 20th-Century Painters and Sculptors*, Woodbridge (Antique Collectors' Club) 1991

Beate Stärk, *Contemporary Painting in Germany*, Sydney (Craftsman House) 1994

Leon Underwood, *Figures in Wood of West Africa*, London (Alec Tiranti) 1951

Dorothy Walker, *Modern Art in Ireland*, Dublin (Lilliput Press) 1997

Exhibition Catalogues: General (chronological)

Documenta I, exhib. cat., Kassel, various locations, July–September 1955

Metavisual Tachiste Abstract, exhib. cat., intro. by Dennys Sutton, London, Redfern Gallery, 1957

Documenta II, exhib. cat., Kassel, various locations, July–October 1959

Documenta III, exhib. cat., Kassel, various locations, June–October 1964

Documenta IV, exhib. cat., Kassel, various locations, June–October 1968

Live in Your Head: When Attitudes Become Form, exhib. cat., ed. H. Szeeman, London, ICA, and Berne, Kunsthalle, 1969

Documenta V, exhib. cat., Kassel, various locations, June–October 1972

The Human Clay, exhib. cat. by R.B. Kitaj, London, Hayward Gallery, 1976

Documenta VI, exhib. cat., Kassel, various locations, June–October 1977

A New Spirit in Painting, exhib. cat., ed. Christos M. Joachimides, Norman Rosenthal and Nicholas Serota, London, Royal Academy of Arts, 1981

Objects and Sculpture, exhib. cat., ed. Lewis Biggs, Iwona Blaszczyk and Sandy Nairne, London, ICA; Bristol, Arnolfini; 1981

Zeitgeist, exhib. cat., ed. Christos M. Joachimides and Norman Rosenthal, Berlin, Martin-Gropius-Bau, 1982

Documenta VII, exhib. cat., ed. Rudi Fuchs, Kassel, various locations, June–October 1982

Transformations: New Sculpture from Britain. The XVII São Paulo Bienal, exhib. cat. by Teresa Gleadowe, The British Council, 1983

Expressions: New Art from Germany, exhib. cat. by Jack Cowart, Siegfried

340

Gohr and Donald B. Kuspit, St Louis, The St Louis Art Museum, *et al.*, 1983

"Primitivism" in 20th-Century Art, exhib. cat., ed. William Rubin, New York, Museum of Modern Art, 1984

German Art in the 20th Century: Painting and Sculpture 1905–1985, exhib. cat. by Christos M. Joachimides, Norman Rosenthal and Wieland Schmied, London, Royal Academy of Arts, 1985

Deutsche Kunst seit 1960. Sammlung Prinz von Bayern, exhib. cat. by Carla Schulz-Hoffmann and Peter-Klaus Schuster, Munich, Staatsgalerie Moderner Kunst, 1985

British Art in the 20th century, exhib. cat., ed. Susan Compton, London, Royal Academy of Arts, January–April 1987

Berlin Art 1961–1987, exhib. cat., ed. Kynaston McShine, New York, Museum of Modern Art, *et al.*, 1987

Current Affairs, exhib. cat., ed. David Elliott, Oxford, Museum of Modern Art, *et al.*, March 1987

Documenta VIII, exhib. cat., Kassel, various locations, June–September 1987

Terry A. Neff (ed.), *A Quiet Revolution: British Sculpture Since 1965*, London (Thames and Hudson) 1987, published on the occasion of *British Sculpture Since 1965: Cragg, Deacon, Flanagan, Long, Nash, Woodrow*, curated by Mary Jane Jacob and Graham Beal, Chicago, Museum of Contemporary Art, and San Franciso, Museum of Modern Art, 1987–88

Binationale: German Art of the late 80s, exhib. cat. by Jürgen Harten, Rainer Crone, Ulrich Lockhardt and Jiři Svetska, Düsseldorf, Städtishe Kunsthalle, *et al.*, 24 September–27 November 1988

Freeze [curated by Damien Hirst], exhib. cat., intro. by Ian Jeffrey,

London, Port of London Authority Building, 1988

Refigured Painting: The German Image 1960–88, exhib. cat. by Thomas Krens, Joseph Thompson and Michael Govan, New York, Solomon R. Guggenheim Museum, *et al.*, 1989

Blasphemy on our Side: Fates of the Figure in Postwar German Painting, exhib. cat., New York, Guggenheim Museum, 1989

The British Art Show, exhib. cat., ed. Caroline Collier, Andrew Nairne and David Ward, London, South Bank Centre, *et al.*, 1990

Possible Worlds: Sculpture from Europe, exhib. cat. by Iwona Blazwick and Andrea Schlieker, London, ICA, and Serpentine Gallery, November 1990–February 1991

Pop Art, exhib. cat. by Marco Livingstone, London, Royal Academy of Arts, *et al.*, 1991

Documenta IX, exhib. cat., Kassel, various locations, June–September 1992

High Fidelity, Low Frequency, exhib. cat. by James Roberts, Nagoya, Kohji Ogura Gallery, 1993

Pop Prints from the Arts Council Collection, exhib. cat. by Marco Livingstone, London, South Bank Centre, *et al.*, 1993

The Sixties Art Scene in London, exhib. cat. by David Mellor, London, Barbican Art Gallery, 1994

German Art: Aspekte deutscher Kunst 1964–1994, exhib. cat., ed Thaddaeus Ropac, Salzburg, Thaddaeus Ropac Gallery, 1994

The Romantic Spirit in German Art 1790–1990, exhib. cat., ed. Keith Hartley, Henry Meyric Hughes, Peter-Klaus Schuster and William Vaughan, London, Hayward Gallery; Edinburgh, Royal Scottish Academy; 1994

Contemporary British Art in Print: The Publications of Charles Booth-Clibborn and his Imprint the Paragon Press 1986–95, exhib. cat. by Patrick Elliott, Edinburgh, Scottish National Gallery of Modern Art, 1995

Minky Manky, exhib. cat., ed. Carl Freedman, London, South London Gallery, 1995

Marlene Dumas/Francis Bacon, exhib. cat., ed. Marente Bloemheuvel, Jan Mot and Sune Nordgren, Malmö, Konsthall, 18 March–14 May 1995

Art in the 20th Century, exhib. cat., Cologne, Museum Ludwig, 1996

Austrian Painting 1945–95: The Essl Collection, exhib. cat., ed. Wieland Schmied, Vienna, Künstlerhaus, March–July 1996

The Froelich Foundation: German and American Art from Beuys and Warhol, exhib. cat. by Stefan Germer, Thomas

McEvilley and Nicholas Serota, ed. Monique Beudert, London, Tate Gallery, 1996

Manifesta [curated by Rosa Martinez, Viktor Misiano, Katalin Néray, Hans-Ulrich Obrist and Andrew Renton], exhib. cat., Rotterdam, 9 June–19 August 1996

Distemper: Dissonant Themes in the Art of the 1990s, exhib. cat., ed. Neal Benezra and Olga M. Viso, Washington, D.C., Hirshhorn, 1996

Exiles and Emigrés: The Flight of European Artists from Hitler, exhib. cat. by Stephanie Barron and Sabine Eckmann, Los Angeles, County Museum of Art, *et al.*, 1997

German Art: Thirty Years of German Contemporary Art, exhib. cat., ed. Dieter Ronte and Walter Smerling, Singapore Art Museum, 10 July–21 September 1997

Documenta X, exhib. cat., ed. Catherine David and Jean-François Chevrier,

Kassel, various locations, June–October 1997

Sensation: Young British Artists from the Saatchi Collection [curated by Norman Rosenthal], exhib. cat., London, Royal Academy of Arts, 1997

Eckhart Gillen (ed.), *German Art from Beckmann to Richter*, Cologne (Dumont Buch-verlag) 1997, published on the occasion of *Deutschlandbilder. Kunst aus einem geteilten Land*, exhib. cat., Berlin, Martin-Gropius-Bau, September 1997–January 1998

When Time Began to Rant and Rage: Figurative Painting from Twentieth-Century Ireland, exhib. cat., ed. James Steward, Liverpool, Walker Art Gallery, *et al.*, 1998–99

German Open: Contemporary Art in Germany, exhib. cat., ed. Veit Görner and Anelie Lütgens, Wolfsburg, Kunstmuseum, 1999

Landschaften eines Jahrhunderts aus der

Sammlung Deutsche Bank, exhib. cat., ed. Ariane Grigoteit, Frankfurt, Deutsche Bank, 1999

Signature Pieces, exhib. cat., ed. Alan Cristea and Kathleen Dempsey, London, Alan Cristea Gallery, 5 January–6 February 1999

Irish Art Now: From the Poetic to the Political, exhib. cat. by Declan McGonagle, Fintan O'Toole and Kim Levin, Boston MA, McMullen Museum of Art, *et al.*, 1999–2001

Global Art [curated by Marc Sheps, Yilmaz Dziewior and Barbara M. Thiemann], exhib. cat., Cologne, Museum Ludwig, November 1999–March 2000

Photographics, exhib. cat., intro. by Marco Livingstone, London, Alan Cristea Gallery, 2000

Live in Your Head: Concept and Experiment in Britain 1965–75, exhib. cat. by Clive Phillpot and

Andrea Tarsia, London, Whitechapel Art Gallery, 4 February–2 April 2000

Blue: Borrowed and New, exhib. cat., curated by Peter Jenkinson, Walsall, The New Art Gallery Walsall, February–May 2000

Exhibition Catalogues: Artists
(alphabetical by artist)

Horst Antes: Recent Paintings and the Votive, exhib. cat., New York, Lefebre Gallery, 1984

Michael Peppiatt, *Francis Bacon: Anatomy of an Enigma*, London (Weidenfeld and Nicholson) 1996

David Sylvester, *Interviews with Francis Bacon, 1962–1979*, 2nd edn, London (Thames and Hudson) 1980

Georg Baselitz: Deutsche Bank Collection, exhib. cat. by Britte Färber, Ariane Grigoteit and Friedhelm Hütte, Moscow,

Chemnitz and Johannesburg, 1997–99

Caroline Tisdall, *Joseph Beuys: We Go This Way,* London (Violette Editions) 1998

Marco Livingstone, *Tony Bevan*, London (Michael Hue-Williams Fine Art) 1998

Prunella Clough, exhib. cat. by Judith Collins and Sacha Craddock, London, Camden Arts Centre, 1996

Maurice Cockrill, exhib. cat., preface by Margaret Drabble, London, Bernard Jacobson Gallery, 1992

Germano Celant, *Tony Cragg*, London (Thames and Hudson) 1996

Alan Davie: The Quest for the Miraculous, exhib. cat., ed. Michael Tucker, London, Barbican Art Gallery, 1993

John Davies, exhib. cat. by Norbert Lynton, New York, Marlborough Gallery, 1989

Sharmini Pereira (ed.),

342

Susan Derges: Liquid Form, intro. by Martin Kemp, London (Michael Hue-Williams Fine Art) 1999

Arturo Schwartz, *The Complete Works of Marcel Duchamp*, 2 vols., London (Thames and Hudson) 1997

Felim Egan, exhib. cat., ed. Jan Hein Sassen, Amsterdam, Stedelijk Museum, 1998

Felim Egan, exhib. cat., intro. by Alistair Smith, Dublin, Kerlin Gallery, 1990

Ralph Fleck, exhib. cat., intro by Katrin Zschirnt, ed. Axel Zimmerman, Munich, Galerie von Braunbehrens, 1997

Günther Förg, exhib. cat. by Christian Gether and Rune Gade, Ishøj, Arken Museum for Moderne Kunst, January–June 2000

Early Work: Lucian Freud, exhib. cat. by Richard Calvocoressi, Edinburgh, Scottish National Gallery of Modern Art, 18 January–13 April 1997

Gotthard Graubner, exhib. cat., ed. Hans Albert Peters and Katharina Schmidt, Baden Baden, Staatliche Kunsthalle, 1980

Friedemann Hahn, exhib. cat. by Jürgen Schilling, London, Flowers East, 1986

Friedemann Hahn: The Eye of the Seaman, exhib. cat. by Brian Kennedy, Belfast, Ulster Museum, 1996–97

Mona Hatoum: The Entire World as a Foreign Land, exhib. cat. by Stephen Deuchar, Edward W. Said and Sheena Wagstaff, London, Tate Gallery, 2000

Damien Hirst and Gordon Burn, *Damien Hirst: I Want To Spend the Rest of My Life Everywhere, With Everyone, One to One, Always, Forever, Now*, London (Booth-Clibborn Editions) 1997

Shirazeh Houshiary, exhib. cat., intro. by Lynne Cook, London, Lisson Gallery, 1984

Anselm Kiefer: Les Plaintes d'un Icare [curated by Nicholas Serota], exhib. cat., London, Whitechapel Art Gallery, 1981

Anselm Kiefer: Eleven Paintings 1976–1984, exhib. cat. by Mark Rosenthal, Tokyo, Entwhistle Japan, 1998

Ken Kiff: Paintings 1965–85, exhib. cat., ed. Alister Warman and Peggy Armstrong, London, Serpentine Gallery, *et al.,* 11 January–23 February 1986

R.B. Kitaj, *First Diasporist Manifesto,* London (Thames and Hudson) 1989

Yves Klein, *The Monochrome*, exhib. cat., New York, Leo Castelli Gallery, 11–29 April 1961

Leon Kossoff, exhib. cat., London, Tate Gallery, 1995

John Russell Taylor, *Bill Jacklin*, London (Phaidon) 1997

Richard Long: Walking in Circles, exhib. cat. by Anne Seymour, London, South Bank Centre, 1991

Richard Long: Old World, New World, exhib. cat., intro. by Anne Seymour, London, Anthony d'Offay Gallery, and Cologne, Walter König, 1988

Ian McKeever: Black and White … or how to paint with a hammer, exhib. cat. by Ian McKeever, London, Matt's Gallery, 1982

Ian McKeever: Paintings 1978–1990, exhib. cat., ed. Catherine Lampert, London, Whitechapel Art Gallery, 1990

Philip James, *Henry Moore on Sculpture*, New York (Da Capo), revised edn 1992

David Nash: Fletched over Ash, exhib. cat., London, Air Gallery, 1978

Fionnuala Ní Chiosáin, exhib. cat., intro. by Martin Steer, Dublin, Kerlin Gallery, November 1999–January 2000

Hughie O'Donoghue: Corp, exhib. cat., ed. Sarah Glennie, Dublin, Irish Museum of Modern Art, 1998

Markus Oehlen, exhib. cat., Cologne, Galerie Max Hetzler, 1985

Cornelia Parker, exhib. cat., ed. Jessica Morgan, Boston, The Institute of Contemporary Art, 2 February–9 April 2000

A.R. Penck, exhib. cat. by Lucius Grisebach, Thomas Kirchner, Jürgen Schwinebraden, Freiherr von Wichmann-Eichorn, Berlin, Nationalgalerie, 1988

A.R. Penck: Memory. Model. Memorial, exhib. cat. by Dieter Brunner, Siegfried Gohr, Arie Hartog, Pamela Kort, Christine Lutz and Hans Jürgen Schwalm, Deutsche Bank Luxembourg *et al.,* 1999

Gerhard Richter: The London Paintings, exhib. cat., intro. by Jill Lloyd, London, Anthony d'Offay Gallery, 11 March–16 April 1988

James Rosenquist: The Swimmer in the Econo-mist, exhib. cat. by Robert Rosenblum, Berlin, Deut-sche Guggenheim Berlin, 7 March–14 June 1998

Thomas Ruff, exhib. cat., intro. by Boris v. Brauchitsch, Frankfurt, Museum für Moderne Kunst, 1992

Sean Scully: Twenty Years, 1976–1995, exhib. cat. by Ned Rifkin, with contributions by Victoria Combalia, Lynne Cooke and Armin Zweite, Atlanta, High Museum of Art, *et al.*, October 1995–January 1996

Alice Stepanek/Steven Maslin, exhib. cat., intro. by Hans Irrek, Cologne, Johnen & Schöttle, *et al.*, 1997

Pier Luigi Tazzi, Jon Thompson and Peter Schjeldahl, *Richard Deacon*, London (Phaidon) 1995

Bill Viola: Unseen Images, exhib. cat. by Rolf Lauter, Marie Louise Syring and

Jörg Zutter, London, Whitechapel Art Gallery, *et al.*, 1993

Andy Warhol with Pat Hackett, *POPism: The Warhol '60s*, London (Hutchinson) 1981, reprinted London (Pimlico) 1996

Articles
(alphabetical by author)

Lawrence Alloway, 'US Modern Painting', *Art News & Review,* 21 January 1956, pp. 1–9

Sarah Barruso, 'Interview with Damien Hirst', *Hot Wired*, 11 June 1996

Georg Baselitz, 'Das Bild hinter der Leinwand ist keine Utopie', *Die Welt*, no. 267, 16 November 1987

Benjamin H.D. Buchloh, 'Figures of Authority, Ciphers of Regression: Notes on the Return of Representation in European Painting', *October*, 16, Spring 1981, p. 55

Diedrich Diederichsen, 'Albert Oehlen: The Rules of the Game', *Artforum,* November 1994, pp. 66–71

Wolfgang Max Faust, '"Du hast keine Chance. Nutze sie!" With It and Against It: Tendencies in Recent German Art', *Artforum*, September 1981, pp. 33–39

Richard Gott, 'Sexual in-tent', *Guardian Weekend*, 5 April 1997, pp. 27–33

Andrew Graham-Dixon, 'Damien Hirst, trader in sharks, entrails and butterflies is ONE STRANGE FISH in the art market' [interview], *Vogue*, March 1992, p. 212

Patrick Heron, 'The School of London', *The New Statesman & Nation*, 9 April 1949

Phillip King, 'My Sculpture', *Studio International,* June 1968, pp. 300–02

Sol LeWitt, 'Paragraphs on Conceptual Art', *Artforum*, Summer 1967, pp. 79–83

Douglas Maxwell, 'Anish Kapoor', *Art Monthly,* May 1990, p. 6

Craig Owens, 'Represen-tation, Appropriation, and Power', *Art in America,* May 1982, p. 9

Adrian Searle, 'Me, me, me, me', *The Guardian*, 22 April 1997, p. 13

Will Self, 'Tracey Emin: A Slave to Truth', *The Independent on Sunday*, 21 February 1999, pp. 6–8

Bernard Smith, 'Modernism in its Place', *Tate Magazine,* 21, pp. 81–82

G.R. Swenson, 'What is Pop Art?', *Art News,* November 1963, p. 24

Index, including all artists in Deutsche Bank London's collection

It has been possible to illustrate only the smallest fraction of the images in the bank's collection. It is a valid complaint against art history books that they show only the tip of the iceberg. Although the editors have tried to give an objective picture of contemporary art, borrowing illustrations from the bank around the world as well as key black-and-white text pictures from international collections, the book has been produced by Deutsche Bank London, and so, with the bank's art concept designed to encourage the support of national art, it naturally has a British perspective.

Below, within the index, we list all those artists in the London collection in order to emphasize that the art concept, as applied in London, is not primarily concerned with telling the recent history of British and German art, but in surrounding those working in the bank with art by their contemporaries. The history is only an attempt to make sense of it all.

345

346

Copyright

First published 2001 by
Merrell Publishers Limited
42 Southwark Street
London SE1 1UN
www.merrellpublishers.com
and
Deutsche Bank AG London
1 Great Winchester Street
London EC2BN 2DB

Distributed in the USA and Canada by Rizzoli
International Publications, Inc.
through St Martin's Press, 175 Fifth Avenue, New York,
New York 10010

British Library Cataloguing-in-Publication Data:
Hicks, Alistair
Art works : British and German contemporary art
1960–2000
1.Art, British 2.Art, German
3.Art, Modern – 20th century – Great Britain
4.Art, Modern – 20th century – Germany
I.Title II.Findlay, Mary III.Hütte, Friedhelm
709.4'1'09045

ISBN 1 85894 118 0

Co-ordinated on behalf of Deutsche Bank AG London
by Lucille Morris
Edited by Julian Honer
Designed by Peter B. Willberg
at Clarendon Road Studio, London

Produced by Merrell Publishers Limited
Printed and bound in Italy

Endpapers: Tony Cragg, *Secretions*, 1998
(detail; see p. 207)
Frontispiece: Ken Kiff, *Drawing a Curtain* (detail), 1980,
oil on canvas, 147 × 186 cm (58$\frac{1}{2}$ × 74 in.)

Deutsche Bank ◪

Collection